TIMES OF SORROW & HOPE

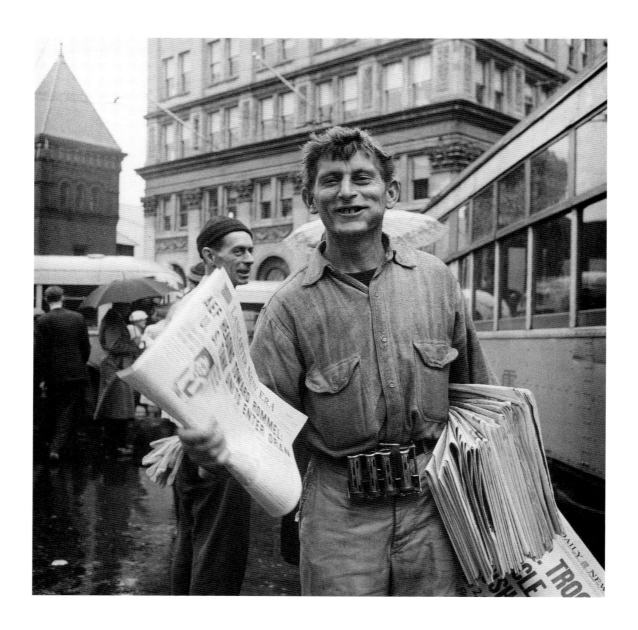

# Times of Sorrow & Hope

Documenting Everyday Life in Pennsylvania During the Depression and World War II

## A PHOTOGRAPHIC RECORD

Allen Cohen and Ronald L. Filippelli

With a Foreword by Miles Orvell

THE PENNSYLVANIA STATE UNIVERSITY PRESS | UNIVERSITY PARK, PENNSYLVANIA

A KEYSTONE BOOK

A KEYSTONE BOOK

A Keystone Book is so designated to distinguish it from the typical scholarly mono-
graph that a university press publishes. It is a book intended to serve the citizens of
Pennsylvania by educating them and others, in an entertaining way, about aspects
of the history, culture, society, and environment of the state as part of the Middle
Atlantic region.

Library of Congress Cataloging-in-Publication Data

Times of sorrow and hope : documenting everyday life in Pennsylvania during the
 Depression and World War II : a photographic record / [compiled by] Allen Cohen
 and Ronald L. Filippelli ; with a foreword by Miles Orvell.
    p.    cm.
 Includes bibliographical references.
 ISBN 0-271-02252-3 (cloth : alk. paper)
 1. Pennsylvania—Social life and customs—20th century—Pictorial works.
 2. Pennsylvania—Social conditions—20th century—Pictorial works.
 3. New Deal, 1933–1939—Pennsylvania—Pictorial works.
 4. World War, 1939–1945—Pennsylvania—Pictorial works.
 5. Documentary photography—Pennsylvania.
 I. Cohen, Allen 1935– . II. Filippelli, Ronald L.

F154 .T56 2003
974.8'042—dc21                                              2002152273

It is the policy of The Pennsylvania State University Press to use acid-free paper.
Publications on uncoated stock satisfy the minimum requirements of American
National Standard for Information Sciences—Permanence of Paper for Printed
Library Materials, ANSI Z39.48–1992.

*Frontispiece:* Newsboy at Center Square on a rainy market day. Lancaster, November
1942. Marjory Collins.

*Jacket illustrations:* Flag Day. Pittsburgh, June 1941. John Vachon (front); Polish family
living on High Street. Mauch Chunk, August 1940. Jack Delano (back).

For Hinda, my wife, whose fortitude and patience made it all possible,
and in memory of my brother Richard, who while a schoolteacher was also a dedicated photographer.
—*Allen Cohen*

For Sandy, Ron, Paul, and Rachel, my Pennsylvanians.
—*Ronald Filippelli*

# CONTENTS

# FOREWORD

THE DOCUMENTARY PHOTOGRAPHY project initiated by the Farm Security Administration in 1935 was an unprecedented experiment in the history of photography, and it remains a monument to a collective effort that will never be equaled—the recording of an entire nation, from the city and town to the farm, from the home to the factory, from work to leisure, from school to church, from the baseball field to the movies. Looking back on this effort now, well more than sixty years later, we can appreciate the full scope of the project and see more clearly what was at stake and how it related to the history and tradition of documentary photography.

The camera has, from the beginning, recorded the actuality of life, including urban and rural social conditions. Such observations, however, were accidental, picked up by the eye of the camera as it sought to record and memorialize everyday life. The deliberate and programmatic recording of social conditions would wait until the 1880s and 1890s, when Jacob Riis undertook a more systematic exposure of conditions in the tenements and slums of the Lower East Side of New York City. Riis was followed by Lewis Hine shortly after the turn of the last century; Hine photographed immigrants at Ellis Island and factory workers in Pittsburgh as well as the lower strata of urban society in Boston and New York. As Alan Trachtenberg has argued, Hine's work for *The Survey,* a Progressive magazine, "reflected a new idea in the reform movement," a shift away from individual pauperism to the more systemic problems (e.g., child labor) "which required legislative intervention and professional expertise."[1] Even the magazine's name—*The Survey*—suggested this more synoptic approach, confirming Allan Sekula's observation that the archive, the effort to construct a complete catalog or description, became "the dominant institutional basis for photographic meaning" around the turn of the twentieth century.[2]

By the 1920s, though, the leading edge of the Progressive movement had become blunted in the face of growing anti-immigrant sentiment after World War I and a chauvinistic politics that wanted to exclude foreign elements. Hine, with his liberal attitudes and documentary strategies, was marginalized, while the more self-consciously avant-garde modernist photographers—influenced by the innovative European art movements emanating from Germany and France—created a new space for photography within the art world. Alfred Stieglitz and Paul Strand were in the ascendant now, and the mood of photography, influenced by the strong example of Cubism, was to cultivate form for its own sake. Transforming the everyday objects of the immediate urban environment, Stieglitz, Strand, Alvin Langdon Coburn, and Edward Weston constructed an abstract photography that favored the fragment, the close-up, the studious meditation on the thing itself. The modernists were also exalting photography as the art of the moment, of freezing time in ways that provided exciting juxtapositions, elegant formal matches, and the discovery of form in the natural world.

The stock-market crash of 1929 and the economic depression that followed it placed everything in a new light. Silent factories, growing unemployment, and breadlines created widespread fear as the Depression continued and Americans began to look for apocalyptic solutions. There was no apocalypse, but the election of Franklin Delano Roosevelt in 1932 heralded a gradual restoration of confidence in the American system of government. Roosevelt brought with him a host of new faces, new talents, and new ideas, among them the creation of federal agencies that would employ the unemployed—including, to everyone's surprise, artists, writers, musicians, performers, editors, and photographers. The government also went into the business of providing information about its own programs, a move designed to promote support for farm subsidies, land conservation, dam control, and a host of other beneficial projects. (Today we would call this effort propaganda, but in the 1930s the term did not have its negative post–World War II connotation.) Leading that effort was the Farm Security Administration, which saw the great potential that visual portrayals—through photography and film—might have. At the head of the FSA's historical division was the pivotal figure of the 1930s documentary movement, Roy Stryker, who had been brought to the agency by Rexford Tugwell, Roosevelt's close advisor.

Stryker worked with about a dozen photographers at any given time, assigning them to different regions across the United States. They went equipped with background information and "shooting scripts" that gave detailed instructions on what material was needed. The resulting images were made available, free of charge, to news magazines and newspapers and for local exhibitions. The FSA archive—about 164,000 black-and-white images and about 1,600 color slides—may be the greatest collection in photographic history.

The ostensible motive of the FSA photographers was to gather images relating to the agricultural policies of the government, but in practice, Stryker and his crew quickly developed a much broader conception of their documentary project. They set out to render a sociological portrait of American life, across classes, in urban and rural areas—a portrait guided consciously by the sociological approach of Robert Lynd, whose *Middletown* had been a pioneering ethnography of an American city. The FSA's ambitious aims were captured in an interoffice memo written by John Vachon, who (with Stryker's encouragement) was starting out as a photographer while working as the archivist of the FSA files:

The statement that photography is the medium best suited to true documentation can no longer be challenged. Still photography, not cinematic, is the most impersonal and truthful device yet perfected for factual recording. It is able to include the widest range of subject matter and employ the least plastic materials of all the arts. In still photography the artist's material is one simple phenomenon,—the splash of light on a sensitized emulsion.

The camera, then, intelligently used, should leave for the future a very living document of our age, of what people of today look like, of what they do and build. It should be a monumental document comparable to the tombs of Egyptian Pharoahs [*sic*], or to the Greek Temples, but far more accurate.

Such a body of work is the well organized, intelligently selected and edited file of photographs. The most important, perhaps the only important file of this sort is the FSA collection in Washington, D.C.[3]

Eschewing in this memorandum any overt political purpose, Vachon argued for a more lofty, comprehensive perspective: "While accepting limits of detail, the documentary file should accept no general limits. It should not portray exclusively either the rural scene or the urban scene, lower classes or upper classes. It should be like the philosopher, who without a profound knowledge of all special sciences, yet includes and understands them all." Vachon's youthful memo expresses some of the excitement and sense of purpose that infused the FSA photographers as they fanned out across the country in search of pictures that would definitively portray America's present conditions.

The young photographers Stryker gathered around him were to revive the dormant tradition of documentary photography that Hine had championed (they knew Hine's work, as did Stryker, of course). They had also been schooled, however, in the aesthetics of modernism. Though they remained adamantly committed to documentary, this younger generation of photographers—Dorothea Lange and Jack Delano, Ben Shahn and Arthur Rothstein, John Vachon and Marjory Collins—was stylistically more self-conscious than the relatively straightforward Riis and Hine. Only Walker Evans, in this group, had a notable prior reputation. Evans had begun his career in the late twenties, and his early work—close-ups of commercial signs, fragments of buildings, architectural studies, street snapshots—revealed his mastery of the modernist idiom of abstraction as well as his interest in capturing the flow of urban life. Bringing these resources into his work for Stryker, Evans produced images that had an elegance of composition and technical brilliance. He favored architectural images and landscapes, his eye alert for formal resonances—repetitions, contrasts—within the image and for the odd detail of signage or furnishings. He excelled as well in the portrait.

Two of Evans's best-known works are part of the Pennsylvania FSA archive and are included in the present volume. "Johnstown housing" (December 1935) and "Bethlehem graveyard and steel mill" (November 1935), both taken with Evans's 8 × 10 view camera with a long depth of field, fill the frame up to the edges, with everything in focus, from the foreground to the background. The result is a radical foreshortening of the picture plane and the creation of patterns through the juxtaposition of objects in space, objects brought close together in the photograph. The pattern created by the houses in "Johnstown housing" is straightforward enough; in "Bethlehem graveyard and steel mill," however, the juxtaposition of the cemetery cross in the foreground and the workers' housing in the middle ground against the steel mills in the background gives to the scene a compressed symbolic quality, as if to sum up the living and dying of this town within the ruling structure of the steel industry.

Two other well-known Evans images in the Pennsylvania FSA archive also appeared, in more severely cropped versions, in Evans's classic *American Photographs* (1938), and they are reproduced here: "Legionnaire" (Bethlehem, November 1935) and "Sons of American Legion" (Bethlehem, November 1935).

Looking at the "American Memory" Library of Congress Web site, which offers on-line versions of most of the FSA prints, one can see that Evans took about a half-dozen images of this Bethlehem parade with a 35 mm camera (thus affording him mobility and speed). The first shot in the series shows the formidable legionnaire as Evans initially saw him—part of a larger group of legionnaires who were informally clustering around him. Evans must have closed in to get this close-up, provoking the glowering and disapproving stare of the sternly patriotic, proudly decorated veteran. The subsequent frame captures the boys in caps, bored and waiting for some action, trying to look the part of junior legionnaires but so far still in the training stage.

Patriotism and the flag figure as themes in several other photographs in this collection, especially those taken by Marjory Collins in 1942. By then, the United States was in the war, and home-front activity is visible not only in displays of loyalty but also in the work performed by women in jobs that would normally have gone to men—working on the Pennsylvania Railroad, in factories, or at filling stations. Such pictures might have come from anywhere in the United States during these late Depression years, but others in this collection give us a portrait of a specific region and a particular state.

This state—Pennsylvania—was anything but a single unit, as the photographs reveal. During the 1930s, regional differences were more distinct; since then, they have been blurred to some extent by suburbanization. For one, the farming industry and the family farm were far more important to the overall Pennsylvania economy than at present. How deeply Pennsylvania farmers suffered the strain of the Depression is clear in Marion Post Wolcott's

photographs of York County farm auctions in 1939. In some ways, the images of the Amish and Mennonites serve as a counterpoint to the depiction of Pennsylvania more generally, for their perpetually conservative way of life, from dress and custom to religion and technology, vividly contrasts with the changes in fashion and the vicissitudes of life outside these communities. But even the Amish and Mennonites were not immune to the downturns of the Depression, as one can see in the depictions of farm auctions in 1942 by Marjory Collins and Jack Collier. Throughout this period strife and labor conflict also featured in Pennsylvania life, and though such conflicts seldom appear in the FSA archive, we do see them in an image such as John Vachon's portrayal of the strikebreakers at the King Farm near Morrisville in 1938.

The industrial state of Pennsylvania is also made visible here. The mining regions dominated western Pennsylvania, and the photographs by Carl Mydans, Ben Shahn, Jack Delano, and John Collier reveal workers caught up in a massive industrial machine confronted by a determined John L. Lewis, president of the United Mine Workers of America from 1920 to 1960. Meanwhile, Jack Delano's 1941 photographs of the Bethlehem and Aliquippa steel mills show us an industry gearing up for war production. Pittsburgh, the industrial anchor of western Pennsylvania, is here portrayed with its factories lining the riverfront, a city of production. At the eastern end of the state, the tall towers of Philadelphia in Paul Vanderbilt's images represent the city as a bastion of financial power.

We also see, amid the deprivations, the pleasures that remained for Depression-era Pennsylvania: fiddling, baseball,

dancing, and drinking, the full table at the Lancaster farm in Sheldon Dick's 1938 photo, the customers portrayed by Jack Delano shopping at a cooperative farmers' market in 1940. But holding it all together, at the center, are the images of family, none more symbolic of the American ideal than the 1942 Neffsville Thanksgiving photographed by Marjory Collins.

The documentary photographers framing these images of Pennsylvania were working within a generally understood notion of what documentary photography was—a vision articulated by Stryker and embodied in the practice of the various leading photographers in the group. For images of the rural landscape, the FSA photographers might be governed by pictorial conventions derived from painting (e.g., a centered composition, framed by natural elements). For images of the modern city and modern industry, they might draw on the more recent aesthetic conventions of Precisionism, with hard edges and geometric lines creating an abstract design within the picture frame. Or—as with Evans—they might create within a more purely photographic aesthetic, taking advantage of the peculiar way things look when they are photographed.

Human subjects dominate the FSA archive, in which we find three basic approaches to photographing people: (1) candid images, in which the action is taken by the photographer with the subject generally unaware of his or her presence, although in a few cases the subject seems suddenly aware of the camera; (2) posed portraits (the most frequent type of image), in which the subject is obviously aware of the camera and is looking at it, composing him- or herself under the direction of the photographer; and (3) the posed dramatic image, in which the subject is positioned by the photographer so as to represent some "typical" action, feeling, or gesture. Documentary photographers were, more often than not, directing the picture in order to achieve the appearance of "truth" or to gain the desired appearance of a generalized type that the portrait might reveal.

There are so many vital images in this collection of Pennsylvania photography that it is difficult to select just a few to hold up to closer view. Ben Shahn's 1937 "Man gathering good coal from the slag heaps at Nanty Glo" offers a visceral sense of the man's perilous angle; Sheldon Dick's "Second shaft tower at Maple Hill mine as seen from the first tower" (1938?) beautifully uses the foreground structure to divide the picture beyond it into geometric segments. John Collier's "Mennonite girls waiting for 'Deutsch School' to begin in Mennonite church" (1942) is an elegant study of the group of girls in their traditional dress, framed by the strict lines of the corner. Esther Bubley's 1943 studies of the Pittsburgh bus terminal capture the posture and attitudes of impatient patience. Jack Delano's portrait of the tinplate worker (1941), who is seen in profile with his head turned toward us, is a striking composition, the man's gaze fixed unalterably on the camera and the viewer; another of Delano's tinplate workers holds a balletic pose, the steam rising off the forge to the right. And—to close a catalog that might go on and on—Marjory Collins's curbside sewing machine in Lititz (1942) has an almost surreal presence, framed perfectly within the perspective lines of the sidewalk.

The FSA photographers were, of course, beneficiaries of the Roosevelt administration, and most of them felt in full sympathy with its new definitions of the role of government in our lives

and with its goals of social welfare. But—to place them in the larger context of social documentary of the time—they were surely to the right of the more deliberately leftist Photo League. Emerging in 1936 out of the Workers' Film and Photo League, an earlier leftist organization whose purpose was to promote the workers' struggle, the Photo League was a self-supporting photo school, gallery, and camera club based in New York City and headed by Sol Libsohn and Sid Grossman. Given the generally leftist tenor of the times, the Photo League managed to enlist an older generation of photographers (e.g., Hine, Strand, Weston) along with younger photographers including Ansel Adams, Richard Avedon, Helen Levitt, Lisette Model, and Walter Rosenblum. Seeking subjects outside of the idealized imagery of "advertised America," the Photo League featured scenes of urban life regularly ignored by the media, such as Aaron Siskind's study of Harlem. Following a triumphant exhibition in 1948 entitled "This Is the Photo League," the organization fell victim to the paranoid political climate of the postwar years, and—in the face of accusations of communist influence—the group disbanded in 1951. Their work would be virtually forgotten until its rediscovery in the 1980s.

But the Photo League was certainly not the only cultural organization to fall before the anticommunist right. To Congressional Republicans, the federal arts programs and the photography project of the FSA were themselves just short of communist; eventually, the Republicans succeeded in shutting down the New Deal and dismantling the various agencies of the Roosevelt era. Roy Stryker, seeing the writing on the wall, made arrangements to have the FSA file (which had become in 1942 the Farm Security Administration–Office of War Information file) shifted to the Library of Congress for storage and safekeeping. Ironically, the major effort of the FSA-OWI group at that time was to present an idealized vision of America, one that would rally the troops and the home front in support of the battles abroad.

Despite its official termination, the FSA effort continued, in a way, into the forties, when Stryker moved his operations to private industry and began to work for the Standard Oil Company. He managed to pull together a team of photographers, many from the FSA years, who would sustain the documenting of America (enlarging their sphere to incorporate South as well as North America) in order to portray the ramifications of the oil industry in our lives, from production to consumption. In effect, it was another grand opportunity to construct a visual sociology of American life, one paid for by an oil company looking for improved public relations. Mainstream magazines, too—*Life, Look,* and *Fortune,* for example—employed a number of former FSA photographers in the forties and fifties as they evolved and perfected the concept of the narrative picture story.

The spirit of the FSA movement reached a kind of apogee in the *Family of Man* exhibition organized by Edward Steichen at the Museum of Modern Art in 1955.[4] Steichen, by then the curator of photography at the Modern, had seen the FSA show at Grand Central Station in 1938 and had been impressed by the power of documentary photography to portray a national condition and move people's emotions. During the recovery period after World War II, Steichen conceived the idea of developing a similar show on a global scale, one that would articulate a vision of common interest within a world of difference and promote

the peaceful coexistence of nations. Putting out a universal call for images, Steichen, with Wayne Miller's help, selected 503 images taken by 273 photographers. In addition, Steichen culled images from the files of the FSA and the National Archives in Washington; he went to *Life* magazine as well. The result—perhaps the most popular photography show ever—featured a selection of images from sixty-eight countries that was shaped by the tradition of American FSA documentary photography as well as by the Henri Cartier-Bresson tradition of the "decisive moment," which was also at that time very influential and was giving rise to a new generation of street photographers. Under the auspices of the United States Information Agency, *The Family of Man* toured Europe, Asia, Africa, and Russia.

But just as *The Family of Man* was proclaiming its consensus vision of America and of the world, Robert Frank was traveling the country, creating what would become a classic of dissensus—*The Americans*. His book would take social observation and documentary photography in a more subjective direction, signaling a

skepticism about American society and American prejudices that would open the door to a range of social commentary and description in the decades to follow. Though the FSA under Stryker was striving for a coherent vision, one can find the seeds of Frank's work and that of other social documentary photographers in the exemplary images by Walker Evans and his FSA colleagues.

Pennsylvania—with its mix of cities and small towns, its rural and wilderness areas, its mining industries and rich farming areas, its financial and cultural centers—has always offered a microcosm of American life. The Pennsylvania FSA photographs constitute a record of America at a crucial turning point in its history, a nation struggling to survive the worst economic depression of the twentieth century. Because of their great artistic value, these photographs are a record worth looking at again and again.

—*Miles Orvell*

# PREFACE AND ACKNOWLEDGMENTS

THIS BOOK AROSE from our interest in Ben Shahn, the artist—and our discovery that he was also one of the photographers employed by the Farm Security Administration (FSA) project to take photographs in different parts of the country during the Great Depression. The FSA—in its earlier guise as the Resettlement Administration (RA)—functioned between 1935 and 1942. During the war years of 1942–43, the photographic project continued under the administration of the Office of War Information (OWI). Over those eight years, photographers ranged across the country, documenting how Americans endured and overcame economic hardship and wartime demands.

Eventually the original negatives of the FSA-OWI images were deposited at the Library of Congress. For many years, those who hoped to see the thousands of FSA-OWI photographs had to make the trip to the Prints and Photographs Division of the Library of Congress in Washington, D.C. Our visits to Washington to have a look at Ben Shahn's photographs also introduced us to the rich body of work that had been created by other documentary photographers during the Depression and the war years. Pennsylvania was well represented among the images. Given the complex industrial, agricultural, and social history of the state, we felt sure that a comprehensive work must have been published on the FSA-OWI in Pennsylvania. We found, however, that this was not the case, and the idea for such a book began to germinate.

A number of years later—years in which we were occupied with other projects—we returned to the idea of a book on the FSA-OWI project in Pennsylvania. Still no book had been published. Some books dealt with the photographic project in other states, but none of them was as complete as the one we planned for the Keystone State. We meant ours to include a comprehensive catalog of all the photographs taken in Pennsylvania—an idea that seemed deceptively simple at the beginning but proved to be a massive and challenging undertaking. Fortunately, Penn State Press saw merit in our vision and became our partner in the enterprise.

We estimate that about 6,000 photographs were taken in Pennsylvania. It became apparent that a comprehensive catalog of the photographs would be quite substantial. When the initial manuscript of the catalog grew to 425 printed pages, we decided that it made more sense to make the catalog available on-line through the Web site of the Pennsylvania State University Libraries. In the age of the Internet, this decision was fortuitous: experience has already shown that this catalog, like so many others, is a living thing that requires changes, corrections, and additions. Obviously such emendations are much easier to effect with an on-line product than a printed one.

The book itself includes an introduction by Miles Orvell, Professor of English and American Studies at Temple University; an essay on the FSA-OWI project in Pennsylvania; and an essay on

the Keystone State during the Great Depression and World War II. There are also brief biographies of some of the photographers, an introduction to the on-line catalog, some indexes to the on-line catalog, and a bibliography.

Of course, the photographs are the heart of the project. From the thousands of photographs taken in the state, we have selected 150 examples for the book—and their selection posed a major challenge. (A perusal of the various indexes to the on-line catalog reveals the extent of the photographers' work.) Some of these photographs have reached almost iconic status among historians and have become highly collectible, though it is doubtful that the photographers thought of themselves as artists when they were working in the field. Yet much of what they produced deserves to be treated as art under almost any definition of the term.

We hope that this book will be not only a contribution to the literature on Pennsylvania but also an introduction to the rich resources that are available through this vast collection of photographs. The photographers captured life in America as it existed then, and perhaps, sadly, still exists in some form.

Many people provided invaluable assistance in making this catalog possible. Thanks to Mary Ison, Head of Reference, and her staff, and Beverly Brannan, Photo-Archivist, Library of Congress Prints and Photographs Division, as well as Nancy Velez, Head of the Library of Congress Photoduplication Service, and her staff; to Julie Van Haflin, Head, Sharon Frost, Photo-Archivist, and Devon Cummings, Photography Specialist, all of the New York Public Library's Photography Collection; to Jenna Webster, Curatorial Assistant of the Ben Shahn Archive, Department of Photographs, Fogg Art Museum, Harvard University; to Amy Purcell, Associate Curator of the Roy Stryker Papers, University of Louisville; to Jeff Rosenheim, Assistant Curator in the Department of Photographs, Walker Evans Archive, Metropolitan Museum of Art, New York, and Mia Fineman, Department of Photographs Study Room Manager, also of the Metropolitan Museum of Art; to Lynette Korenic, former Head, and Susan Moon, current Head, and the staff of the Arts Library, University of California, Santa Barbara; to Gary Johnson and his staff, Interlibrary Loans, Davidson Library, University of California, Santa Barbara; to the library staff at the Brooks Institute of Photography in Santa Barbara; to Sandra Stelts, Bonnie MacEwan, Roberta Astroff, Lois Green, Elizabeth Gross, Elizabeth Mazzolini, and Rebecca Spitler, as well as the staff of the Government Documents Department of the Pennsylvania State University Libraries; and to Baiba Breidis of the Research Office of the College of the Liberal Arts at Penn State. Susan Lentz, Arts Cataloger and Reference Librarian at the University of California, Santa Barbara, was instrumental in having the Library acquire for their collections the microfilm edition of the FSA-OWI photographs, thus making that Library an important research center for study in this area: the Library now holds the FSA-OWI fiche and microfilm editions of photographs and written records as well as the Roy Stryker Papers on microforms. Special thanks go to Raymond Lombra, Associate Dean for Research of the College of the Liberal Arts at Penn State, and the College's Research and Graduate Studies Office for support, as well as to Peter Potter, Editor-in-Chief, who envisioned the need for such a work, Tim Holsopple, Editorial Assistant, and Laura Reed-Morrisson, Manuscript Editor, all of the Pennsylvania State University Press. Their hard work and guidance made the publication of this book possible.

All of the photographs in this book appear courtesy of the Library of Congress.

# Pennsylvania from Depression to War

THINGS LOOKED SO promising across America in the fall of 1928 that President Herbert Hoover confidently declared, "we in America today are nearer to the final triumph over poverty than ever before in the history of our land." "The poorhouse," he added, "is vanishing from among us."[1] Less than a year later, those words rang hollow for millions of Americans. Black Thursday, the stock-market crash of October 24, 1929, signaled the descent of the United States into the worst depression in the history of the modern industrial world. By mid-November, the standard statistical index of common stock prices had declined 39 percent from its September peak, and the value of all shares on the New York Stock Exchange had fallen by nearly $26 billion.

The Depression took a catastrophic toll on total national income, which dropped 54 percent between 1929 and 1933, a period during which the business failure rate soared by 50 percent. Corporate profits before taxes declined by two-thirds in 1930 and turned into huge losses by 1932. Attempts to soften the impact on workers through shorter hours and share-the-work schemes failed. Wage cuts soon became widespread. By 1933, almost 87 percent of businesses had lowered wages by an average of 18 percent from their 1929 levels. Total income in the form of wages and salaries dropped 42.5 percent between 1929 and 1933. Construction workers lost 75 percent, those in mining 55 percent, and workers in manufacturing as a whole suffered a 51 percent wage loss. Much of this reflected part-time employment.

A March 1932 survey of more than 6,500 companies in all branches of industry revealed that less than 26 percent of the firms operated full-time.

Still, fewer hours and lower wages were better than none at all. Those still working were the lucky ones. By 1933, 24.9 percent of the labor force had no work. The unemployment rate declined only slowly throughout the 1930s; it remained above 20 percent in 1934 and 1935, and in no year before 1941 did it fall below 14 percent.

Pennsylvania, an industrial giant in the early stages of a long relative decline, was especially vulnerable to the shock of the Depression. Iron and steel, manufacturing, mining, construction, and railroads—all pillars of Pennsylvania's economy—suffered staggering losses. Although the state still housed one of the nation's largest rural populations, nearly a million Pennsylvanians labored in small and large manufacturing plants. Indeed, Pennsylvania boasted 17,314 industrial establishments; only New York State had more.

The economic storm hit a state that had not participated much in the postwar boom of the 1920s. Pennsylvania's share of the nation's iron and steel production continued to shrink. Automobile manufacturing, the growth industry of the 1920s, largely bypassed the state, depriving Pennsylvanians of the many skilled jobs that the industry and its suppliers provided. (Automobiles also competed with the Pennsylvania Railroad, one of the state's

economic giants and largest employers.) A similar pattern emerged in the coal mining industry. The war had led to a dramatic increase in mining capacity. After the armistice, however, the newer, lower-cost, nonunion mines in West Virginia, Kentucky, and Alabama captured a growing share of a smaller market. Additionally, the rise of oil as a home heating fuel had a catastrophic impact on the demand for northeastern Pennsylvania's anthracite coal. The industry produced a record one hundred million tons of anthracite in 1917 and employed 180,000 anthracite miners when the war in Europe began. By the eve of the Great Depression, production had declined by a quarter and employment by 17 percent. A similar story unfolded in the bituminous regions, where employment dropped by 32 percent between 1918 and 1929. The textile industry, the state's major employer (particularly in Philadelphia and other eastern cities such as Reading and Allentown), saw orders go increasingly to the South, where wages were from 25 to 60 percent lower.

Although Pennsylvania remained the second state in the value of its manufactured goods throughout the twenties—with Philadelphia and Pittsburgh the nation's third and sixth industrial cities—the annual rate of growth during the decade amounted to only 0.1 percent, placing Pennsylvania twenty-third among the twenty-five industrial states. And Pittsburgh, in particular, depended on a limited range of heavy industry, which caused it to suffer even more than some other parts of the state. Primarily a coal and steel town, Pittsburgh lacked the industrial diversity and new industries that would help offset the decline. Unemployment in Pittsburgh just before the crash in 1929 stood at nearly 10 percent. In addition, the city had long been plagued with all the evils of untrammeled industrial growth: it faced unplanned building sprawl, congested streets, and polluted rivers. Whole neighborhoods where steelworkers lived were without plumbing and furnaces. The environs of the city were no better. On a trip through Westmoreland County in 1927, H. L. Mencken commented on the contrasts of a region that was the very heart of industrial America: "Here was wealth beyond computation, almost beyond imagination—and here were human habitations so abominable that they would have disgraced a race of alley cats. I am not speaking of mere filth. One expects steel towns to be dirty. What I allude to is the unbroken and agonizing ugliness, the sheer revolting monstrousness, of every house in sight."[2]

In Philadelphia, manufacturers managed to maintain a slow rate of growth. The Quaker City differed from Pittsburgh in the diversity of its economy. Its mills and factories, too, were smaller, and spread across more industries. But the migration of manufacturing, particularly textiles, to other parts of the country hurt Philadelphia. So did the conservative nature of the traditional elite that controlled the city's industries, always slow to adopt new technology and new ways of doing business. The city's relative decline had begun as early as 1890, and the twenties did little to arrest that trend.

Fortunately for Pennsylvania, agriculture was a more steady industry. Diversification and accessible markets in the densely populated northeastern United States produced a reasonably stable income. While dirt farming suffered in the twenties, dairy farming, the state's most important branch of agriculture, persevered. Nevertheless, corn and wheat prices during the twenties fell by nearly half and wholesale milk prices by a quarter. Despite

the prosperity of the twenties in much of the country, Pennsylvania clearly did little more than hold its own.

The physical characteristics of the Commonwealth and the subsequent course of its economic development conspired to create circumstances in which the Great Depression would lead not only to unimaginable suffering but also to fundamental political and social reform and modernization. Pennsylvania had been blessed with an abundance of the raw materials that made her the nation's workshop for nearly two centuries. The bituminous coalfields of central and western Pennsylvania lie at the northernmost extension of the great Appalachian coalfield; northeastern Pennsylvania boasts one of the world's richest deposits of anthracite coal. In the Lehigh Valley, vast deposits of limestone became the basis of the nation's cement industry. Along with Pennsylvania coal, rich iron ore deposits at Cornwall in Lebanon County and in the Juniata Valley launched the iron and steel industries. Abundant timber, particularly the white pine and hemlock forests of north-central Pennsylvania, provided a rich source of tannin for the leather industry. Oil and natural gas deposits enriched the northwestern and western regions of the state.

The economic development of the state followed the dictates of this mineral wealth. The cities developed as manufacturing centers: they were characterized by mill districts surrounded by ethnically and racially segregated neighborhoods in which workers were bound to one employer and a few trades with strong loyalties to family, church, ethnic group, and trade union. Although Pittsburgh and Philadelphia were the metropolises, a plethora of smaller industrial cities (e.g., Erie, Allentown,

Reading, McKeesport, and Johnstown) and a host of small mill and mining towns dotted the state. The decentralization of the population into regional groupings allowed for political, economic, and social domination by powerful industrial and financial barons. Their control over towns and industries came as close to feudalism as could be imagined in the midst of an industrial capitalist economy.

By the time of the Great Depression, the northward migration of black southerners added another dimension to the spatial and demographic isolation of Pennsylvania communities and their citizens. It produced segregated neighborhoods marked by poverty and discrimination in many Pennsylvania cities and mill towns. Racial bias in work assignments and promotions limited the occupational mobility of black workers, leaving them to do hard, hot, dirty work in the mills and mines. When the Depression came, black people were the first laid off and the last rehired if production resumed. Race, therefore, became an asset of tremendous importance to white workers in times of job scarcity. Unions often reacted to competition for jobs with exclusionary tactics, and employers used desperate black workers as strikebreakers and low-wage competition to keep their employees docile.

Nowhere was this almost feudal system more apparent than in the company-owned coal towns of Pennsylvania. As the coal industry spread across the state in the late 1800s, companies built their own villages (or "patches") in isolated valleys and ran them as fiefdoms. Coal and iron police, legal in Pennsylvania after 1866, controlled the towns. Called "Cossacks" by the Slavic miners, they enforced the private laws of the mine owners: they

possessed all the authority of normal police forces and were also charged to "expedite the production of coal and maintain a peaceful community."[3] This consisted of spying on and blacklisting union activists, protecting strikebreakers, deporting "troublemakers," and other police-state activities. The towns they ruled were grim collections of identical mean wooden structures without indoor plumbing, lighted by kerosene, and packed with miners and their families. By 1929, over 1,200 such blighted communities dotted the Pennsylvania landscape and sheltered more than 300,000 residents. Thousands more lived in mill-town equivalents in the steel valleys of western Pennsylvania. As a result, Pennsylvania harbored a huge, fragmented population, both urban and rural, that had little or no exposure to the modernizing trends that had marked much of the United States after the Industrial Revolution, World War I, and the Progressive Era.

If Pennsylvania did not share equally in the prosperity of the 1920s, it certainly shared fully in the poverty of the 1930s. The Great Depression shattered Pennsylvania's deteriorating economy. The state's concentration in mining, manufacturing, and transportation exposed workers to the Depression's full force. By 1932, industrial production had withered to less than half of its 1929 level. The value of the state's mineral products dropped from $872 million in 1929 to $405 million in 1933. Between 1927 and 1932 more than 5,000 manufacturing establishments closed. Bituminous coal production fell by half. Practically every industry had the same experience—and aggregate wages plummeted with production. They fell by half in textiles and by over two-thirds in the metals industries. By March 1933, unemployment peaked at an astonishing 37 percent of the labor force. Almost a

million and a half Pennsylvanians lost their jobs. As a result, per capita income fell from $775 in 1929 to $421 in 1933.

The impact of joblessness, reduced working hours, and pay loss was devastating. As families used up their life savings and fell behind on rent and mortgage payments, many lost their homes. More than 91,500 Philadelphia homes fell under the sheriff's hammer between 1928 and 1933. Some groups were hit harder than others. Employers often laid off young workers (women, in particular) before older workers, because they favored heads of households over single men and women. Black workers suffered disproportionately. As poverty deepened, working-class people survived by scavenging, begging, and selling produce and pencils on street corners. The leisure activities of hunting and fishing became ways to stay alive in rural areas. In the coal regions, families tunneled into veins of coal that companies had deemed unprofitable. Sympathetic local authorities often looked the other way when mining companies tried to stop the illegal "bootlegging." No wonder. Some miners' families subsisted wholly on dried beans and coarse bread, the children never knowing the taste of cow's milk. One coal-town physician said that young people were literally dying from hunger before his eyes. A coal-company president agreed: "I am sorry to admit it, but the children are starving in our coal district."[4]

Agricultural areas also languished. Farm prices throughout the nation dropped more than 50 percent. Pennsylvania corn, which sold at $1.69 a bushel in the boom year of 1919, brought only 43 cents in 1931. In all, the crisis slashed Pennsylvania farmers' total cash receipts by 46 percent in the first three years of the Depression. Thirty-seven percent of the workforce in rural

Fayette County had no work by 1934, and in one heavily agricultural county, medical services had so broken down that one public service nurse delivered sixty-seven babies.

Not surprisingly, Pennsylvania harbored one of America's largest relief populations. By 1932, state relief administrators claimed that more than 324,000 families, or close to two million people, were on the dole. Although the cities were hardest hit—more than 18 percent of Pittsburgh families and 11 percent of those in Philadelphia were on relief—many of the state's small towns and rural areas also suffered horribly.

## The Political Response

The misery of the Depression gave rise to a chaotic political decade in which millions across the nation moved in and out of various radical and reform movements. Political candidates from right to left attracted large, if often temporary, followings. Senator Huey Long of Louisiana's "Share the Wealth" program offered everyone a guaranteed income of $2,500 a year. "Every man a king" was Long's slogan. L. W. Allen's "Ham and Eggs" movement promised $30 every Thursday for every unemployed or retired person over fifty. Dr. Francis Townsend's national recovery plan presaged Social Security by promising $200 a month for the aged. The "radio priest," Father Charles Coughlin, attracted millions of listeners to his combination of fascist, anti-Semitic, and populist preaching. Though none of these movements had their origins in the Commonwealth, many Pennsylvanians supported one or the other of the panaceas put forward to cope with the distress of economic collapse. One Pennsylvania variant came out of Pittsburgh, where the radical Catholic priest Father James

Cox created the Blue Shirt Jobless Party. Cox called for a dictatorship in the United States to deal with the Depression and the threat of communism. A fiery orator, Cox's appeal brought fifty-five thousand people to Pitt Stadium for a mass meeting, and he led fifteen thousand to Washington in late 1931 to demand government relief.

In New Kensington, the unemployed marched on city hall and forced the city to create a relief bureau. A similar group marched through Uniontown to dramatize their hunger and demand help. Threats and outbreaks of violence increased. The unemployed began to band together—sometimes simply to parade under such banners as "Black and White, Join and Fight," and sometimes to attack. One volunteer relief chairman lost an eye and another was nearly choked to death by a group of angry women demanding food for their children. "I don't want to steal," wrote one Pennsylvanian to Governor Gifford Pinchot, "but I won't let my wife and boy cry for something to eat." A social worker in western Pennsylvania predicted that if adequate relief did not come soon, "in all likelihood there will be rioting and bloodshed."[5] Grassroots organizations emerged in 1931 among homeowners threatened by foreclosures, taxpayers facing penalties for nonpayment, and unemployed men and women demanding a better relief system. In the absence of action by the legislature to appropriate funds for relief, hundreds took part in a hunger march on Harrisburg. Veterans played an active role in these groups. Across Pennsylvania, they began to coordinate their protests, and in 1933 the Pennsylvania Security League emerged, a socialist-led organization that lobbied for legislation to establish old-age pensions, unemployment insurance, and minimum wages.

Lorena Hickock, a field representative for the federal government, toured Pennsylvania to observe the condition of the unemployed and noted that radical activity was growing: many of the unemployed, she said, had reached the point where "it wouldn't take much to make Communists out of them." A coal miner's wife confirmed her observation during a Communist-led strike. "Sure, I'm a Bolshevist," she proclaimed, "and so's my old man, and my four kids. What of it? You'd be a Bolshevist too, if you didn't have enough to eat."[6] Indeed, although left-wing radicals of all stripes played key roles in the local and statewide organizations of unemployed workers, the Communists proved to be the most effective. The Communist Party built a network of "unemployed councils" throughout the state. In the anthracite region, fifteen thousand to twenty thousand people joined or participated in the councils between 1931 and 1934. In addition to demanding relief payments and allotments of food and clothing from local poor boards, they frequently took direct action to stop evictions of families and sheriff's sales of mortgaged properties. Communist influence culminated in a 1934 march on Harrisburg: under the banner of the Workers Alliance, the Communists led a coalition of unemployed groups to demand relief. The marchers occupied the Pennsylvania capitol and slept in the rotunda of the House and Senate galleries. With no response from the conservative Republican-dominated legislature forthcoming, the marchers became unruly. They held a mock session of the legislature on the capitol steps and then kept the senators in session for two hours after the scheduled adjournment time. A wild scene ensued. Officials of the Pennsylvania Security League charged that "the Senate has deserted the party which since the days of Lincoln has been a party of humanitarianism and have formed a new party—the starvation party."[7]

Characterizing the Republican Party in Pennsylvania at the beginning of the Great Depression as a "party of humanitarianism" must have been tongue in cheek, because one of America's most powerful Republican machines dominated Pennsylvania politics and had done so without interruption since 1890. The Pennsylvania Manufacturers' Association, representatives of a group of powerful industrial and manufacturing interests, controlled the state. Very few Progressive-Era reforms had reached the Commonwealth. Pennsylvania's industrial barons and their retainers in the legislature and the governor's mansion had effectively retarded the pace of modernization by regularly thwarting the passage of progressive legislation, limiting popular political participation, and permitting near feudal relations between employers and workers to exist. During the Roaring Twenties, Pennsylvania legislators continued to proclaim the sanctity of protection and the open shop. As the decade ended, industrialist-politicians such as Bucks County textile magnate Joseph Grundy anticipated a glorious new era of prosperity founded upon industrial paternalism, trade associationalism, and the benevolence of government toward business. When the market crashed, Bethlehem Steel's Charles Schwab, the elder statesman of Pennsylvania industry, and other prominent individuals joined President Herbert Hoover in proclaiming the economy fundamentally sound.

**The Reformers Respond**

Fortunately for Pennsylvanians, Governor Gifford Pinchot did not share that view. More than any other person, Pinchot

dominated Pennsylvania politics in the 1920s and 1930s. He served two terms as governor—from 1923 to 1927 and from 1931 to 1935. An ally of Theodore Roosevelt, he gave Pennsylvania a Progressive administration during the reactionary 1920s and a reform administration during the early years of the Great Depression. The scion of a wealthy family, Pinchot had made his name as first head of the U.S. Forest Service. In 1910, after a well-publicized break with Richard A. Ballinger (Roosevelt's Secretary of the Interior) had made him a national figure and a hero to environmentalists, Pinchot returned to Pennsylvania. He ran for senator in 1912 on the Progressive Party ticket against the boss of Pennsylvania Republicans, U.S. Senator Boies Penrose. Pinchot lost badly, but the lesson he learned was that third-party politics could not succeed in Pennsylvania. The road to power ran through the Republican Party. When Penrose died, Pinchot put together a coalition of Progressives, labor unions, farmers, and women's organizations to win the Republican nomination and the gubernatorial election in 1922. Forced to step down after four years by Pennsylvania's one-term rule, Pinchot waited and ran again in 1930. Considering the abject weakness of the Democratic Party in the Commonwealth at the time and the profound conservatism of mainstream Republicanism, Pennsylvania's Depression-struck citizens could not have hoped for a better alternative. Pinchot exploited a bitter split among the old-guard leaders of the party and swept into the governorship.

Pinchot believed that vigorous action by the state was necessary, but he also knew that "the only power strong enough, and able to act in time, to meet the new problem of the coming winter is the Government of the United States." "No governor,"

observed Pinchot's biographer, "pounded more consistently or vigorously on Washington's door to obtain the various kinds of relief which the federal government made available." True to his Progressive roots, Pinchot blamed the wealthy for the Depression and urged that the graduated income tax be used to make them "carry at least half of their fair share of the load."[8] With the system of local, voluntary relief breaking down across the state, Pinchot called the legislature into special session in September 1931. After a bitter dispute with Republican legislative leaders who believed that unemployment was only temporary and that responsibility for relief belonged at the local level, the General Assembly allocated $10,000,000 to the local poor boards. No new taxes were levied to raise the sum, nor were any controls put on its use. The result was a great deal of waste and little impact. Pinchot called three more special sessions between 1932 and 1934, but these and the regular session of 1933 produced little more than quarrels between the Republican governor and his Republican legislature.

Pinchot did what he could in the absence of support from the legislature. He directed the state to take over twenty thousand miles of rural roads from townships. Conceived as both a political tactic to draw the support of the farm vote and as a relief project, the Commonwealth embarked on an ambitious road-building and road-renovation project. Pinchot opted for "more miles of good roads rather than fewer miles of faultless boulevards."[9] These narrow, inexpensive "Pinchot Roads" brought the farmer closer to market and farm children closer to school—and helped immensely in relieving the stultifying isolation in which many rural Pennsylvanians lived. In addition, Pinchot's highway

department carried out the work as a labor-intensive project, using manual labor rather than machines wherever possible and employing as many as eighty thousand men.

Pinchot also turned out to be a friend of the labor movement. Though the effort was ultimately unsuccessful, Pinchot called on the legislature to pass old-age pensions, compulsory unemployment insurance, minimum wages for women, maximum hours, and prohibition of child labor. He urged employers to take into account human as well as property rights during strikes. In this he was aided by his wife, Cornelia Bryce, an independent, pro-labor feminist who was "equally at home on the picket line with striking workers or as a lovely and gracious hostess at a formal reception."[10] In 1933, Pinchot reported to President Roosevelt that conditions in the bituminous coalfields were horrible, with miners working six and seven days a week and still earning so little that they had to go on relief. When tensions led to violence during a coal strike in Fayette County, Pinchot sent in the National Guard—not to support the owners and the local sheriff, as would have been the case in the past, but as strictly neutral peacekeepers.

He opposed discrimination as well. He appointed women, African Americans, Catholics, and Jews to his administration in higher numbers than ever before. When the University of Pittsburgh fired a professor for his political views, Pinchot lectured the chancellor and told him that academic freedom was a condition for state aid. "If the Mellons want a school to teach their own ideas," he cracked, "then let them support it."[11] For these and other acts, Pinchot earned the bitter enmity of most of his fellow Republican politicians. When he tried for the party's nomination for the U.S. Senate in 1934, the old guard defeated him, but in the process they lost the general election as the Democrats took both the governorship and the Senate seat. "The Republican Party," Pinchot lamented, "must go progressive or stay bust . . . the American people are sick of the Old Deal."[12]

The Pennsylvania Democratic Party that benefited from the GOP's reluctance to confront the crisis was among the most pathetic in the nation. The party had occupied the governor's mansion only twice since the Civil War, and there had not been a Democrat in any statewide office since 1912. So deplorable was the condition of the party in the 1920s that no area of the state could be considered nominally Democratic. All sixty-seven counties had Republican leadership, and both Philadelphia and Pittsburgh were in the hands of powerful Republican machines. The nadir came in 1930 when the Democratic nominee for governor, Lawrence Rupp, withdrew from the campaign to concentrate on becoming the Grand Exalted Ruler of the Elks. In most areas, the party survived as a functioning unit because it suited the needs of the Republicans. In Philadelphia, for example, the powerful Republican machine under the control of William Vare actually paid the rent on the Democratic Party's headquarters. One writer pointed out that the Democratic organization had become "hardly more than the morganatic wife of the Republican."[13]

Rebuilding the party began in earnest in 1932 under the leadership of Pittsburgh Democratic boss Joseph Guffey, who became the master of the Pennsylvania Democrats when he supported Franklin Roosevelt at the 1932 Democratic convention. Guffey knew that the Great Depression and the incipient New Deal were changing the rules of politics dramatically and that

even Pennsylvania was up for grabs. Republicans still clung to their laissez-faire philosophy. The state's senior Republican senator, David Reed, characterized the early New Deal programs as "futile and fantastic experiments," and he lamented that America was being "fed poison from which it will take decades to recover."[14]

Others, however, were moving en masse toward the Democrats—and Roosevelt was the reason. In 1932, Robert Vann, editor of the *Pittsburgh Courier,* America's leading black newspaper, told African Americans to "go home and turn Lincoln's picture to the wall. The Debt has been paid in full." By 1934, black voters in Philadelphia and Pittsburgh had moved toward the Democratic Party. The same was true of the ethnic vote. By 1936, Democrats carried every ward in Philadelphia that had a foreign-born majority. The same held true for the labor movement, which was in the midst of a revival because of the collapse of capitalism and would become one of the major beneficiaries of Franklin Roosevelt's New Deal.[15]

The presidential campaign of 1932 in Pennsylvania demonstrated Roosevelt's appeal. He campaigned in the state, and even though he did not carry the Commonwealth, he received over a million votes, a historic high for the Democrats. Nearly all the mining and industrial areas of the state, with the exception of Philadelphia, went for Roosevelt. African American districts gave him the highest vote a Democrat had ever received. Guffey capitalized on Roosevelt's popularity in his choice of candidates for the elections of 1934. For governor, he chose an independent Republican, George H. Earle III, a Roosevelt supporter. To solidify the labor vote, he named Thomas Kennedy, secretary-treasurer of the United Mine Workers, as candidate for lieutenant governor. Kennedy's selection, coupled with the pro-labor platform of the party, initiated the alliance between labor and Pennsylvania Democrats that endures to this day. Finally, Guffey ran for the Senate. The Democrats campaigned as New Dealers, and the election results vindicated Guffey's strategies. The Democrats not only won the governorship and the U.S. Senate seat but also took twenty-three seats in the U.S. House of Representatives and captured control of the Pennsylvania House of Representatives. Only the Pennsylvania Senate, where only half of the incumbents were up for reelection, remained in Republican hands. Democrats were under no illusions about their victories. Earle admitted that he "literally rode into office on the coat-tails of President Roosevelt, and I have no hesitation in saying so."[16]

*The Little New Deal*

Not surprisingly, Earle took the New Deal as a model, and for the next four years he proposed a host of legislative acts popularly referred to as Pennsylvania's "Little New Deal." Earle's program reflected the needs of the groups that had flocked to his banner. Labor legislation received much of his attention. He wanted the minimum age for working coal miners raised from fourteen to sixteen, a minimum wage and maximum hours for women and minors, the elimination of the coal and iron police, the regulation of home-based manufacturing to clean up sweatshops, an increase in workers' compensation, and a right to collective bargaining for workers not covered by New Deal labor legislation. Pennsylvania was ripe for an overhaul of its labor laws. Pennsylvania employers' almost feudal control for so many years had left

the second-richest state in the union thirty-third in workers' compensation, fortieth in compensation for widows, and forty-fourth in medical provisions for injured workers. Unfortunately, the Republican-controlled state senate blocked most of Earle's initiatives between 1934 and 1936.

It made sense that Earle's program focused so intently on labor issues. The Great Depression and the coming of the New Deal had revitalized the American labor movement. Two major pieces of New Deal legislation, the National Industrial Recovery Act of 1933 and the National Labor Relations Act of 1935, had ensured that unions could organize and bargain collectively. Industrial workers were especially receptive to the call. John L. Lewis rebuilt the United Mine Workers of America and helped found the Congress of Industrial Organizations (CIO), a new federation representing unions who organized America's industrial workers. The impact on the nation in general, and Pennsylvania in particular, was enormous. Steelworkers, electrical workers, glass workers, aluminum workers, and a host of others organized rapidly. In the period between 1935 and 1941, Pennsylvania turned from being a "right-to-work" state ruled by industrial barons to a union stronghold. Overwhelmingly, these new unionists and their leaders became staunch supporters of the Democratic Party.

The Democratic sweep of 1934 placed the state in a key position for the pivotal election of 1936. The Democratic Party selected Philadelphia as the site for the renomination of Franklin Roosevelt. African Americans came over en masse to the Democrats: loyalty to the party of Lincoln had finally ended. The labor vote came over as well. Earle recognized its importance by formally opening his campaign at a Labor Day rally sponsored by the Steel Workers' Organizing Committee. Republicans fought desperately to hold the bastion of Republicanism for Alf Landon, attacking the Democrats as the party of "communists, Socialists, and job holders."[17] There was more than a little truth in the last charge. True to the Pennsylvania tradition, the Democrats had used some of the New Deal federal relief programs, particularly the Works Progress Administration, as patronage windfalls.

Nevertheless, the Democratic sweep had little to do with patronage and everything to do with the popularity of Franklin Roosevelt and the New Deal. Roosevelt captured the state's electoral vote with an astonishing margin of 660,000 votes. He carried every ward in Pittsburgh and took all of Allegheny County. Philadelphia, seemingly impregnable, finally fell. Not surprisingly, Roosevelt had broad coattails. The Democrats won nearly everything, including (for the first time since 1871) the Pennsylvania Senate. Just about every demographic group voted Democratic—African Americans, immigrants, women. Only some rural areas in central and north-central Pennsylvania stayed in the Republican column.

Earle moved quickly after the election. Some seventeen states had passed unemployment compensation legislation, enabling them to participate in the Social Security program, but the rearguard action of Republican legislators had ensured that Pennsylvania was not among them. At a special session of the legislature late in 1936, the Democrat-controlled General Assembly gave Earle his first great triumph. The unemployment compensation legislation, according to Earle, "banishes the fear of helpless destitution which hangs over so many of our wage earners. Under this

bill industry in Pennsylvania is obliged to take up a burden which legitimately devolves upon industry, and to accept the social responsibility which it has for too long refused to meet."[18] The legislature passed the bill in five days. It was a harbinger of what was to come.

Earle challenged the members of the first Democrat-controlled session of the General Assembly in 1937 to complete the work they had begun in the special session: "We have before us a tremendous responsibility and an unprecedented opportunity. Liberal forces control both executive and legislative branches of our state government for the first time in 91 years. It is now our duty to translate that liberalism into positive effective action."[19] There was no stopping the Little New Deal. As historians Ari Hoogenboom and Philip S. Klein described it, "The Assembly enacted the most sweeping reform program in Pennsylvania's history. It created an efficient and professionalized department of public assistance, improved workmen's compensation, abolished privately paid deputy sheriffs, prohibited the importation of strikebreakers, and eliminated the sweatshop by establishing minimum wages and maximum hours and by regulating industrial work performed at home. It also restricted the issuance of labor injunctions and created a state labor relations board appointed by the governor. Pennsylvania's 'Little Wagner Act' protected labor's right to organize and bargain collectively, outlawed company unions, and prohibited unfair labor practices against workers trying to organize."[20]

The Little New Deal benefited a wide swath of Pennsylvanians. For African Americans and other minorities, the legislature created the Bureau of Civil Liberties to deal with complaints about discrimination. It continued to shift the tax burden from real estate to business by taxing the majority stockholdings of Pennsylvania corporations in out-of-state companies. It created the Pennsylvania Turnpike Commission, which built a four-lane toll road from Middlesex to Irwin in western Pennsylvania. With its maximum 3 percent grade and seven tunnels, it was the first of the nation's truly modern superhighways. The Little New Deal also tackled some unfinished business of the Progressive Pinchot administration by establishing the Public Utility Commission and giving it sweeping powers to regulate utilities in the state. For rural Pennsylvanians, Earle and the Assembly enabled farmers to participate in the soil conservation program of the U.S. Department of Agriculture and helped them through reforestation, contour plowing, and the construction of small dams to prevent gullying and flooding. Rural Pennsylvanians also benefited from the Flood Control and Pure Streams Act. A permanent milk-control law, the first in the nation, brought stability to dairy farmers. It was a breathtaking performance. While a leading Republican characterized the results of the Little New Deal as "vicious . . . unsound, unhealthy, and unwarranted class legislation," David Lawrence, by then the mayor of Pittsburgh, praised them as "the most constructive, liberal, and humane in generations."[21]

The Little New Deal left a rich heritage of progressive legislation, much of which continues in effect to this day. But it also redirected the role of government in Pennsylvania in fundamental ways. Pennsylvanians, whatever their party, now had and expected greater access to their government and greater influence in its deliberations. Pittsburgh, long a bastion of Republicanism

and the fiefdom of steel, coal, and banking barons, emerged as a Democratic stronghold. Philadelphia, though still nominally Republican in 1937, now had a thriving two-party system and would soon become a Democratic city as well.

The Democratic success, though impressive, was short-lived. True to the heritage of machine- and patronage-driven Pennsylvania politics, the Democrats began to fight among themselves, and the 1938 primary campaign all but destroyed the state party. Demoralized Democrats faced the general election. In November, they lost the state, though they held on to new strongholds such as Pittsburgh. But even with the Republicans back in control, the rules of the political game in Pennsylvania had been changed fundamentally. The old days of one-party domination had ended.

## Welfare and Workfare

Throughout the political and social turmoil that followed the crash of 1929, Pennsylvanians struggled to cope with the crisis. The state was unprepared to meet the challenge. Poor relief in the Commonwealth had traditionally been a local matter, usually handled by the counties, townships, or boroughs, or left to charity. Poor boards, dating back to colonial times, were organized at the local level. Typically supported by woefully inadequate local taxes, relief came in the form of vouchers for food, clothing, rent, and fuel, or through lodging and some modest work in alms-houses. In 1931, Pennsylvania had 425 poor boards spread across the state.

This system collapsed with the Depression. Counties raised taxes by 50 percent between 1929 and 1932, but receipts fell by 20 percent because of the enormous increase in the number of people on relief. There were no uniform standards, and amounts varied from place to place. Politics affected the operation of the boards as well. Many who sat on the poor boards came from the upper and middle classes and often held the traditional view that the poor were responsible for their own plight. Allentown, for instance, had no municipal experience in helping the poor. The city gave small annual contributions to private welfare agencies and hospitals. With the collapse of much private industry, the tax base dried up. Local resources simply could not meet the demand.

Private charity was even less effective. During the twenties, the argument that poor relief was the responsibility of private charitable agencies took hold. In Philadelphia and Pittsburgh, political machines used the doling out of relief as a means to ensure the loyalty of the poor. These tendencies led to the virtual abandonment of public responsibility. When extraordinary crises occurred, such as a depression or a financial panic, voluntary charitable organizations were expected to step into the gap. This led to a heterogeneous, inefficient, and inadequate response. Soup kitchens, ward organizations, and missions acted. Churches and beneficial, fraternal, and patriotic societies provided food, fuel, and clothing to their members. Some fraternal societies waived the dues of jobless members, thus allowing them to maintain the insurance benefits that often went with member-ship. There were other creative responses. Leopold Stokowski, the renowned music director of the Philadelphia Orchestra, assem-bled a group of unemployed professional musicians for a benefit concert to raise money for relief. The American Institute of Architects' Philadelphia chapter employed fifty-seven laid-off

draftsmen to map the city's landmarks and create an architectural archive of Philadelphia's eighteenth- and nineteenth-century buildings. The rich also responded. In late 1930, Philadelphia socialites followed this pattern and created a relief operation to supplement the mixture of soup kitchens, missions, and ward organizations that had stepped in after the crash. They raised almost $5,000,000. But the Great Depression did not resemble earlier severe depressions, which had been relatively short-lived. As the business failures mounted and the income of the middle class declined, relief efforts stalled. By March 1932, the private resources of the state's richest city had been exhausted. Pittsburgh found itself in similar straits. In the winter of 1930, the city could raise only $100,000 for charity. The next year, contributions totaled less than $2,000,000 to sustain about 150,000 unemployed workers and their families. During that same year, however, Richard K. Mellon announced a gift of $4,000,000 to build the East Liberty Presbyterian Church, which he hoped "would do its part to reassure those who fear that the country is doomed to become engulfed in materialism."[22]

Governor Gifford Pinchot, however, advocated other approaches to the crisis. The state provided public employment in the winter of 1931–32, although there were many more applicants than available positions. Pinchot authorized the setting up of six labor camps and the creation of ten thousand jobs. Thirty thousand unemployed men applied. In order to spread the labor, each worker was allotted a maximum of thirty days. When the applicants showed up, the extent and effects of unemployment across the state became clear. Crowds of men poured into the camps. Many had walked to the camps from ten to fifty miles

away. The autos of others lined the highway for blocks. The physical and psychological conditions were distressing. Many were too weak to do the work. One labor camp official noted the emotional price the crisis had exacted. "It is hard to see men break down," he lamented, adding, "this has often happened when they tell their story. They bring their children with them to show how badly they need shoes and clothing."[23]

In the face of the collapse of the antiquated system of poor relief, Pinchot did convince the General Assembly to pass legislation that became the cornerstone of Pennsylvania's relief system. In addition to appropriating the first significant amount of funding for relief, it created the State Emergency Relief Board (SERB) and charged it to organize a comprehensive program for the expenditure of funds. The money could be used for both direct and work relief. SERB moved immediately. In August 1932, it appointed boards in each county to administer their funds either through existing poor boards and private agencies or directly. In September, the statewide system began operations.

The county boards and relief agencies soon confronted the problem of what kind of relief to support. Most of the board members favored an antiquated view of work relief that led to the creation of a multitude of menial "make-work" projects—one relief administrator described them as "raking leaves back and forth in the yard until the leaves are worn out."[24] Instead of improving self-respect, they undermined it. There was also strong resistance to direct relief. On her trip through Pennsylvania, Lorena Hickock noted that while there was general satisfaction with the new relief system, direct relief was not popular. In Northampton County, the secretary of the Communist-led

Unemployed League complained that food orders drawn on local markets made the unemployed feel like charity cases. "There are lots of things we could do around here," he argued. "We could fix up the river front, we could plant trees, we could repair buildings." Hickock concluded, "The feeling seems to be that every American should have the right to earn the money he gets for relief, receive it in cash, and spend it as he sees fit." "These people aren't children," she repeatedly heard from the relief workers she met. "They're honest, self-respecting citizens who, through no fault of their own, are temporarily on relief. The vast majority of them have always managed their own affairs, can be trusted with cash, and should be."[25] Hickock's boss, Harry Hopkins, served as President Roosevelt's chief relief administrator and shared that view. "Give a man a job and pay him an assured wage," he said, "and you save both the body and the spirit."[26] Hopkins, himself a former New York social worker, rejected both direct relief and the punitive make-work philosophy characterized by nineteenth-century workhouses. He wanted the unemployed to be offered useful work. Roosevelt agreed—and work relief became the cornerstone of the New Deal's efforts.

The major meaningful work relief in Pennsylvania was on highway construction, mostly in rural areas. Pinchot had long advocated "getting the farmers out of the mud." Cynics argued that Pinchot was actually building a constituency to vote him into the U.S. Senate after his term as governor ended in 1935. One observer quipped, "Gifford will pave his way to the Senate yet, even if he has to put macadam on every cow path in the state to do it."[27]

Nevertheless, well-meaning state programs did not measure up to the task at hand. First, the state appropriations, while historic, offered far too little money—so little, in fact, that the federal government refused to send matching funds because it did not believe that the state was doing enough to help itself. In addition, program administration at the local level depended upon the skill and dedication of the local boards. Most lacked professional administrators. Social workers were overwhelmed: in Media, a social worker with one assistant had a caseload of eight hundred families. Philadelphia and Pittsburgh abandoned their programs, which lacked ideas and professional supervision. In mining towns, even the creation of make-work projects proved to be difficult to organize, because the companies owned all the property and the citizens had no incentive to improve things. One of the bright spots was the thrift garden program, but an Italian American who won the pennant for the best garden in Scranton remarked that he would "rather be back in the mines than doing this."[28]

By the time of the Democratic triumph in 1936, the state's reorganized relief system had been in operation for nearly four years. Nevertheless, the economy remained in desperate shape. The number of unemployed workers did not drop below the one million mark until April of that year. The mining areas were particularly resistant to change. In Shamokin, close to one-third of the population existed on direct relief with an emergency food ration of 31 cents per person per day. According to Lorena Hickock, the miners "seem to have no faith at all in anyone save the President. They carry his picture in their picket lines and their little parades. . . . The people on relief generally seem to have that same feeling about him. The state government they ignore. They look to the federal government for aid."[29]

## Federal Intervention: The New Deal

The federal attitude toward relief had begun to change dramatically as soon as the Roosevelt administration took office in March 1933. The old strictures about clear distinctions between the responsibilities of the federal government and those of the states were swept away. In May 1933, Congress passed the Federal Emergency Relief Act. The law established the Federal Emergency Relief Administration (FERA) and gave it half a billion dollars to distribute to the states. Half was for matching grants, with the states contributing three dollars for every dollar of federal funds. The remainder could be given in direct grants. Roosevelt appointed Harry Hopkins to head the agency.

The legislation establishing the FERA gave Hopkins extensive powers to set standards, oversee administration, and approve grants. Though the states acted as partners in the enterprise, the federal government had the upper hand. Federal aid could be dispensed only by public agencies. This caused a major shift in many Pennsylvania communities where private agencies had played a major role.

The first large-scale attempt at federal relief occurred in the winter of 1933 as the number of unemployed soared and state relief systems everywhere buckled under the challenge. On November 9, 1933, President Roosevelt issued an executive order establishing the Civil Works Administration (CWA). The goal was to provide work for 4,000,000 unemployed workers in the coming winter. Hopkins appointed Eric Biddle, executive director of the SERB, as Pennsylvania's CWA administrator. The largest projects involved construction and repair of highways, waterways, and government-owned utilities. Schools and government buildings got face-lifts and renovations. Statisticians did statistical studies and planners drafted urban and regional plans. Abandoned coal mines were sealed. A project at the University of Pennsylvania proved to have the most long-lasting impact. There, professors and researchers built a three-ton calculating machine called a "differential analyzer." It turned out to be the first truly successful computer. Although few projects were so dramatic, the impact of the CWA on rural Snyder County is a measure of what the program meant. More than 500 Snyder Countians built roads, drained swamps, rebuilt schoolhouses, painted the courthouse, and did a variety of other useful tasks. By January 1934, almost 400,000 Pennsylvanians were at work on CWA projects.

### The Civilian Conservation Corps

The CWA, though a success, was an emergency response, meant to be temporary. Other New Deal efforts had more lasting significance. The first was the Civilian Conservation Corps (CCC). Between 1933 and 1942, it provided outdoor employment for 2,500,000 young men, mostly from the cities. These workers operated some three thousand camps and significantly improved America's environmental resources (particularly parklands and forest lands). The CCC's achievements were even more amazing because of its cumbersome bureaucratic structure. The Department of Labor and the War Department recruited the men, administered the camps, and supervised the projects.

In Pennsylvania, the SERB, through the county and city relief boards, played the major role in recruiting, and the Department of Forests and Waters had responsibility for identifying and

supervising projects. Not surprisingly, the old forester Gifford Pinchot supported the CCC enthusiastically and was one of its strongest advocates in testimony before Congress. CCC enrollees had to be between the ages of 18 and 25, unmarried, and from families on relief. The period of enrollment was held to one year to provide opportunity for more men. Participants were paid thirty dollars a month, twenty-five of which were to be sent to the family. Many more men presented themselves than could be handled. Once selected, most Pennsylvania enrollees went to the "reconditioning" center at Fort Meade in Maryland. The idea was to prepare them for life in the woods, though the two weeks allotted to transforming city boys into woodsmen usually proved to be far too short.

Pennsylvania's early CCC camps were among the first in the country to begin operations. The earliest arrivals encountered a disheartening sight. Most camps were nothing but tent colonies of the crudest kind. "My first view of the campsite caused me to become disgusted with the place," remarked one enrollee. "I thought I would never stay in that hole more than six months. . . . Then I thought of home and decided I had better stick as I was the only bread winner."[30] Most did stick and built permanent facilities; some, including the "flower camp" near Lancaster, were very attractive. The CCC camp in Snyder County was probably typical, with its mess hall, bathhouse, blacksmith's shop, garage, and six barracks.

Typical CCC projects in Pennsylvania included road building, reforestation, bridge building, or small dam construction. The work took place after an early wake-up call and a hearty breakfast. Many enrollees gained weight during their stays in the camps in spite of the hard physical labor. Most camps had recreational and educational programs for evenings and weekends. There were district, state, and corps championship sports competitions. Educational programs, often provided by faculty from local high schools and colleges, ranged from vocational to academic subjects. A number of enrollees improved their skills in math and English while in a CCC camp.

Not everything was rosy, as desertion figures indicate. Many enrollees found the harsh military organization and discipline of the camps too hard to take. Desertions began to be a serious problem in 1935 and reached crisis proportions by 1937. This is not surprising. After 1935, men had other options. The economy had gradually begun to improve and a more attractive new federal program, the Works Progress Administration, did not require the men to leave home. And although no summary figures exist for the injury and death rates among Pennsylvania CCC workers, injuries and fatalities regularly occurred, many resulting from truck accidents and forest fires. On October 19, 1938, in the worst single CCC accident, eight men died attempting to extinguish a fire in Cameron County.

The treatment of African American applicants also caused problems. African Americans suffered most from the Depression, and they applied for placement in federal projects more than any other group. New Deal relief agencies were generally sensitive to the need to guard against discrimination. The CCC established quotas for African Americans that matched their percentage of the population. Pennsylvania officials protested these limitations because of the heavy demand from African Americans, but to no avail. Army pressure, for one, kept the quotas in place. Being

itself a heavily segregated organization, the U.S. Army insisted on rigid segregation into black and white camps. This caused a double disadvantage for African Americans. Although the demand was greater, far fewer camps were created for them. The Army established a black camp only when the residents of nearby communities agreed. Because the camps were in rural areas where few African Americans lived, permission was difficult to obtain. The residents of Thornhurst in Lackawanna County petitioned the government to stop the establishment of a camp in their vicinity. This resistance led to the founding of black camps on federal land, such as at the Gettysburg National Military Park, or in very remote areas, such as on state lands in Centre County. Once the CCC established the original twelve camps for African Americans, no more were instituted. This limited African American participation at any one time to 2,400 men. Thus, although African Americans constituted 25 percent of the total relief load in Pittsburgh and Philadelphia, they made up only 8 percent of the CCC selection quota. To his credit, J. Fred Kurtz, who served as the chief selection officer for Pennsylvania, always fought for an expanded quota for African Americans; his appeals nevertheless went unheeded.

Congress eliminated the appropriation for the CCC in the summer of 1942. The entry of the United States into the war made the program superfluous. By that time, there were only fourteen camps still operating in the Commonwealth, and eight of those were scheduled to close. Although the CCC had always had its critics, it must be considered a success by any fair assessment. More than 160,000 men participated in the program in Pennsylvania. The vast majority were Pennsylvanians who came from urban families of four or more. They provided support not only for themselves but also for more than 500,000 others. Critics charged that the program was too expensive, and in comparison with other New Deal relief programs, the charge has merit. The complex bureaucracy of cooperating state and federal agencies added administrative costs. The need to house and feed the enrollees far from their homes made the cost per man a great deal higher than those for the CWA and the WPA. Nevertheless, the work that the CCC did added lasting value to the Commonwealth. Few Pennsylvanians living after 1942 have not benefited directly from it. CCC workers planted millions of trees, built thousands of miles of roads and trails, and constructed and improved parks and recreational areas across the state. Dams, fire towers, bridges, disease control measures, and thousands of acres saved from forest fires added to the CCC's splendid legacy.

## The Works Progress Administration

In 1935, the federal government demonstrated again its commitment to work relief over direct relief. As part of a package of bills to provide security for Americans—a package that included the landmark Social Security legislation—the New Deal created the Works Progress Administration (WPA). Social Security covered the aged, the blind or disabled, and dependent children; the states were expected to support the unemployable through the dole. The WPA's mission was to give jobs to the employable jobless. It was one of the most famous and most controversial of the New Deal's "alphabet agencies." More than any other New Deal agency, the WPA rejected the belief that the unemployed were responsible for their own condition and replaced it with the idea

that unemployed workers were victims of social and economic forces over which they had no control. It embodied the fundamental principles that guided New Deal relief programs: that providing work was better than the dole, that when the private sector could not provide jobs the government should act as employer of the last resort, that work should be useful and give workers dignity, and that people who wanted to work had a right to a job, whenever possible, commensurate with their skills and training. The red, white, and blue symbol of the WPA became one of the most pervasive and enduring icons of the Great Depression.

Unlike its predecessor, the CWA, which was operated on a cost-sharing basis with the states and administered by them, the federal government assumed all employment costs and centrally administered the WPA. This, combined with other New Deal relief programs such as the Public Works Administration and the National Youth Administration, meant that the federal government had effectively assumed the cost of relief in the states. As early as February 1936, Washington was paying three-quarters of Pennsylvania's relief bill. The WPA spent more and employed more people than any other New Deal program. In Pennsylvania, it employed more people and cost more than in every other state but New York. For example, the WPA spent over $1,000,000 in rural Snyder County alone between 1936 and 1939.

While the WPA paid employment costs, states and localities paid for materials and other infrastructure support. In southwestern Pennsylvania, Fayette and Washington Counties joined the state in sponsoring large street and highway projects. These newly paved roads tied isolated mining towns to the principal cities of the region. In addition to costly road building, the WPA also carried out many smaller projects. WPA workers sealed abandoned mines, worked on local history projects, preserved the historical records of communities, renovated school and college buildings, improved parks and municipal facilities, conducted health surveys, gave English lessons to immigrants, and provided medical care to the poor and homebound. Throughout Pennsylvania, women sewed clothing and blankets for the needy.

In the cities, projects varied even more. By June 1936, the WPA employed forty thousand Philadelphians in projects that ranged from installing exhibitions in the Museum of Art to building and staffing playgrounds for children. In Pittsburgh, there were recreational projects, statistical surveys, mural paintings, educational programs, and sewing projects. The WPA Symphony—composed of "65 men and a girl"[31]—gave public concerts. Writers researched and wrote about the city's history. The Red Cross trained thousands in first aid and home accident protection. Illiterate adults learned to read in evening classes. Thanks to the WPA, Allentown emerged from the Depression with a new airport, a new sewer system, two reservoirs, and a splendid park system.

Unlike other federal relief programs that concentrated on industrial workers, the WPA also developed programs for professionals and white-collar workers through its Division of Professional and Service Projects. The most famous, designated as Federal Project Number One, included the Federal Theater Project, the Federal Writers' Project, the Federal Art Project, and the Federal Music Project. All four operated in Pennsylvania with varying degrees of success. In terms of sheer numbers, Federal

One touched relatively few workers—never more than a thousand in any one year. But its impact reached far beyond its relative size.

The Theater Project proved to be the least successful. The WPA authorized seven theatrical troupes in Pennsylvania, four of them in Philadelphia. Unfortunately, the cultural conservatism of much of the state, exemplified by blue laws that severely restricted recreational activities on Sunday, had a stultifying effect on theater. The single exception to that involved the "Negro" vaudeville unit. It achieved critical acclaim and public success, and despite the segregated nature of the troupe, it broke new ground with innovative theatrical and dance productions.

As part of the Federal Writers' Project, some 240 unemployed writers, newspapermen, and teachers—most of whom lived in Philadelphia—produced an impressive number of publications. One of the most unusual was a series of elementary science books that was widely used in Pennsylvania schools. In addition to a score of pamphlets, the Writers' Project also produced a number of enduring books, among them *Pennsylvania Cavalcade*, a collection of historical essays of sufficient scholarly quality to be published by the University of Pennsylvania Press. There was also *Philadelphia: A Guide to the Nation's Birthplace*, and the project's magnum opus, *Pennsylvania: A Guide to the Keystone State*, both of which remain general reference works for the history and natural attractions of the Commonwealth. Nevertheless, the project was riven with conflict and badly led throughout its history, and although some of its publications proved durable, most were lambasted at the time for their reliance on broad stereotypes and myths in explaining the Commonwealth's rich history.

The Philadelphia Federal Music Project became a great success. Though the city was relatively cool toward the theater, it had a rich musical tradition. Between 1935 and 1943 the WPA Civic Symphony Orchestra premiered 163 works, many of them by local composers.

Probably more than any other project, the Federal Art Project made a lasting impression, especially in Philadelphia. Federal patronage for artists predated the WPA. The New Deal's initial foray into art patronage occurred during the winter of 1933–34, when the Public Works of Art Project (PWAP), part of the Public Works Administration, employed painters, sculptors, printmakers, and other artists. But the PWAP was a stopgap measure, and its funding ended in 1934. The Treasury Department, then responsible for the construction and maintenance of all federal buildings, stepped into the void with two projects, the Treasury Relief Art Project and the Section of Fine Arts. The first employed artists on relief. The second had a broader goal: to make art a part of daily life not only in the cities but also in small towns and rural areas. Post offices across the country—places where art could be seen daily by ordinary citizens conducting the normal business of their lives—served as the means for realizing this vision. Nationally, the Section commissioned 1,400 murals for post offices and a few other federal buildings. Artists were encouraged to propose subject matter of local cultural and historical significance. By 1939, when the project ended, artists had painted 94 murals in eighty-four Pennsylvania towns and cities. Only New York State boasted more. Most of the murals had historical relevance to the locality, but many also featured local industries such as iron and steel, glass, coal, the railroad, lumber, and agriculture.

But no matter how important the Treasury Projects turned out to be, they paled in relation to the WPA's Federal Art Project. As in the rest of the WPA, the Art Project employed artists already on relief. It focused on large cities, where most of the artists lived, and unlike the Treasury Department projects, the work produced went to state and municipal institutions rather than federal ones. Indeed, WPA workers built the Philadelphia Museum of Art. Fittingly, the museum holds one of the finest collections of WPA art—and WPA prints, in particular—in the country. The Art Project owed much of its success to print innovations developed by African American artists Dox Thrash, Claude Clark, and Raymond Steth. Philadelphia was home to the Federal Art Project's only fine print studio, which was a national leader in quality reproduction techniques. Dox Thrash's creation of the Carborundum print marked an achievement of artistic innovation that had international implications. And the African American artists left a rich fund of prints representing the deprivation and hardship of Depression life in Philadelphia's African American community.

In spite of its successes, the WPA remained controversial throughout its brief life. There were, of course, always the attacks from conservatives who objected to the idea of using tax money for work relief and who lambasted WPA workers as lazy and shiftless. A more serious complaint in the context of Pennsylvania politics was the heavily politicized nature of the WPA in the state. The organization of the WPA followed a rigid hierarchical model along state, regional, county, and finally project lines. At each level, there was the opportunity for patronage—and Pennsylvania was the patronage state par excellence. (The problem had surfaced earlier with the administration of the CWA. Harry Hopkins's fact finder, Lorena Hickock, had reported to her boss as early as 1933 that the major problem relief efforts confronted in Pennsylvania was politics: "From township to Harrisburg, the state is honeycombed with politicians all fighting for the privilege of distributing patronage."[32]) Because local communities administered relief and because Republicans controlled the state until 1935, most of the conflict took place in the Grand Old Party. But the triumph of the Democrats in 1936 coincided nicely with the inception of the WPA, and Democrats became the major beneficiaries of the ability to dole out patronage jobs. Senator Joe Guffey, who had helped ensure the nomination of Franklin Roosevelt in 1932, controlled federal patronage in Pennsylvania. Guffey believed that the administration of state relief programs had been a "Republican racket," and he intended to make federal programs a "Democratic show."[33] Under Guffey's leadership, the Democrats used two of the three categories of WPA jobs to appoint loyalists. There is no evidence that the project workers themselves—the unemployed people receiving jobs—were hired for political reasons. The WPA in Washington required that they all be certified as in need of relief. The other two categories, administrative and noncertified (or supervisory), however, were overwhelmingly political in their appointment processes.

Approximately three thousand WPA administrators worked in Pennsylvania, more than in any other state and more than in the Washington headquarters. There is no doubt that the WPA in Pennsylvania was the most politicized in the country. Patronage was important in building a political machine, and the enormous federal patronage created by agencies like the WPA strengthened

local politicians. Party members with patronage jobs could be counted on to work hard for the ticket, and although the non-patronage jobs of the thousands of WPA workers on the projects did not depend upon their political loyalty, there is little doubt that they were urged to consider which party was responsible for the New Deal. In Guffey's stronghold, Pittsburgh, this was particularly true. His chief lieutenant, Mayor David Lawrence, could soon report to Roosevelt that the registered Democrats in Pittsburgh outnumbered Republicans for the first time since the Civil War.

*A New Deal for Farmers*

Although the New Deal relief programs softened the effects of the Depression in cities and smaller urban areas, nowhere did they have more long-term impact than in Pennsylvania's rural areas. Road construction and road improvement helped reduce the isolation of rural life. Nevertheless, in the 1930s, the greatest divide between rural and urban America resulted from the absence of electric power on most of the nation's farms. More than a half-century after Thomas Edison built the first central-station electric system in New York City in 1882, nine out of ten farms in the United States lacked electric power. In Pennsylvania, where the population was denser than in many western states, approximately a quarter of the farms had electricity. For those, the cost of electricity was a heavy burden. Most had to pay $1,500 to $3,000 for line construction to their properties in an era when yearly farm income averaged $1,800. In addition, minimum monthly rates were often higher than in towns.

The lack of electric service affected farm families' standard of living as well as their social status. Rural life was also made much more difficult without power. Without electricity, farmers relied on manual labor and the assistance of unreliable gasoline motors. Without electric pumps, families pumped water from wells or drew it from streams and carried it indoors. Farmwives cooked on wood stoves that filled their houses with smoke and were difficult to regulate. No refrigeration meant laborious canning or smoking of vegetables and meat. Women worked all day on the laundry, heating tubs of water, boiling and scrubbing the clothes, and ironing with several flatirons, called "sadirons," which were heated on the stove. The main symbol of rural domestic difficulties, though, was the kerosene lamp. Such lamps frequently led to fires, and small children had to be watched constantly in a room with lamps or candles.

Private power companies made decisions about the placement of their lines based on profitability. In many areas, the population was too thin to make providing service profitable. Consequently, most people had come to believe that electric service in rural areas was impossible. In 1935, a Philadelphia Gas Company official informed a convention of the Edison Electric Institute that "only in the imagination . . . does there exist any widespread demand for electricity on the farm or any general willingness, or ability, to pay for it."[34]

The isolation of rural Americans had been a matter of concern to reformers for many years. Progressives and conservationists such as Theodore Roosevelt and Gifford Pinchot had advocated electric power for farmers. During his first term as governor in 1923, Pinchot commissioned the "Giant Power" survey, which recommended that the state build huge generating facilities near the mouths of its coal mines and transmit low-cost

power to Pennsylvanians. Although the General Assembly never adopted the recommendation, the survey's director, a Philadelphia engineer named Morris Llewellyn Cooke, carried on the crusade. He joined the Roosevelt administration in 1933 and within two years handed the president a plan for rural electrification. On May 11, 1933, Roosevelt signed an executive order creating the Rural Electrification Administration (REA).

The REA hoped to lend money to power companies to employ men from the relief rolls, thereby offsetting the cost of building lines in the country. Cooke had few takers, and he soon realized that investor-owned utilities would not be the solution. He then made the funding available to user-owned cooperatives. In support, the General Assembly passed Pennsylvania's Electric Cooperative Corporation Act after a heated legislative battle during which the state's private power industry lobbied fiercely against it. It gave cooperatives the legal right to organize residents in rural areas not served by private power companies. Farmers quickly organized to persuade their neighbors of the benefits of the new system. Three members per mile and a five-dollar membership fee were required to form a cooperative and qualify for a loan. Construction crews sometimes worked for no more than the hope of getting electricity for their farms.

By 1941, farmers and their rural neighbors had formed thirteen cooperatives in Pennsylvania. At first, families concentrated on electric lights to banish the hated lanterns. Gradually, they began to stock their houses with all manner of appliances—electric irons, radios, stoves, refrigerators, and washing machines. Electric motors, milkers, and poultry brooders appeared in their barns. For hundreds of thousands of rural Pennsylvanians, "the

day the lights came on" was one of the most memorable occasions of their lives.[35]

Rural Pennsylvania played a major part in another New Deal venture. The Jeffersonian belief in the virtues of the agrarian life still existed in the minds of some New Dealers. The disasters in the nation's cities and industrial towns made the contrast between idealized rural life and modern industrial society even starker. A faith in the healing qualities of work on the land found expression in two "new towns" developed in Pennsylvania based on the concept of producers' cooperatives. In 1933, Congress created the Division of Subsistence Homesteads of the Department of the Interior. The President and the Secretary of the Interior, Harold Ickes, held that the homesteads would primarily offer temporary relief. Eleanor Roosevelt, the President's wife, had a grander vision, as did the American Friends Service Committee (AFSC), a Quaker social-service organization located in Philadelphia. The AFSC had been working with unemployed laborers, particularly bituminous coal miners in southwestern Pennsylvania, since the beginning of the Depression. Eleanor Roosevelt and the AFSC viewed the new town projects as models for future cooperative communities. When Clarence Pickett, executive director of the AFSC, became the assistant to the director of the new agency, it was not surprising that the First Lady's views prevailed and that the two Pennsylvania experiments took place near the bituminous fields of Westmoreland and Fayette Counties.

The government began purchasing tracts and accepting applications for its new "Westmoreland Homesteads" in 1933. The need was obvious. The local coal industry was almost entirely shut down. Miners living in company towns could not

pay rent and were sometimes evicted. Families alone were eligible to participate, and some 250 of them—around 1,200 people—were chosen from among thousands of applicants.

Before anyone could move in, the community had to be built. The members themselves did this for a daily wage of four dollars, three of which were withheld to pay the rent on the property leased from the federal government. Skilled foremen from outside supervised the work, but the enterprising settlers used secondhand machinery to set up a craft shop to manufacture doors, windows, shutters, and cabinets. In 1935, the first families moved into the town, which was called Norvelt (a combination of the last syllables of Eleanor Roosevelt's first name and surname). Each house had two acres for garden plots.

In that same year, Roosevelt transferred the control over the new towns to the new Resettlement Administration (RA). The head of that agency, Rexford Guy Tugwell, had little time for the Jeffersonian vision of agrarian utopia and doubted that the communities could survive on subsistence agriculture. He proved to be correct, and in 1937, the RA approved a loan to build a garment factory—an enterprise that succeeded. The community also included a cooperative farm and a cooperative store. Both supplied commodities and merchandise at low prices.

Tugwell's view of the communities did not square with the hopes of the Quakers. When Tugwell ended federal funding for the projects in the late thirties, the AFSC set out to develop its own new town in Fayette County. The Quakers raised $200,000 from private sources, including a large donation from the United States Steel Corporation, whose local mines had been shut down. The AFSC project was much smaller than Norvelt. The homesteaders agreed to name the community Penn Craft, combining William Penn's name with the name of the family from whom the farm had been bought. Penn Craft residents donated one thousand person-hours of labor in 1938 to build a stone factory building, the Redstone Knitting Mill, which would provide employment. The mill only became profitable a few years later when it was leased to and managed by a private entrepreneur.

Both towns had been conceived by their founders as permanent ventures, but they began to lose their cooperative character during World War II. Norvelt's cooperative store and cooperative farm were sold or leased to private individuals during the war. In 1946, most of the homesteaders took advantage of a government offer to allow them to buy their properties. The more isolated Penn Craft took longer to abandon its New Deal origins. The Quaker-style cooperatives gradually disappeared; the last vestige of the experiment, the cooperative store, was bought by a resident in 1963. In the final analysis, Norvelt and Penn Craft proved to be something between cooperative communities and temporary resettlement camps. More important, they demonstrated the indefatigable optimism of the unemployed and their families at a time when hopelessness and despair seemed more in order.

## From Relief to Defense

Although America did not declare war on the Axis powers until 1941, the buildup to war affected the economy as early as 1937. Growth quickened with the outbreak of war in 1939 and soared when America entered the war. By the time the Japanese attacked Pearl Harbor, American industry had been deeply involved in defense production for more than two years. Pennsylvania

contributed greatly to the Allied cause, providing both matériel and soldiers. Thirty-three thousand Pennsylvanians died in the service, and Pennsylvania citizens won thirty-two Medals of Honor, more than any other state. Pennsylvania also furnished leadership in the war effort. General of the Army George C. Marshall, Chief of Staff and architect of the Allied victory, hailed from Uniontown. Henry "Hap" Arnold from Gladwyn led the Army Air Force, and Admiral Howard Stark of Wilkes-Barre commanded the U.S. Navy in Europe and served as Chief of Naval Operations.

Pennsylvania, with its vast industrial base and skilled labor force, became a bulwark of the war effort. The Philadelphia Navy Yard employed nearly seventy thousand workers, built 50 warships, fitted out an additional 480 vessels built elsewhere, and repaired disabled and old vessels. Ships were also built in Pittsburgh. Overall, the state ranked fourth in the building of ships. Because of its large garment industry, Philadelphia also became the main procurement area for uniforms. The Philadelphia Radio Company (Philco) helped develop radar, and the Hershey Corporation was responsible for the D-ration bar. The jeep, the archetypal American military vehicle, was developed by the Bantam Car Company of Butler. Overall, between 1939 and 1944, Pennsylvania production jumped from $5 billion to $15.1 billion.

In the frenetic activity of wartime production, scarcity replaced unemployment as the critical labor market problem. With more than 1,000,000 Pennsylvanians—most of them men—in the armed services over the course of the war, women became the reserve army of the employed. Nearly one-fourth of all war workers were women, and women also constituted nearly half of all other workers. And with the help of the Pennsylvania Fair Employment Practices Committee, large numbers of black workers moved into the skilled positions in heavy industry that had previously been denied them. All in all, the rise in nonagricultural employment from 2,700,600 in 1939 to 3,512,200 in 1943 all but ended unemployment in the Commonwealth.

The Great Depression and the New Deals, both big and little, brought enormous changes to Pennsylvania. Perhaps the shock of economic collapse was necessary to shatter the Commonwealth's old problems of isolation, social fragmentation, industrial plutocracy, and one-party rule. Poverty was no stranger to millions of the state's workers and farmers long before the Great Depression. But the New Deal was different: it rejected the old verities about the limited role of government in order to intervene aggressively on behalf of needy Pennsylvanians. In the process, the Democratic Party capitalized on the frustration of destitute miners, steelworkers, and farmers, black and white, to forge a new political coalition. Through a variety of relief experiments and progressive social and economic measures, this coalition revolutionized the expectations of Pennsylvanians about the responsibility of their government to insure the health and welfare of the people against economic and other disasters beyond their control. By the end of the Depression, the New Deal's programs had reached into every city, every town, every neighborhood, and even into the most isolated areas of the state. Millions of Pennsylvanians once consigned to isolation on remote farms or grim mining and industrial towns were literally thrust into the modern era by the labor movement, rural electrification, new highways, and participation in programs such as

the CWA, the CCC, and especially the WPA. These programs left a rich and enduring heritage of progressive legislation but also marked a fundamental change in how Pennsylvania was governed. Previously powerless groups, such as labor and African Americans, now played important roles in the political life of the Commonwealth.

Although the Democrats' Little New Deal lasted only four years during the Depression, a true two-party system emerged and the transferring of power between Republicans and Democrats in Harrisburg became commonplace. When the Republicans regained power in 1938, they did not resurrect the industrial feudalism of the old days: the Depression had also reshaped the GOP into a new, modern party.

While the New Deal improved the lives of millions of Pennsylvanians in the face of the worst economic disaster in history, it did little to arrest the long economic decline of the state. The increase in production during the war masked this trajectory for a time, but in fact, in relative terms, the state continued to decline. Although Pennsylvania had the second-largest manufacturing sector, it ranked only seventh in the value of its war contracts. Pennsylvania's share of the national income diminished by 1 percent, in fact, between 1939 and 1943.

Pennsylvania—and the rest of the United States—was at a crossroads between 1929 and 1945. These years marked a transition from the Industrial Revolution of the previous century to the technological and social revolutions of the postwar years. Although important political and economic changes loomed, they would be dwarfed by the cultural and social transformation of the nation by the automobile, the interstate highway system, the extension of electric power to all parts of the country, the popularization of air travel, and the television. The moving and lucid images created by the Farm Security Administration photographers that are the main topic of this book brilliantly caught Pennsylvania at this crossroads. The images allow us to look back to a time long gone but still inextricably linked to our lives, encouraging us to ponder our profound connection to these landscapes, these places, and these people.

# The FSA-OWI Photographic Project

DURING THE GREAT DEPRESSION and World War II, a government-sponsored photographic project created an unparalleled pictorial record of American life. As employees of the Resettlement Administration and later the Farm Security Administration (FSA) and the Office of War Information (OWI), a group of American photographers—some famous, others to become famous, and some who remain largely unknown—fanned out across the country to document the effects of the Depression and the war on the American people. When the project began in 1935, its goal was to compile a visual record of the repercussions of the Great Depression on America's rural population, spurring the public to support government relief and resettlement efforts. But as the Depression lengthened, the photographers reached into the cities, into mining and mill towns, into white working-class, African American, and Latino neighborhoods, recording the misery, the resilience, and the spirit of the American people.

The agency they worked for until America's entry into World War II was established as the Resettlement Administration in 1935. A product of the "second New Deal," a period characterized by massive and direct intervention by the federal government to provide relief and reconstruction, the RA dealt with emergencies resulting from the effects of the Depression, drought, and soil erosion on American agriculture. RA services included resettlement for farmers made homeless, temporary loans, and free distribution of government supplies. Migrant workers, among the poorest of the poor, also received aid. In 1937, the responsibilities of the RA moved within the Department of Agriculture to the Farm Securities Administration, which was headed by one of Franklin D. Roosevelt's closest advisors, Rexford Guy Tugwell. When Tugwell assumed his duties, he realized that the agency needed a public-relations arm to tell city dwellers of the plight of farm families and migrant workers and, equally important, to present the work of the FSA in a positive light. Like many other New Deal agencies, the RA and the FSA were controversial. Critics saw their emphasis on collective solutions—communal farms, sanitary migrant labor camps, and "new towns" for resettled farmers—as "socialistic" or even "communistic." To counter this criticism and ensure the continued support of Congress and the public, Tugwell formed an Information Division that would supply articles, films, tapes, traveling exhibitions, and photographs to newspapers, radio stations, museums, and community organizations.

Tugwell chose Roy Stryker to direct the Information Division's photography project. Stryker had been his student at Columbia University, where Tugwell taught economics before joining the Roosevelt administration. The two men had previously collaborated on producing a book, *American Economic Life,* that made extensive use of photographs to complement the text. Even though Stryker was not a photographer, Tugwell knew that he had effectively used images as a powerful teaching tool,

infusing life into the dry material of economic theory and practice. Tugwell recognized this as the skill that the FSA needed to document the agency's work and illustrate it for the public. "Tugwell gave me a great chance," Stryker later wrote. "He wanted to prepare a pictorial documentation of our rural areas and rural problems, something that had always been dear to my heart." Tugwell did not just want a collection of pictures, however. One day he brought Stryker into his office and told him, "Roy, a man may have holes in his shoes, and you may see the holes when you take the picture. But maybe your sense of the human being will teach you there's a lot more to that man than the holes in his shoes, and you ought to try and get that idea across." Tugwell wanted the human face of the Depression, not just a catalog. He reminded Stryker that he had a "real chance . . . to tell the people of America that those in distressed areas are the same as everybody else except they need a better chance."[1]

When Stryker took the job, no one could have imagined the role he would play in the history of American photography. The job description charged him with enhancing the public's perception of FSA relief programs. Even though he was not a professional photographer, he had a talent for hiring the best and getting exceptional work from them. Walker Evans, Dorothea Lange, Carl Mydans, Arthur Rothstein, and Ben Shahn joined the agency in 1935. Evans's work was already well known in photographic circles, and Lange had come to Stryker's attention because of her acclaimed photos of migrant farm workers in California. Of the rest, Carl Mydans was a photojournalist, Rothstein a student who had studied with Stryker at Columbia, and Shahn an artist with a strong social conscience who saw the

camera's potential for both art and propaganda. Over the next eight years, Stryker involved a number of other photographers in the program, including John Collier, Jack Delano, Russell Lee, Gordon Parks, Esther Bubley, John Vachon, Marion Post Wolcott, Marjory Collins, and Sheldon Dick. These and other young, liberal photographers headed out with a sensitivity honed by their experiences in the Depression. As they worked, they exploited new photographic techniques made possible by the small, highly portable, 35 mm cameras recently introduced from Germany.

In addition to attracting top photographers to work for him, Stryker—a teacher at heart—prepared them well. He made sure that when they went on an assignment, they were informed about the subject of their shoots. Stryker did not have their technical skill, but he was able to recommend books they should read and would carry on lengthy conversations with them about their tasks. For example, when Carl Mydans was about to travel to Alabama to photograph cotton fields, Stryker gave him reading assignments and then, he said, "We sat down and we talked almost all day about cotton. We went to lunch and we went to dinner and we talked well into the night about cotton. I told him about cotton as an agricultural product, cotton as a commercial product, the history of cotton in the South, what cotton did to the history of the country, and how it affected areas outside the country. By the time we were through, Carl was ready to go off and photograph cotton."[2] Stryker believed that education, coupled with a photographer's sensitivity, would bring forth images that would combine understanding and compassion.

However, the first priority for the FSA photo project was to publicize the Farm Security Administration's efforts in coping

with the Great Depression. Aesthetic and social considerations took a backseat to the propaganda value of the photographs. In an effort to get the government's message of reform across to the American people, Stryker worked to establish an extensive network of contacts among book, newspaper, and magazine publishers, ensuring that the FSA photographs would be widely used. The mass-circulation picture magazines *Life* and *Look* included photo-essays on the project. The photographs also found their way into museums and galleries around the country, and they appeared prominently in the 1939 World's Fair in New York.

Nevertheless, Stryker's relations with his superiors and his photographers were not always harmonious. Agency officials criticized him for not producing more utilitarian photos; photographers criticized him for relying too much on a small group of photographs that had become very popular because of their frequent use by magazines and newspapers. John Collier's opinion probably represented the photographers rather well. He believed that the real value of the project lay not so much in the best-known photographs in the file but in the vast number of undramatic images that constituted a collective national portrait. "For every great Lange," Collier argued, "there are as many great but unknown works of other photographers, buried in the tremendous wealth of the material."[3] Tugwell defended Stryker from this charge, blaming instead the laziness of the newspapermen who came in and, rather than sifting through hundreds or even thousands of images, simply requested the photographs that they had seen published elsewhere. These relatively few photographs in time became familiar to millions of people and remain icons of the Great Depression to this day.

Eventually Stryker concluded that the project would have two missions. One was to make the pictures demanded by the government—the everyday images of the FSA and other New Deal programs. The second, more important mission would be to produce images that would constitute a social document of the times. "Most of what the photographers had to do to stay on the payroll," wrote Stryker, "was routine stuff showing what a good job the agencies were doing in the field." After that, the photographers could use "a day here, a day there, to get what history has proved to be the guts of the project."[4] Arthur Rothstein noted that while the original purpose was to portray rural scenes, especially those related to the work of the FSA, the photographers were "curious, inquisitive people" who were exposed to the cities when they passed through—and when the photographers saw things that they believed should be documented, they shot them.[5] As the New Deal's reforms continued, the pressure for immediate documentation of rural problems and progress began to lessen. And by the late thirties and early forties, the scope of the project had expanded to include almost anything that was significant to American culture. Urban photographs found their way into the file as FSA photographers were "rented out" to other government agencies. Arthur Rothstein spent a great deal of time in Pittsburgh taking still photos to help filmmaker Pare Lorentz with his production of the classic documentary film, *The River*, which dealt with flood-control problems on the Allegheny and Monongahela Rivers. When he was not helping Lorentz, Rothstein roamed the city and made hundreds of images that ended up in the FSA files.

The great American photographer Ansel Adams came close to the truth when he quipped that the FSA photographers were

"a bunch of sociologists with cameras."[6] "Anthropologists" might have been a more accurate description. While the FSA photo file did not ultimately produce a systematic depiction of American culture, it came closer than any other visual project before or since. Not surprisingly, Stryker early on discussed his ideas for the project with Columbia professor Robert Lynd, author of *Middletown*, the famous sociological study that made Muncie, Indiana, the prototype for an average American community. Lynd saw that the camera could serve as a tool for social documentation. He suggested a list of topics for the FSA photographers to include in their assignments, such as home in the evening, attending church, where people meet, backyards, looking down my street, people on and off the job, the effects of the Depression, how people look, the decorations in homes, and many more. Out of his meeting with Lynd, Stryker developed the idea of preparing "shooting scripts" for his assignments. In addition to a list of topics to cover, the photographers were encouraged to "look for the significant detail. The kinds of things that a scholar a hundred years from now is going to wonder about."[7] Stryker and his photographers never really deviated from that underlying goal. They set out to produce what Ben Shahn called the "stark presentation of actual conditions, the wordless, statistics-less, visual, inescapable truth."[8] When Walker Evans prepared his outline for his first trip for the FSA, he described his first objective in the Pittsburgh area as "photography, documentary in style, of industrial subjects, emphasis on housing and home-life of working-class people. Graphic record of a complete, complex, pictorially rich modern industrial center."[9]

Of course, the goal of absolute objectivity was unattainable. Photographs inevitably reveal the point of view of the person behind the camera. As noted earlier, the FSA photographers were mostly young and burning with the desire to change the country. Stryker professed to want documentation of all social classes, but with few exceptions, the photographs in the FSA file primarily depict farmers and working-class people and their surroundings. Stryker's letter to Sheldon Dick in 1938 before Dick's trip to photograph the anthracite coal town of Shenandoah, Pennsylvania, illustrates his sociopolitical orientation. Stryker had visited the town. "Everywhere you look is man-made desolation, waste piles, bare hills, dirty streets," he wrote. "It is terribly important that you in some way try to show the town against this background of waste piles and coal tipples." Stryker went on to write about the unemployed, the consumption of liquor, and the overall shabbiness of the town. He recommended that Dick try to depict the condition of the town's youth—hopelessness, confusion, "liquor, swing, sex, and more liquor."[10] Fortunately, Dick came back with a good deal more. As the scholar Alan Trachtenberg has noted, Stryker's instructions to Dick on Shenandoah were an "amalgam of social science (geography, ethnography, sociology), New Deal politics, and liberal reformism."[11] Stryker felt proud that no picture in the file attempted to ridicule the subject, invade anyone's privacy, or replicate a cliché. He also boasted that there was only one picture of Franklin Roosevelt, no record of famous events, and "absolutely no celebrities."[12]

World War II signaled the end of the FSA. Franklin Roosevelt underwent a transformation from "Dr. New Deal" to "Dr. Win the War," and the battle against rural poverty was subsumed into the war against fascism. During the Great Depression, Roosevelt had sought to unify the nation in the struggle against economic disaster. The FSA photographers had enlisted in that war.

Now the enemy was totalitarianism—and Stryker saw that the only way to save the project was to move it into the Office of War Information. The project's orientation changed dramatically. "Emphasize the idea of abundance—the 'horn of plenty'—and pour maple syrup over it," he told Jack Delano. "I know your damned photographer's soul writhes, but to hell with it. Do you think I give a damn about a photographer's soul with Hitler at our doorstep?"[13] Photographer John Vachon put it more succinctly: "What was left of Stryker's outfit was turned into a branch of the Office of War Information to photograph defense plants, shipyards, and God Bless America."[14]

While the mission of the unit changed with its move to the OWI, its documentary method did not. OWI photographers added substantially to the file before the project ended. Several of these contributions focused on Pennsylvania, including Marjory Collins's in-depth photographic essay of Lititz, a Pennsylvania town. The Lititz story portrays a young war wife who works in a munitions factory, and it follows a shooting script much like the one Stryker sent out early in 1942 calling for pictures of war industries, civil defense activities, Selective Service registration, home gardens, and meetings of all kinds. According to Stryker, "the people should appear as if they really believed in the U.S."[15] Collins delivered. Her photo-essay provides a inventory of the town's occupations and personalities, and it is every bit as ethnographically sweeping as any of the Great Depression photo-essays.

Much the same can be said about Esther Bubley's project on cross-country bus travel during wartime. Her photos document a Greyhound bus trip from Washington, D.C., through the Midwest and South and back again. An integral part of the project explores a bus station in Pittsburgh, where Bubley documented all aspects of the life of the station, its workers, and its passengers.

Aside from the contributions of Collins and Bubley, many other FSA-OWI photographers worked in the Keystone State—twenty-three in all. Most active were John Collier, Marjory Collins, Jack Delano, Sheldon Dick, Esther Bubley, Arthur Rothstein, and John Vachon. Others who took fewer (but no less important) photographs included Walker Evans, Carl Mydans, Edwin Rosskam, and Ben Shahn. Two of the most famous FSA photographers, Dorothea Lange and Russell Lee, took only a few Pennsylvania shots. Gordon Parks took none. Others less well known, such as Pauline Ehrlich ("Spring Run Farm"), Howard Hollem ("Bach Festival, Bethlehem"), and Arthur Siegel ("Burpee Seed Company, Philadelphia"), did essays concentrating on single assignments during the war years. A few of the Pennsylvania photographs are among the iconic images that remain engraved in America's collective memory of the Great Depression. Walker Evans's "Bethlehem graveyard and steel mill" and Jack Delano's "Mr. Merritt Bundy of the Tri-County Farmers Co-op Market at Du Bois at the entrance to his mine on his farm near Penfield" and "Polish family living on High Street in Mauch Chunk" are in that company, as is Marjory Collins's Lititz project.

But what is true of the national files is also true of the Pennsylvania collection. Roy Stryker was correct when he pointed out that "the work . . . can be appreciated only when the collection is considered as a whole. The total volume . . . has a richness and distinction that simply cannot be drawn from the individual pictures themselves."[16] Approximately 130 Pennsylvania communities

are represented in the collection, which comprises some six thousand images, one of the largest files for any state. Certain topics predominate. There are numerous photographs of farming and rural life. Because of the Resettlement Administration's interest in documenting its own projects, five FSA photographers visited Westmoreland Homesteads (later known as Norvelt), a new town for unemployed coal miners. Obviously, documenting the ravages of the Depression led the photographers to Pennsylvania's coal and steel towns. Jack Delano, Arthur Rothstein, and John Vachon depicted industrial Pennsylvania in especially noteworthy ways. The tranquility and resilience with which the Amish communities of Lancaster County lived through the Depression and the war drew the attention of John Collier, Marjory Collins, Sheldon Dick, Arthur Rothstein, and Marion Post Wolcott. And Pittsburgh—particularly in its grimier aspects—is represented in the work of Walker Evans, Jack Delano, and Arthur Rothstein, but the Pennsylvania collection also contains urban images from Erie, Bethlehem, Harrisburg, Philadelphia, York, and Lancaster.

The images that follow are merely a small selection from the Pennsylvania photographs in the FSA-OWI files. They were chosen for several reasons. First, because the FSA-OWI project was above all a documentary project, it is our hope that this selection will give as comprehensive a view as possible, in the ethnographic sense, of how ordinary Pennsylvanians lived in the years between 1935 and 1943. In addition, the selection is meant to be representative of the great industries that gave the Commonwealth its particular character—agriculture, iron and steel, and mining—and their effects on the people and environment of the state. We have also been mindful of geographic representation. Finally, there is the aesthetic question. All of the already famous Pennsylvania photos are included, but so are many others that, along with their documentary value, also rise to the highest level of photographic art. We hope that by viewing these images, readers will gain a better understanding of how an earlier generation of Pennsylvanians lived, worked, played, worshipped, struggled, and endured.

PHOTOGRAPHS FROM PENNSYLVANIA

# CHILDREN

CHILDREN FREQUENTLY ATTRACTED the attention of FSA-OWI photographers. The photos chosen for this section represent a range of topics and sentiments. Some concentrate on the devastating effects of the Great Depression, as in John Vachon's stark photos of deplorable living conditions in Aliquippa or Ben Shahn's pictures of boys scavenging for coal on slag heaps in Nanty Glo. More often, however, children were depicted in activities that were unrelated to the Depression or to wartime. In such photos, the viewer can get some sense of what childhood was like on the farms, in the cities, and in the mining and steel towns of Pennsylvania. Despite the momentous events through which they lived, children continued to attend birthday parties, work as newsboys, take the bus, go to the movies—and, most of all, make their towns their own with an ease that only childhood allows.

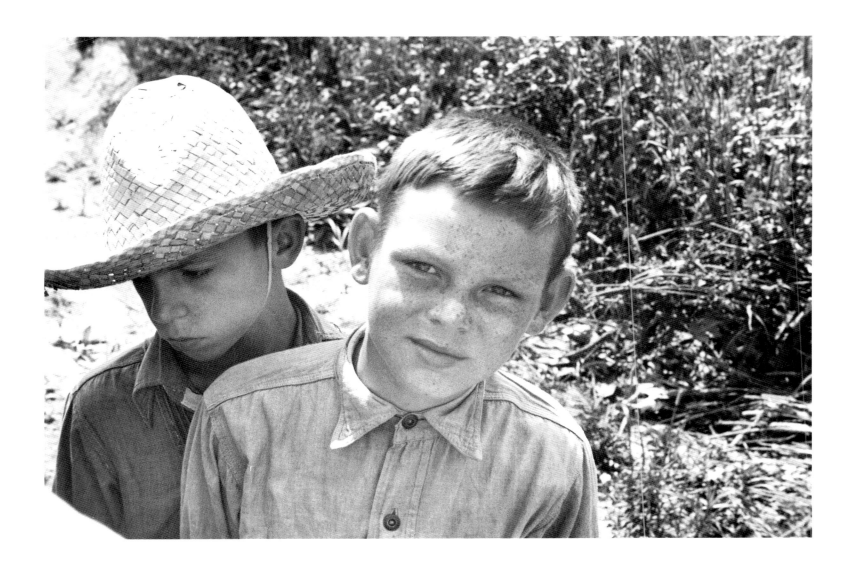

Boys. Westmoreland County, July 1935. Walker Evans.

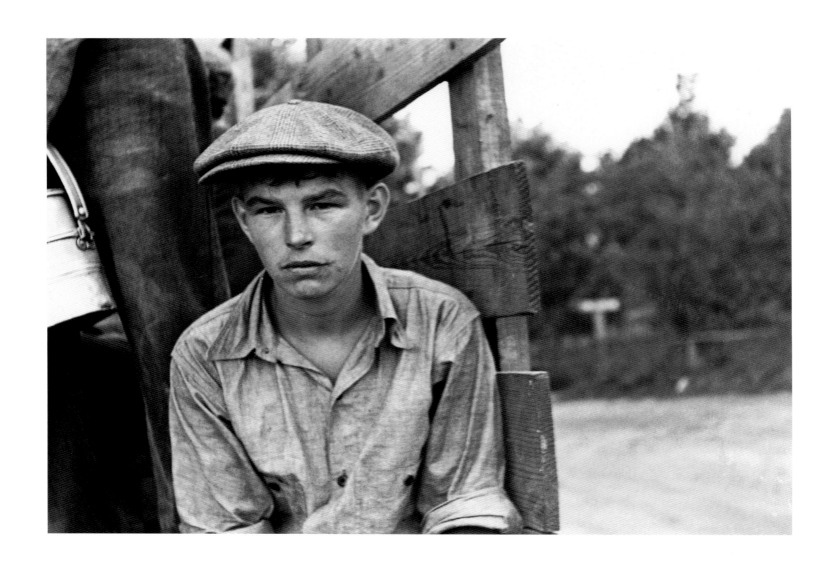

A boy. Westmoreland County, July 1935. Walker Evans.

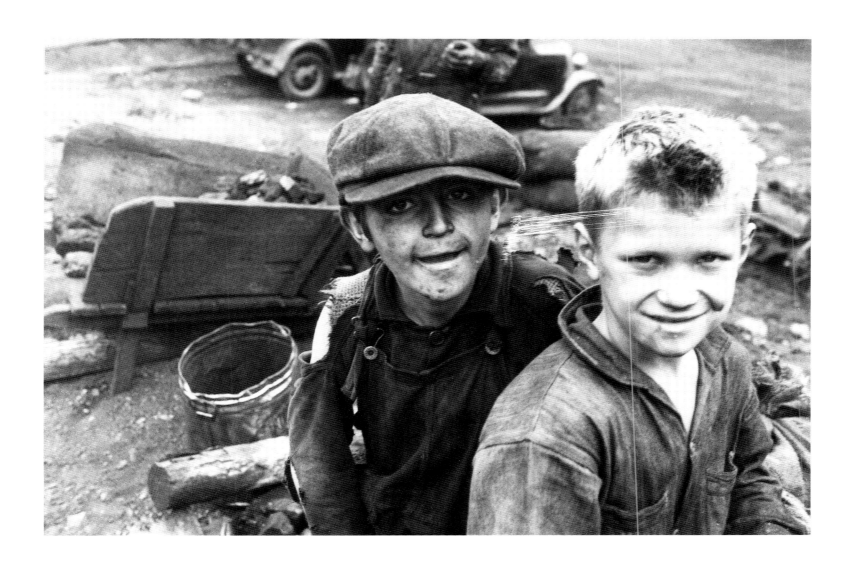

Boys who salvage coal from the slag heaps at Nanty Glo. 1937. Ben Shahn.

x

37

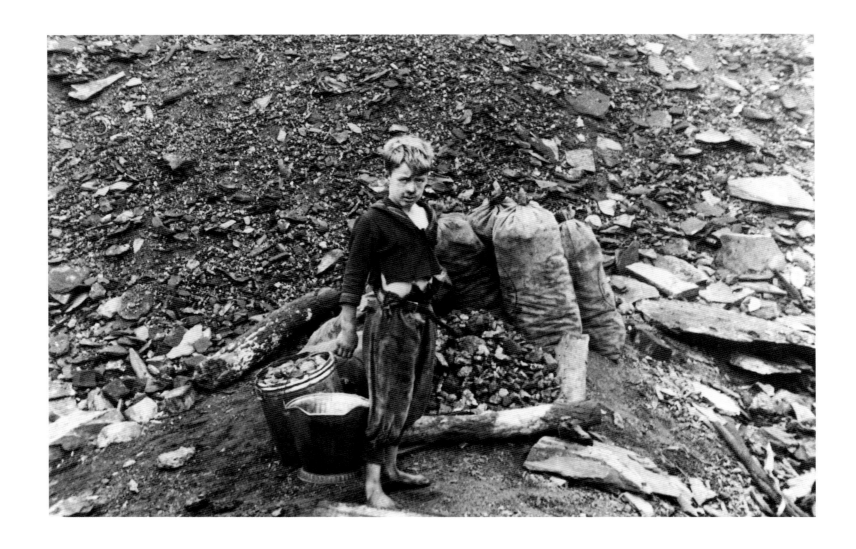

Young boy who salvages coal from the slag heaps. Nanty Glo, 1937. Ben Shahn.

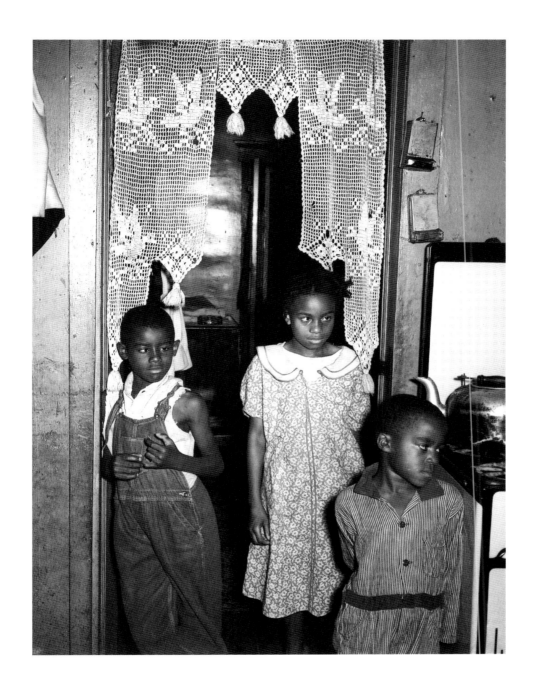

Steelworker's children. Midland, July 1938. Arthur Rothstein.

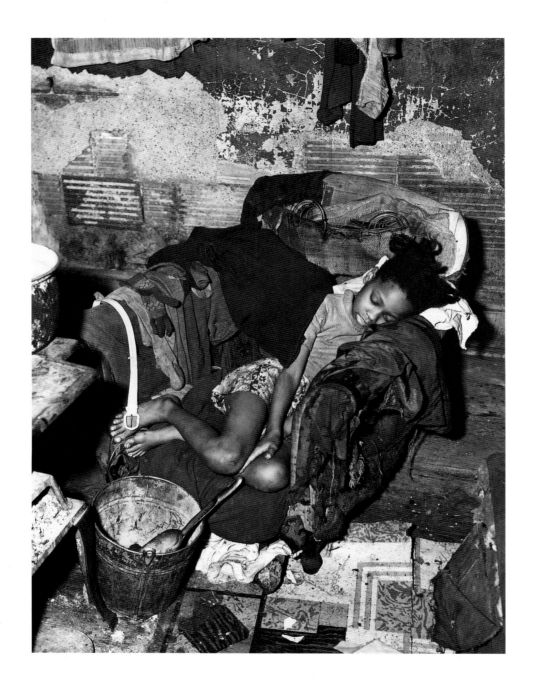

Sick child. Aliquippa, January 1941. John Vachon.

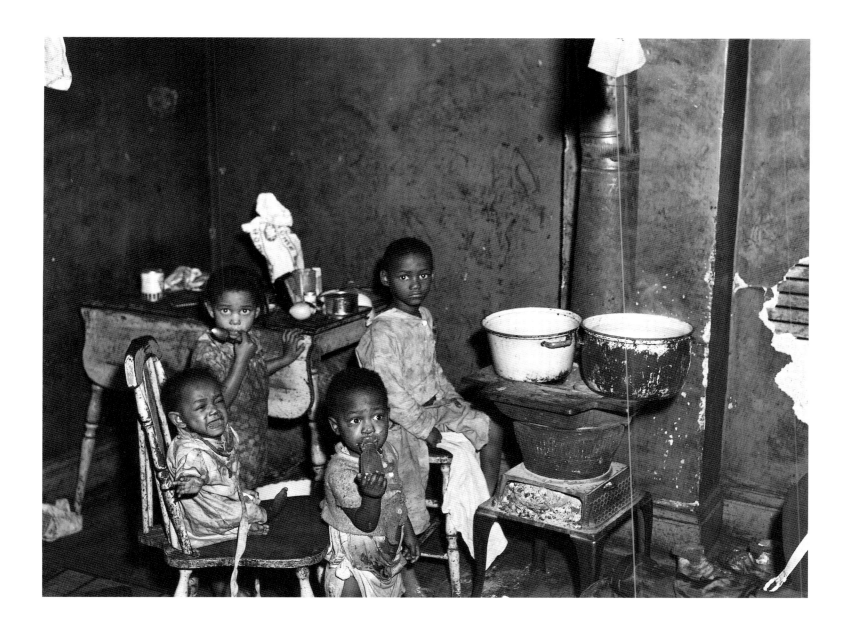

Children living in a two-room slum apartment. Aliquippa, January 1941. John Vachon.

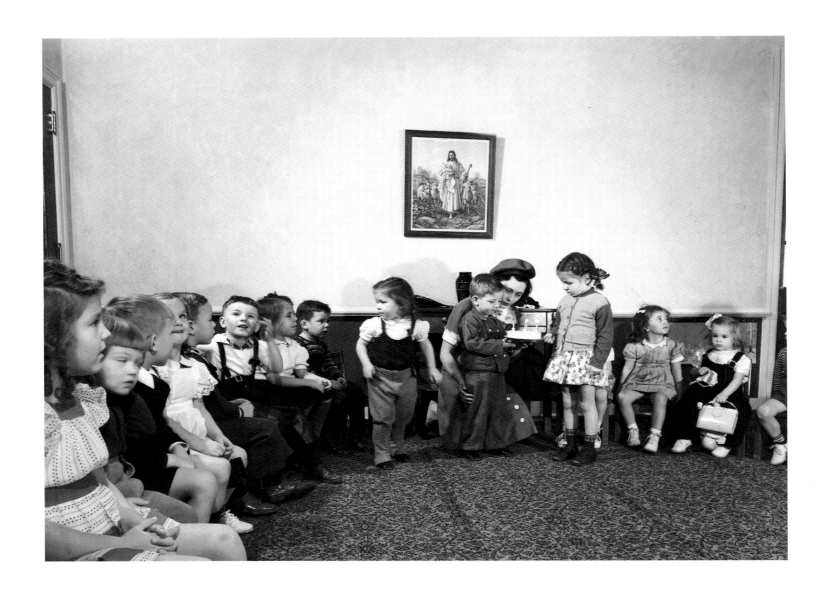

Birthday party in a Moravian Sunday school. Lititz, November 1942. Marjory Collins.

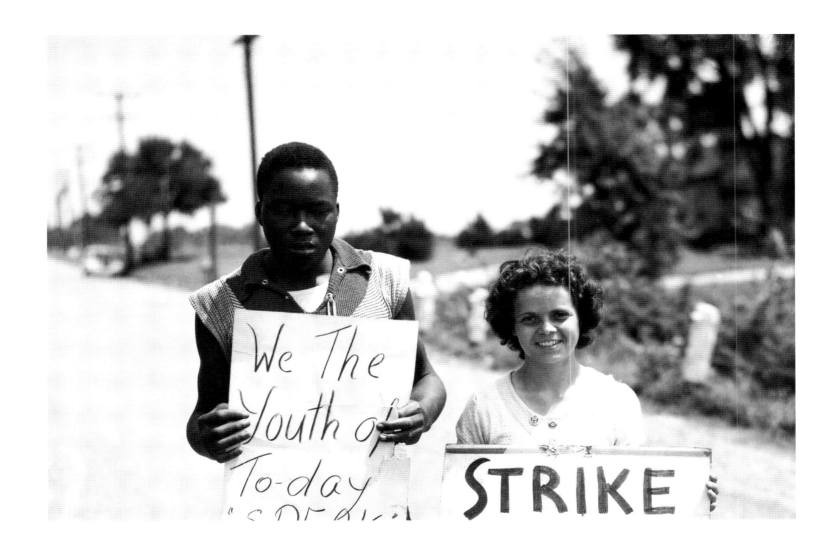

Members of the picket line at the King Farm strike. Morrisville, August 1938. John Vachon.

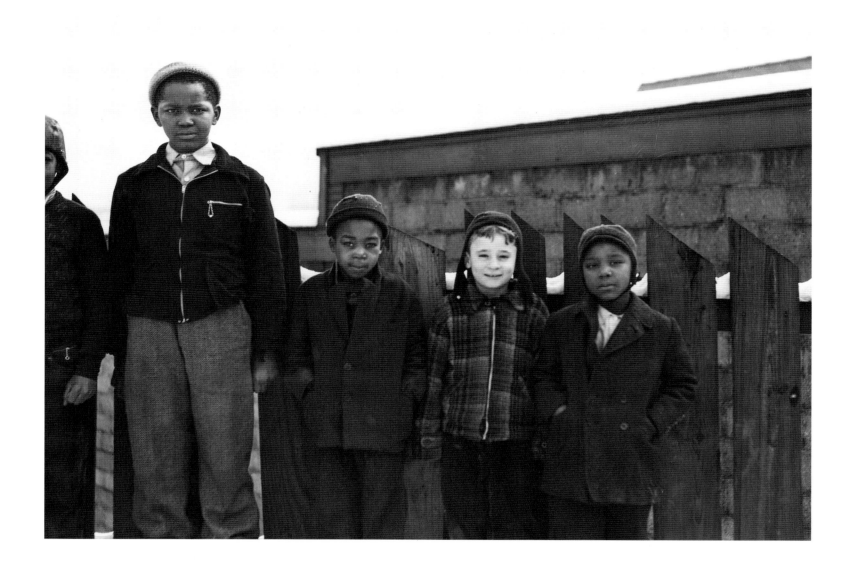

Steelworkers' sons. Aliquippa, January 1941. John Vachon.

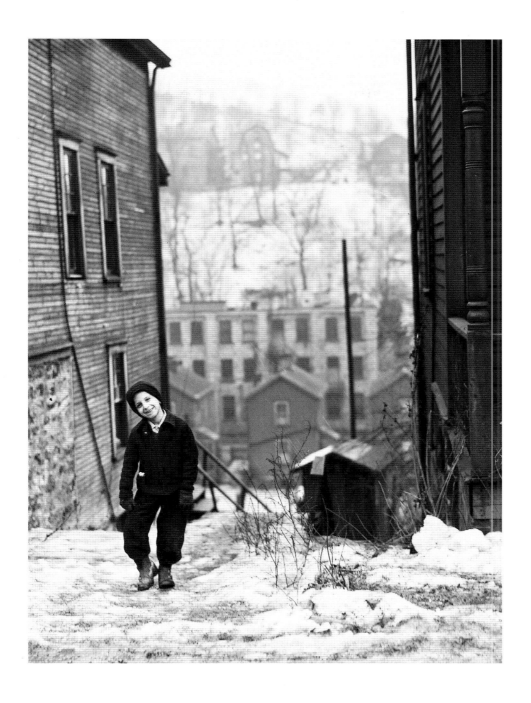

Little boy in Conway. January 1941. Jack Delano.

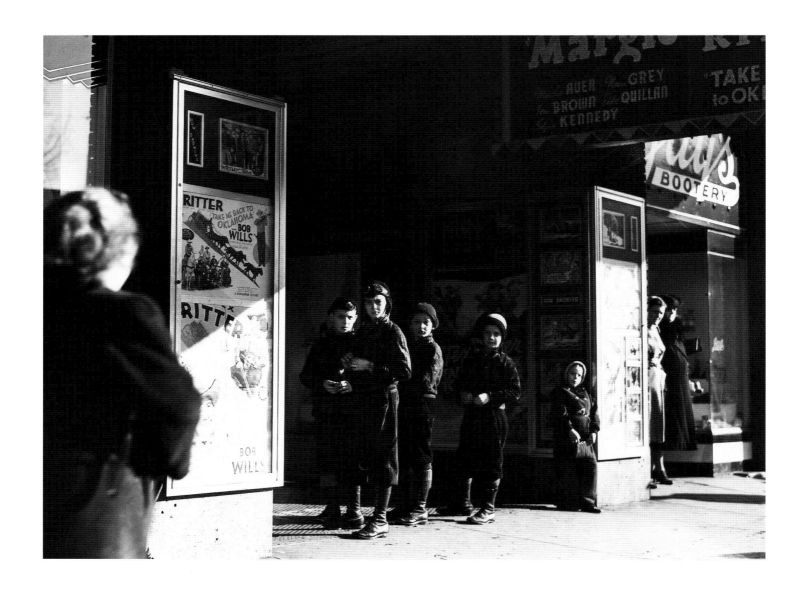

Children at a movie house on Saturday afternoon in Beaver Falls. January 1941. Jack Delano.

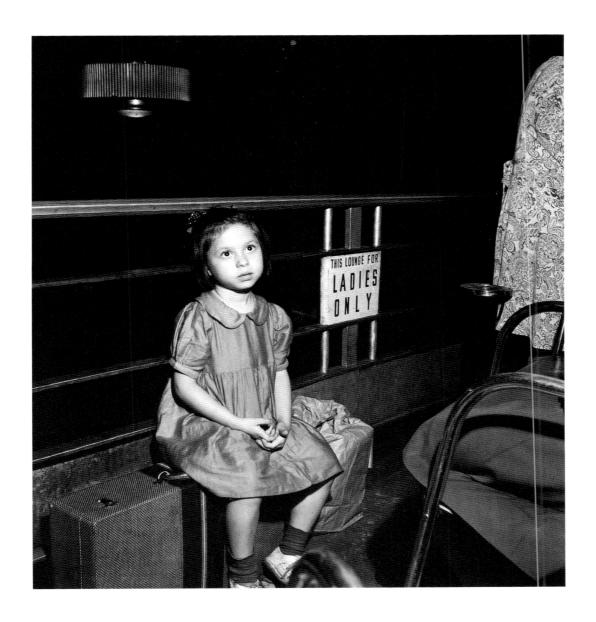

Waiting for a bus at the Greyhound bus terminal. Pittsburgh, September 1943. Esther Bubley.

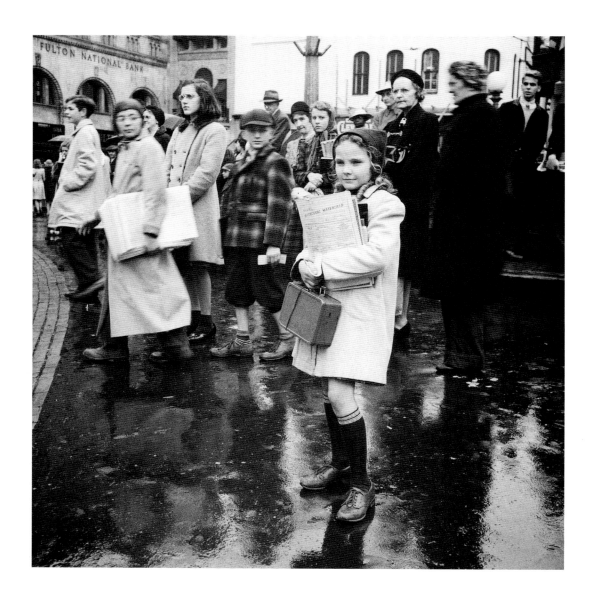

School child waiting for a bus in the rain. Lancaster, November 1942. Marjory Collins.

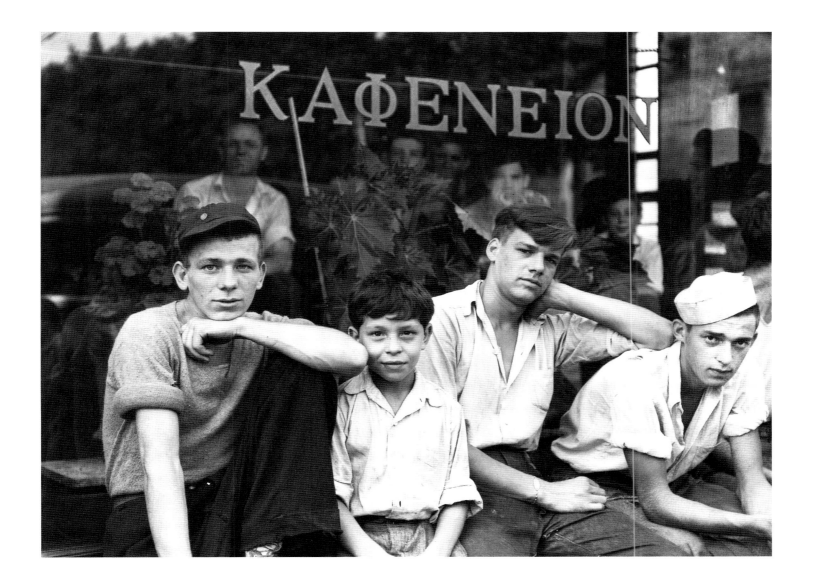

Boys in the town in front of a Greek coffee shop. Ambridge, July 1938. Arthur Rothstein.

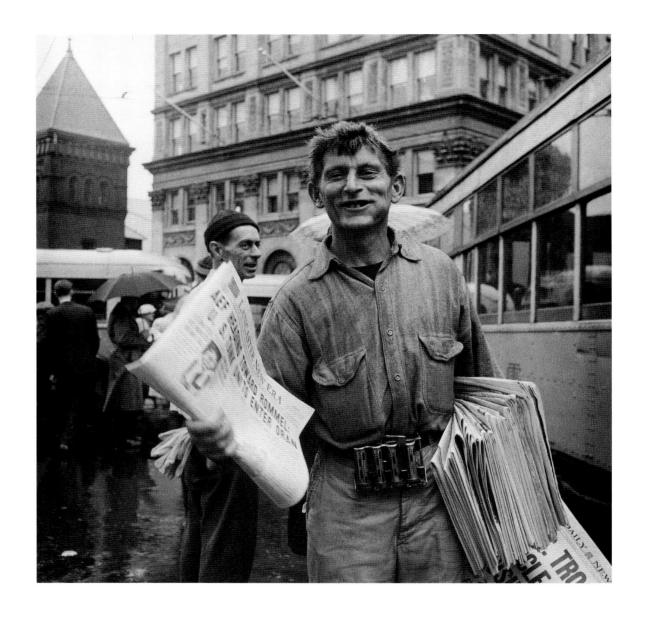

Newsboy at Center Square on a rainy market day. Lancaster, November 1942. Marjory Collins.

# TOWN AND CITY

ALTHOUGH THE FSA-OWI photographers represented a federal agency whose main concern was the impact of the Great Depression on rural America, much of their activity in Pennsylvania centered on life in the cities and the coal and steel towns. These choices made sense in the context of the state, which possessed a huge rural population but was most noted for its mining and manufacturing. Unlike the American South and West, Pennsylvania felt the force of the Great Depression mainly in its urban and industrial areas. Consequently, photographs of Pittsburgh and the surrounding region of western Pennsylvania—home to steel and coal—appear frequently in the file. Pittsburgh was an obligatory stop for almost all of the photographers working in the state; others also recorded life in the steel towns of Aliquippa, Ambridge, and Midland. Philadelphia, on the other hand, received relatively little consideration. In the eastern part of the state, Walker Evans, Marjory Collins, and Jack Delano took noteworthy urban photos in Bethlehem, Lancaster, and the anthracite coal towns, respectively. The town- and cityscapes of industrial Pennsylvania were generally not pretty. Poor and working-class people lived in old and often substandard housing stock, their neighborhoods cramped and without amenities. Yet the photographs tell more than that. In them one also sees determination, pride, dignity—and occasionally joy.

Gravestone in Bethlehem graveyard. December 1935. Walker Evans.

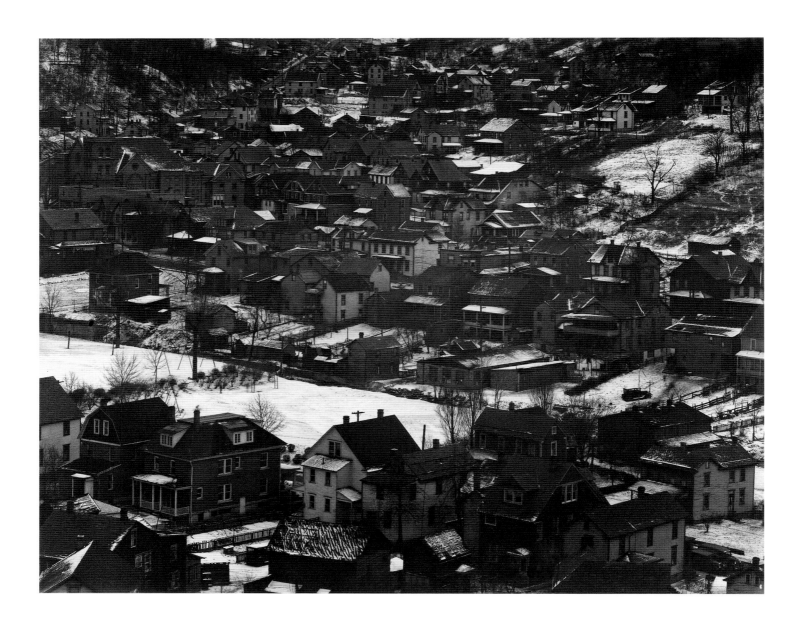

Johnstown housing. December 1935. Walker Evans.

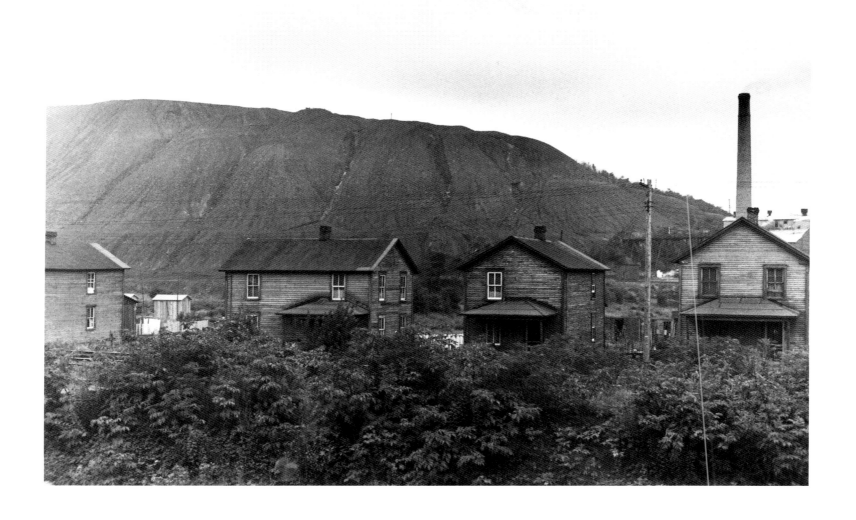

Houses and slag heap. Nanty Glo, 1937. Ben Shahn.

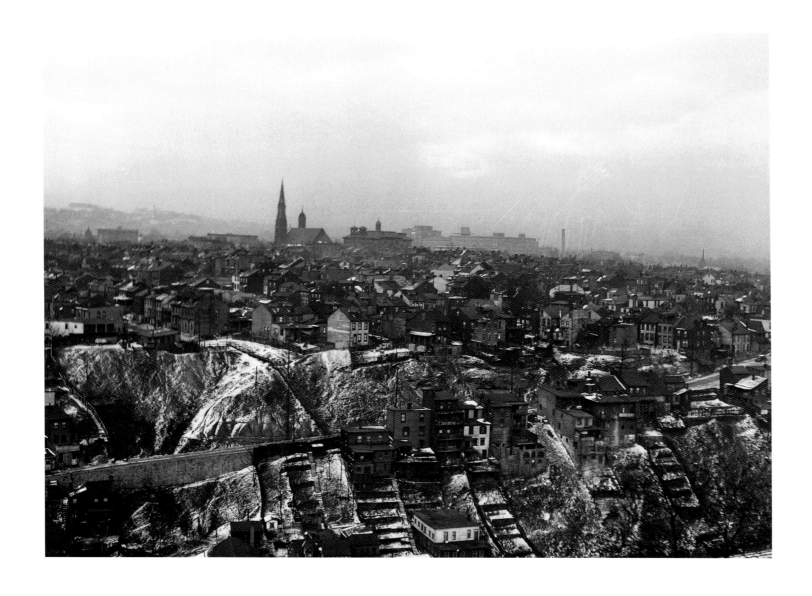

Pittsburgh, January 1941. John Vachon.

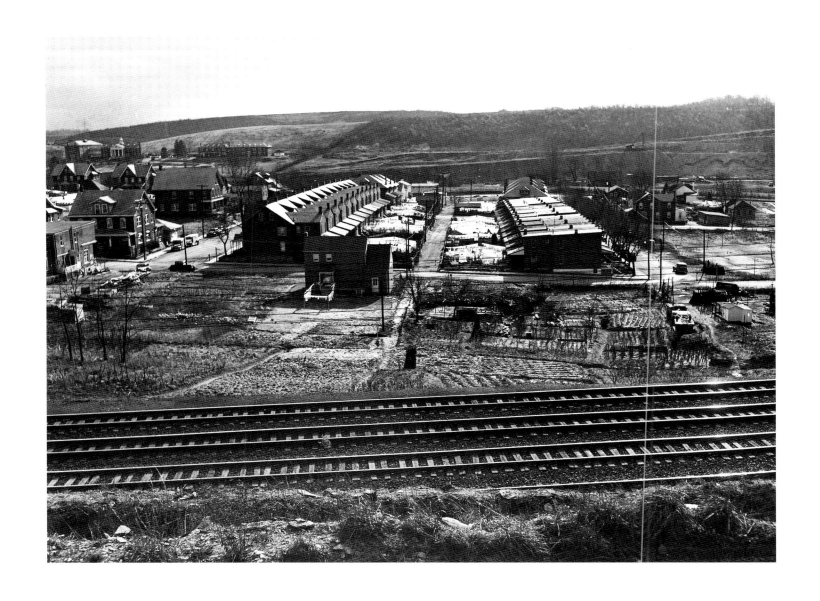

Factory workers' homes. Coatesville, December 1941. Arthur Rothstein.

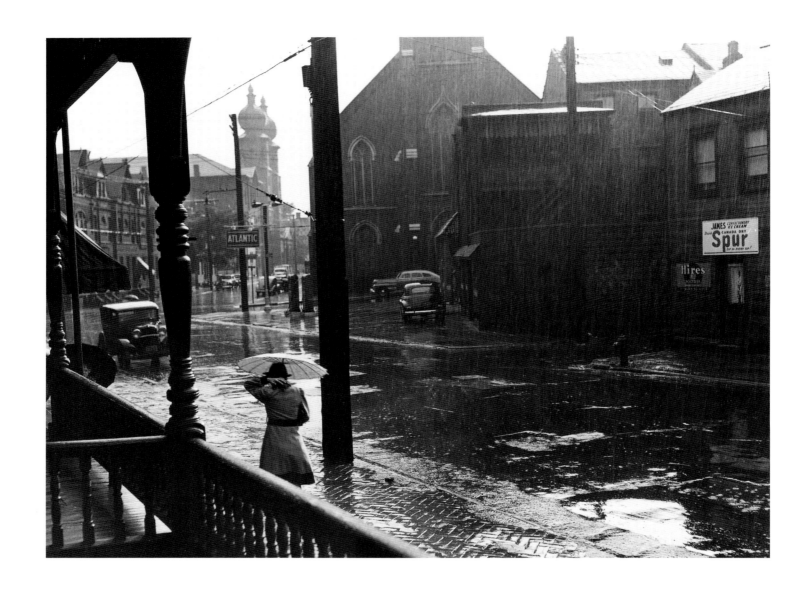

Rain. Pittsburgh, June 1941. John Vachon.

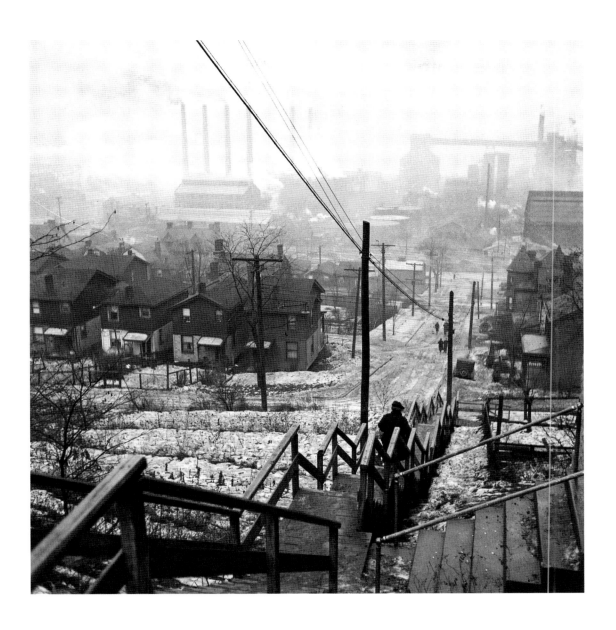

Long stairway in the mill district of Pittsburgh. January 1941. Jack Delano.

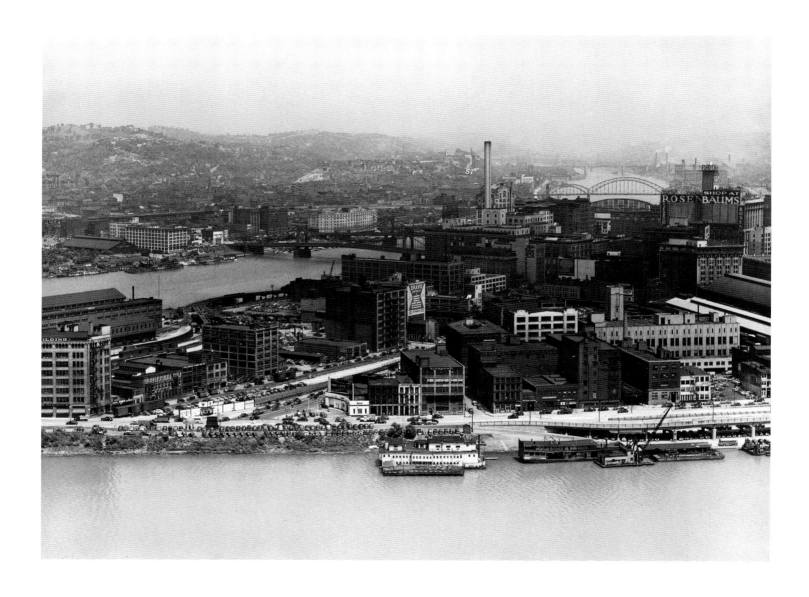

Pittsburgh, August 1941. Marion Post Wolcott.

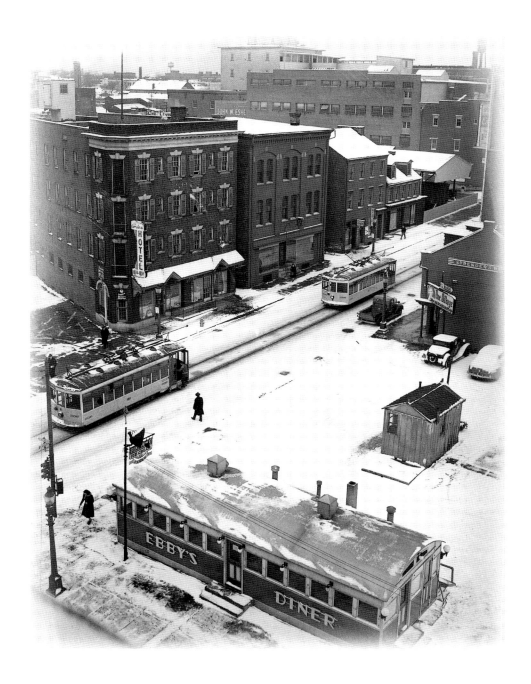

Lancaster, February 1942. John Vachon.

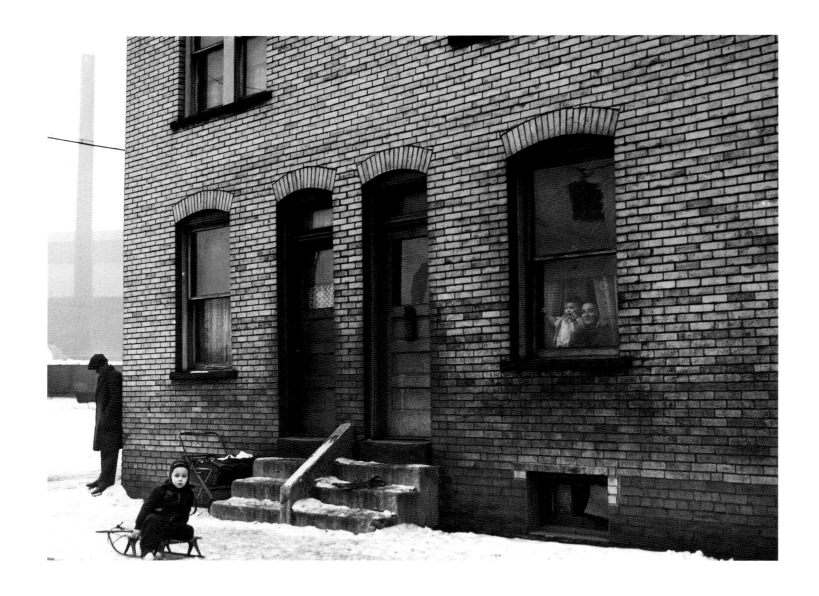

Workers' houses near the Pittsburgh Crucible Steel Company. Midland, January 1941. Jack Delano.

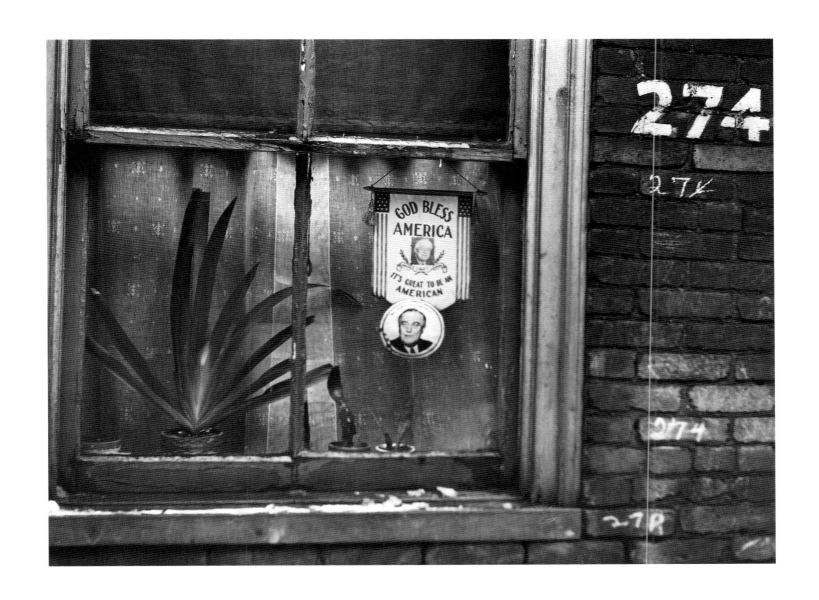

Window in home of an unemployed steelworker. Ambridge, January 1941. John Vachon.

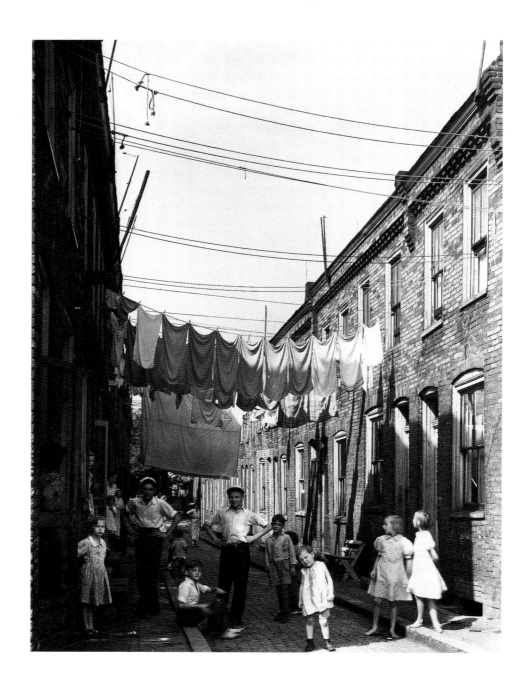

Housing conditions in Ambridge, home of the American Bridge Company. July 1938. Arthur Rothstein.

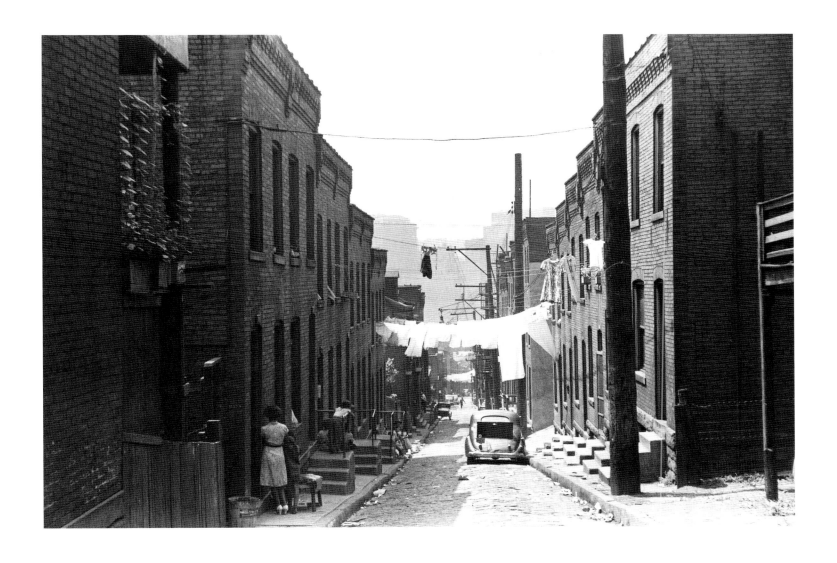

Houses on "The Hill" slum section. Pittsburgh, July 1938. Arthur Rothstein.

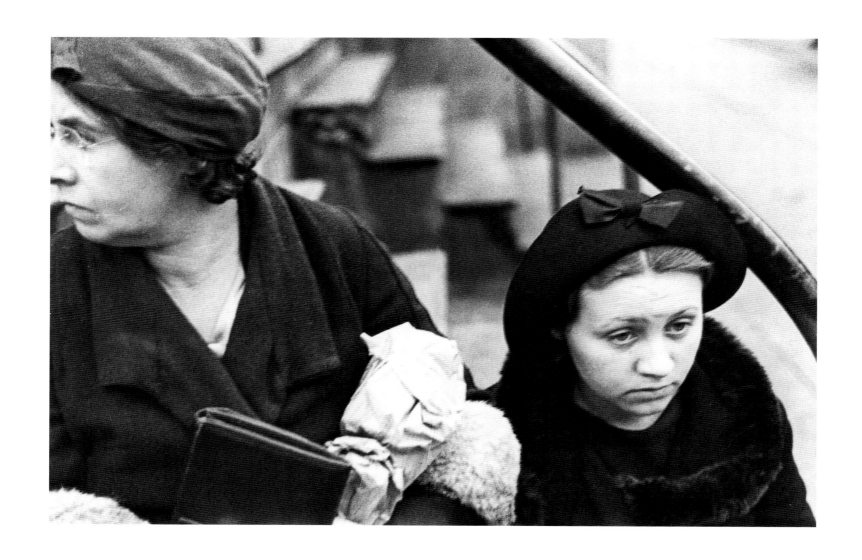

Bystanders. Bethlehem, March 1936. Walker Evans.

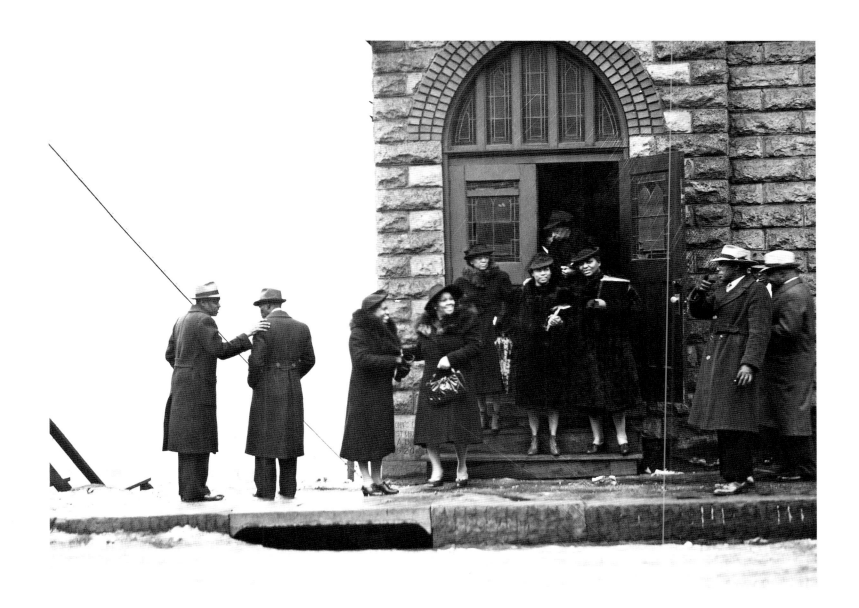

Negro church in the mill district of Pittsburgh. January 1941. Jack Delano.

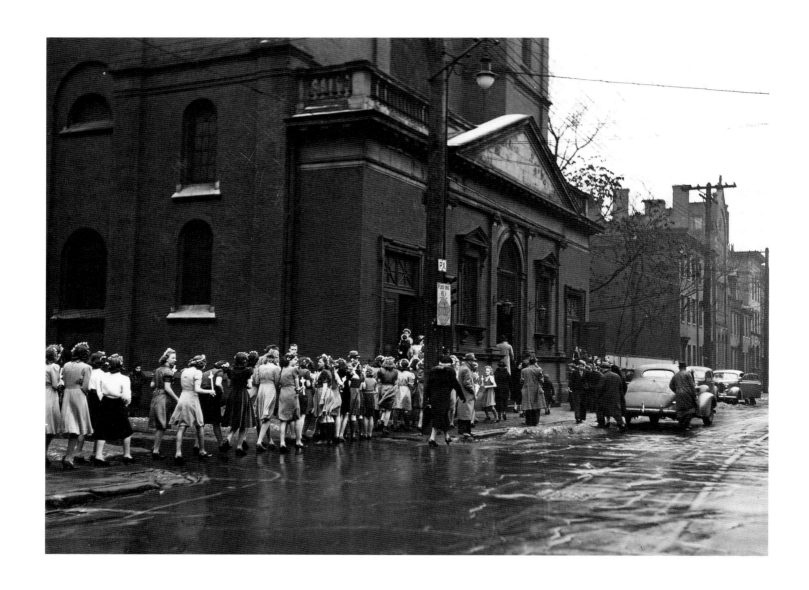

Sunday morning. Pittsburgh, January 1941. John Vachon.

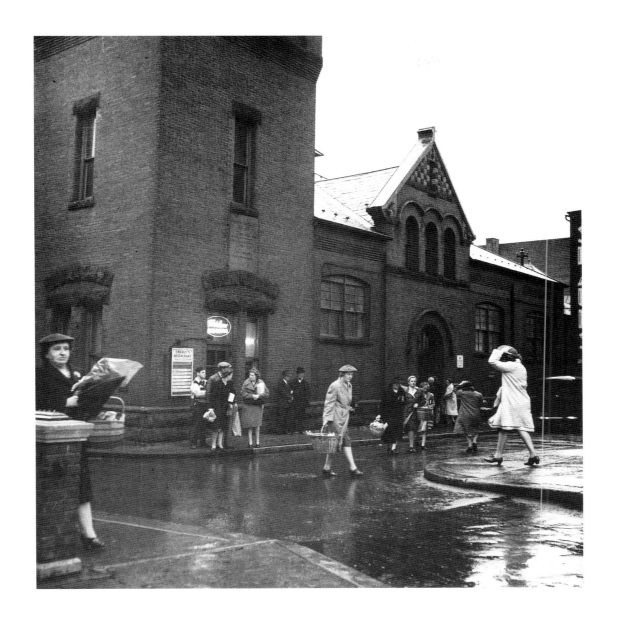

Central market. Lancaster, November 1942. Marjory Collins.

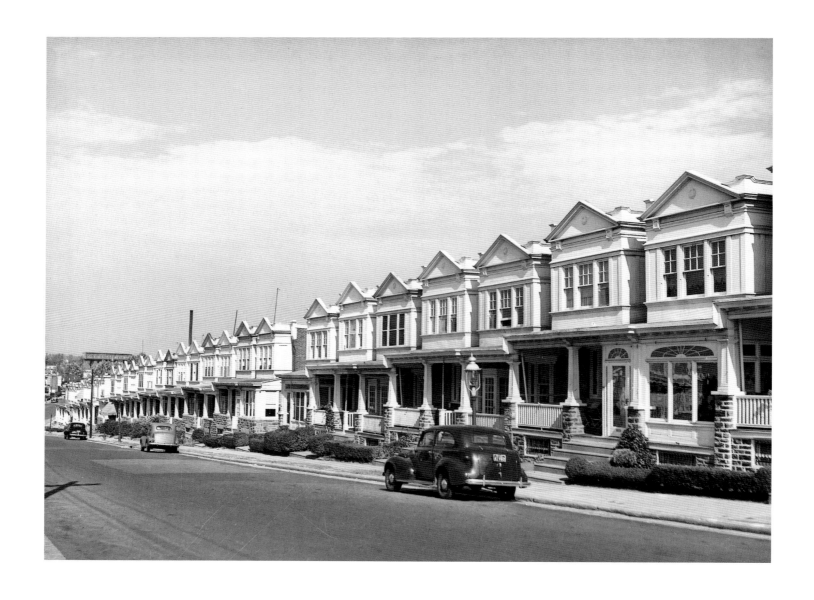

Row houses. Philadelphia, October 1941. John Vachon.

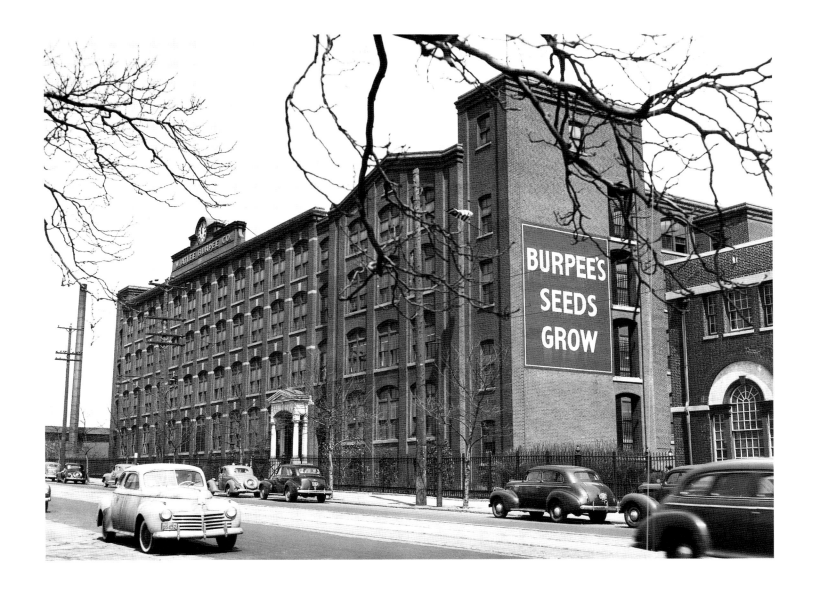

Exterior of the W. Atlee Burpee seed plant. Philadelphia, April 1943. Arthur Siegel.

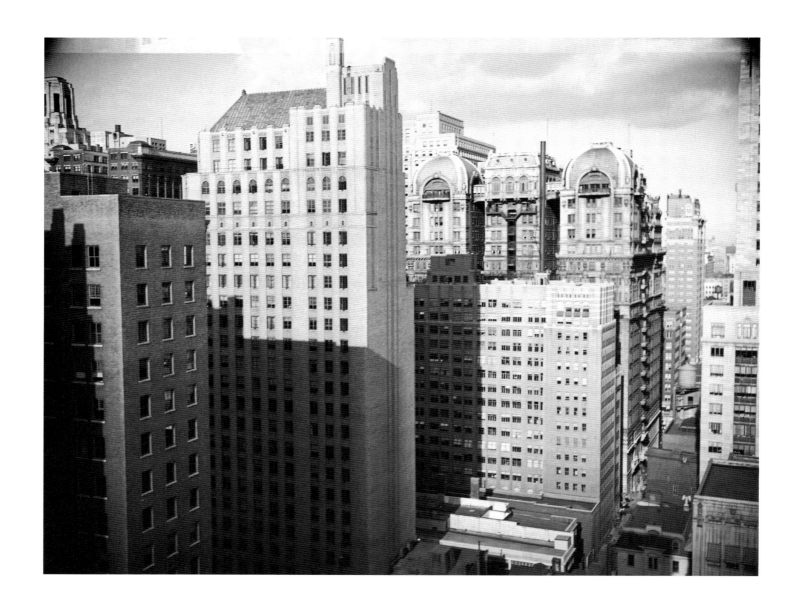

Downtown buildings looking east over Walnut and 15th Streets. Philadelphia, Spring 1939. Paul Vanderbilt.

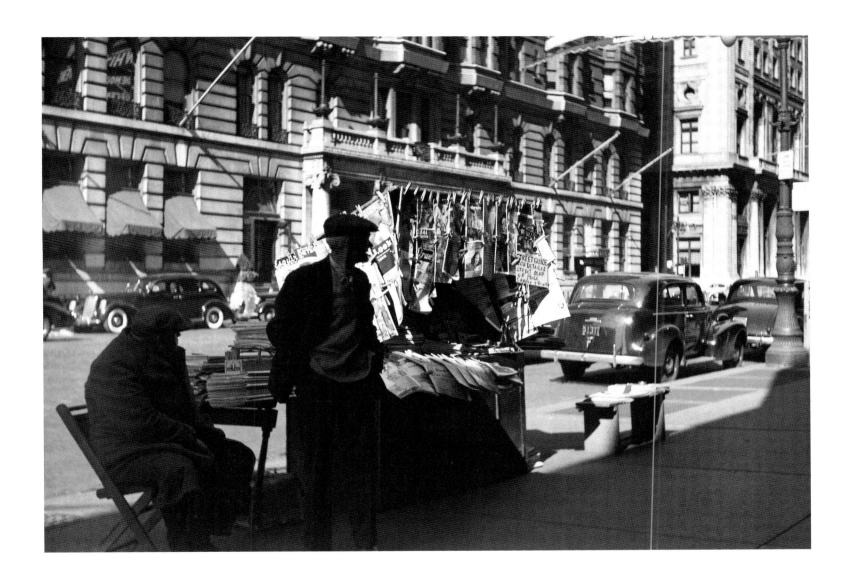

Newsstand on South Broad Street. Philadelphia, Spring 1939. Paul Vanderbilt.

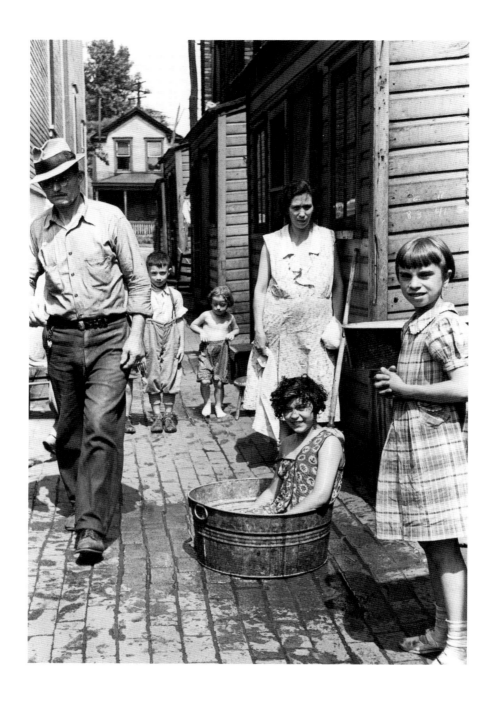

Scene in the alley on the east side of town. Ambridge, July 1938. Arthur Rothstein.

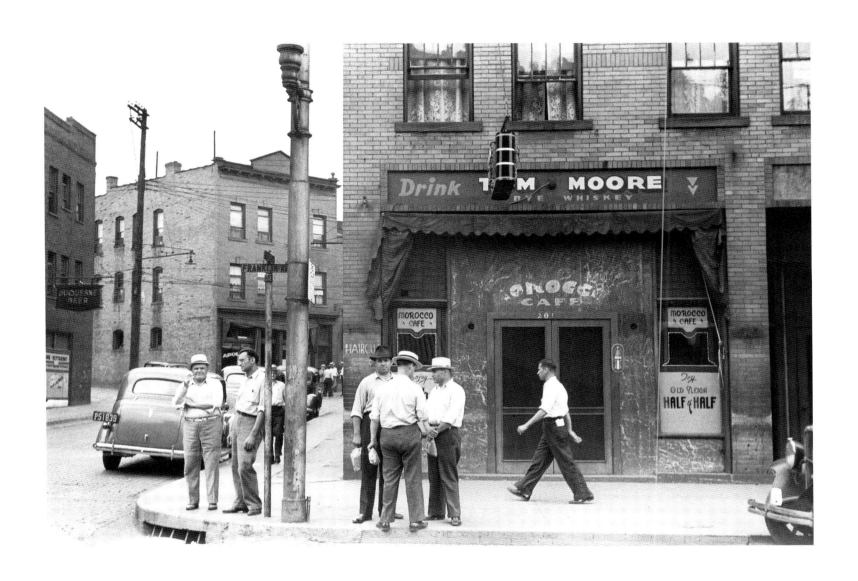

Street scene. Aliquippa, July 1938. Arthur Rothstein.

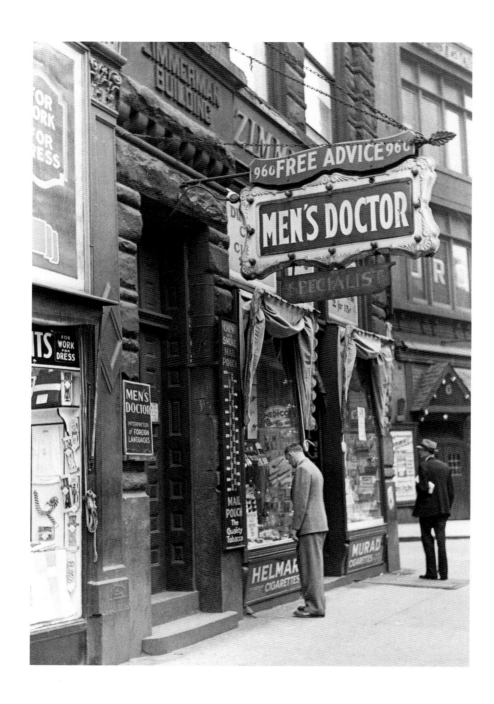

Quack doctor's office. Pittsburgh, May 1938. Arthur Rothstein.

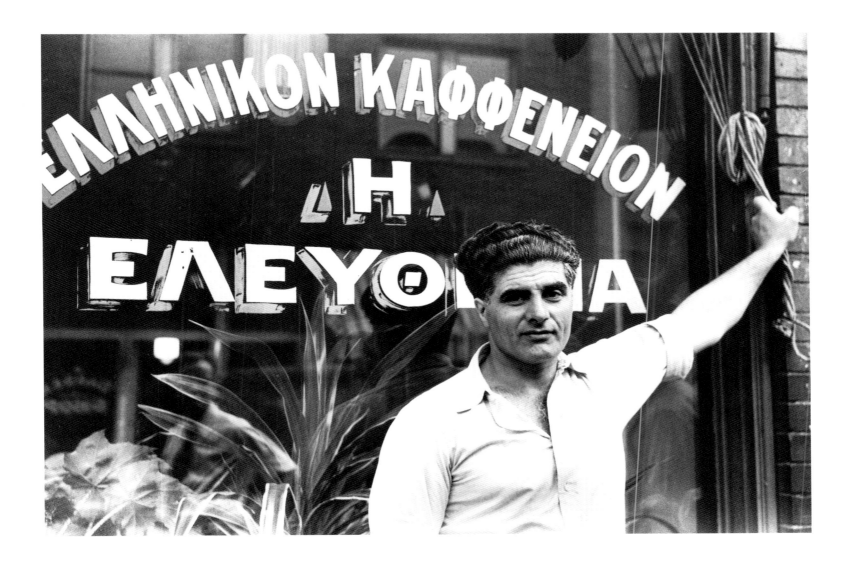

Proprietor of a Greek coffee shop. Aliquippa, July 1938. Arthur Rothstein.

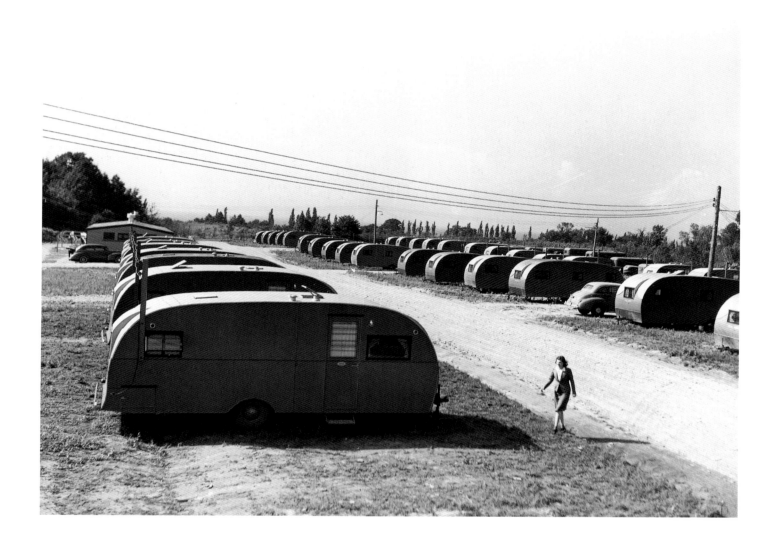

FSA trailer camp near the General Electric plant. There are two hundred trailers here, occupied by childless couples and by families of one and two children. Erie, June 1941. John Vachon.

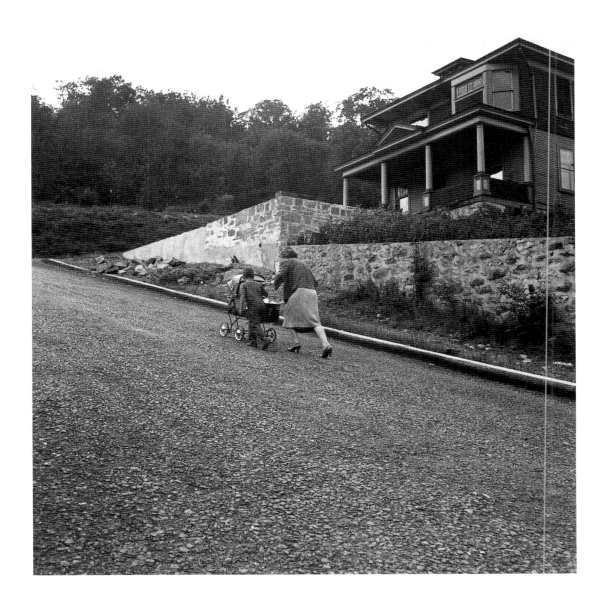

On a street in Upper Mauch Chunk. August 1940. Jack Delano.

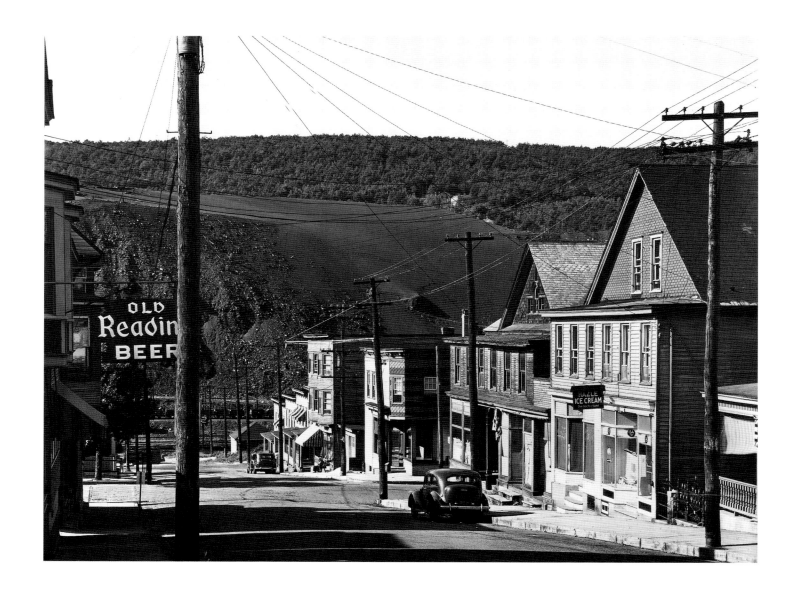

Street in the important anthracite town of Coaldale, showing the huge coal bank in the background. August 1940. Jack Delano.

# AT HOME

THE FSA-OWI COLLECTION offers rich visual data on all aspects of people's lives in Pennsylvania. None are more suggestive than the photographs of people in and around their homes. In the difficult times of the Depression and the war, the photographers celebrated the values of family, often depicting people in their parlors, around the dinner table, and on the porch together, surrounded by the things that comfort and help define them. The careful viewer will note the almost anthropological detail of ordinary household objects and furnishings that place the photos unmistakably—and forever—in those lost years. In keeping with the ethos of the photographic project, one does not enter here the homes of the rich and famous. These are the homes of ordinary people—workers and farmers. One is struck not by their meanness, or even their plainness, but instead by their warmth, individuality, and security.

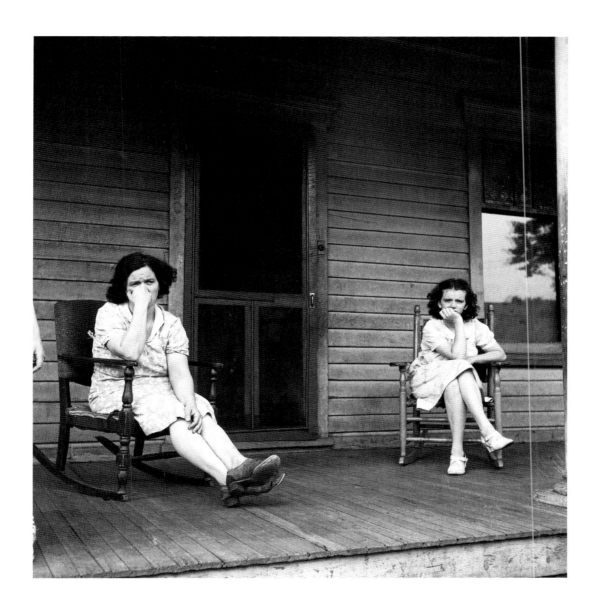

Mother and daughter. Upper Mauch Chunk, August 1940. Jack Delano.

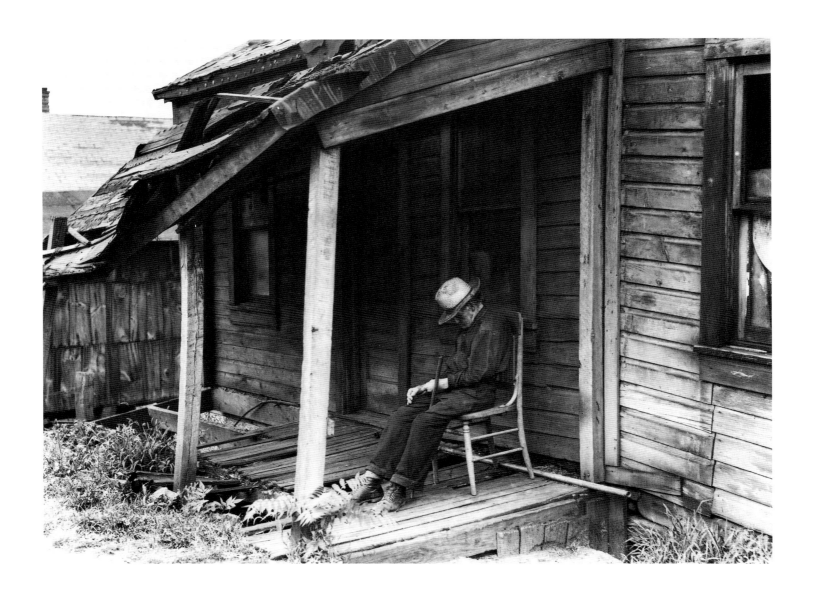

"Old age" near Washington. July 1936. Dorothea Lange.

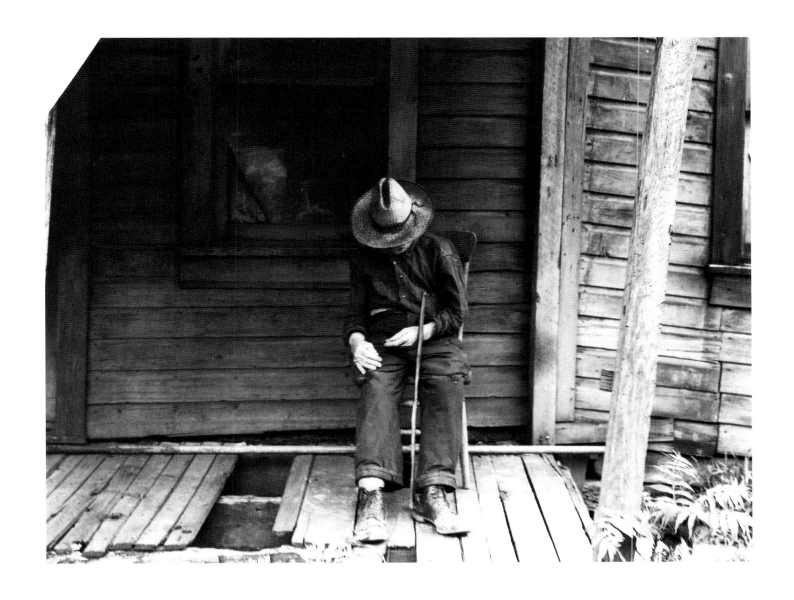

"Old age" near Washington. July 1936. Dorothea Lange.

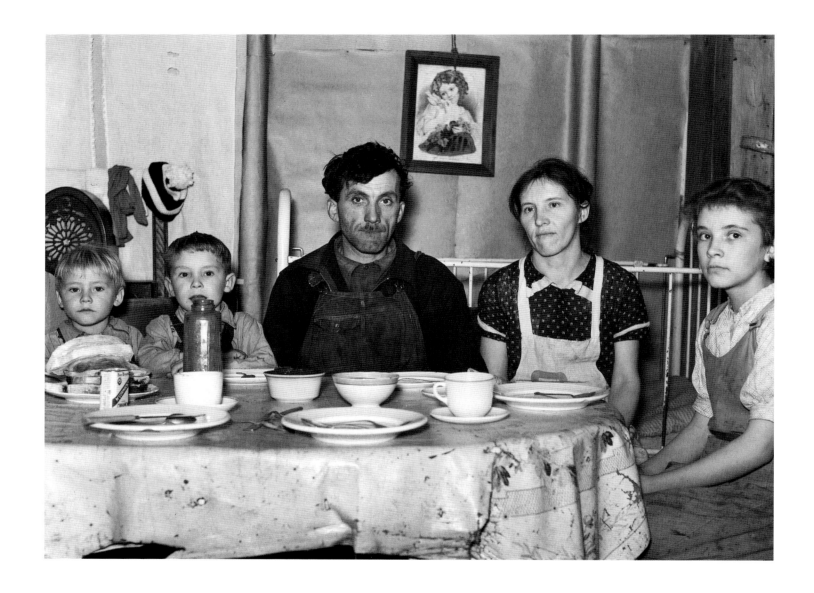

Part of the Valentine family at dinner. Bedford County, December 1937. Arthur Rothstein.

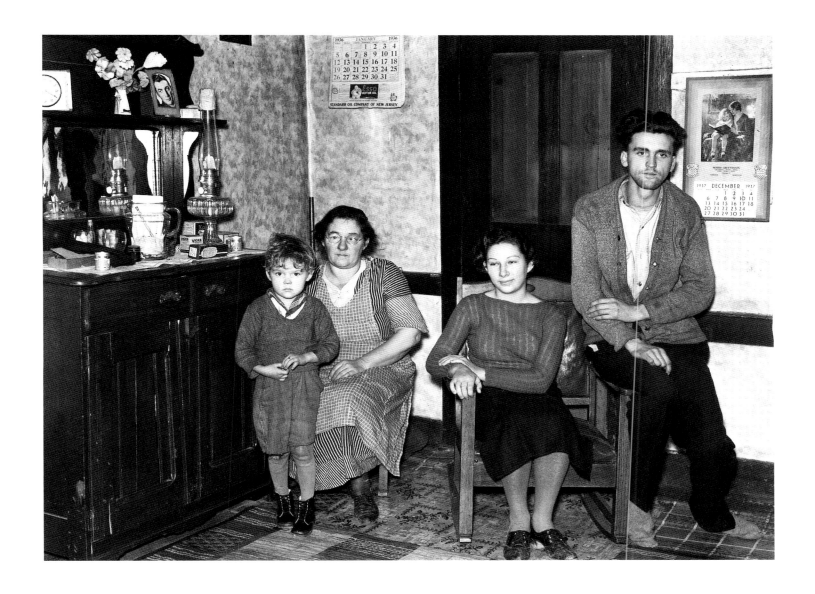

Mollie Day and children. Bedford County, December 1937. Arthur Rothstein.

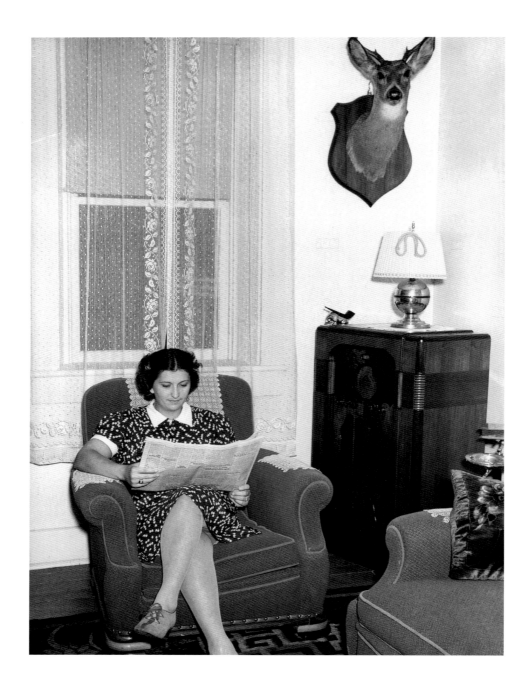

Mrs. Paul Minnich in her living room on the farm of her father-in-law, C. F. Minnich. Lititz vicinity, Lancaster County, August 1938. Sheldon Dick.

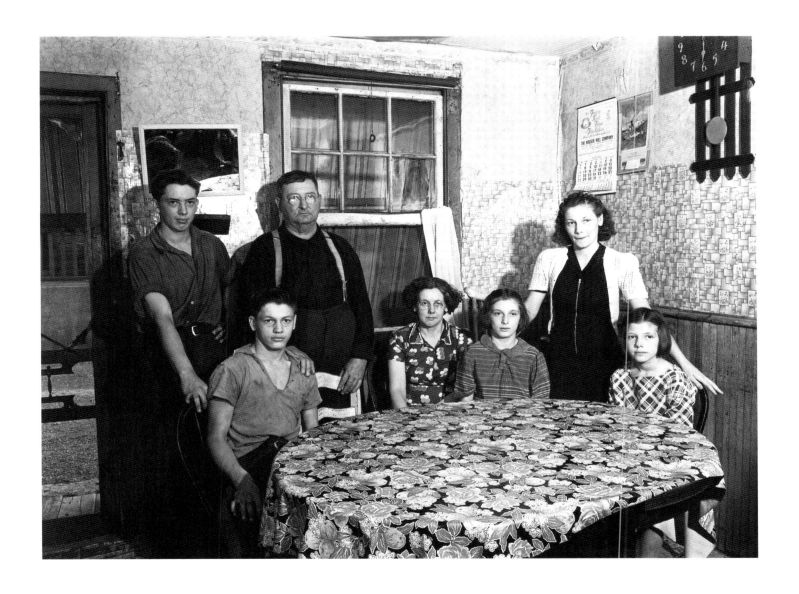

The family of John Yenser. Mauch Chunk, August 1940. Jack Delano.

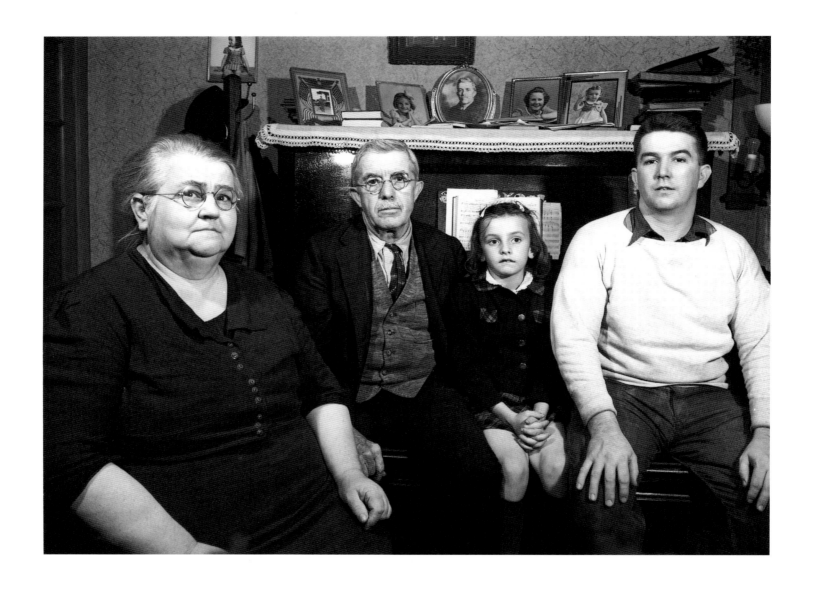

Mr. and Mrs. Benjamin Lutz, unmarried son Henry, and granddaughter Roberta Jean at home. Benny is a butcher; he also writes hymns and patriotic songs. Lititz, November 1942. Marjory Collins.

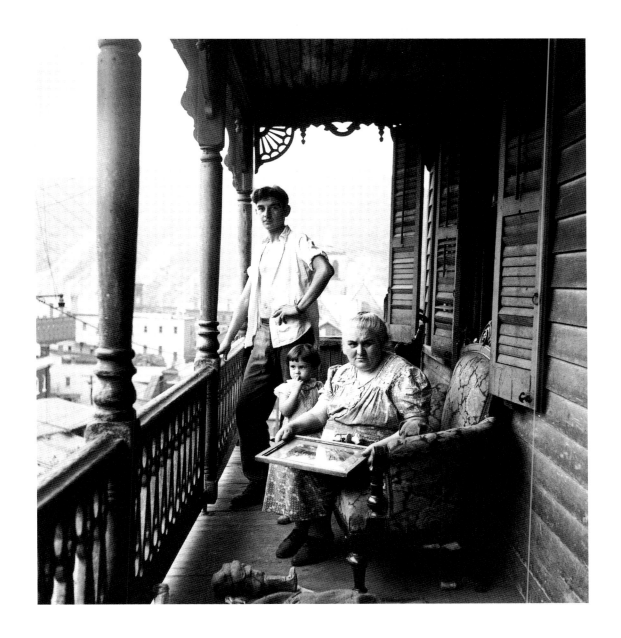

Polish family living on High Street. Mauch Chunk, August 1940. Jack Delano.

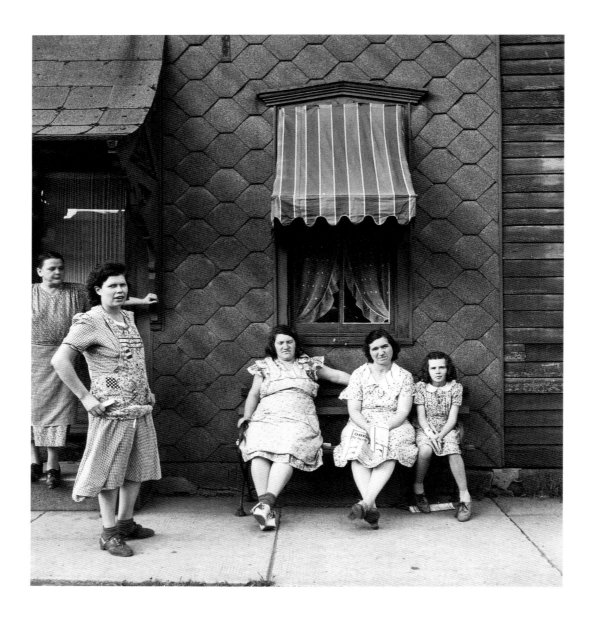

Women in Upper Mauch Chunk. August 1940. Jack Delano.

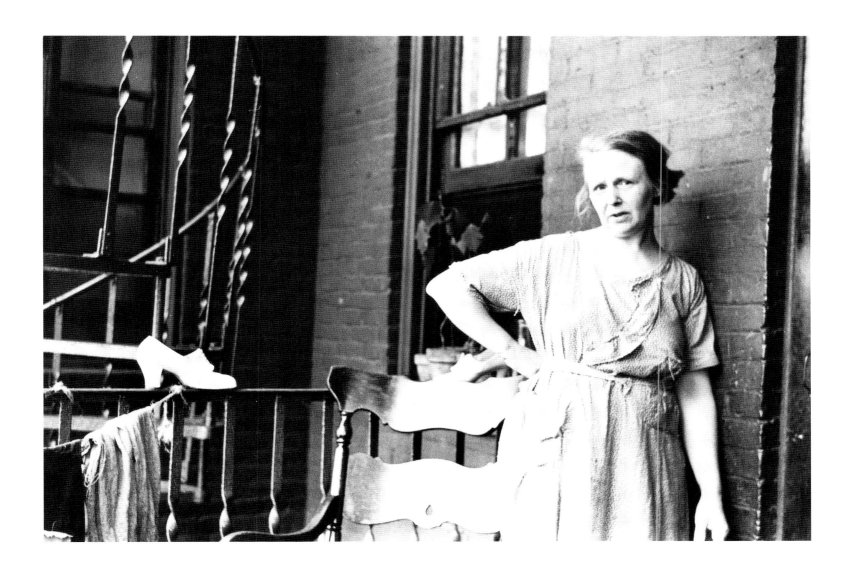

Wife of steelworker. Pittsburgh, July 1938. Arthur Rothstein.

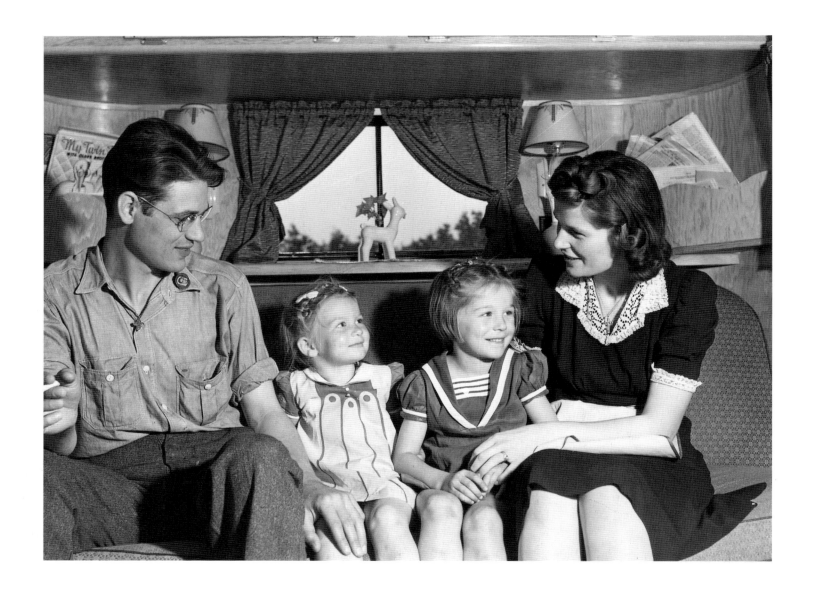

Jack Cutter and his family, who have lived in the FSA trailer camp about two weeks. They came from Indiana for a job in the General Electric plant. Erie, June 1941. John Vachon.

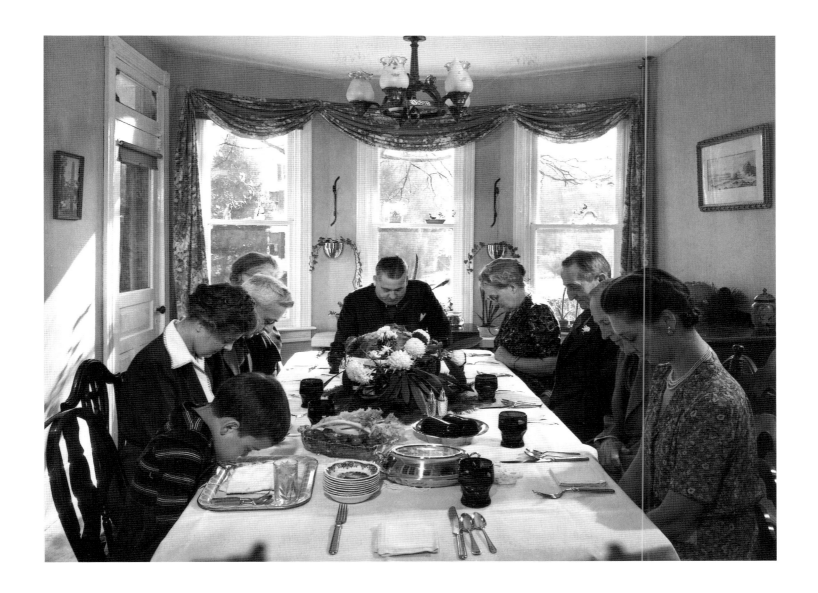

Saying grace before carving the turkey at Thanksgiving dinner in the home of Earle Landis. Neffsville, November 1942. Marjory Collins.

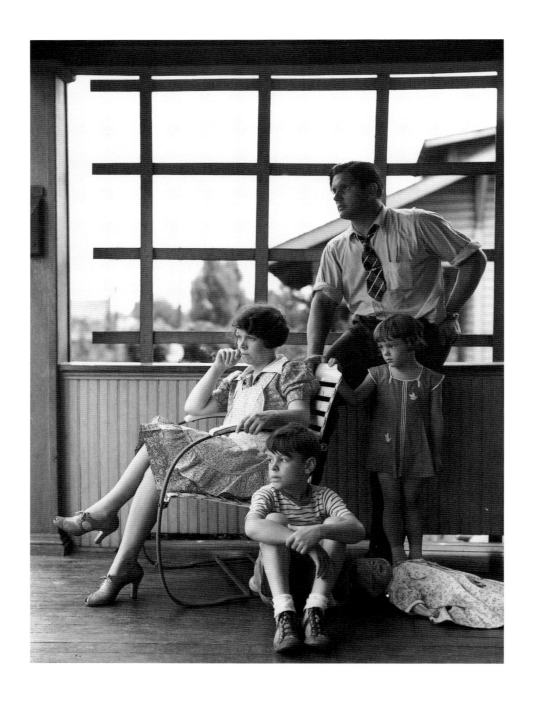

Clifford Shorts and his family. Aliquippa, July 1938. Arthur Rothstein.

## AT LEISURE

WE TEND TO think of periods of depression and war as unrelentingly grim and largely taken up with the hard work of survival. Of course, even in the most desperate of situations, this is not how people live. Though many Americans suffered economically, mentally, and physically during the Depression years, life went on, and leisure was part of the warp and woof of everyday life. The photographs that follow show leisure's more modest character before the automobile, the interstate highway system, and television had transformed the nation. For the most part, Pennsylvanians relaxed close to home—hunting, fishing, and enjoying the sociability of taverns, dance halls, swimming holes, picnics, and parades. The image of the tourists at the Allegheny Mountain overlook, however, hints at the newer forms of leisure to come.

Mrs. Van Horn and her mother (85 years old)—two generations of Strohls—at the Strohl family reunion in Flagstaff Park.
Mauch Chunk, August 1940. Jack Delano.

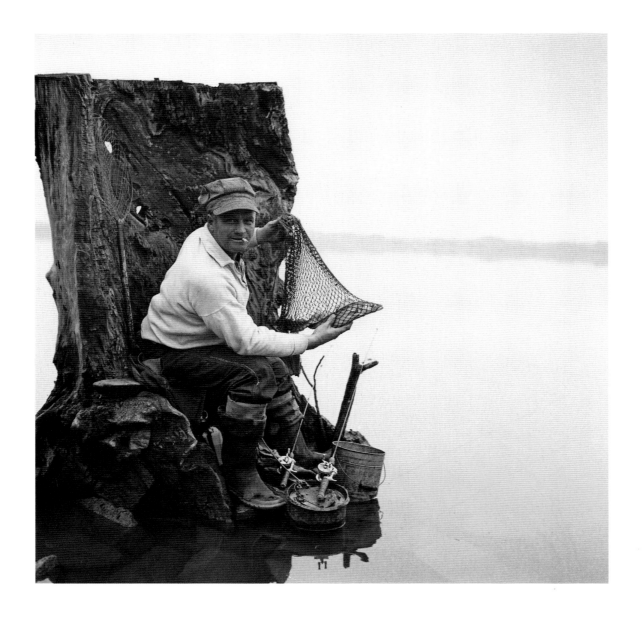

Fishing for salmon on the Susquehanna River at 6 P.M. This man is a state supervisor of highways. In his time off late in the afternoon, he fishes with a bottle of hard cider beside him. Lancaster County, November 1942. Marjory Collins.

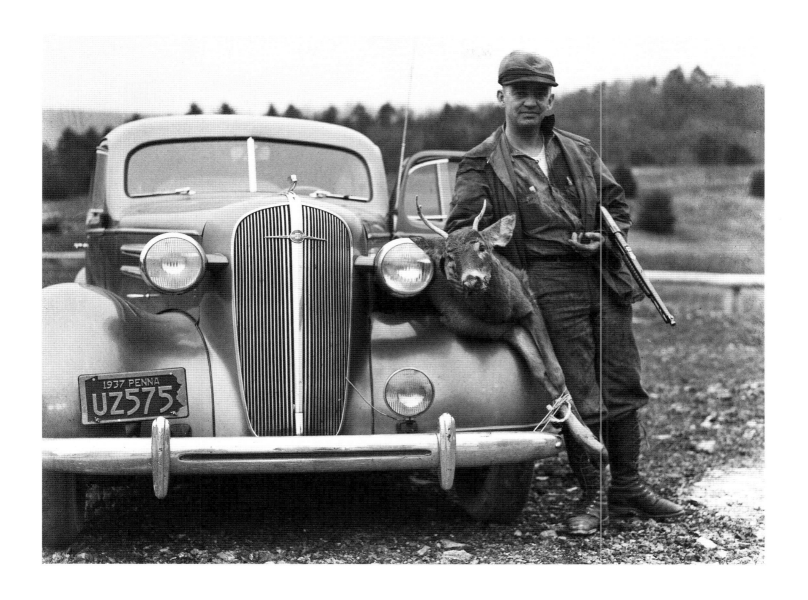

Deer hunter. Huntingdon County, December 1937. Arthur Rothstein.

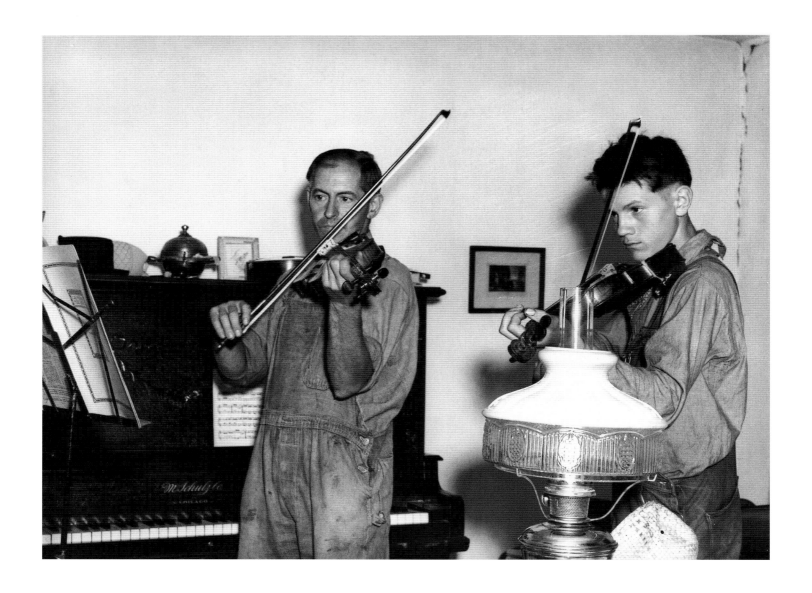

Thomas Evans, an FSA client, giving a violin lesson to one of the neighbor's boys. Barto, Berks County, August 1938. Sheldon Dick.

Bach Festival. People on the lawn outside Packer Memorial Chapel during the afternoon performance of the choir. Bethlehem, May 1944. Howard Hollem.

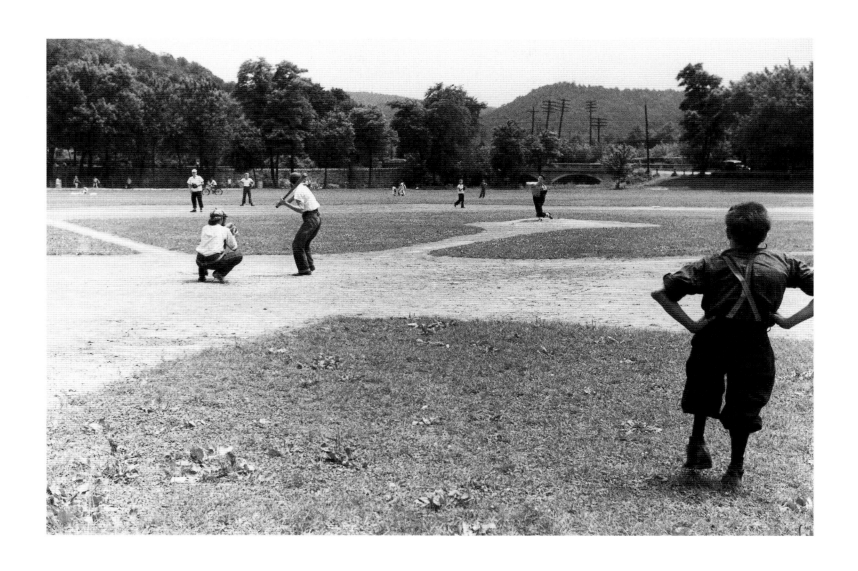

Baseball game. Huntingdon, July 1941. Edwin Rosskam.

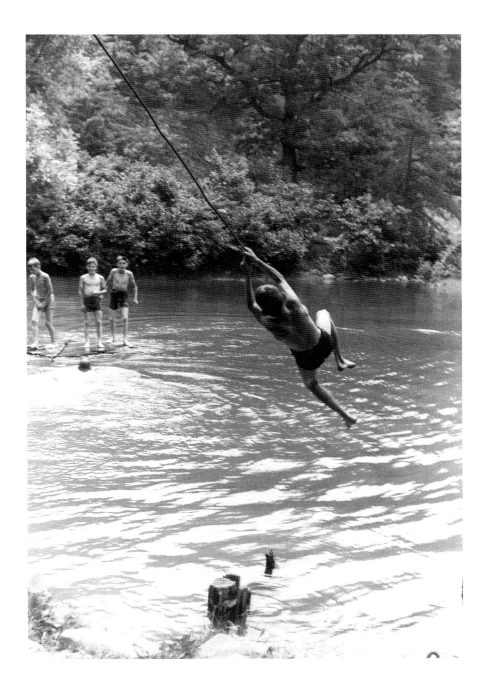

Swimming hole. Pine Grove Mills, July 1941. Edwin Rosskam.

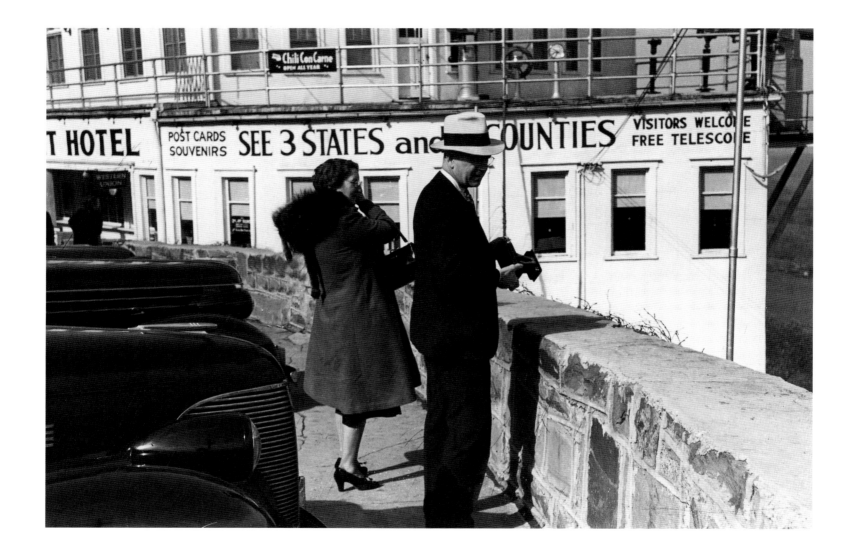

Tourist and his wife looking at the view. Allegheny Mountains, June 1939. Arthur Rothstein.

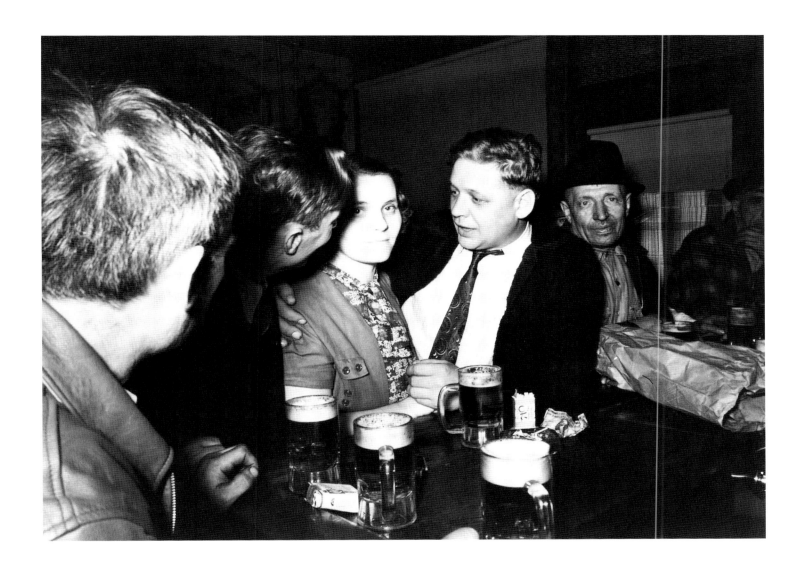

Some men and a woman at Filipek's Bar. Shenandoah, 1938[?]. Sheldon Dick.

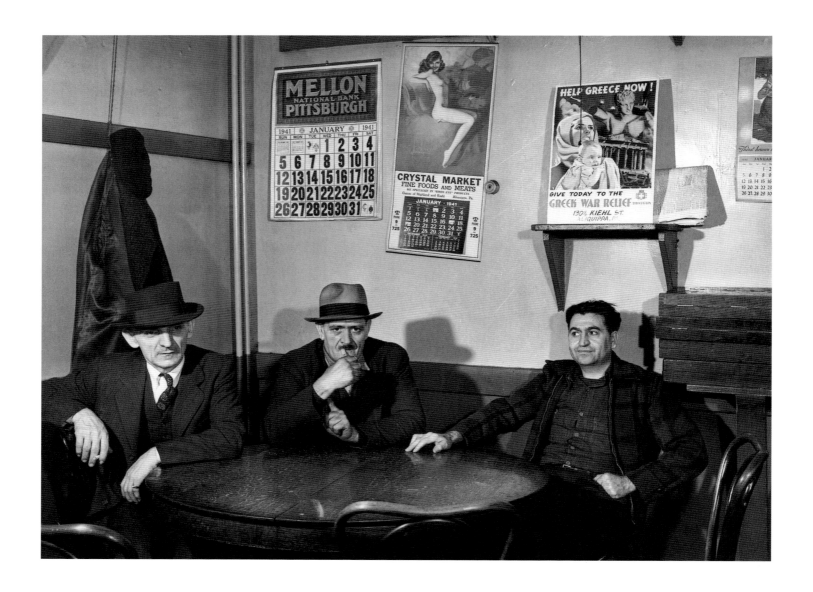

Steelworkers in a Greek restaurant. Aliquippa, January 1941. Jack Delano.

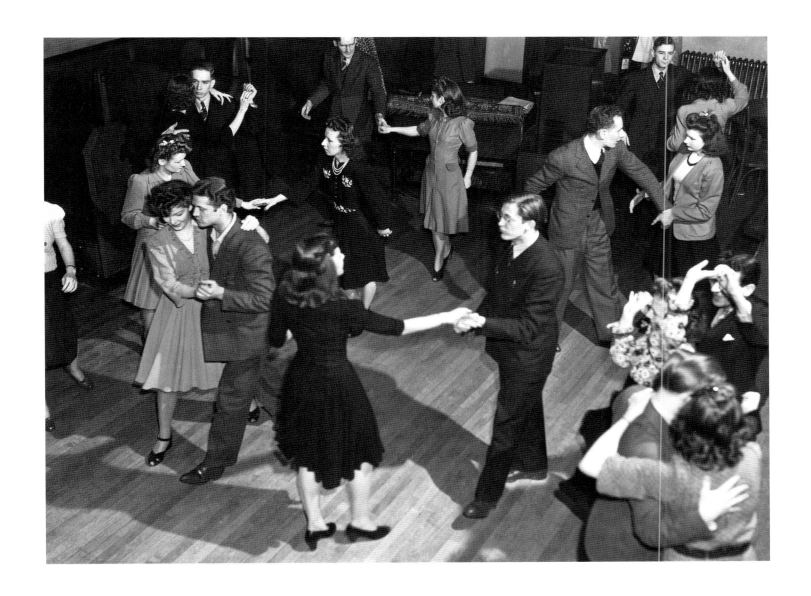

Dance floor at the Carlton Nightclub. Ambridge, January 1941. John Vachon.

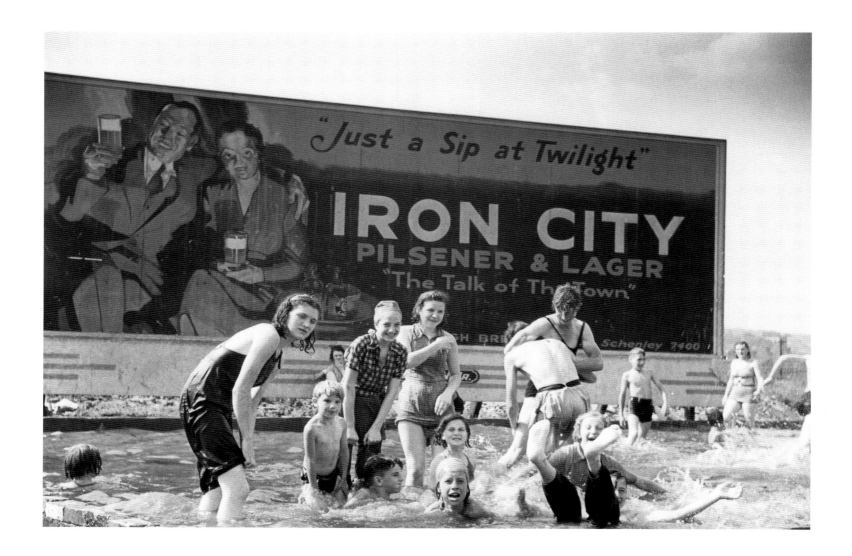

Homemade swimming pool built by steelworkers for their children. Pittsburgh, July 1938. Arthur Rothstein.

# ON THE MOVE

ALONG WITH STEEL and coal, nothing so defined Pennsylvania in this period as transportation. The Commonwealth had pioneered canals, railroads, and superhighways. FSA-OWI photographers documented the Pennsylvania Railroad and the Pennsylvania Turnpike, but few of these photos achieved the level of artistry and passion that one associates with their images of people and places. Nevertheless, sprinkled throughout the collections are photographs confirming that this was the era when long-distance bus travel began to tie the nation together through the growing interstate highway system, when the automobile began to serve reliably for more than simply local transportation, and when commercial air travel began to come of age. The following photos give a taste of the newness and the timeliness of the travel experience.

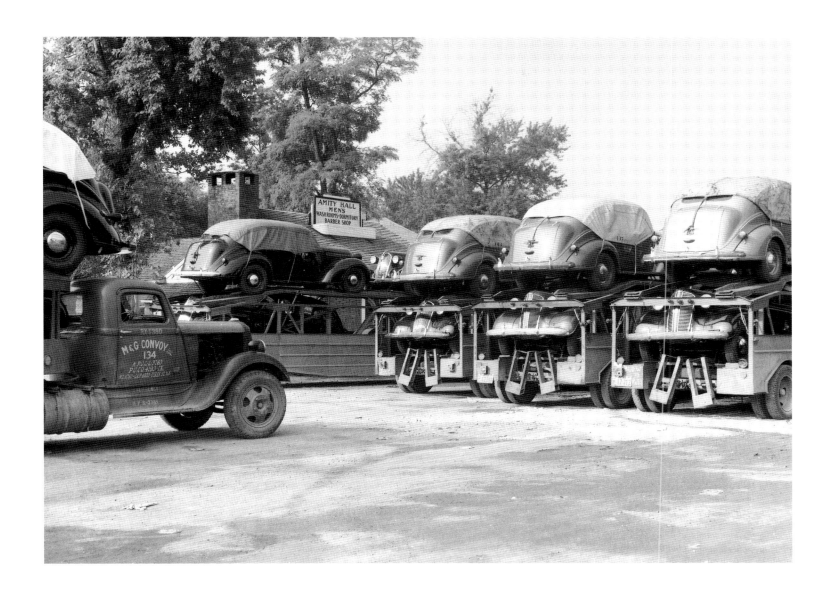

Automobile convoys at Amity Hall. August 1937. Edwin Locke.

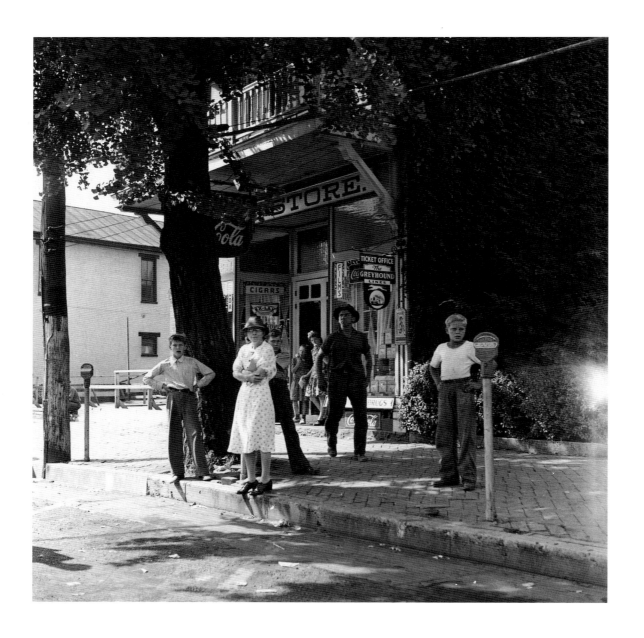

The Greyhound bus station. Gettysburg, September 1943. Esther Bubley.

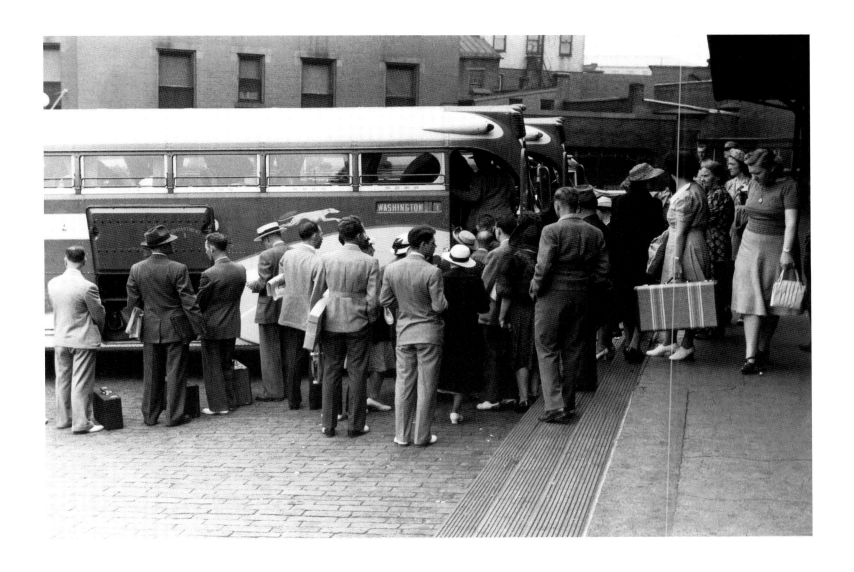

The Greyhound bus station. Harrisburg, July 1940. John Vachon.

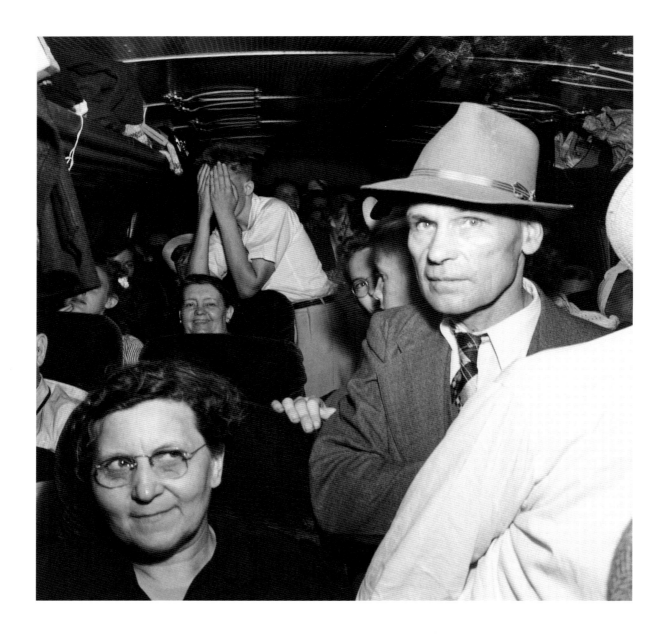

Passengers on a Greyhound bus going from Washington, D.C., to Pittsburgh. September 1943. Esther Bubley.

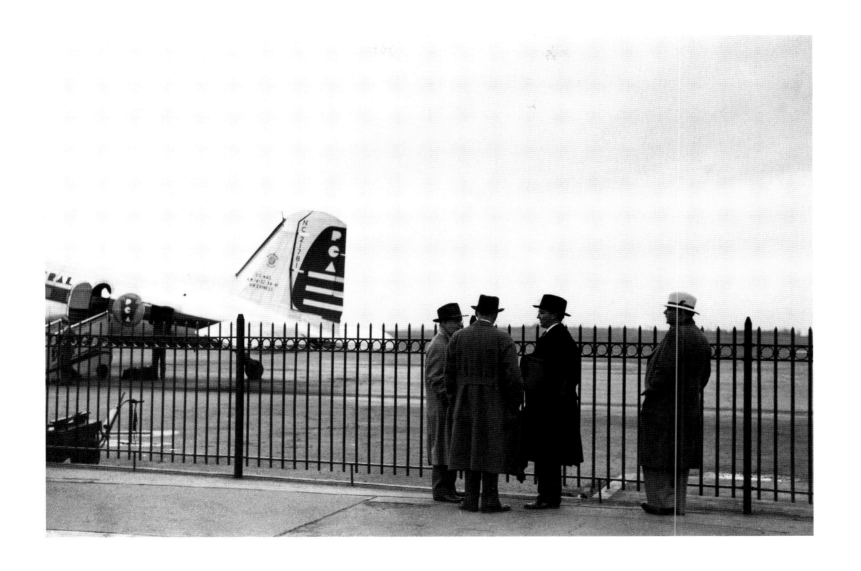

Airport. Pittsburgh, April 1940. John Vachon.

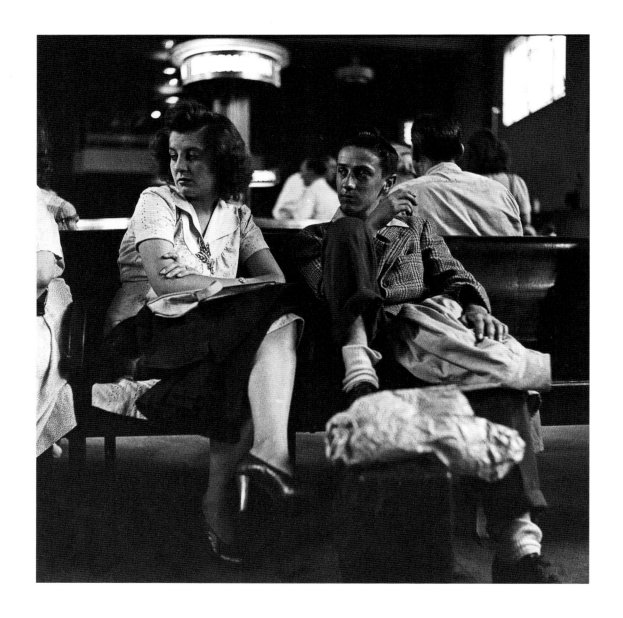

Passengers in the waiting room of the Greyhound bus terminal. Pittsburgh, September 1943. Esther Bubley.

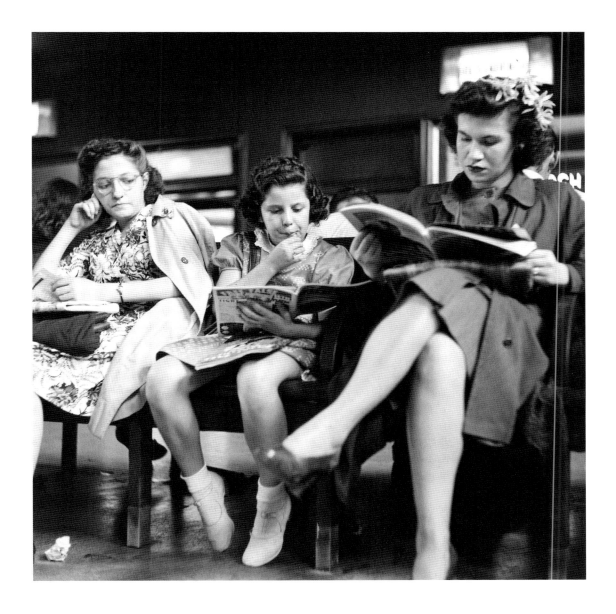

Passengers in the waiting room of the Greyhound bus terminal. Pittsburgh, September 1943. Esther Bubley.

# ON THE LAND

MOST PEOPLE FAMILIAR with the FSA-OWI photographic project think first of the iconic photos of migrant agricultural workers, dust-bowl immigrants to California, and impoverished cotton workers in the American South. Indeed, the project, at its inception, meant to show Americans why their tax dollars were needed and how they were being used by the New Deal to rescue rural America from the ravages of the Depression and drought. In Pennsylvania and the northeastern United States more generally, however, rural and urban subjects were more evenly balanced. This may seem odd in the case of Pennsylvania, which had one of the largest (if not *the* largest) rural populations in America. But farms in the state, mostly small family businesses, were not struck by drought and were less severely affected by the Great Depression than farms in other parts of the country. Still, millions of Pennsylvanians drew their livelihoods from agriculture, and these photos give some sense of the pleasures, trials, and tribulations of life on the land.

Lloyd Kramer farm. Farmersville, Northampton farm site, November 1936. Carl Mydans.

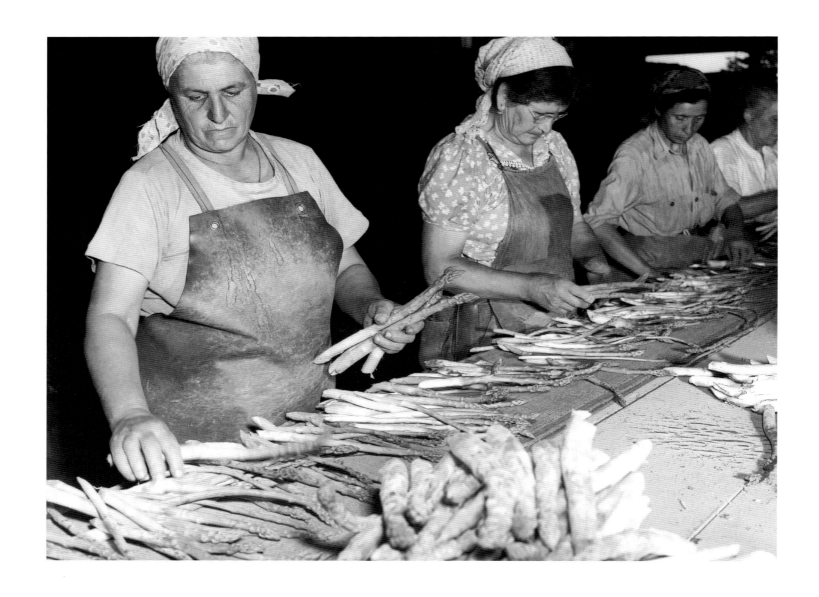

Italian workers from Trenton and nearby areas grading and bunching asparagus in the packing house. Starkey Farms, Morrisville, May 1941. Marion Post Wolcott.

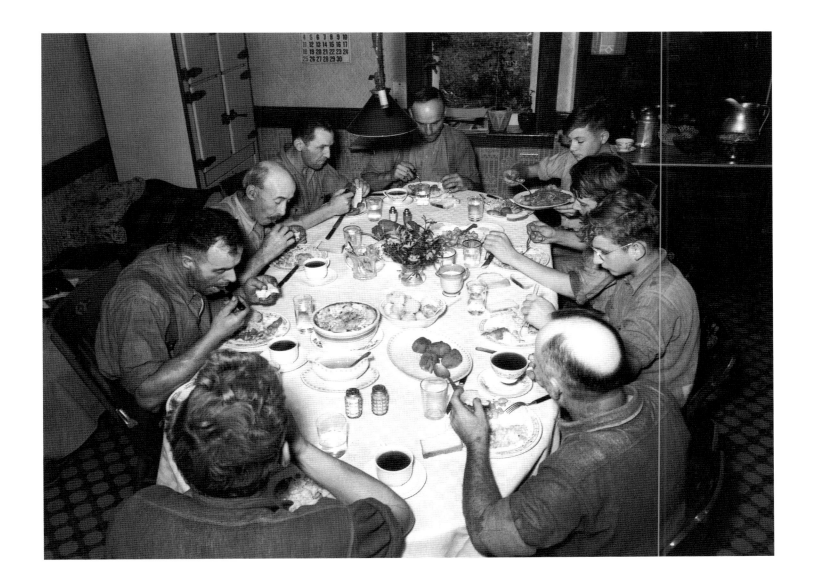

Enos and Herbert Royer and the farmhands having dinner on the farm of Enos Royer. Three of the men are his hired hands, and the rest have come to help fill the silo. Lancaster County, 1938[?]. Sheldon Dick.

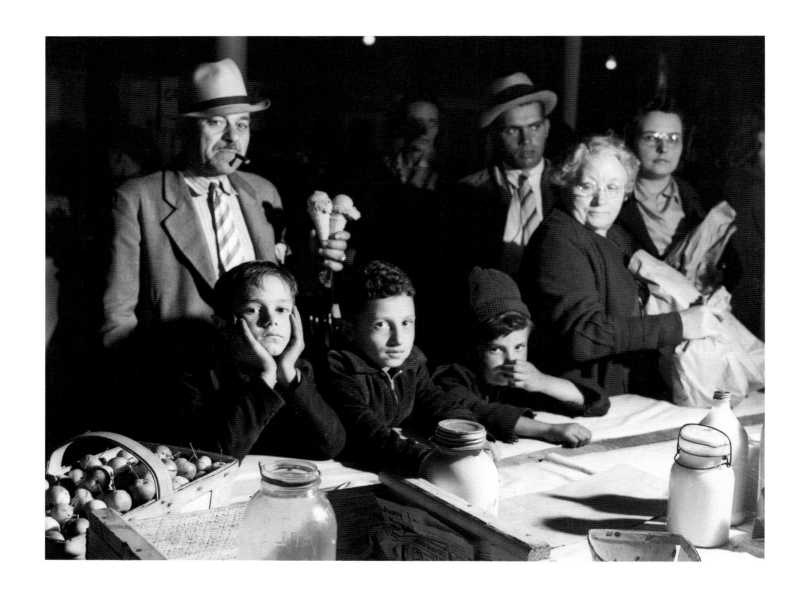

Customers at the Tri-County Farmers Co-op Market at Du Bois. August 1940. Jack Delano.

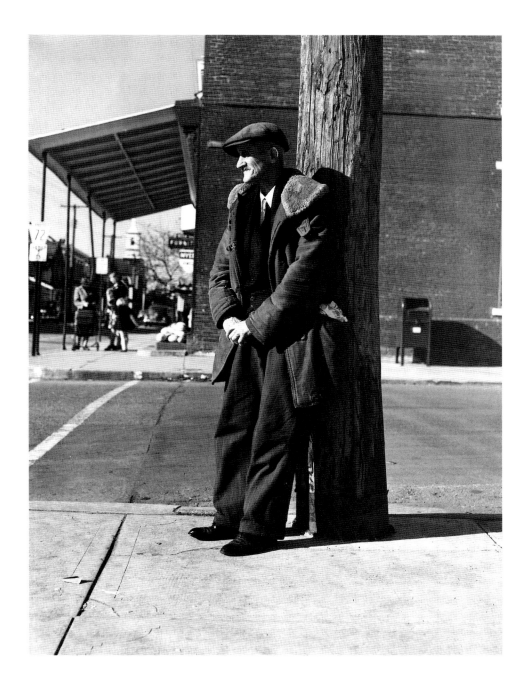

Farmer in town to shop. Manheim, Lancaster County, November 1942. Marjory Collins.

Barn in eastern Pennsylvania. November 1936. Russell Lee.

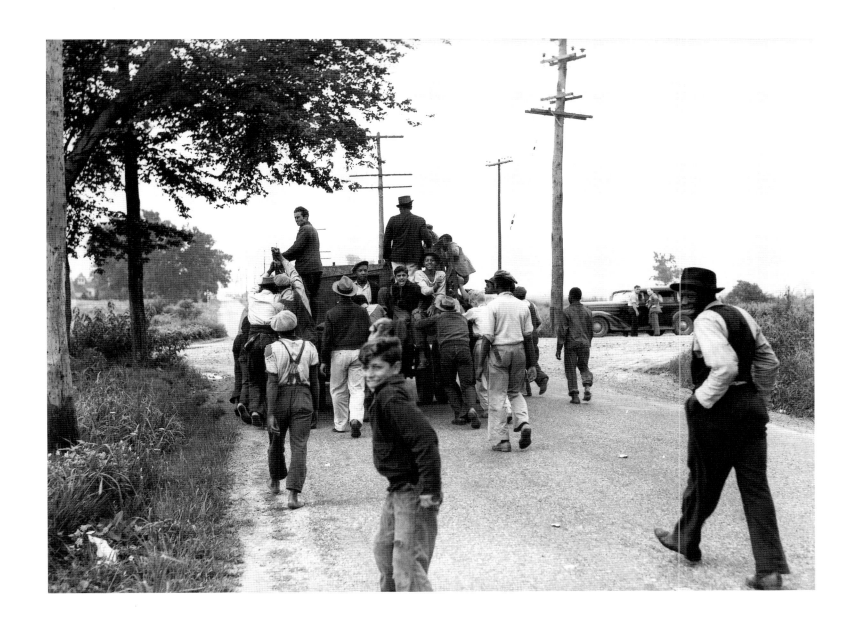

Migrant workers hired as strikebreakers after the strike at the King Farm near Morrisville. August 1938. John Vachon.

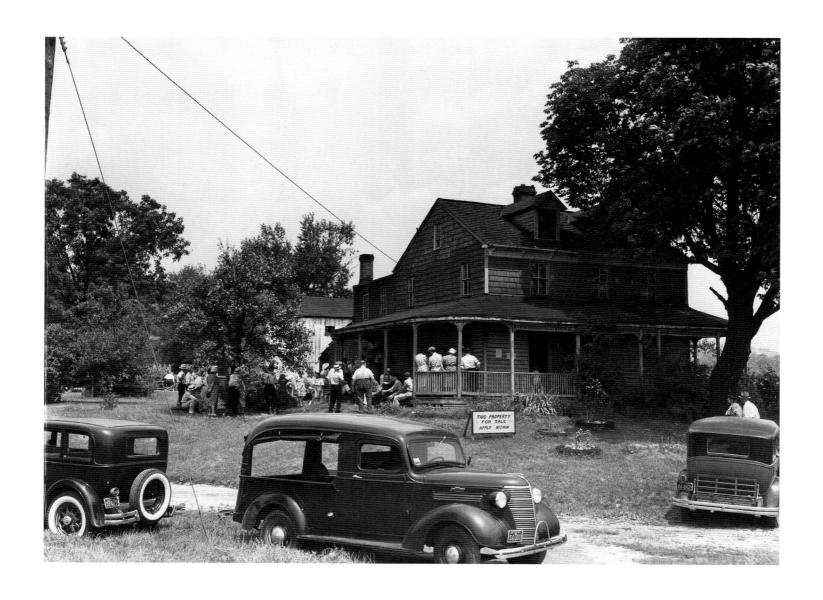

A public auction at a farm near York. June 1939. Marion Post Wolcott.

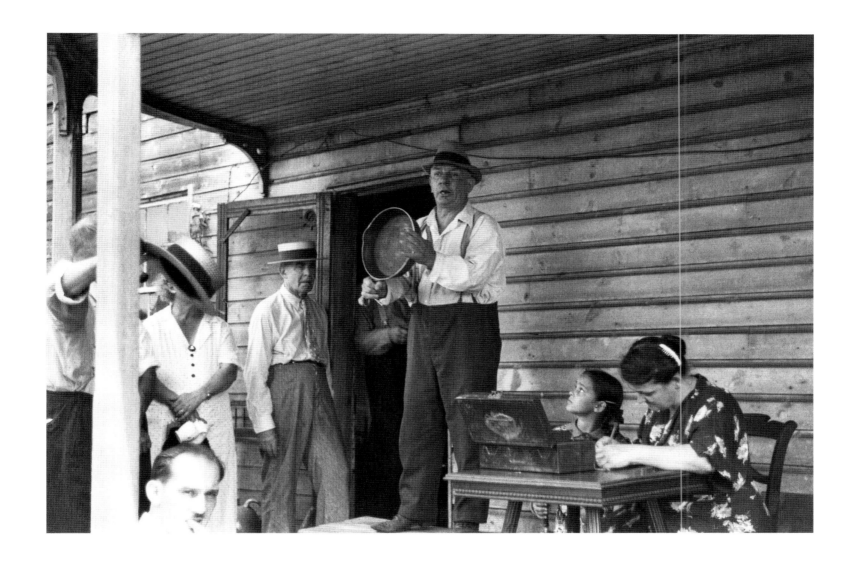

An auction sale of a house and household goods. York County, June 1939[?]. Marion Post Wolcott.

Homemade tractor on the farm of FSA client Dallas E. Glass. Birdsboro vicinity, Berks County, August 1938. Sheldon Dick.

The owner of the Spring Run Farm and his wife. Dresher, July 1944. Pauline Ehrlich.

# THE PLAIN PEOPLE

THOUGH THE FSA-OWI photographers concentrated on urban and industrial subjects in Pennsylvania, some—especially Marjory Collins, John Collier, and Marion Post Wolcott—found another subject of considerable interest in the Commonwealth's Plain People. The largest population of Amish and Mennonites in the United States lived in Pennsylvania. For millions of Americans, even in the 1930s, the term "Pennsylvania Dutch" conjured up images of simple, premodern, rural lives. The Amish and Mennonites were pious Anabaptists descended from German and Swiss immigrants who found religious tolerance on the fertile land of Lancaster County. Their peaceful, antimaterialistic lives and unique culture must have seemed idyllic antidotes to the anxieties and deprivations of the Depression and the war.

Mennonite farmer going to town near Lancaster, May[?] 1941. Marion Post Wolcott.

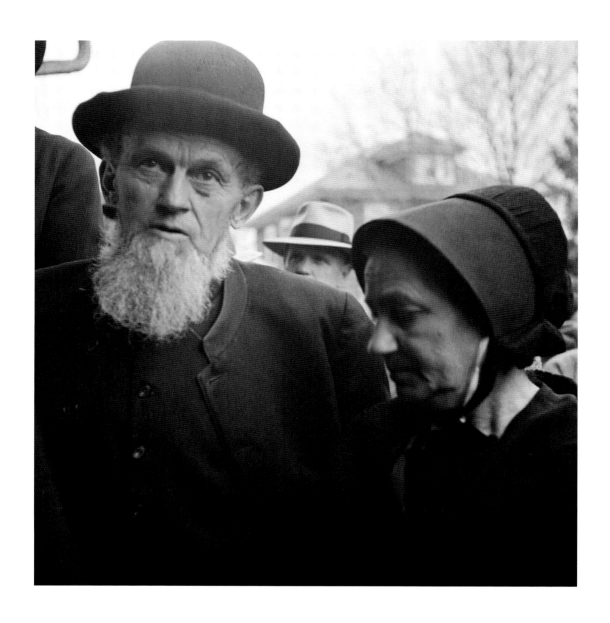

A Mennonite and his wife at a public sale. Lititz, November 1942. Marjory Collins.

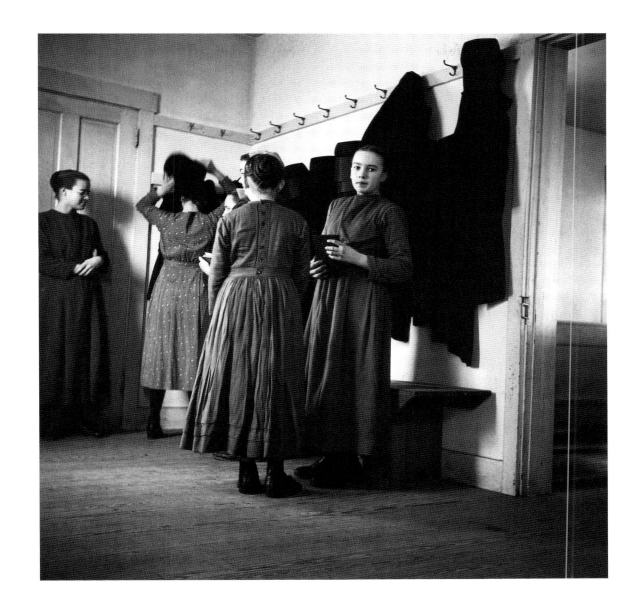

Mennonite girls waiting for "Deutsch School" to begin in Mennonite church. Hinkletown vicinity, March 1942. John Collier.

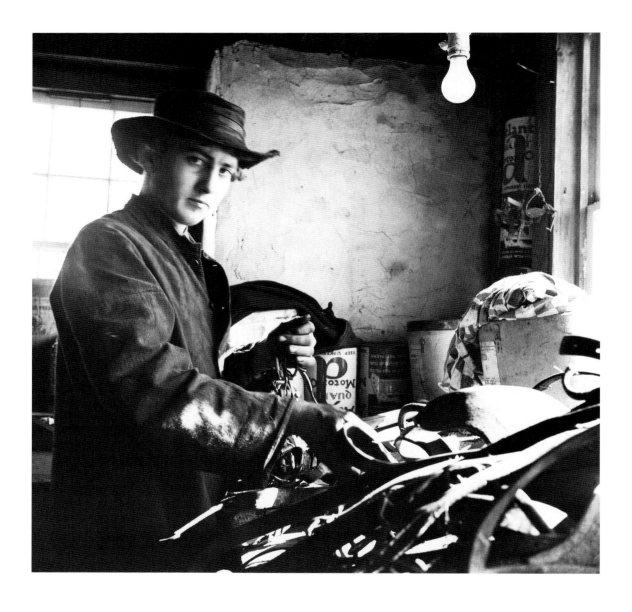

Amish farmhand mending a harness on the Zook farm. The electric light overhead has been disconnected for religious reasons. Honey Brook vicinity, March 1942. John Collier.

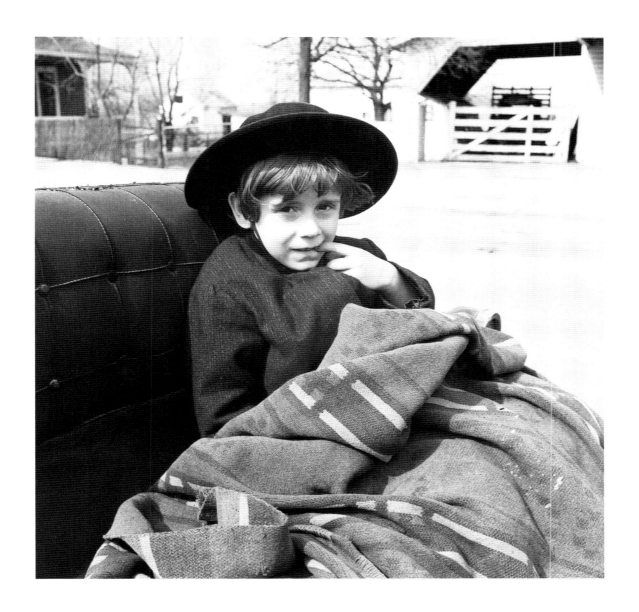

Mennonite boy. Lancaster, March 1942. John Collier.

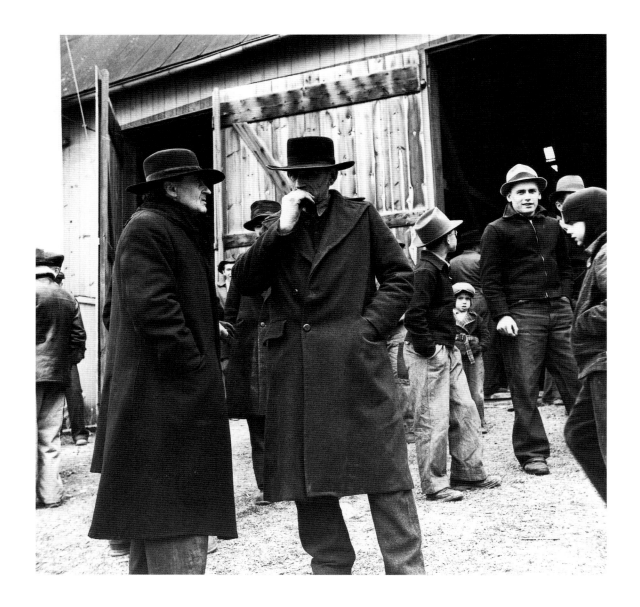

Mennonite farmers at auction. Lancaster County, March 1942. John Collier.

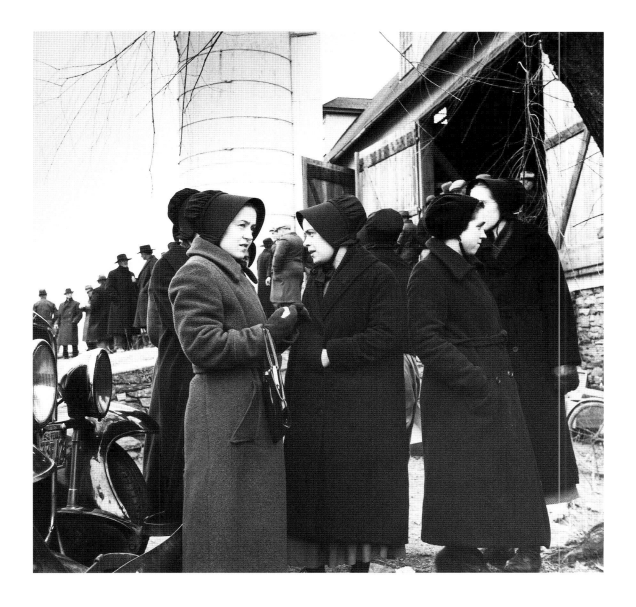

Amish women attending farm auction. Lancaster County, March 1942. John Collier.

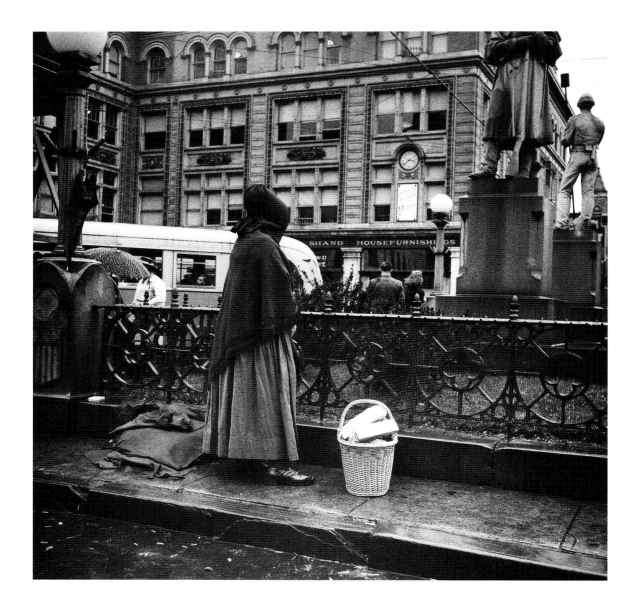

Mennonite woman waiting for a bus on a rainy market day. Lancaster, November 1942. Marjory Collins.

# COAL

BY THE 1930S, Pennsylvania had lost its nineteenth-century preeminence among the nation's coal-producing states. The industry had moved west to Ohio and Illinois and south to West Virginia, Virginia, Kentucky, and Alabama. Nevertheless, Pennsylvania was still a major coal state. Rich veins of bituminous coal lay below vast tracts of the central and southwestern sections of the state; in northeastern Pennsylvania, one of the world's largest deposits of anthracite coal continued to support hundreds of small towns (or "patches," in the miners' vernacular). A myriad of ethnic groups had come to the coalfields—largely during the great emigration from southern and eastern Europe— and they gave sections of the Commonwealth a cosmopolitan, almost European flavor. But ethnic traditions and Eastern Orthodox onion-domed churches could not disguise the often dreary, dangerous, and hardscrabble lives of the miners and their families. Quite a few scratched out a living working both as farmers and as miners. Not surprisingly, some of the nation's greatest labor conflicts took place across the Pennsylvania coalfields. Coal was already in decline when the Great Depression hit, as heating oil had captured much of the nation's home-heating market after World War I. The Depression exacerbated an already difficult situation, though the demands of defense industries in World War II led to a temporary revival. Coalfields were magnets for the FSA-OWI photographers not only because of the dramatic visual possibilities but also because of the archetypal proletarian subjects that the miners themselves provided.

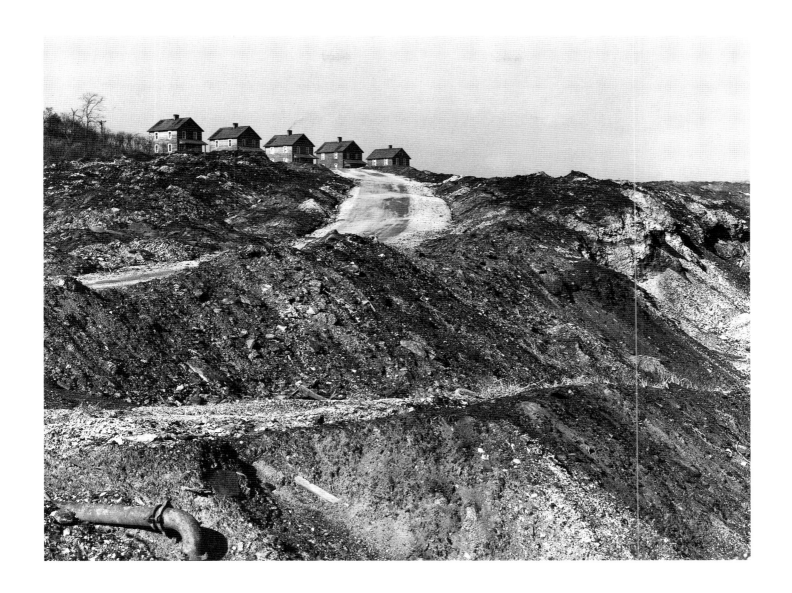

Montour no. 4 mine of the Pittsburgh Coal Company. Slag pile beneath company village. Pittsburgh vicinity, November 1942. John Collier.

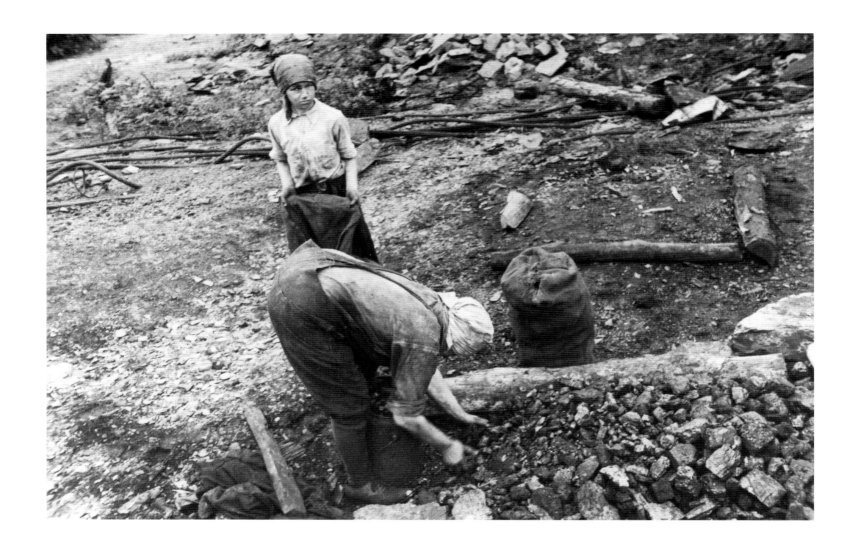

Woman and child picking coal from a slag heap. They are paid ten cents for each 100-pound sack. Nanty Glo, 1937. Ben Shahn.

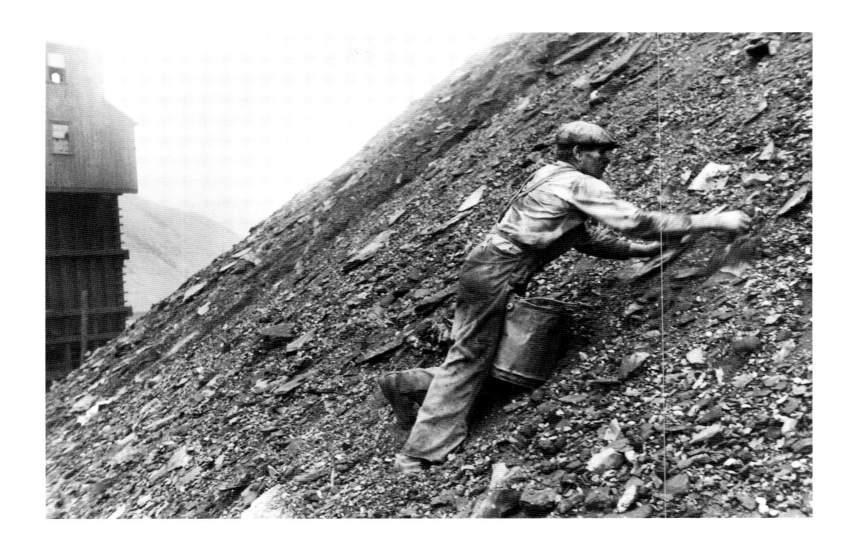

Man gathering good coal from the slag heaps at Nanty Glo. 1937. Ben Shahn.

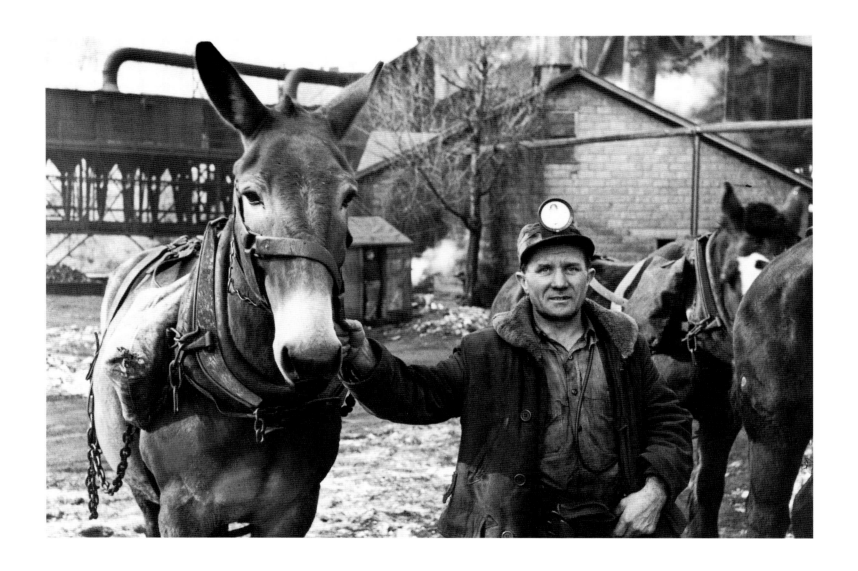

Miner and mule at the American Radiator Company Mine. Mount Pleasant, Westmoreland County, February 1936. Carl Mydans.

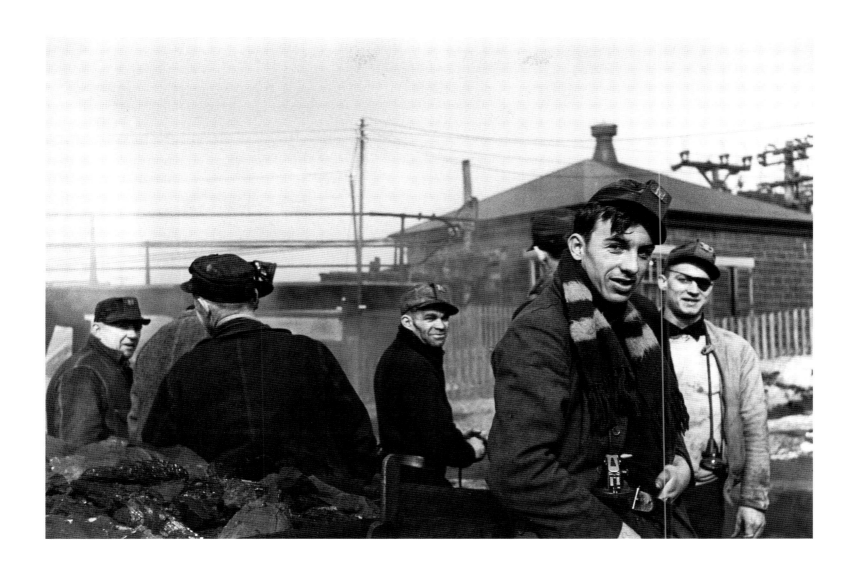

Miners about to go below at the American Radiator Company Mine. Mount Pleasant, Westmoreland County, February 1936. Carl Mydans.

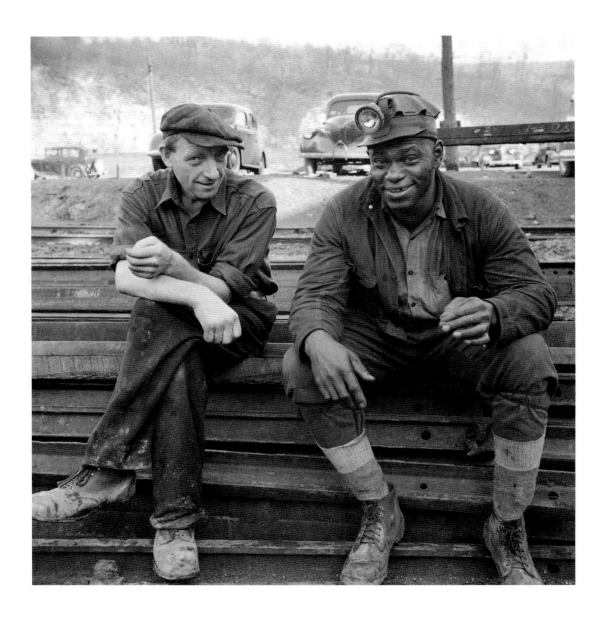

Montour no. 4 mine of the Pittsburgh Coal Company. Miners waiting to go underground. Pittsburgh vicinity, November 1942. John Collier.

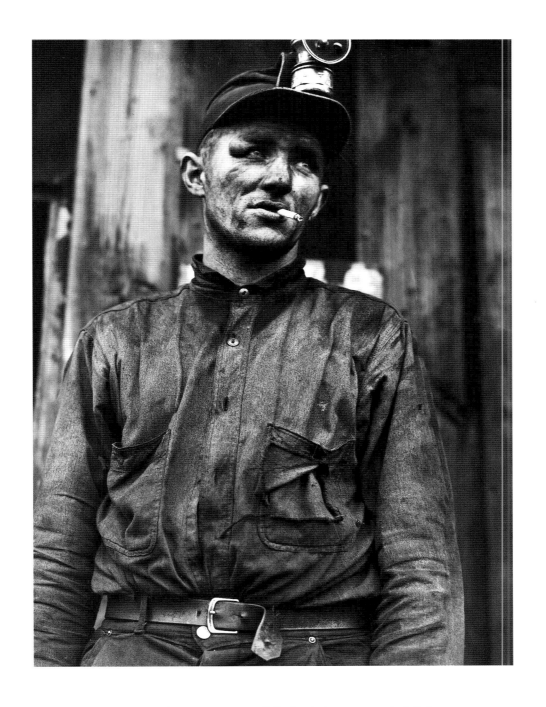

Miner at Dougherty's mines near Falls Creek. August 1940. Jack Delano.

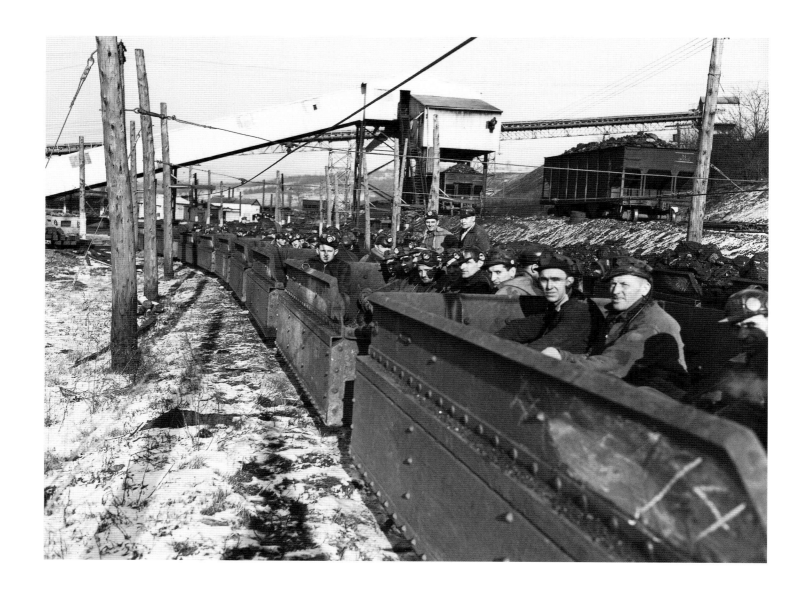

Westland coal mine. "Mantrip" going into a "drift mine." Pittsburgh vicinity, November 1942. John Collier.

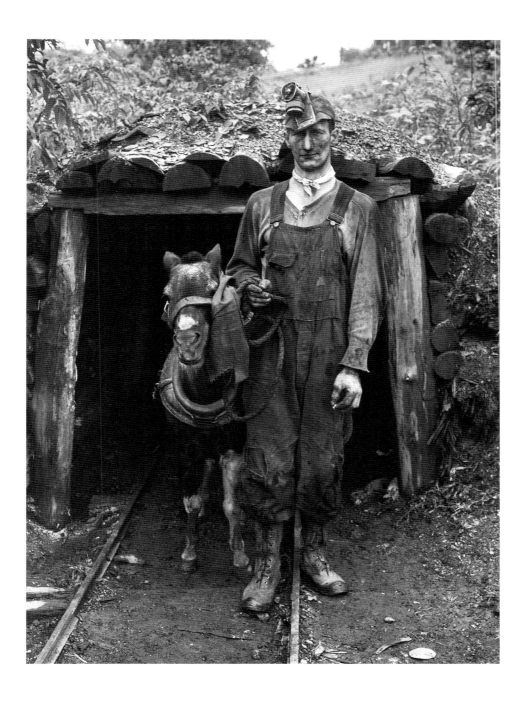

Mr. Merritt Bundy of the Tri-County Farmers Co-op Market at Du Bois at the entrance to his mine on his farm near Penfield. August 1940. Jack Delano.

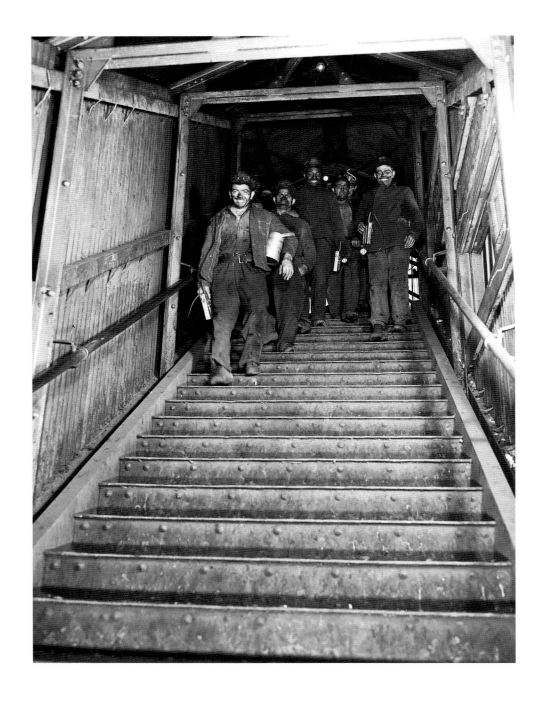

Montour no. 4 mine of the Pittsburgh Coal Company. Miners coming off shift. Pittsburgh vicinity, November 1942. John Collier.

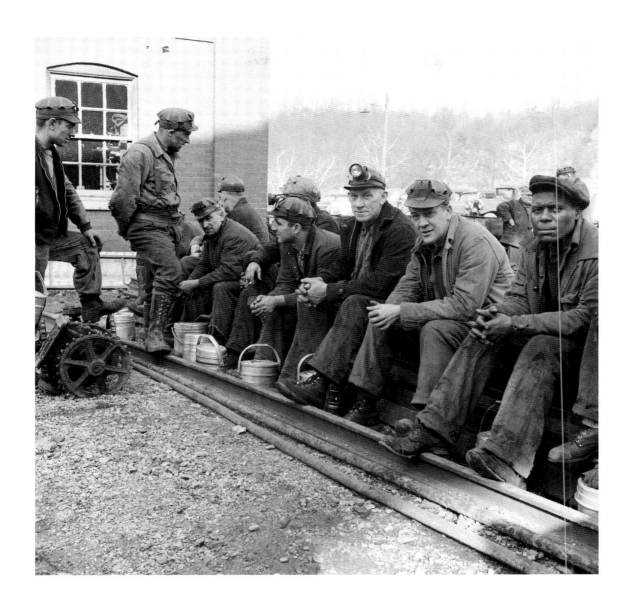

Montour no. 4 mine of the Pittsburgh Coal Company. Waiting for the noon shift. Pittsburgh vicinity, November 1942. John Collier.

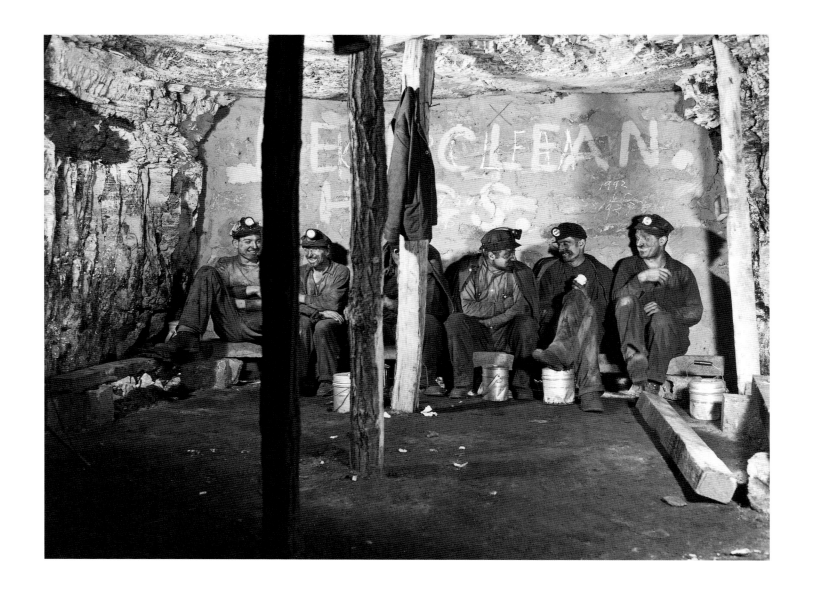

Montour no. 4 mine of the Pittsburgh Coal Company. "Bean hole" where the miners gather to eat lunch. Pittsburgh vicinity, November 1942. John Collier.

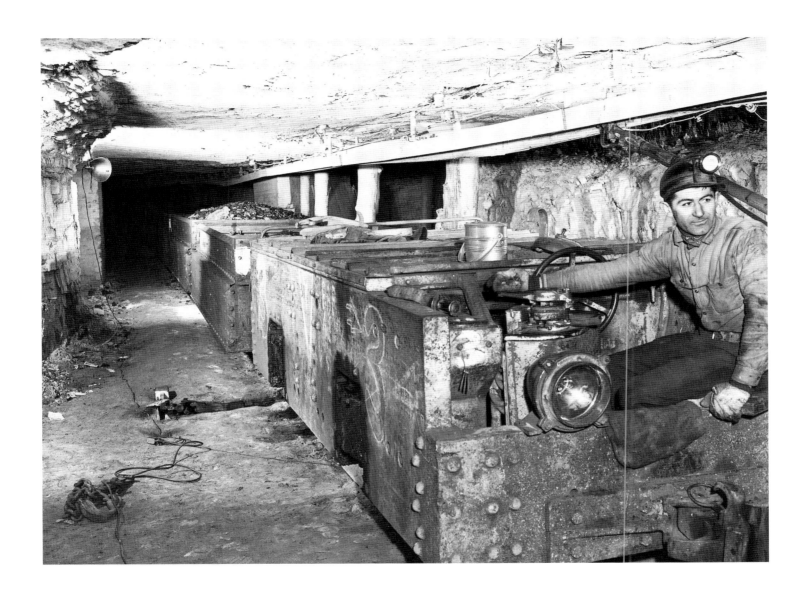

Montour no. 4 mine of the Pittsburgh Coal Company. A trip of coal bound for the surface. Pittsburgh vicinity, November 1942. John Collier.

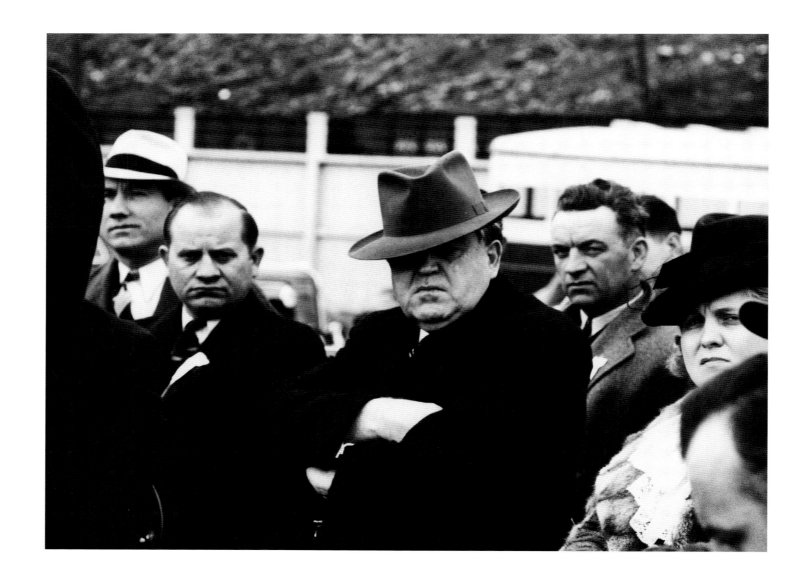

John L. Lewis, center, at the stadium on the occasion of a district[?] meeting of the mine workers, seen among a crowd of people.
Shenandoah[?], 1938[?]. Sheldon Dick.

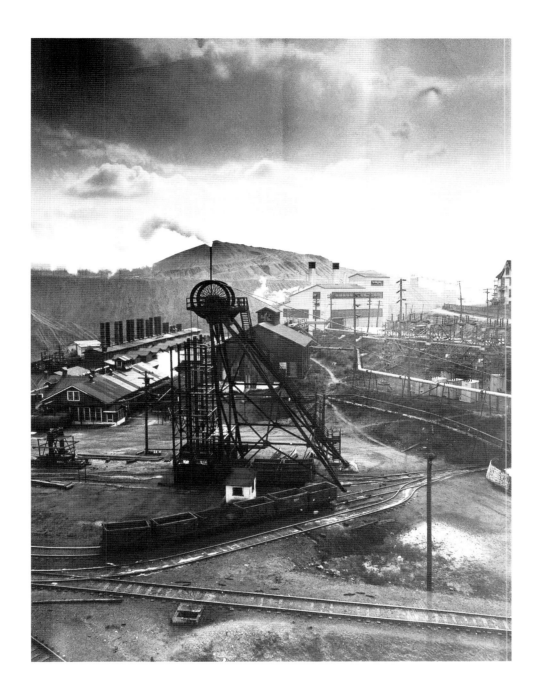

The second shaft tower at Maple Hill Mine as seen from the first tower. Shenandoah vicinity, 1938[?]. Sheldon Dick.

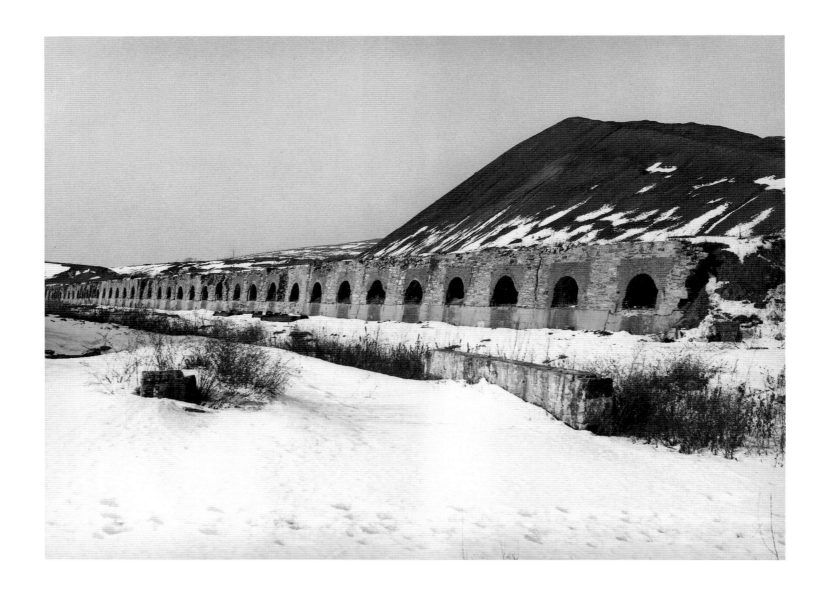

Beehive coke ovens near Westmoreland Homesteads. Mount Pleasant, Westmoreland County, February 1936. Carl Mydans.

# STEEL

LIKE COAL, STEEL defined Pennsylvania to people around the world. It was the fundamental industry of the Industrial Revolution, and cities such as Pittsburgh, Bethlehem, and the gritty steel towns that dotted the Pennsylvania landscape became synonymous with the industry that propelled the United States into undisputed world economic leadership on the eve of the Great Depression. But Pennsylvania's steel mills, too, were in relative decline as production moved increasingly west to the Great Lakes. And like the coal towns, the steel towns were composed of ethnic enclaves. Generations of workers, born and raised in the towns, went into the local mills to work and died not far from the mill gates. In the lives of the steelworkers and their families, the mills assumed the role that the great cathedrals had played in medieval towns. Walker Evans's famous photograph of the graveyard, workers' houses, and the looming mills of Bethlehem in the background captures this seemingly inexorable cycle of industrial life. Not surprisingly, the drama of this mighty but wounded industry drew the attention of a number of the FSA-OWI photographers.

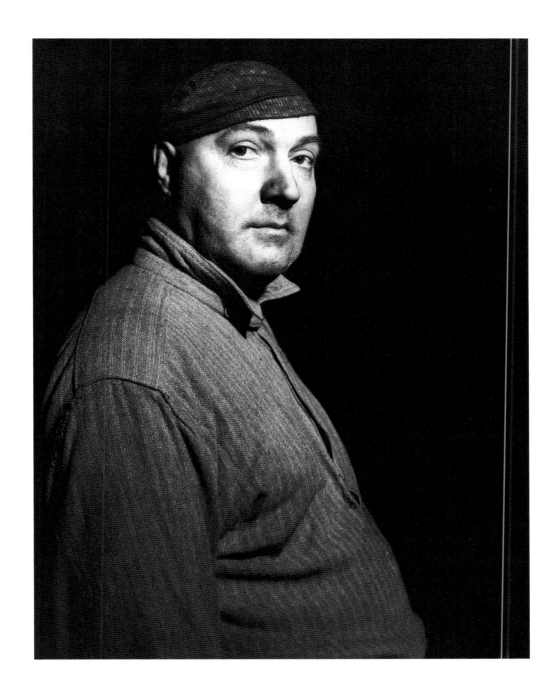

At the Washington Tinplate Works. Washington, January 1941. Jack Delano.

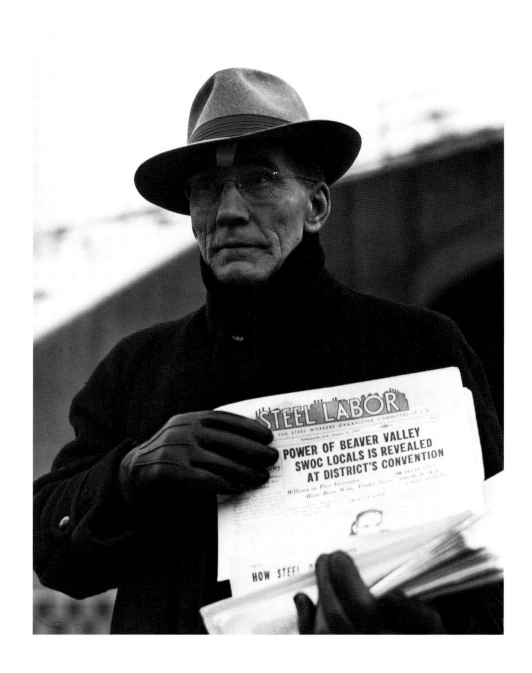

Union member distributing "Steel Labor" near the entrance to the Jones and Laughlin Steel Corporation. Aliquippa, January 1941. Jack Delano.

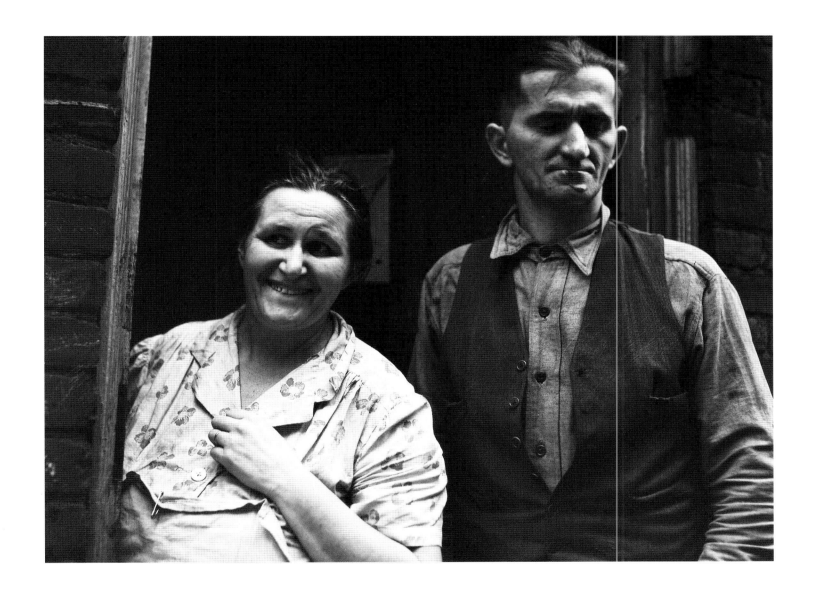

Unemployed steelworker and his wife. Ambridge, January 1941. John Vachon.

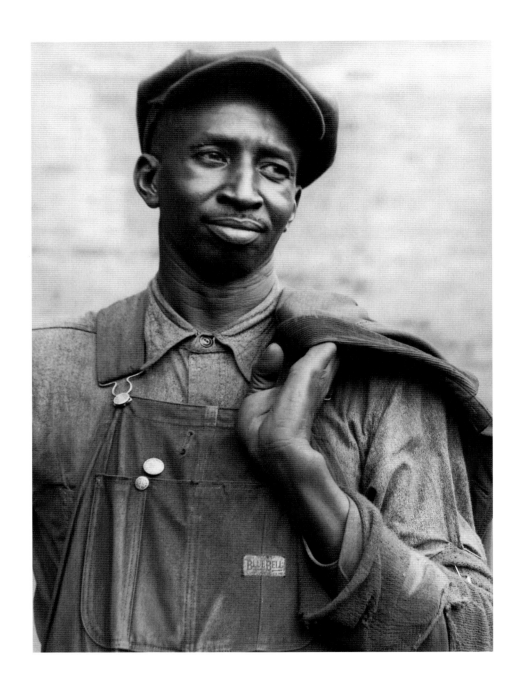

Steelworker. Midland, July 1938. Arthur Rothstein.

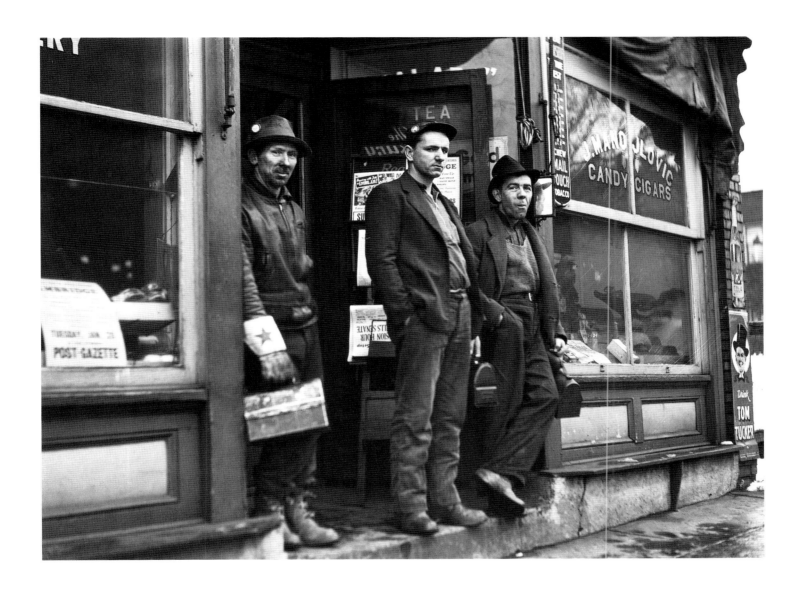

Employees of the American Bridge Company (United States Steel) waiting for a bus. Ambridge, January 1941. John Vachon.

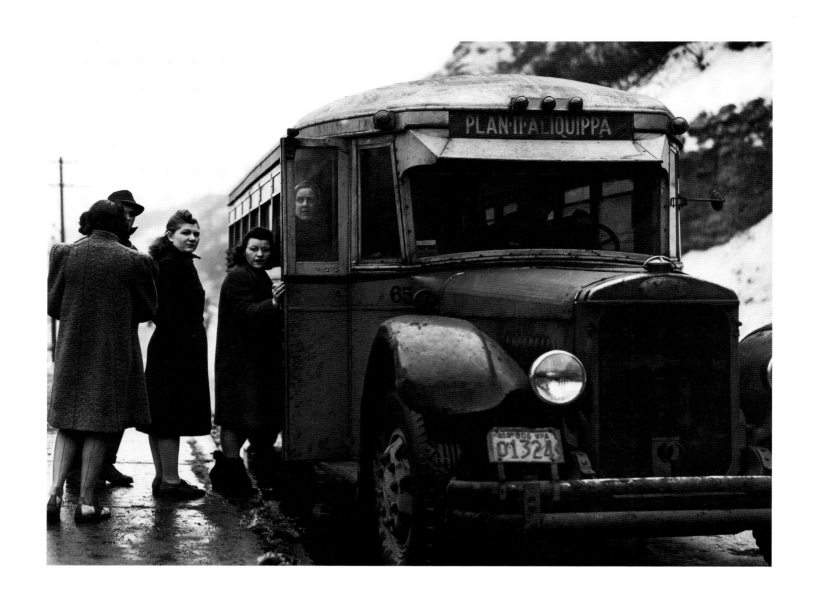

Girls working at the Jones and Laughlin Steel Company going home after a day's work. Aliquippa, January 1941. Jack Delano.

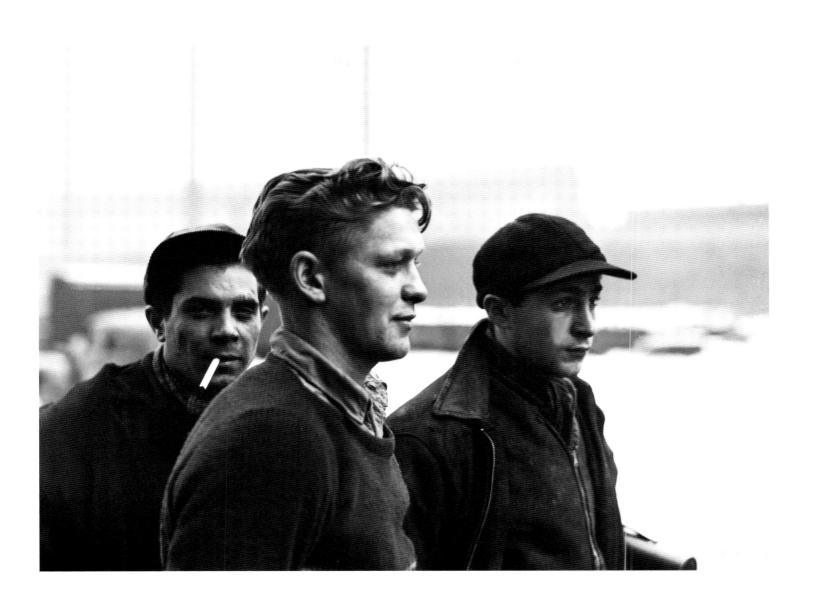

Young workers at the steel mill in Midland. January 1941. Jack Delano.

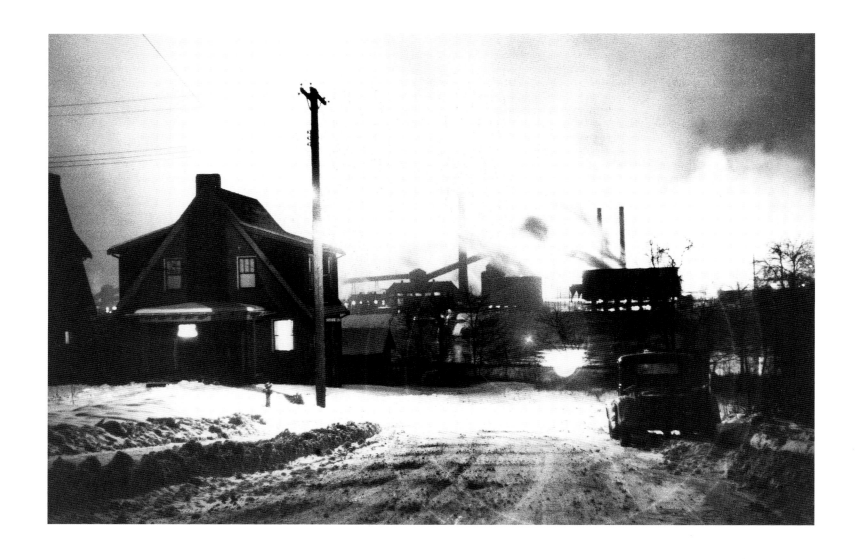

The Aliquippa plant of the Jones and Laughlin Steel Company seen from across the Ohio River. Baden, January 1941. Jack Delano.

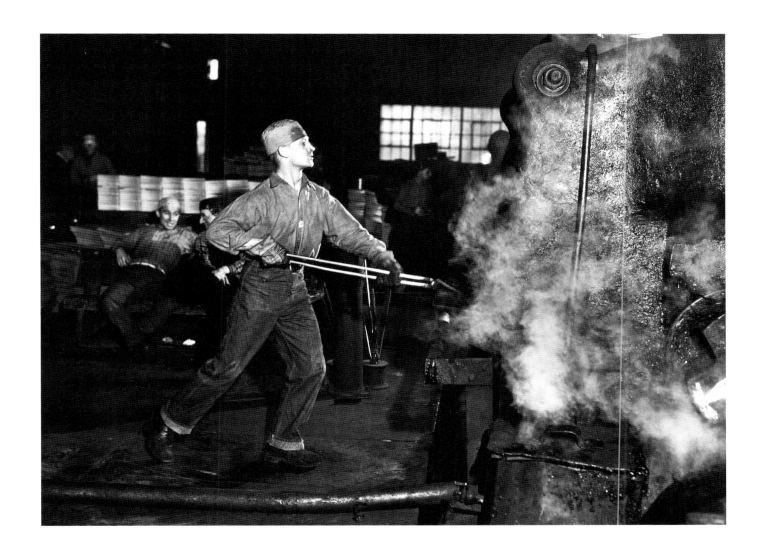

At one of the rolling machines in the Washington Tinplate Company. Washington, January 1941. Jack Delano.

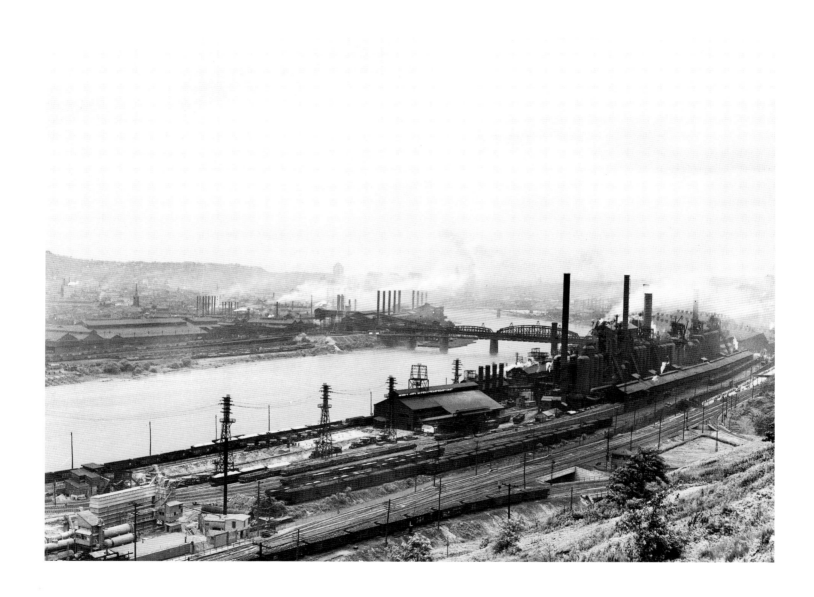

Jones and Laughlin Steel Company on both sides of the river. Pittsburgh, June 1941. John Vachon.

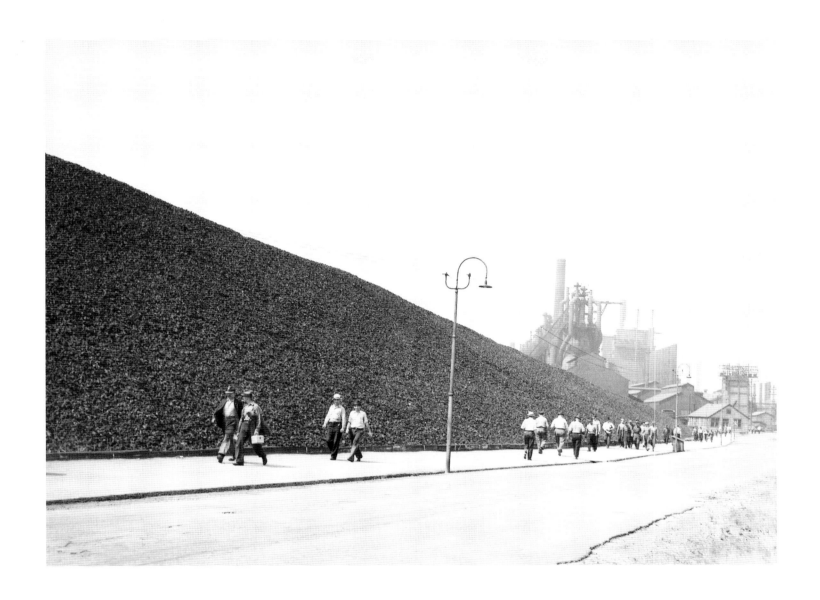

Change of shift at the steel plant. Aliquippa, July 1938. Arthur Rothstein.

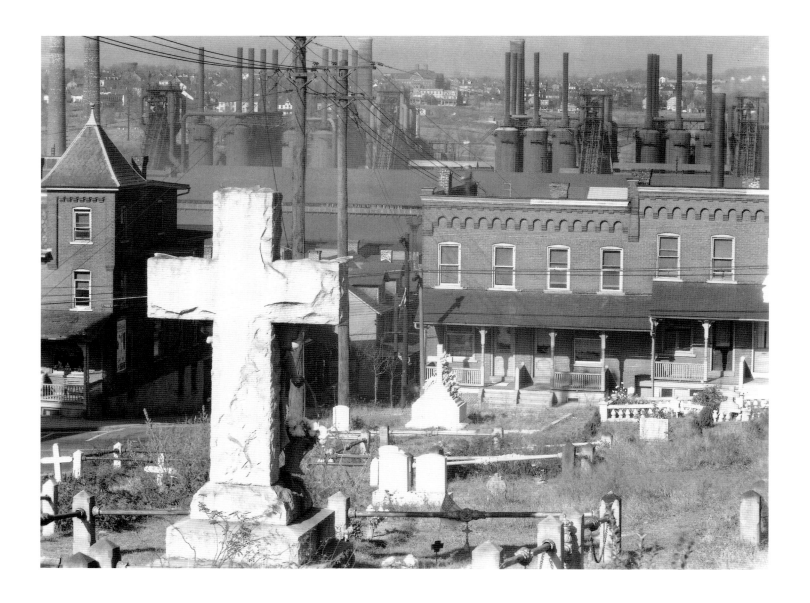

Bethlehem graveyard and steel mill. November 1935. Walker Evans.

# THE WESTMORELAND PROJECT

IN 1933, CONGRESS created the Division of Subsistence Home-steads in the Department of the Interior. The goal was to create cooperative communities that would provide housing and work for people displaced by the Great Depression. One of the first of these was Westmoreland Homesteads, located near the bitumi-nous coalfields in southwestern Pennsylvania. The government purchased the land in 1933 and began accepting applications from coal miners who had been thrown out of work (and thus out of company-owned housing) as the mines closed. Only families could participate, and some 250 of them—1,200 people—were chosen from among thousands of applicants. The Westmoreland community, largely constructed by the homesteaders, operated as a cooperative and offered work, schooling, and leisure activities. Because of the propaganda value of the homestead projects to the Farm Security Administration, many of the FSA photographers who worked in the state, including Walker Evans, Edwin Locke, Carl Mydans, Arthur Rothstein, and Ben Shahn, made a manda-tory stop there when they traveled through western Pennsylvania.

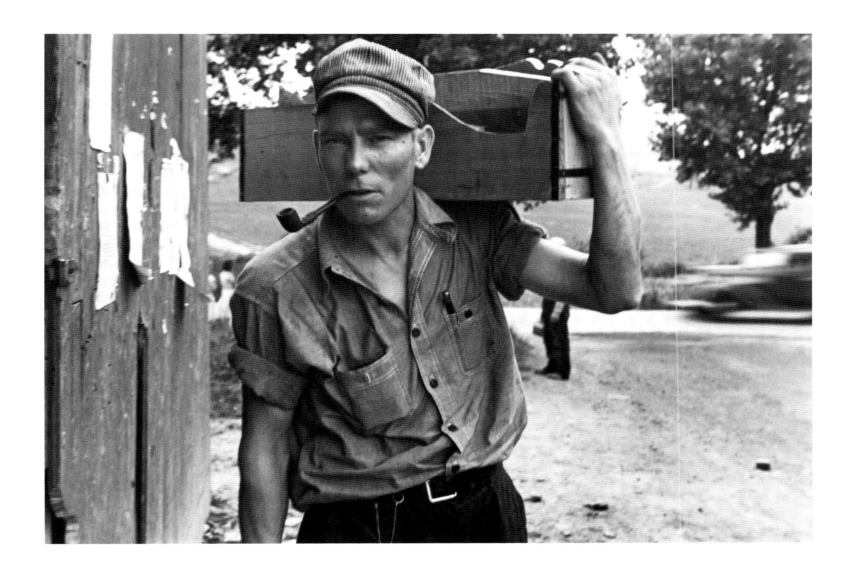

A carpenter, Westmoreland Subsistence Homestead Project. July 1935. Walker Evans.

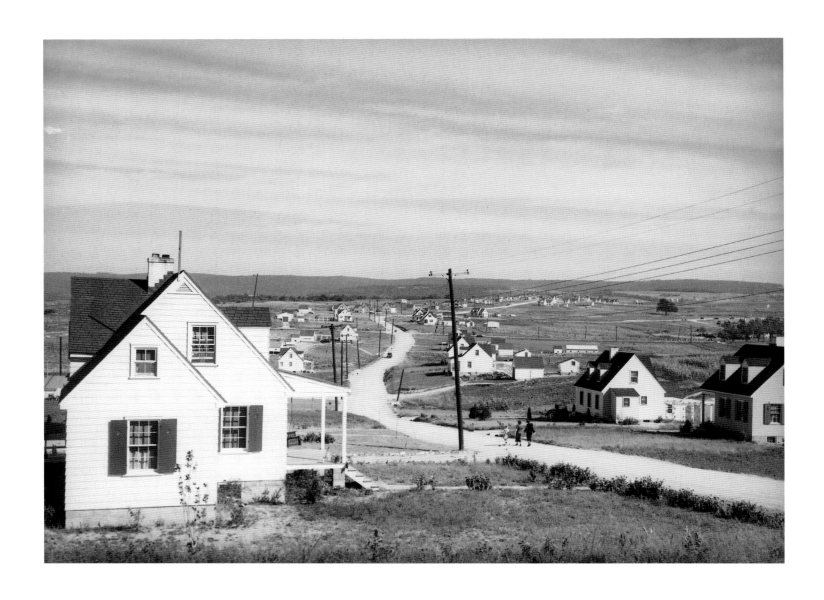

View of Westmoreland Homesteads. September 1936. Arthur Rothstein.

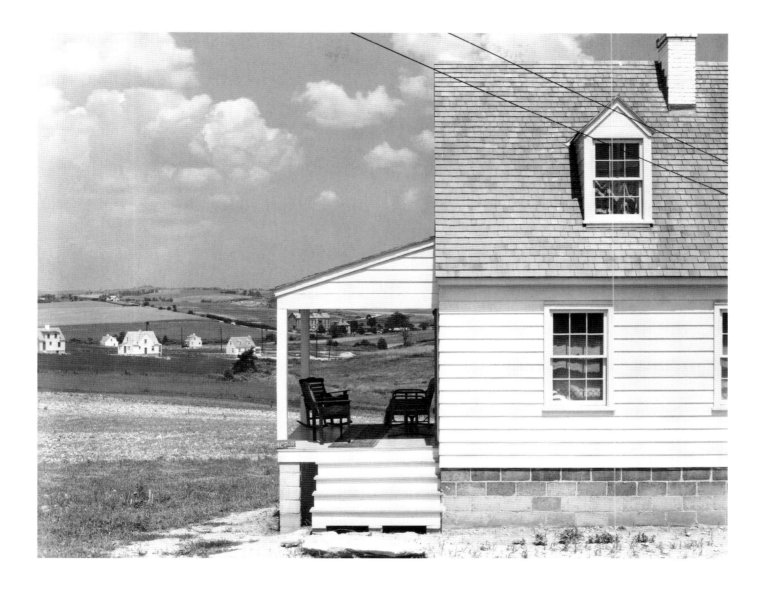

Westmoreland Project. July 1935. Walker Evans.

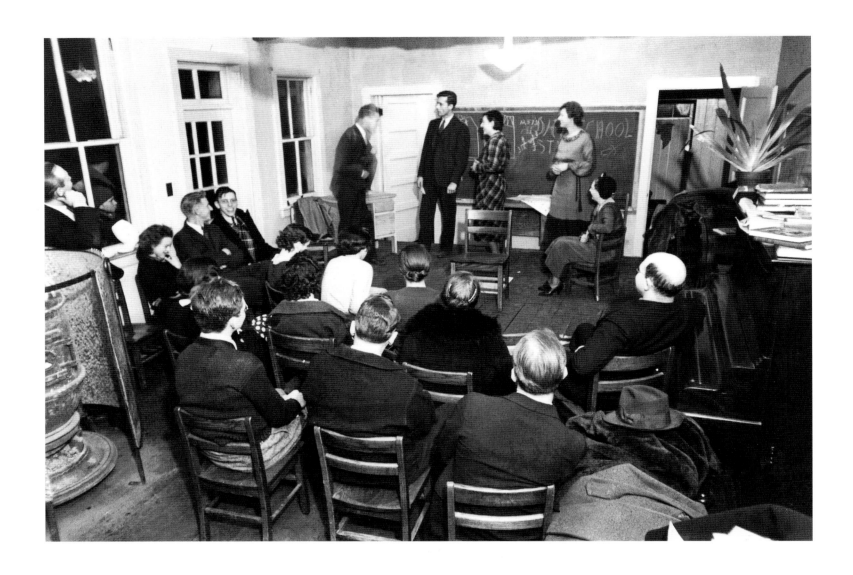

Dramatic group, Westmoreland Homesteads. February 1936. Carl Mydans.

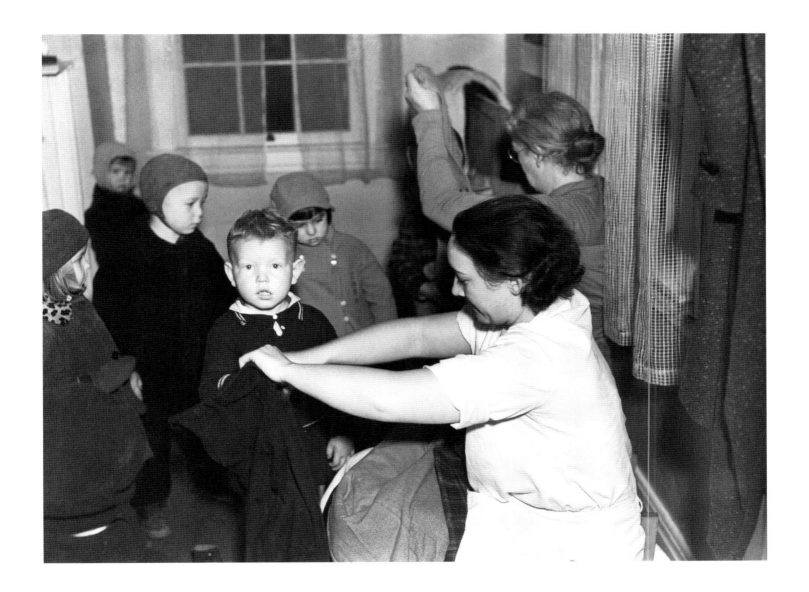

Children being dressed before leaving the nursery school for the day, Westmoreland Homesteads. November 1936. Edwin Locke.

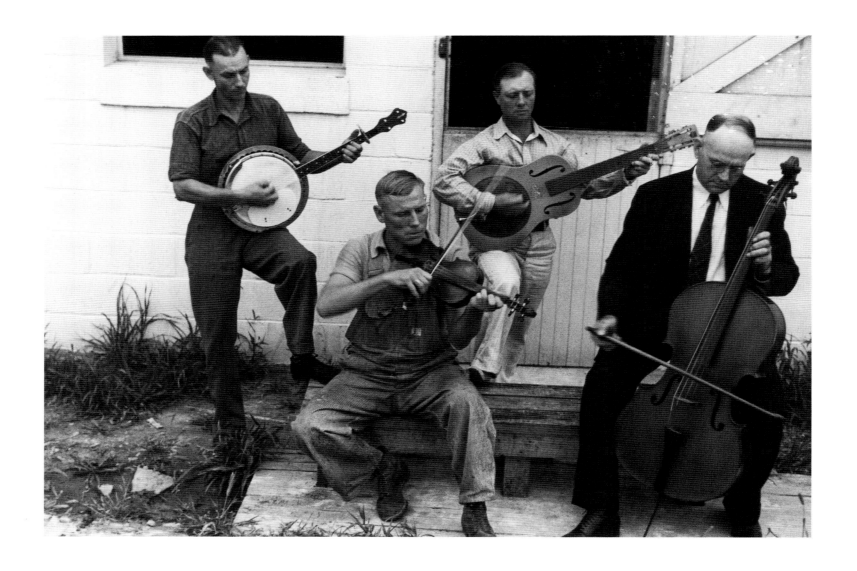

Practicing for the fair held on the U.S. Resettlement Administration's Subsistence Homestead Project.
Greensburg vicinity, Westmoreland Homesteads, 1937. Ben Shahn.

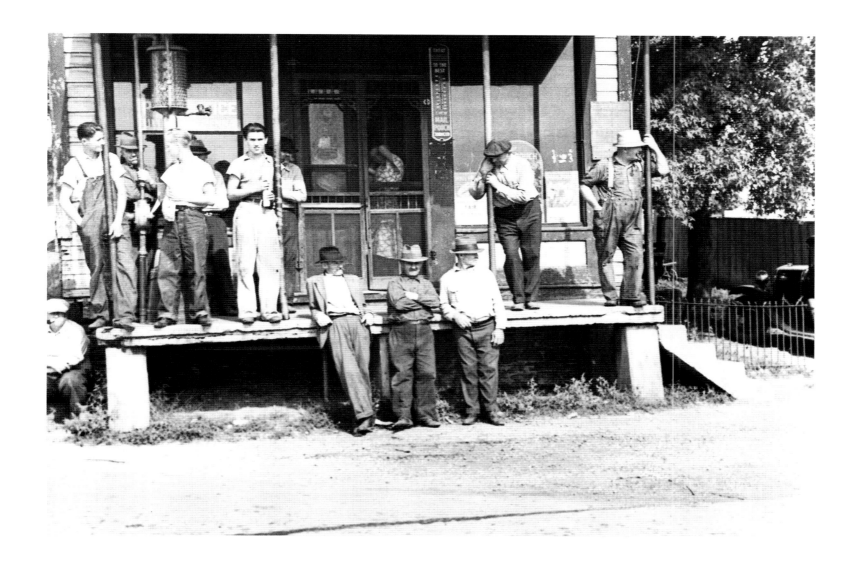

Prospective homesteaders in front of the post office at United, Westmoreland County. October 1935. Ben Shahn.

# PATRIOTIC ACTIVITY

NO MATTER HOW devastating the Great Depression was to the economy of the Commonwealth, it did not manage to sap the will of the people. Holidays and their attendant celebrations continued apace and, as always in times of national crisis, Pennsylvanians rallied around their symbols. John Vachon's photo of an African American citizen hanging his flag with the grim urban industrial landscape of Pittsburgh behind him best captures that determination and belief in the strength and permanence of the nation. Scenes of citizens at parades, playing bingo, or just lolling around remind us that at the local level, life's rhythms went on pretty much as they always had.

Armistice Day parade. Lancaster, November 1942. Marjory Collins.

Boys on the 4th of July. State College, July 1941. Edwin Rosskam.

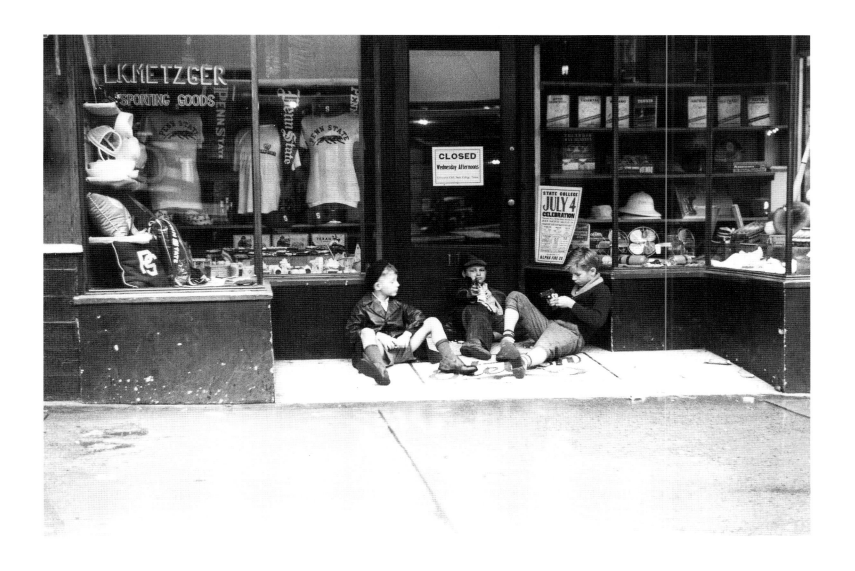

Boys on the 4th of July. State College, July 1941. Edwin Rosskam.

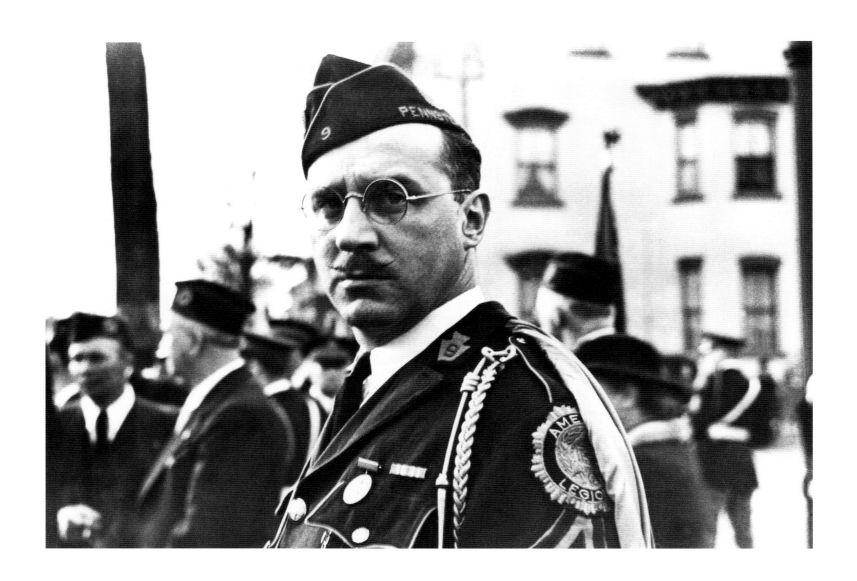

Legionnaire. Bethlehem, November 1935. Walker Evans.

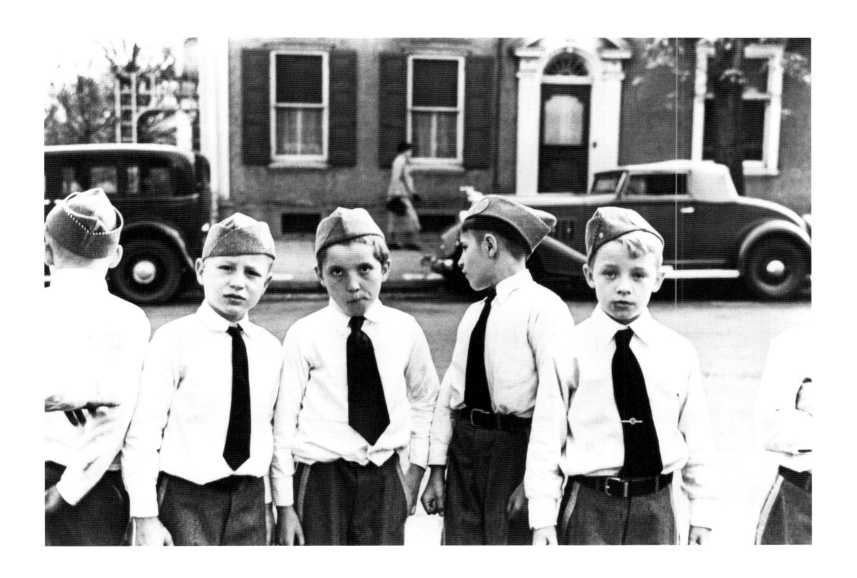

Sons of American Legion. Bethlehem, November 1935. Walker Evans.

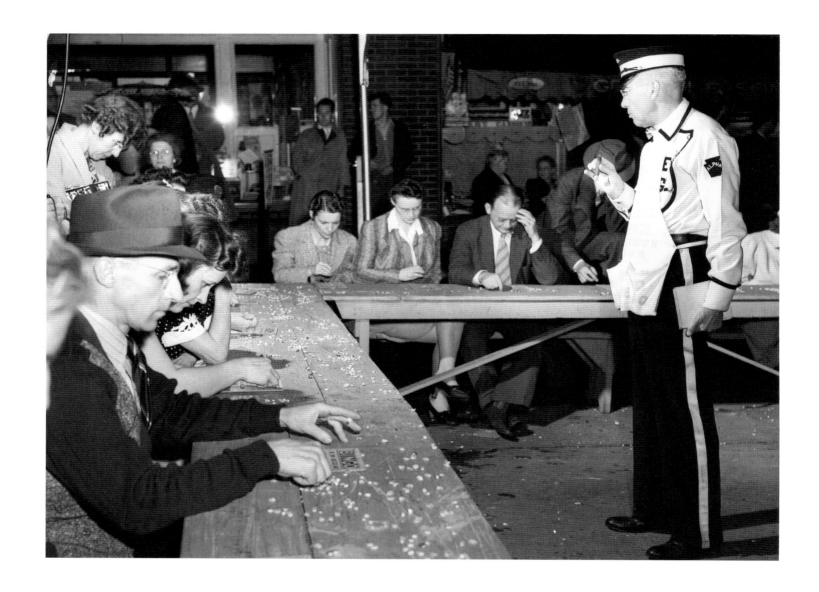

Bingo game at the July 4th celebration. State College, July 1941. Edwin Rosskam.

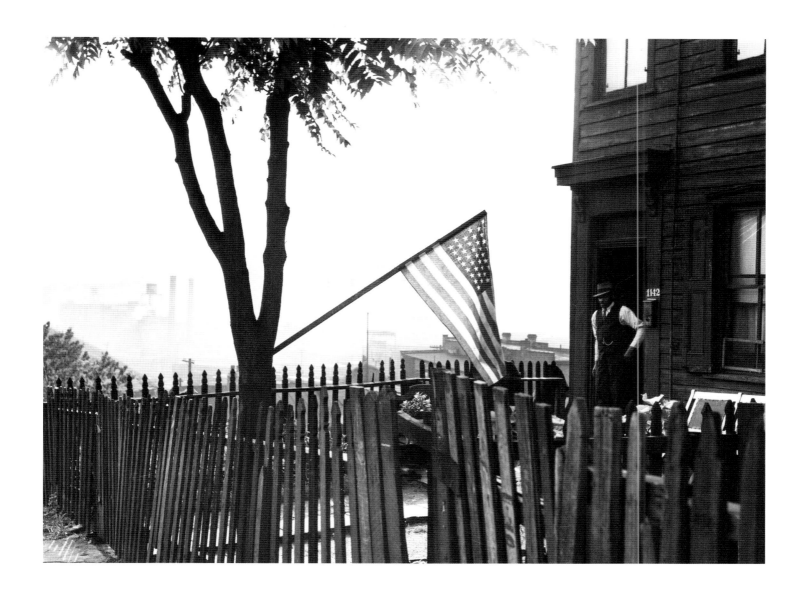

Flag Day. Pittsburgh, June 1941. John Vachon.

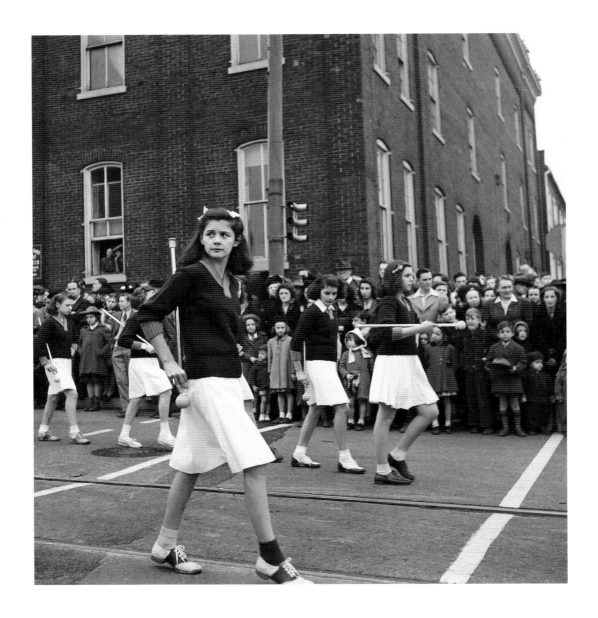

Armistice Day parade. Lancaster, November 1942. Marjory Collins.

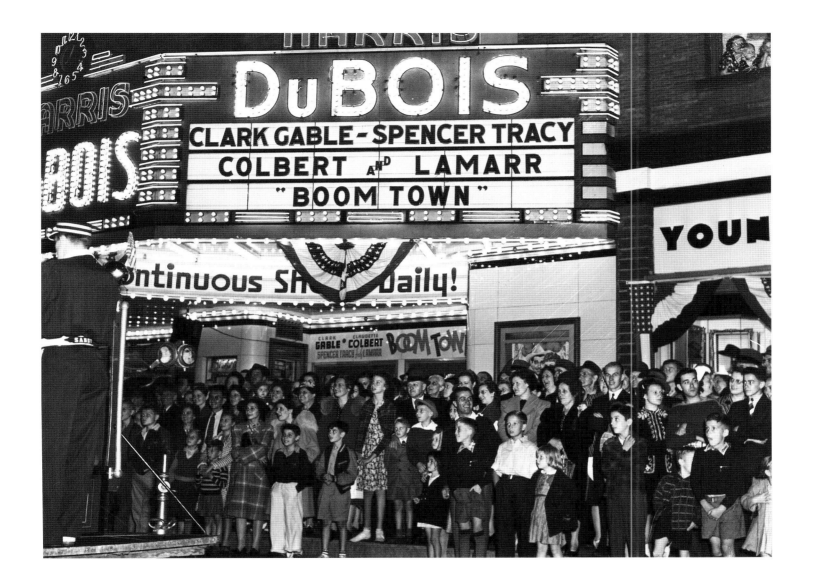

Spectators and theatre at Labor Day parade in Du Bois. September 1940. Jack Delano.

# THE WAR AT HOME

AFTER PEARL HARBOR, with unemployment rapidly declining, the nation geared up for war production. Gone were photo-essays of the problems of the Great Depression. Instead, the photographers set out on a patriotic mission to document the home front during wartime. Pennsylvanians were shown rolling up their sleeves to support the war effort. (John Collier's series on coal miners at the Montour No. 4 mine near Pittsburgh demonstrates this shift in focus; see the collection of photographs entitled "Coal" in this volume.) Marjory Collins's photo-essay of Lititz, Pennsylvania, during wartime was probably the most comprehensive look at the effects of the war on small-town America. In addition, her photos of women who filled the wartime jobs that their husbands and sons left behind bring the well-known image of "Rosie the Riveter" vividly to life.

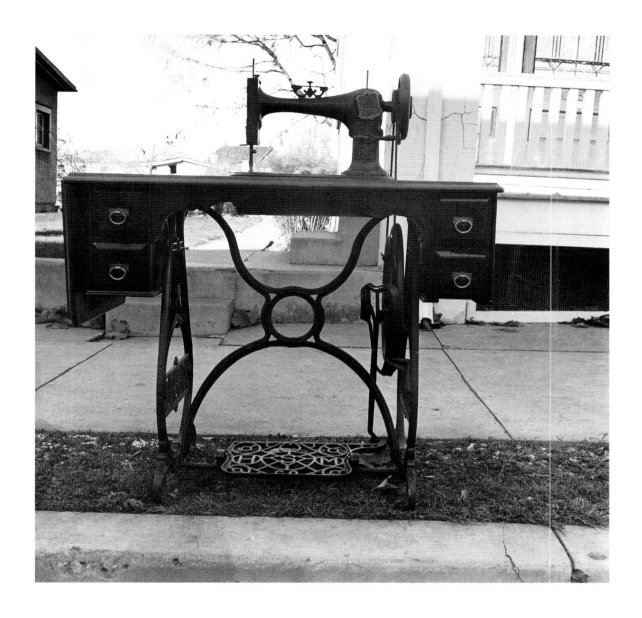

In curb scrap collection drive, one housewife donated a sewing machine. Lititz, November 1942. Marjory Collins.

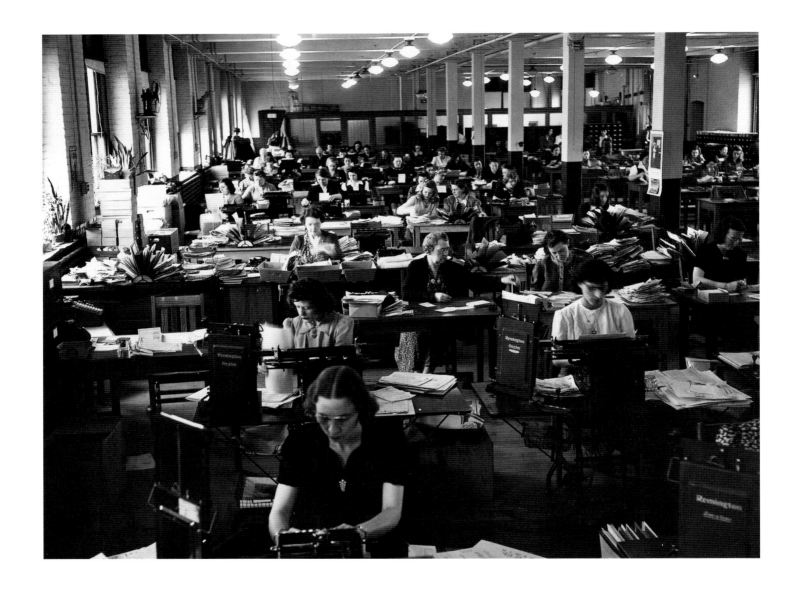

General view of the office at the W. Atlee Burpee Company, seed dealers. Philadelphia, April 1943. Arthur Siegel.

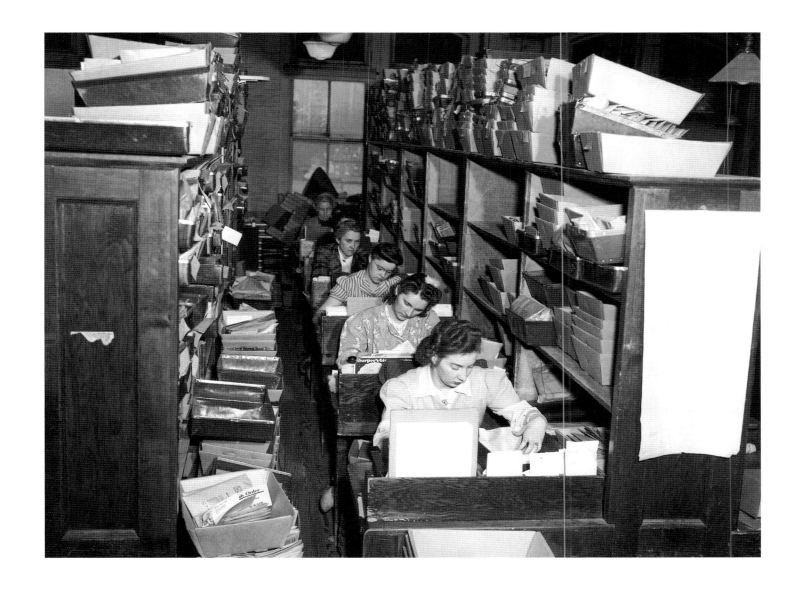

Women checking filled orders at the W. Atlee Burpee Company, seed dealers. Philadelphia, April 1943. Arthur Siegel.

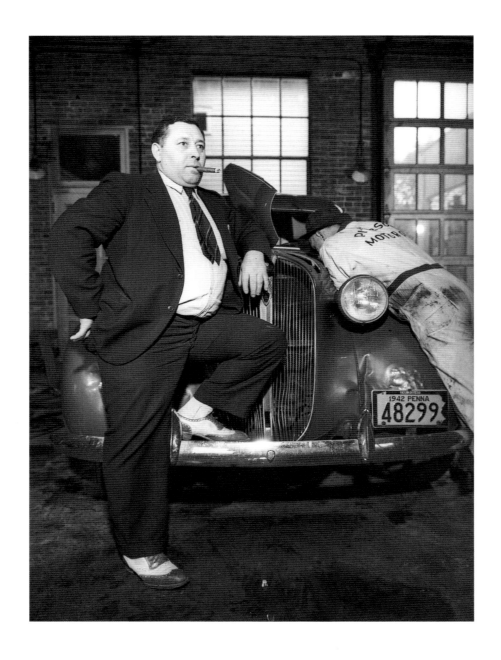

Irwin R. Steffy having his car gone over in the Pierson Motor Company garage. He uses it to go into Lancaster every day, where he is doing a defense job at the Armstrong Cork Company; he shares a ride when hours permit. Before the war he worked for nine years for Spachts, the undertaker. Now he serves four hours a week as an airplane spotter at the nearby observation post. Lititz, November 1942. Marjory Collins.

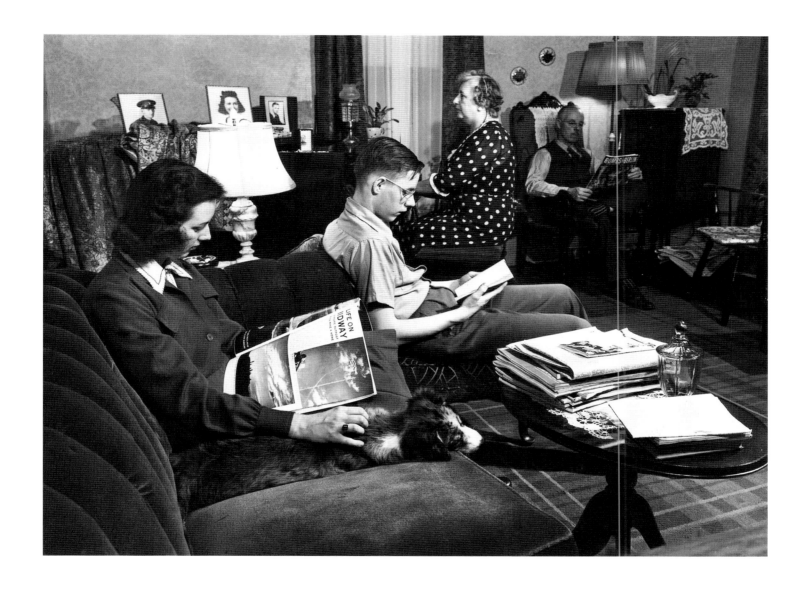

Mrs. Julian Bachman at home with her family. Her brother is sixteen and in high school. She is twenty-three years old and has been married a year. Her husband is in Officers' Candidate School of the U.S. Army Air Corps in Kentucky, so she is living at home and works at the Animal Trap Company from 7 to 4. She spends her evenings writing him daily letters. Lititz, November 1942. Marjory Collins.

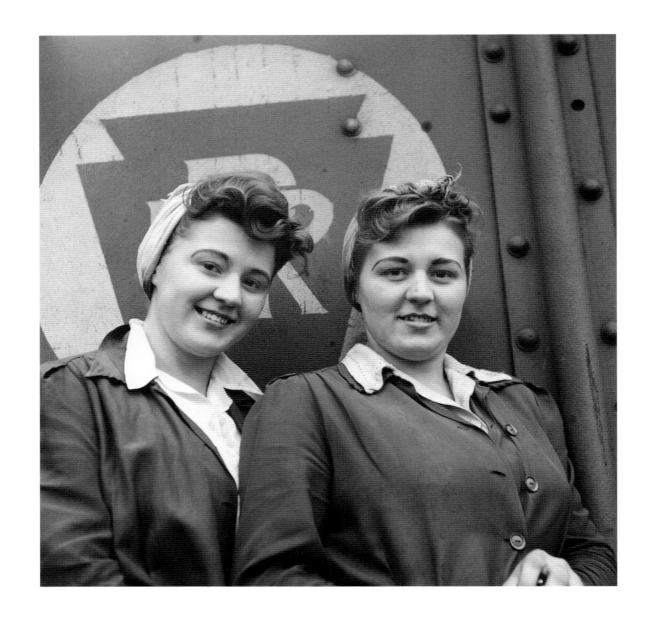

Twins Amy and Mary Rose Lindich, twenty-one, are employed at the Pennsylvania Railroad as car repairmen helpers, earning seventy-two cents per hour. They reside in Jeanette and carpool with fellow workers. Pitcairn, May 1943. Marjory Collins.

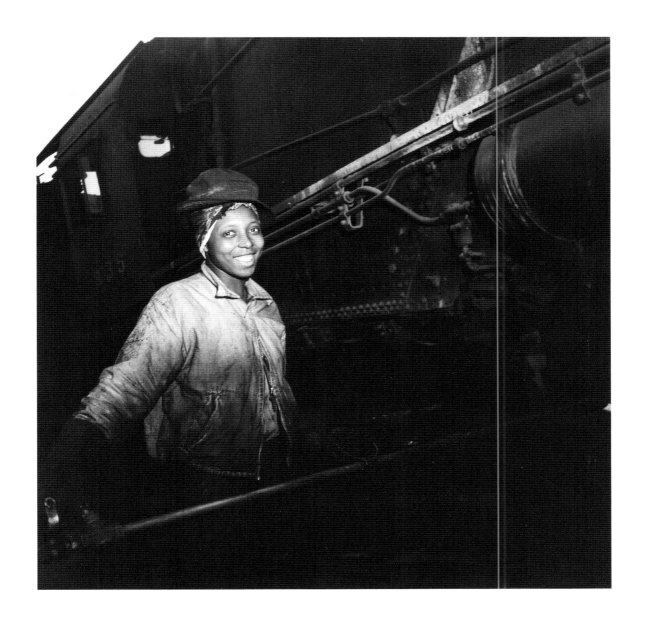

Mrs. Bernice Stevens of Braddock, mother of one child, employed in the engine house of the Pennsylvania Railroad, earns fifty-eight cents per hour. She is cleaning a locomotive with a high-pressure nozzle. Mrs. Stevens' husband is in the U.S. Army. Pitcairn, June 1943. Marjory Collins.

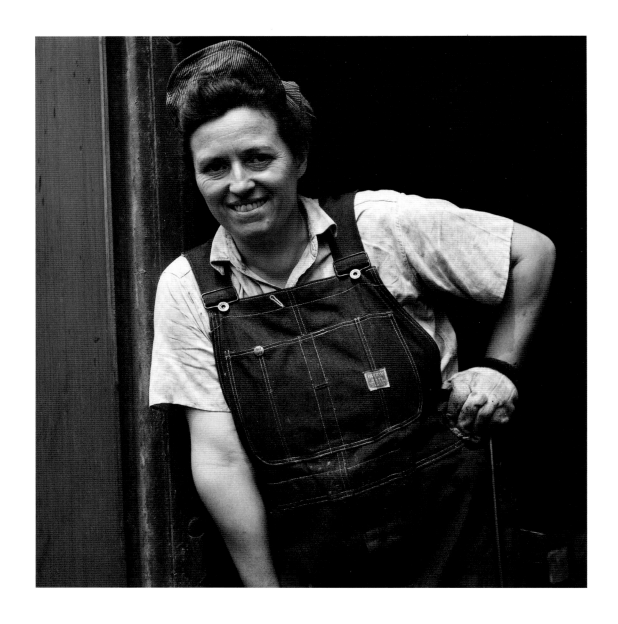

Mrs. Lois Micheltree, thirty-six, is employed as a laborer at the Pennsylvania Railroad lumber yard, earning fifty-five cents per hour. She helps load and unload lumber from cars. Mrs. Micheltree has a son in the U.S. Navy. Pitcairn, May 1943. Marjory Collins.

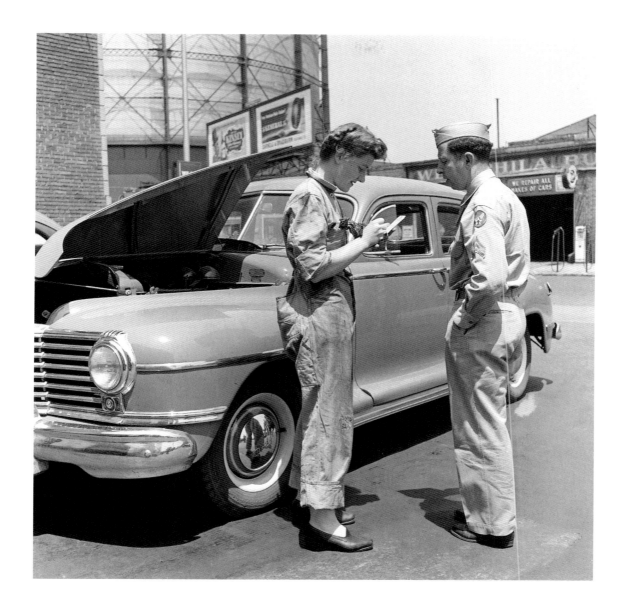

Miss Frances Heisler, a garage attendant at one of the Atlantic Refining Company garages. She was formerly a clerk in the payroll department of the Curtis Publishing Company. Philadelphia, June 1943. Jack Delano.

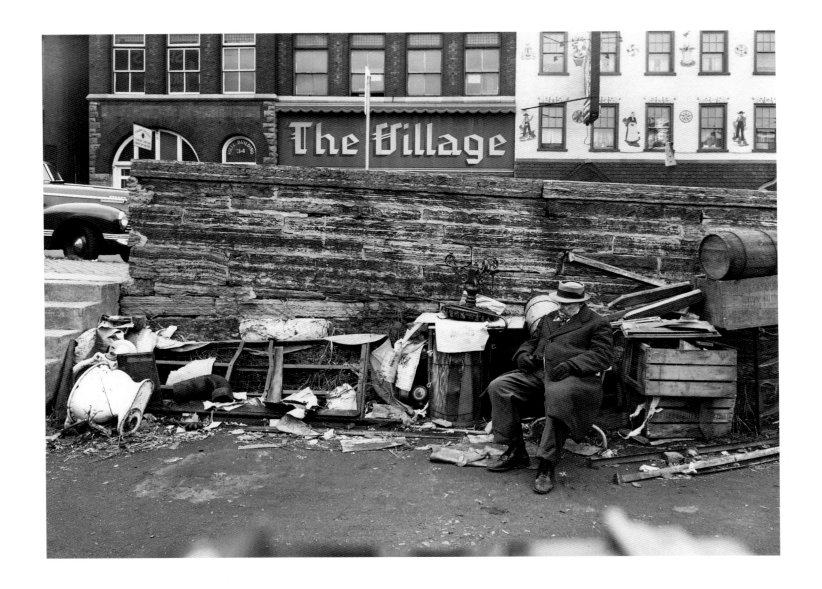

Guardian of the community scrap pile, asleep. Lancaster, November 1942. Marjory Collins.

# The *Times of Sorrow and Hope* On-line Catalog

## INTRODUCTION

**Cataloging the Photographs**

The *Times of Sorrow and Hope* on-line catalog of Pennsylvania photographs taken by the photographers assigned to the Resettlement Administration (1935–37), the Farm Security Administration (1937–42), the Office of War Information (1942–43), and related governmental and nongovernmental bodies provides a comprehensive inventory of all the photographs taken in Pennsylvania during those years. (There are some photographs dated before 1935 and some dated after 1943.) When this project began, the Library of Congress—the main depository of the negatives and prints of the photographs—indicated that more than 112,000 images were available digitally on its Web site. Its FSA-OWI collection includes photographs taken throughout the country, not just those from Pennsylvania. The Library of Congress now indicates that there are 160,000 photographs available on its Web site from a total of 164,000 images in the FSA-OWI collection. The collection, then, is still very much in flux.

This sense of flux, however, is not new: for many years, the vast FSA-OWI collection has presented challenges to catalogers and researchers alike. When the prints and negatives from the collection were deposited at the Library of Congress in 1944, researchers could only gain access to the images by visiting the Reading Room of the Prints and Photographs Division of the Library of Congress. Roy Stryker, head of the FSA-OWI photographic sections, hired Paul Vanderbilt in 1943 to bring some

organization to the thousands of prints. Vanderbilt created two major files. First, he arranged the photographs by assignments and called them "lots." These were transferred to 109 reels of microfilm in the 1940s, providing researchers outside the Library of Congress access to about 77,000 of the images. This resource, though, was not well known, and even today very few libraries hold copies of it. Vanderbilt then took the photographs and devised a new subject system, arranging the photographs by subject and by broad geographical area. Prints from the original negatives were mounted on cardboard. Caption information accompanied each item, identifying the photographer, place, date, title, and Library of Congress number. (The Library of Congress number evolved from the numbering system assigned to each photographer as he or she worked in the field.) These mounted prints were placed according to Vanderbilt's subject arrangement in vertical file drawers in the Prints and Photographs Reading Room. From 1978 to 1979, the publisher Chadwyck-Healey transferred the photographs as they appeared in the vertical file drawers to microfiche, a project that reproduced 87,000 photographs on 1,572 fiche. Of this number, 434 fiche contain photographs from the Northeast region, which includes Pennsylvania and twelve other states.

Microfiche, microfilm, and now the Internet have certainly made primary source information more readily available over the years. In addition to the fiche and microfilm editions of the

photographs and their on-line counterparts, the written records of the FSA-OWI are now available on microfilm as well. These records contain many of the caption lists compiled by the photographers themselves—lists that describe the photographs and indicate which images should be included in the official file and which should not. The photographs not used were designated as "killed" in the caption lists. These so-called killed photographs were not available in the fiche or microfilm editions of the FSA-OWI collection, but as the negatives were never destroyed, digital images of them now appear on the Library of Congress Web site (and for the most part, they are classified as "untitled"). In the present on-line catalog of Pennsylvania photographs, an attempt has been made to bring together the titled photographs and their equivalent untitled or killed images. Appropriate notes are provided when necessary.

The *Times of Sorrow and Hope* on-line catalog represents photographs taken by close to forty photographers in nearly two hundred Pennsylvania towns, villages, and cities and at other landmarks. Approximately 6,000 Pennsylvania photographs have so far been identified; as additional information becomes available, it will be added to the catalog. The on-line catalog is largely arranged by photographer and place. Images without attribution and photographs by other governmental agencies and organizations appear at the end of the catalog in a section entitled "Other and Unidentified." There are two guides to the *Times of Sorrow and Hope* on-line catalog available in this book, again arranged by photographer and place. These two guides also appear on the Web site for the on-line catalog, along with three other guides that index the photographs by date, subjects, and personal names.

Indeed, the captions accompanying the photographs mention quite a few personal names. (Many more photographs taken in various villages, towns, and cities in Pennsylvania do not identify the people in the photographs by personal names.) One wonders how many Pennsylvanians realize that these photographs recorded the presence of their relatives—some of whom lived during the Civil War. The "Personal Names" index attempts to locate these people in the on-line catalog.

A typical citation under each photographer lists the place, title, and date of the photograph, followed by sources for the photograph and variations in titles. If a digital image exists on the Library of Congress Web site, two access points for that on-line collection are given. For example, a photograph in the on-line catalog with the access numbers fsa 8d32915 (digital identification number) or LC-USW3-037187-E (class number) can be located through the "Searching Numbers" section of the Library of Congress Web site. (See the Web site address below.) If the photograph had a title, the access point designations are given first, followed by untitled or killed variants, if available, with their access point designations. Other search capabilities on the Library of Congress Web site include "Searching All Text in the Catalog Records," "Searching Subjects and Formats," "Searching Creators and Other Associated Names," and "Searching Titles." Each of these search capabilities is accompanied by examples of how to do that particular search. The Web site also explains how to order prints of the photographs from the Library of Congress.

After the Library of Congress information, the *Times of Sorrow and Hope* on-line catalog provides other locations for the

images, including fiche and microfilm editions, the New York Public Library collection, and the like, including reproductions in printed books. (In many cases, the photograph titles used in books do not match titles on the Library of Congress Web site or in the fiche or microfilm editions, and the notes discuss such discrepancies.) When digital images are not available on the Library of Congress Web site but may be available from other sources, this is also indicated. Chadwyck-Healey put the Roy Stryker Papers from the University of Louisville—including duplicate FSA-OWI photographs in his private collection—on microfilm. The Pennsylvania photographs from that set are also available through the University of Louisville Web site. Stryker also gave some 40,000 duplicate prints to Romana Javitz, the first head of the Picture Collection at the New York Public Library, and these are located in the Research Library's Photography Collection. (In fact, Javitz occasionally lent photographs back to Stryker as he attempted to fill gaps in the subject areas of the FSA's collection.) Ben Shahn's photographs from this period are on deposit at the Fogg Museum at Harvard University as well as the Library of Congress, and his photographs are available on the Fogg Museum Web site. And the Metropolitan Museum of Art houses the Walker Evans Archive, including many of the photographs he took in Pennsylvania. Virtually all of these photographs are also available on the Library of Congress Web site. Information about these resources can be found in the on-line catalog entries.

The on-line catalog of Pennsylvania photographs was compiled in conjunction with the publication of *Times of Sorrow and Hope* and is available through the Pennsylvania State University Libraries Web site at <http://alias.libraries.psu.edu/ebooks/timesofsorrowandhope>. Questions about the catalog can be addressed to Allen Cohen at <ahcohen@worldnet.att.net>.

## Sources for Photographs

The Library of Congress Web site contains thousands of FSA-OWI photographs taken in Pennsylvania as well as in other states. For efficient searching through the Library of Congress FSA-OWI collection of black-and-white images, visit <http://lcweb2.loc.gov/pp/fsaquery.html>. To search the collection of color photographs, visit <http://lcweb2.loc.gov/pp/fsacquery.html>. Access is also available through the American Memory project of the Library of Congress: see <http://memory.loc.gov/ammem/fsowhome.html>. Photographs by Ben Shahn are available through the "Ben Shahn at Harvard" Web site, sponsored by the Harvard University Art Museums, located at <http://www.artmuseums.harvard.edu/Shahn/index.html>. For information about the photographs in the Roy Stryker Papers at the University of Louisville, visit the Web site located at <http://digilib.kyvl.org/dynaweb/kyvldigs>. For published sources, consult the "Works Cited in On-line Catalog as Sources for Published Photographs" section of the bibliography for this volume.

# GUIDES TO THE CATALOG

WHAT FOLLOWS ARE two guides to the on-line catalog of Pennsylvania photographs. The first lists each photograph according to the photographer's name and also provides the place and date of the image; in some cases, the photograph was taken in a different place than that mentioned in the caption. In the second, each photograph appears according to the place in which it was taken, and the date and photographer's name follow. Three other guides—photographs arranged by date, subjects, and personal names—are available on the Web site. Updates of all guides will be on-line.

**Guide to Photographers**

*Brown, Philip*
 Windber, November 1940

*Bubley, Esther*
 Gettysburg, September 1943
 New Bedford, September 1943
 Pittsburgh, September 1943

*Carter, Paul*
 Bethlehem, 1935, April 1936
 Canton and Canton vicinity, April 1936
 Easton vicinity, 1935
 Fall Brook vicinity, no date

*Collier, John*
 Barreville, March 1942
 Blue Ball vicinity, March 1942
 Bucks County, March 1942
 Ephrata vicinity, March 1942
 Glenwood, June 1943
 Hinkletown vicinity, March 1942
 Honey Brook vicinity, March 1942
 Intercourse vicinity, March 1942
 Lancaster, March 1942
 Lancaster County, March 1942
 Landis Valley, March 1942
 Manheim, March 1942
 New Holland and New Holland vicinity, March 1942
 Pittsburgh vicinity, November 1942
 Red Run vicinity, March 1942

Parrino, Nick
Manifold, April 1943

Perlitch, William
Hazleton, between 1941 and 1943, October 1942
Mount Carmel, October 1942
Scranton, between 1941 and 1943, October 1942
Wilkes-Barre, between 1941 and 1943, October 1942

Perlitch, William, or Alfred Palmer
Hazleton, between 1941 and 1943
Pottsville, between 1941 and 1943
Scranton, between 1941 and 1943
Wilkes-Barre, between 1941 and 1943

Roberts, H. Armstrong
Philadelphia, 1930–35[?], 1937

Rosener, Ann
Pennsylvania Turnpike, September 1942
Philadelphia, February 1943
Pittsburgh, September 1942
Scranton, February 1943

Rosskam, Edwin
Huntingdon, June 1941
Mercersburg vicinity, July 1941
Pine Grove Mills and Pine Grove Mills vicinity, July 1941
State College and State College vicinity, June–July 1941
Waynesboro and Waynesboro vicinity, 1940, Spring 1940
Unidentified place, Spring 1940

Rothstein, Arthur
Aliquippa, July 1938

Allegheny Mountains, June 1939, Summer 1939
Ambridge, July 1938
Bedford County, September 1936, December 1937
Bucks County, April 1939
Carpenterville, no date
Chaneysville, December 1937
Clairton, July 1938
Coatesville, December 1941
Economy, July 1938
Homestead, July 1938
Huntingdon County, December 1937
Lancaster, December 1941
Lancaster County, December 1941
McConnellsburg, December 1941
Midland, July 1938
Paradise vicinity, December 1941
Pennsylvania Turnpike, July 1942
Pittsburgh, September 1936, July 1938
Riddlesburg, December 1937
Westmoreland County, September 1936
Westmoreland Homesteads (Greensburg vicinity), September 1936

Shaffer, W. H.
U.S. Forest Service Photographs: Civilian Conservation Corps, August 1933

Shahn, Ben
Calumet, October 1935
Connellsville, October 1935
Hecla vicinity, October 1935
Nanty Glo, 1937
Norvelt, October 1935
Pleasant Unity, October 1935
Uniontown vicinity, October 1935

United, October 1935
Westmoreland County, October 1935
Westmoreland Homesteads (Greensburg vicinity), October 1935, 1937
Unidentified place, 1935

Shipp, E. S.
Allegheny National Forest, 1926

Siegel, Arthur
Philadelphia, April 1943

Vachon, John
Aliquippa, January 1941
West Aliquippa, January 1941
Ambridge, January 1941
Beaver Falls, January 1941
Carlisle, June 1940
Confluence, July 1940
Connellsville, July 1940
Conway, January 1941
Ellwood City, January 1941
Erie, June 1941
Etna, January 1941, June 1941
Freedom, January 1941
Harrisburg, July 1940
Lancaster, February 1942
Lewistown, July 1940
Mercersburg, July 1940
Midland, January 1941
Morrisville vicinity, August 1938
Pennsylvania Section of the War Emergency Pipeline, February 1942
Philadelphia, October 1941
Pittsburgh, April 1940, January 1941, June–July 1941
Rochester, January 1941

Washington, January 1941

Zelienople, January 1941

*Vanderbilt, Paul*

Ambler vicinity, Summer 1940

Chester, Spring 1938, 1938[?]

Haverford, 1937[?]

Manayunk, Spring 1938, Spring 1938[?], 1939

Philadelphia, between 1936 and 1939

Upper Darby, Summer 1936

*Wolcott, Marion Post*

[There are a number of date discrepancies for the following photographs. There might even be some question as to whether Wolcott was taking many of the Pennsylvania photographs in June 1939; there is some evidence that she was in the South in July 1939.]

Bucks County, June 1939

King of Prussia, June 1939

Lancaster County, June 1939, May 1941[?]

Morrisville, May 1941

Pittsburgh, August 1941

York County, June 1939, June 1939[?]

## Guide to Places

*Aliquippa*

July 1938, Arthur Rothstein

January 1941, Jack Delano

January 1941, John Vachon

*West Aliquippa*

January 1941, Jack Delano

January 1941, John Vachon

*West Aliquippa vicinity*

January 1941, Jack Delano

*Allegheny Mountains*

June 1939, Summer 1939, Arthur Rothstein

*Allegheny National Forest*

1926, E. S. Shipp

October 1937, H. C. Frayer

*Allentown*

Between 1941 and 1945, U.S. Army photograph [Note: See the "Other and Unidentified Photographs" section of the on-line catalog.]

*Ambler vicinity*

Summer 1940, Paul Vanderbilt

*Ambridge*

July 1938, Arthur Rothstein

January 1941, John Vachon

*Amity Hall*

August 1937, Edwin Locke

May 1938, Summer 1938, Sheldon Dick

*Arendtsville vicinity*

July 1938, Sheldon Dick

*Baden*

January 1941, Jack Delano

*Barreville*

March 1942, John Collier

*Barto vicinity*

August 1938, Sheldon Dick

*Beaver Falls*

January 1941, Jack Delano

January 1941, John Vachon

*Bedford County*

September 1936, Arthur Rothstein

December 1937, Arthur Rothstein

*Bethlehem*

1935, Paul Carter

1935, November 1935, December 1935, Walker Evans

March 1936, Walker Evans

April 1936, Paul Carter

May 1942, Howard Liberman

May 1944, Howard Hollem

*Birdsboro vicinity*

August 1938, Sheldon Dick

*Blue Ball and Blue Ball vicinity*

March 1942, John Collier

*Brackenridge*

Between 1940 and 1946, Alfred Palmer

1941[?], Alfred Palmer

*Bradford*

September 1941, Alfred Palmer

*Bridgewater*

January 1941, Jack Delano

*Bryn Mawr*

June 1943, Jack Delano

*Bucks County*

April 1939, Arthur Rothstein

June 1939, Marion Post Wolcott

March 1942, John Collier

*Butztown*

November 1936, Carl Mydans

*Byrnedale*

September 1940, Jack Delano

*Calumet*

October 1935, Ben Shahn

*Canton and Canton vicinity*

April 1936, Paul Carter

**Cardiff**
September 1940, Jack Delano

**Carlisle**
June 1940, John Vachon
February 1943, Marjory Collins

**Carpenterville**
No date, Arthur Rothstein

**Catasauqua**
1943, U.S. Army Air Forces photograph [Note: See the "Other and Unidentified Photographs" section of the on-line catalog.]

**Chaneysville**
December 1937, Arthur Rothstein

**Chester**
1938[?], Spring 1938, Paul Vanderbilt
June 1942, "Kelly," U.S. Maritime Commission photograph [Note: See the "Other and Unidentified Photographs" section of the on-line catalog.]

**Cheyney**
July 1939, no photographer indicated. Cheyney State Teachers College, National Youth Administration for Pennsylvania photograph [Note: See the "Other and Unidentified Photographs" section of the on-line catalog.]

**Churchtown vicinity**
1938, Sheldon Dick

**Clairton**
July 1938, Arthur Rothstein

**Coaldale**
August 1940, Jack Delano

**Coal Hollow**
September 1940, Jack Delano

**Coatesville**
December 1941, Arthur Rothstein

**Confluence**
July 1940, John Vachon

**Connellsville**
October 1935, Ben Shahn
July 1940, John Vachon

**Conshohocken**
1942[?], U.S. Army photograph [Note: See the "Other and Unidentified Photographs" section of the on-line catalog.]

**Conway**
January 1941, Jack Delano
January 1941, John Vachon

**Crawford County**
1935–40[?], U.S. Department of Agriculture photograph [Note: See the "Other and Unidentified Photographs" section of the on-line catalog.]

**Dresher**
July 1944, Pauline Ehrlich

**Du Bois and Du Bois vicinity**
August–October 1940, Jack Delano

**Eastern Pennsylvania**
November 1936, Russell Lee [no specific place indicated]

**Easton**
November 1935, Walker Evans

**Easton vicinity**
1935, Paul Carter
November 1935, Walker Evans

**East Pittsburgh**
1941 or 1942[?], 1942[?], no photographer indicated; Westinghouse Electric Company photograph [Note: See the "Other and Unidentified Photographs" section of the on-line catalog.]
December 1942, Alfred Palmer or George Danor

**Economy**
July 1938, Arthur Rothstein

**Edgewood**
1942[?], U.S. Army Signal Corps photograph [Note: See the "Other and Unidentified Photographs" section of the on-line catalog.]

**Ellwood City**
January 1941, John Vachon
December 1941, Alfred Palmer

**Ephrata**
1938, 1938[?], Sheldon Dick
November 1942, Marjory Collins

**Ephrata vicinity**
March 1942, John Collier

**Erie**
June 1941, John Vachon
July 1941, Summer 1941[?], Alfred Palmer

**Etna**
January 1941, June 1941, John Vachon
Between 1940 and 1946, Alfred Palmer
November 1941, Alfred Palmer
1942[?], Alfred Palmer

**Fall Brook vicinity**
No date, Paul Carter

Falls Creek vicinity
August 1940, September 1940, Jack Delano

Fallston
January 1941, Jack Delano

Farmersville
November 1936, Carl Mydans

Farrell
November 1941, Alfred Palmer

Fogelsville
August 1937, Edwin Locke

Force
September 1940, Jack Delano

Frankford
March 1942, Howard Liberman

Freedom
January 1941, John Vachon

Freemansburg
November 1935, Walker Evans

Gettysburg
1935–40[?], U.S. National Park Service photograph [Note: See the "Other and Unidentified Photographs" section of the on-line catalog.]
September 1943, Esther Bubley

Gettysburg vicinity
September 1940, Royden Dixon

Gilberton
1938[?], Sheldon Dick

Glenwood
June 1943, John Collier

Greensburg
December 1942, no photographer indicated [Note: Washington, D.C. photograph.

Place misspelled "Greenburg." See the "Other and Unidentified Photographs" section of the on-line catalog.]

Greensburg vicinity (Westmoreland Homesteads)
July 1935, Walker Evans
October 1935, Ben Shahn
September 1936, Arthur Rothstein
November 1936, Edwin Locke
1937, Ben Shahn

Hanoverville
November 1936, Carl Mydans

Harrisburg
July 1940, John Vachon

Harrisburg vicinity
May 1938, Summer 1938, Sheldon Dick
September 1940, Royden Dixon
[Note: Also see the "Other and Unidentified Photographs" section of the on-line catalog for undated Office for Emergency Management photographs. No photographers indicated.]

Harrisburg and Pittsburgh, highway connecting
1935–40[?], Federal Works Agency photograph [Note: Also see the "Other and Unidentified Photographs" section of the on-line catalog.]

Haverford
1937[?], Paul Vanderbilt

Hazleton
Between 1941 and 1943, William Perlitch or Alfred Palmer
Between 1941 and 1943, William Perlitch
October 1942, William Perlitch

Hecla
July 1935, Walker Evans

Hecla vicinity
October 1935, Ben Shahn

Helen Mills vicinity
September 1940, Jack Delano

Hinkletown vicinity
March 1942, John Collier

Homestead
July 1938, Arthur Rothstein

Honey Brook vicinity
March 1942, John Collier

Huntingdon
June 1941, Edwin Rosskam

Huntingdon County
December 1937, Arthur Rothstein

Industry
January 1941, Jack Delano

Intercourse vicinity
March 1942, John Collier

Johnstown
December 1935, Walker Evans

King of Prussia
June 1939, Marion Post Wolcott

Krunsville vicinity
August 1937, Edwin Locke

Lancaster
April 1937, Lewis W. Hine
1938, 1938[?], Sheldon Dick
December 1941, Arthur Rothstein
February 1942, John Vachon
March 1942, John Collier
November 1942, Marjory Collins

*Lancaster County*
Various dates in 1938, Sheldon Dick
June 1939, Marion Post Wolcott
May 1941[?], Marion Post Wolcott
December 1941, Arthur Rothstein
March 1942, John Collier
November 1942, Marjory Collins

*Landis Valley*
March 1942, John Collier

*Lansford and Lansford vicinity*
August 1940, Jack Delano

*Leacock vicinity*
1938[?], Sheldon Dick

*Lebanon*
November 1942, Fritz Henle

*Lewistown*
July 1940, John Vachon

*Liberty vicinity*
September 1940, Jack Delano

*Lititz*
May 1938, August 1938, Sheldon Dick
April 1942, Howard Liberman
November 1942, Marjory Collins

*Lititz vicinity*
August 1938, Sheldon Dick

*Lorain*
1938[?], Sheldon Dick

*Lyons Station*
1943[?], Alfred Palmer

*Manayunk*
Spring 1938, Spring 1938[?], Paul Vanderbilt
1939, Paul Vanderbilt

*Manheim*
March 1942, John Collier
November 1942, Marjory Collins

*Manheim vicinity*
November 1942, Marjory Collins

*Manifold*
April 1943, Nick Parrino

*Mansfield vicinity*
September 1940, Jack Delano

*Mauch Chunk*
August 1940, Jack Delano
*East Mauch Chunk*
August 1940, Jack Delano
*Lower Mauch Chunk*
August 1940, Jack Delano
*Upper Mauch Chunk*
August 1940, Jack Delano

*Maytown vicinity*
August 1938, Sheldon Dick

*McConnellsburg*
December 1941, Arthur Rothstein

*McKeesport*
1942[?], no photographer indicated [Note: See the "Other and Unidentified Photographs" section of the on-line catalog.]
December 1942, Alfred Palmer

*Mechanicsburg*
1938[?], Sheldon Dick

*Mercersburg*
July 1940, John Vachon

*Mercersburg vicinity*
July 1941, Edwin Rosskam

*Midland*
July 1938, Arthur Rothstein
January 1941, Jack Delano
January 1941, John Vachon

*Mohrsville*
1943[?], Alfred Palmer

*Morgantown*
1938, Sheldon Dick

*Morrisville*
May 1941, Marion Post Wolcott

*Morrisville vicinity*
August 1938, John Vachon

*Mount Carmel*
October 1942, William Perlitch

*Mount Pleasant*
July 1935, Walker Evans
February 1936, Carl Mydans

*Mount Pleasant (Westmoreland Homesteads)*
February 1936, Carl Mydans

*Nanty Glo*
1937, Ben Shahn

*Neffsville*
November 1942, Marjory Collins

*Nescopeck*
ca. 1941, Office for Emergency Management photograph. [Note: See the "Other and Unidentified Photographs" section of the on-line catalog.]

*Nesquehoning*
January 1942, Howard Hollem

*New Bedford*
September 1943, Esther Bubley

New Brighton
   January 1941, Jack Delano

New Castle
   December 1941, Alfred Palmer

New Holland and New Holland vicinity
   March 1942, John Collier

Norristown
   December 1942, U.S. Army Signal Corps
   photograph [Note: See the "Other and
   Unidentified Photographs" section of
   the on-line catalog.]

Norvelt
   October 1935, Ben Shahn

Oil City
   September 1941, Alfred Palmer

Palo Alto
   August 1940, Jack Delano

Paradise vicinity
   December 1941, Arthur Rothstein

Parker's Landing vicinity
   Summer 1940, Office for Emergency Man-
   agement photograph [Note: See the
   "Other and Unidentified Photographs"
   section of the on-line catalog.]

Penfield vicinity
   August–September 1940, Jack Delano

Pennsylvania Section of the War Emergency
Pipeline
   February 1942, John Vachon

Pennsylvania Turnpike
   July 1942, Arthur Rothstein
   September 1942, Ann Rosener

Philadelphia
   1906[?] [Note: See the "Other and Uniden-
   tified Photographs" section of the on-
   line catalog.]
   1930–35[?], H. Armstrong Roberts
   1935–40[?], Federal Works Agency photo-
   graph. [Note: See the "Other and
   Unidentified Photographs" section of
   the on-line catalog.]
   Between 1936 and 1939, Paul Vanderbilt
   1937, H. Armstrong Roberts
   March 1941, National Youth Administra-
   tion for Pennsylvania photograph.
   [Note: See the "Other and Unidentified
   Photographs" section of the on-line
   catalog.]
   October 1941, John Vachon
   1942[?], Alfred Palmer
   1942[?], U.S. Army Signal Corps photo-
   graph [Note: See the "Other and
   Unidentified Photographs" section of
   the on-line catalog.]
   1942–43[?], Federal Works Agency photo-
   graphs [Note: See the "Other and
   Unidentified Photographs" section of
   the on-line catalog.]
   1942 or 1943, George Danor, Albert Free-
   man, or Alfred Palmer
   January 1942, Wide World New York pho-
   tograph. [Note: See the "Other and
   Unidentified Photographs" section of
   the on-line catalog.]
   [Spring 1942?], Marjory Collins
   May 1942, Howard Liberman

February 1943, Ann Rosener
April 1943, Arthur Siegel
June–July 1943, Jack Delano
May 1944, National Folk Festival photo-
   graphs [Note: See the "Other and
   Unidentified Photographs" section of
   the on-line catalog.]

Philadelphia Navy Yard
   Undated photograph, Office for Emer-
   gency Management [Note: See the
   "Other and Unidentified Photographs"
   section of the on-line catalog.]

Pine Grove Mills and Pine Grove Mills vicinity
   July 1941, Edwin Rosskam

Pitcairn
   May–June 1943, Marjory Collins

Pittsburgh
   1900–1905[?] [Note: See the "Other and
   Unidentified Photographs" section of
   the on-line catalog.]
   1930–35[?], Housing Guild ([?]) photo-
   graphs [Note: See the "Other and
   Unidentified Photographs" section of
   the on-line catalog.]
   December 1935, Walker Evans
   September 1936, Arthur Rothstein
   May 1938, Arthur Rothstein
   July 1938, Arthur Rothstein
   1940, Peter Killian
   April 1940, John Vachon
   January 1941, Jack Delano
   January 1941, John Vachon
   June–July 1941, John Vachon
   August 1941, Marion Post Wolcott

1942[?], U.S. Army photograph [Note: See the "Other and Unidentified Photographs" section of the on-line catalog.]
August 1942, Alfred Palmer
September 1942, Ann Rosener
June 1943, Marjory Collins
September 1943, Esther Bubley

*Pittsburgh vicinity*
November 1942, John Collier

*Plains*
January 1942, Howard Hollem

*Pleasant Unity*
October 1935, Ben Shahn

*Pottsville*
1938[?], Sheldon Dick
August 1940, Jack Delano
Between 1941 and 1943, William Perlitch or Alfred Palmer

*Punxsutawney*
August 1940, Jack Delano

*Reading*
1938, Sheldon Dick
1943[?] Alfred Palmer

*Reading vicinity*
1943[?], Alfred Palmer

*Red Run vicinity*
March 1942, John Collier

*Riddlesburg*
December 1937, Arthur Rothstein

*Rochester*
January 1941, Jack Delano
January 1941, John Vachon

*Saint Clair vicinity*
1938[?], Sheldon Dick

*Saint Marys*
September 1940, Jack Delano

*Scranton*
Between 1941 and 1943, William Perlitch or Alfred Palmer
Between 1941 and 1943, William Perlitch
October 1942, William Perlitch
February 1943, Ann Rosener

*Seek*
August 1940, Jack Delano

*Sharon*
February 1942, Alfred Palmer

*Shenandoah*
1902 [Note: See the "Other and Unidentified Photographs" section of the on-line catalog.]
1938, 1938[?], Sheldon Dick

*Shenandoah vicinity*
1938, 1938[?], Sheldon Dick

*Shoenersville*
November 1936, Carl Mydans

*State College and State College vicinity*
June–July 1941, Edwin Rosskam

*Stony Lake*
Between November 1941 and February 1942, Alfred Palmer

*Sykesville vicinity*
August 1940, Jack Delano

*Tamaqua*
August 1940, Jack Delano

*Terre Hill and Terre Hill vicinity*
March 1942, John Collier

*Tioga vicinity*
September 1940, Jack Delano

*Toby vicinity*
September 1940, Jack Delano

*Todd Erie Basin Dry Dock*
1943[?], Alfred Palmer

*Tyler*
September 1940, Jack Delano

*Uniontown*
1942–45, U.S. Army Air Forces photograph [Note: See the "Other and Unidentified Photographs" section of the on-line catalog.]

*Uniontown vicinity*
October 1935, Ben Shahn

*Union Township*
August 1940, Jack Delano

*United*
October 1935, Ben Shahn

*Upper Darby*
Summer 1936, Paul Vanderbilt
April 1942, Spring 1942, Jack Delano

*Washington*
January 1941, Jack Delano
January 1941, John Vachon

*Washington vicinity*
July 1936, Dorothea Lange

*Waynesboro and Waynesboro vicinity*
1940, Spring 1940, Edwin Rosskam

*West Chester*
   Undated National Youth Administration for Pennsylvania photograph [Note: See the "Other and Unidentified Photographs" section of the on-line catalog.]

*Westmoreland County*
   July 1935, Walker Evans
   October 1935, Ben Shahn
   September 1936, Arthur Rothstein

*Westmoreland Homesteads*
   July 1935, Walker Evans
   October 1935, Ben Shahn

   February 1936, Carl Mydans
   September 1936, Arthur Rothstein
   November 1936, Edwin Locke
   1937, Ben Shahn

*Wilkes-Barre*
   Between 1941 and 1943, William Perlitch or Alfred Palmer
   Between 1941 and 1943, William Perlitch
   October 1942, William Perlitch

*Williamsport*
   September 1940, Jack Delano

*Wilson Borough*
   November 1936, Carl Mydans

*Windber*
   November 1940, Philip Brown

*York*
   February 1942, Howard Hollem
   June 1943, John Collier

*York County*
   June 1939, June 1939[?], Marion Post Wolcott

*Zelienople*
   January 1941, John Vachon

# APPENDIX A: FSA-OWI PHOTOGRAPHS IN THIS BOOK

*This appendix presents summary information for the 150 photographs that appear in this book. More complete information for these titles is available in the* Times of Sorrow and Hope *online catalog, which also includes information on the thousands of other* FSA-OWI *Pennsylvania photographs. Here, the images are arranged alphabetically by title. The entry for each photograph gives access numbers for the digital images on the Library of Congress Web site, places the particular photograph in context with others of a similar nature, and provides some historical information when necessary (or available). The entries also contain other essential bibliographical information, including sources for the particular photographs other than the Library of Congress, discrepancies in dates, and variant titles. In this listing, the New York Public Library is referred to as* NYPL.

**Airport**

Pittsburgh, April 1940

John Vachon

Titled digital image: fsa 8a05488 :
LC-USF33-001701-M2. (P. 117)

*Notes:* As one of the early and major photographers of the FSA-OWI project, Vachon took numerous photographs—not only in Pittsburgh but throughout the state as well. In addition to this titled photograph, there are four untitled photographs of the same subject. The fiche edition has this image, and NYPL also has a print.

**The Aliquippa plant of the Jones and Laughlin Steel Company seen from across the Ohio River**

Baden, January 1941

Jack Delano

Titled digital image: fsa 8a35099 :
LC-USF33-020789-M4. (P. 168)

*Notes:* Delano was one of the major FSA-OWI photographers. There are two photographs that he took in Baden—one dated January 1940 and the other dated January 1941 by the Library of Congress. Delano took a number of photographs in the Pittsburgh area in January 1941, including Baden. The January 1940 date could not be correct, as Delano did not start

work for the FSA until May 9, 1940 (see the Delano Papers at the Library of Congress), and his first assignment was in Virginia in May 1940. The fiche and microfilm editions have the titled image, and NYPL has a print. The titles given in different sources vary slightly.

**Amish farmhand mending a harness on the Zook farm. The electric light overhead has been disconnected for religious reasons**

Honey Brook vicinity, March 1942

John Collier

Titled digital image: fsa 8c33975 :
LC-USF34-082421-E. (P. 136)

*Notes:* Collier was one of the major FSA-OWI photographers, and he took numerous photographs of the Amish and Mennonites. He also took some important photographs of coal mining. There are a number of titled and untitled images of this Amish farmhand, and the titles vary. The fiche and microfilm editions have images of the titled photographs, and NYPL has a number of prints.

**Amish women attending farm auction**

Lancaster County, March 1942

John Collier

Titled digital image: fsa 8c33938 :
LC-USF34-082263-E. (P. 139)

*Notes:* Another one of the Amish photographs taken by Collier. There are related photographs on this subject as well; titles vary. Both the fiche and microfilm editions have images of the titled photographs. NYPL has a print of one of the titled photographs.

**Armistice Day parade**

Lancaster, November 1942
Marjory Collins
Titled digital images: fsa 8d23380 :
LC-USW3-010958-E; fsa 8d23422 :
LC-USW3-011000-E. (Pp. 183, 190)

*Notes:* Collins was one of the prolific photographers for the FSA-OWI project. (Along with Collins, the women involved in the project were Esther Bubley, Pauline Ehrlich, Dorothea Lange, Ann Rosener, Louise Rosskam, and Marion Post Wolcott.) There are other related photographs on this subject—at least twenty-four titled and eleven untitled photographs. The fiche and microfilm editions also have these images. An image in this series is reproduced in *Let Us Now Praise Famous Women: Women Photographers for the U.S. Government, 1935–1944,* by Andrea Fisher (London: Pandora, 1987). Related photographs by Collins reflected in the on-line catalog have the titles "Watching the Armistice Day parade" and "Waiting for Armistice Day parade."

**An auction sale of a house and household goods**

York County, June 1939[?]
Marion Post Wolcott
Titled digital image: fsa 8a40773 :
LC-USF33-030503-M3. (P. 129)

*Notes:* One of the major female documentary photographers of the time, Wolcott took a series of photographs of farm scenes, including auctions in Bucks, Lancaster, and York Counties. There are a number of titled and untitled photographs that she took of auctions. Another photograph by her in this book is "A public auction at a farm near York." She also took auction-related photographs with the title "Spectators at an auction sale of a house and household goods." Titles given in different sources vary slightly. Images of this and related photographs are also available in the fiche and microfilm editions, and there are prints in the collection at NYPL.

**At one of the rolling machines in the Washington Tinplate Company**

Washington, January 1941
Jack Delano
Titled digital image: fsa 8c04621 :
LC-USF34-043169-D. (P. 169)

*Notes:* This is one of a number of photographs that Delano took of the Washington Tinplate Company. (John Vachon also took photographs of the Washington Tinplate Company.) There are other related photographs on this subject—two titled and one untitled. The fiche title is "One of the rolling machines at

the Washington Tinplate Works." The microfilm edition also has images of the titled photographs. There are photographs taken by Delano of the Washington Tinplate Company dated January 1940 and January 1941 by the Library of Congress. Delano took a number of photographs in the Pittsburgh area, including Washington, dated January 1941. The January 1940 date could not be correct (Delano's first FSA assignment was in Virginia in May 1940).

**At the Washington Tinplate Works**

Washington, January 1941
Jack Delano
Titled digital image: fsa 8c04688 :
LC-USF34-043242-D. (P. 161)

*Notes:* Another example of the photographs that Delano took of the company and the steel industry. Both the fiche and microfilm editions have images of photographs with this title, and the Roy Stryker Collection also has two images. The titles in different sources vary slightly.

**Automobile convoys at Amity Hall**

August 1937
Edwin Locke
Titled digital image: fsa 8b30923 :
LC-USF34-013188-D. (P. 113)

*Notes:* Locke took photographs at Amity Hall, Fogelsville, Krunsville, and Westmoreland Homesteads. Details of his work are available in the on-line catalog. This photograph is also available in the fiche and microfilm editions,

and there is a print at NYPL. The titles given in various sources vary slightly.

## Bach festival. People on the lawn outside Packer Memorial Chapel during the afternoon performance of the choir

Bethlehem, May 1944

Howard Hollem

Titled digital image: fsa 8d35439 :
LC-USW3-042570-E. (P. 103)

*Notes:* Hollem took a series of photographs of the Bach Festival in Bethlehem. There are other photographs with this title. The fiche and microfilm editions have images; the titles given in different sources vary slightly.

## Barn in eastern Pennsylvania

November 1936

Russell Lee

Titled digital image: fsa 8a21161 :
LC-USF33-011031-M5. (P. 126)

*Notes:* Lee was one of the earliest photographers in the project. He took many photographs throughout the country, but as best as can be determined, this is the only photograph that he took in Pennsylvania. There is one titled photograph and two untitled versions. The titled image also appears in the fiche edition. No specific place other than "eastern Pennsylvania" is indicated.

## Baseball game

Huntingdon, July 1941

Edwin Rosskam

Titled digital image: fsa 8a15987 :
LC-USF33-005212-M4. (P. 104)

*Notes:* Rosskam and his wife, Louise, worked for the FSA-OWI. His main duties were behind the scenes as an editor and layout artist, but he also got out into the field and took photographs. He took a number of photographs in the State College area, including this one of children playing. There are quite a number of versions of this photograph, both titled and untitled. Images are available in the fiche and microfilm editions, and the NYPL collection holds prints.

## Beehive coke ovens near Westmoreland Homesteads

Mount Pleasant, Westmoreland County,
February 1936

Carl Mydans

Titled digital image: fsa 8b27201 :
LC-USF34-002248-D. (P. 158)

*Notes:* Mydans was one of the early major photographers at the FSA. He was one of the photographers who took pictures of the Westmoreland Homestead project; he also took coal mining photographs. There are other related photographs on this subject, both titled and untitled. Other variant titles are "Coke ovens" and "Bee hive coke ovens." The fiche edition has images of this photograph, and NYPL has prints of this title.

## Bethlehem graveyard and steel mill

November 1935

Walker Evans

Titled digital image: fsa 8c52086 :
LC-USF342-001167-A. (P. 172)

*Notes:* This image could be considered one of Evans's iconic photographs—not just for the FSA photographs in Pennsylvania but also for his whole body of work. He was one of the earliest photographers with the project. Along with this image, which also appears in the fiche and microfilm editions, there are prints in the Walker Evans Archive and the Roy Stryker Collection. The Evans Archive dates the photograph as November 8, 1935. The fiche title is "Graveyard and steel mill, Bethlehem." The photograph has been reproduced in numerous printed works. The entry in the online catalog indicates some of those sources.

## Bingo game at the July 4th celebration

State College, July 1941

Edwin Rosskam

Titled digital image: fsa 8b14638 :
LC-USF34-012803-D. (P. 188)

*Notes:* One of the series of July Fourth photographs that Rosskam took in State College. There is one other titled photograph and an untitled photograph of the same subject. Images appear in the fiche and microfilm editions, and the NYPL collection also has a print.

## Birthday party in a Moravian Sunday school

Lititz, November 1942

Marjory Collins

Titled digital image: fsa 8d10662 :
LC-USW3-011786-D. (P. 42)

*Notes:* Collins was one of a group of female photographers working with the FSA-OWI. This photograph is part of her major photographic survey of life in Lititz during the war. The image is also available in the fiche and microfilm editions.

**A boy**
Westmoreland County, July 1935
Walker Evans
Titled digital image: fsa 8a19568 :
LC-USF33-009012-M1. (P. 36)

*Notes:* Evans took a number of portraits of children and adults around the Westmoreland Homesteads area. There are other related photographs on this subject, both titled and untitled. The title is taken from the fiche edition; the Library of Congress title is "Westmoreland County." Images also appear in the microfilm edition, and the NYPL has prints with variant titles. Reproduced in *Walker Evans: Photographs for the Farm Security Administration, 1935–1938: A Catalog of Photographic Prints Available from the Farm Security Administration Collection in the Library of Congress,* by Walker Evans (New York: Da Capo Press, 1973), no. 43, as "Young boy," and in *Walker Evans at Work: 745 Photographs Together with Documents Selected from Letters, Memoranda, Interviews, Notes,* with an essay by Jerry L. Thompson (New York: Harper and Row, 1982), 114.

**Boys**
Westmoreland County, July 1935
Walker Evans

Titled digital image: fsa 8a19563 :
LC-USF33-009007-M1. (P. 35)

*Notes:* Title from fiche edition. The Library of Congress title is "Westmoreland County." One of the boys in 009007-M1 is also the boy in 009011-M1. Reproduced in *Walker Evans: Photographs for the FSA,* no. 42, as "Children." The image appears in the fiche and microfilm editions, and there is also a print in the NYPL collection.

**Boys in the town in front of a Greek coffee shop**
Ambridge, July 1938
Arthur Rothstein
Titled digital image: fsa 8b17092 :
LC-USF34-026532-D. (P. 49)

*Notes:* Rothstein was the first photographer to join the FSA. He took many photographs of the steel towns of Aliquippa, Ambridge, and Midland. The fiche and microfilm editions also have this image. Titles vary slightly.

**Boys on the 4th of July**
State College, July 1941
Edwin Rosskam
Titled digital images: fsa 8a15962 :
LC-USF33-005206-M4; fsa 8a15958 :
LC-USF33-005205-M5. (Pp. 184, 185)

*Notes:* These are two related photographs that Rosskam took of July Fourth celebrations in State College. There is another titled photograph and one untitled photograph on this theme. The fiche and microfilm editions have

the images, and NYPL has two of the three prints.

**Boys who salvage coal from the slag heaps at Nanty Glo**
1937
Ben Shahn
Titled digital image: fsa 8a17113 :
LC-USF33-006229-M1. (P. 37)

*Notes:* Shahn was one of the early photographers in the FSA project, and many of his photographs became the basis for his paintings and other artworks. He took some dramatic photographs in Nanty Glo. The fiche and microfilm editions have this image, as does the Shahn Archive at Harvard. The Harvard copy dates the photograph from October 1935, while the Library of Congress dates it from 1937. Other photographs reproduced in this book on the same theme are "Young boy who salvages coal from the slag heaps" and "Man gathering good coal from the slag heaps at Nanty Glo."

**Bystanders**
Bethlehem, March 1936
Walker Evans
Titled digital image: fsa 8a19686 :
LC-USF33-009059-M1. (P. 66)

*Notes:* One of the series of Bethlehem photographs that Evans took. There are also two untitled photographs of the same subjects. The fiche and microfilm editions have the titled image, and NYPL also has a print. This

image is reproduced in *Walker Evans: Photographs for the* FSA, no. 67, as "Street scene," and *Walker Evans at Work,* 114.

## A carpenter, Westmoreland Subsistence Homestead Project

July 1935

Walker Evans

Titled digital image: fsa 8a19576 : LC-USF33-009020-M1. (P. 175)

*Notes:* The title is a variant in the fiche edition—and is more descriptive than the Library of Congress title. This image appears in the fiche and microfilm editions, and there is also a print in the NYPL collection. Reproduced in *Walker Evans: Photographs for the* FSA, no. 40, and *Walker Evans at Work,* 114.

## Central market

Lancaster, November 1942

Marjory Collins

Titled digital image: fsa 8d23396 : LC-USW3-010974-D. (P. 69)

*Notes:* This photograph is one of a series that Collins took in Lancaster and Lancaster County. In addition to this one titled photograph, there are a number of titled and untitled photographs on the same theme. Both the fiche and microfilm editions have the image. For related photographs, see, in the on-line catalog, "Farmer and wife at her stall in the central market," "Mennonite farm woman at her stall in the central market," and "Mennonite farmer's wife at her stall in the central market."

## Change of shift at the steel plant

Aliquippa, July 1938

Arthur Rothstein

Titled digital image: fsa 8b36379 : LC-USF34-026496-D. (P. 171)

*Notes:* This is one of a series of photographs that Rothstein took in Aliquippa. The photograph is of the Jones and Laughlin steel plant. There are a number of photographs with this title. The fiche and microfilm editions have images of this and the other photographs, and NYPL has some prints.

## Children at a movie house on Saturday afternoon in Beaver Falls

January 1941

Jack Delano

Titled digital image: fsa 8c04584 : LC-USF34-043133-D. (P. 46)

*Notes:* This is one of a series of photographs that Delano took of steel areas in western Pennsylvania. The fiche and microfilm editions also have this image. Photographs taken by Delano in Beaver Falls are dated either January 1940 or January 1941 by the Library of Congress. Fiche and microfilm editions have the January 1941 date. The January 1940 date could not be correct (Delano's first FSA assignment was in Virginia in May 1940).

## Children being dressed before leaving the nursery school for the day, Westmoreland Homesteads

November 1936

Edwin Locke

Titled digital image: fsa 8b15237 : LC-USF34-015291-D. (P. 179)

*Notes:* The fiche and microfilm editions have the image; the fiche title gives more detail about the Westmoreland Homesteads.

## Children living in a two-room slum apartment

Aliquippa, January 1941

John Vachon

Titled digital image: fsa 8c18617 : LC-USF34-062131-D. (P. 41)

*Notes:* Vachon took many photographs in Aliquippa and other steel towns. There is another photograph with this title; the fiche and microfilm editions have the images.

## Clifford Shorts and his family

Aliquippa, July 1938

Arthur Rothstein

Titled digital image: fsa 8b17157 : LC-USF34-026599-D. (P. 96)

*Notes:* Rothstein took a whole series of photographs of Clifford Shorts at the steel plant where he worked and at home with his wife and children. The fiche and microfilm editions also have this image. The titles in different sources vary slightly. The NYPL print has the title "Clifford Shorts, steel worker, and his family."

## Customers at the Tri-County Farmers Co-op Market at Du Bois

August 1940

Jack Delano

Titled digital image: fsa 8c02966 :
LC-USF34-041206-D. (P. 124)

*Notes:* Delano took many photographs of farmers and customers at this co-op market. Some of the farmers in these photographs also had coal mines on their farms. Examples reproduced in this book are "Mr. Merritt Bundy of the Tri-County Farmers Co-op Market at Du Bois at the entrance to his mine on his farm near Penfield" and "Miner at Dougherty's mines near Falls Creek." There are a number of titled and untitled photographs of the market. The fiche and microfilm editions have images of the titled photographs, and NYPL has some prints of the photographs.

### Dance floor at the Carlton Nightclub

Ambridge, January 1941
John Vachon
Titled digital image: fsa 8c18747 :
LC-USF34-062261-D. (P. 109)

*Notes:* One of a series of photographs that Vachon took of steelworkers away from the plant. There are a number of titled and untitled photographs on this subject. The fiche and microfilm editions also have the images, and NYPL has some prints.

### Deer hunter

Huntingdon County, December 1937
Arthur Rothstein
Titled digital image: fsa 8b16881 :
LC-USF34-026101-D. (P. 101)

*Notes:* The image of this photograph also appears in the fiche and microfilm editions, and NYPL has a print.

### Downtown buildings looking east over Walnut and 15th Streets

Philadelphia, Spring 1939
Paul Vanderbilt
Titled digital image: fsa 8d36998 :
LC-USW3-056176-E. (P. 72)

*Notes:* The fiche edition also has a copy of this image.

### Dramatic group, Westmoreland Homesteads

February 1936
Carl Mydans
Titled digital image: fsa 8a00967 :
LC-USF33-000379-M5. (P. 178)

*Notes:* In addition to this titled photograph, there is an untitled image of the same subject. The fiche and microfilm editions have the image of the titled photograph, and NYPL has a print. The fiche edition indicates the place as Mt. Pleasant.

### Employees of the American Bridge Company (United States Steel) waiting for a bus

Ambridge, January 1941
John Vachon
Titled digital image: fsa 8c18758 :
LC-USF34-062272-D. (P. 165)

*Notes:* Another of the series of photographs that Vachon took of steel-town activities. In addition to this titled photograph, there are untitled pho-

tographs of the same subject. The fiche and microfilm editions have an image of the titled photograph, and NYPL has a print. This photograph is related to others with the titles "Employees of American Bridge Company (United States Steel)" and "Steelworker." Information on these photographs is in the online catalog.

### Enos and Herbert Royer and the farmhands having dinner on the farm of Enos Royer. Three of the men are his hired hands, and the rest have come to help fill the silo

Lancaster County, 1938[?]
Sheldon Dick
Titled digital image: fsa 8c02289 :
LC-USF34-040325-D. (P. 123)

*Notes:* Sheldon Dick took a whole series of photographs of Enos Royer and his farm activities. There is one other photograph of this subject with a somewhat shorter title provided by the Library of Congress. The fiche and microfilm editions also have images of the two photographs.

### Exterior of the W. Atlee Burpee seed plant

Philadelphia, April 1943
Arthur Siegel
Titled digital image: fsa 8d16076 :
LC-USW3-022362-D. (P. 71)

*Notes:* Siegel's contributions to the OWI phase of the project included the series of photographs that he took of the inside and outside of this famous seed company, which still

exists. This book features two other photographs of workers inside the plant. The fiche and microfilm editions also have the image.

**Factory workers' homes**

    Coatesville, December 1941

    Arthur Rothstein

    Titled digital image: fsa 8b16234 :

        LC-USF34-024512-D. (P. 57)

*Notes:* This is one example of the many photographs depicting housing conditions—both inside and outside the home—for workers. The "Housing," "Interior of Houses," and "Slums" sections of the *Times of Sorrow and Hope* on-line subject index refer to the numerous photographs on this subject. Both the fiche and microfilm editions have this image.

**The family of John Yenser**

    Mauch Chunk, August 1940

    Jack Delano

    Titled digital image: fsa 8c02893 :

        LC-USF34-041077-D. (P. 89)

*Notes:* Delano was extremely active in Mauch Chunk (now Jim Thorpe), and the Yenser series is one of many series devoted to particular families. The Library of Congress uses "Yenser" and "Yeuser" interchangeably, but the fiche indicates "Yenser." The caption list compiled by Delano as he was working in the field has the name written by hand, and the "n" was interpreted as a "u." Information in the caption list for another photograph in the Yenser family series also has the handwritten name,

and it is spelled out "(Yenser)" underneath. Another photograph in the series has a typed citation for "Yenser" and a handwritten date, "August 21st 1940." The fiche and microfilm editions have this image, and NYPL has a print.

**Farmer in town to shop**

    Manheim, Lancaster County, November 1942

    Marjory Collins

    Titled digital image: fsa 8d10028 :

        LC-USW3-010902-D. (P. 125)

*Notes:* This is one of the many photographs that Collins took in and around Lancaster County. The fiche and microfilm editions also have this image.

**Fishing for salmon on the Susquehanna River at 6 P.M. This man is a state supervisor of highways. In his time off late in the afternoon, he fishes with a bottle of hard cider beside him**

    Lancaster County, November 1942

    Marjory Collins

    Titled digital image: fsa 8d23411 :

        LC-USW3-010989-E. (P. 100)

*Notes:* There are a number of titled and untitled photographs on this subject. The fiche and microfilm editions also have the titled images.

**Flag Day**

    Pittsburgh, June 1941

    John Vachon

    Titled digital image: fsa 8c19359 :

        LC-USF34-062876-D. (P. 189)

*Notes:* This is one of the many photographs that Vachon took in Pittsburgh revolving around the Jones and Laughlin steel plant, which is in the background of this photograph. An image of the photograph is in the fiche and microfilm editions. The NYPL and the Roy Stryker Collection also have prints. Reproduced in *The Years of Bitterness and Pride: Farm Security Administration, FSA Photographs, 1935–1943* (New York: McGraw-Hill, 1975), no. 69.

**FSA trailer camp near the General Electric plant. There are two hundred trailers here, occupied by childless couples and by families of one and two children**

    Erie, June 1941

    John Vachon

    Titled digital image: fsa 8c19262 :

        LC-USF34-062776-D. (P. 78)

*Notes:* Vachon took numerous titled and untitled photographs of this trailer camp, depicting life inside and outside the trailers, including photographs of the GE plant. The photographs in this series have many different variant titles. Images of the titled photographs appear in the fiche and microfilm editions, and NYPL has prints.

**General view of the office at the W. Atlee Burpee Company, seed dealers**

    Philadelphia, April 1943

    Arthur Siegel

Untitled digital image: fsa 8d16067 :
LC-USW3-022353-D. (P. 194)

*Notes:* Arthur Siegel did an extensive survey of the Burpee Company during the war years. There are a number of titled and untitled photographs depicting the interior activities of the company. The photograph chosen for the book is actually one of the untitled photographs, but the title is derived from another LC title (022334-D). Two other Burpee photographs are in this selection of photographs for the book. The fiche and microfilm editions have images of the titled photographs.

### Girls working at the Jones and Laughlin Steel Company going home after a day's work

Aliquippa, January 1941
Jack Delano
Titled digital image: fsa 8c04531 :
LC-USF34-043080-D. (P. 166)

*Notes:* This is one of the many photographs that Delano took in Aliquippa and neighboring areas depicting the life of steelworkers at the Jones and Laughlin Steel Company. The fiche and microfilm editions also have the image. Most of the Aliquippa photographs taken by Delano are dated January 1941 by the Library of Congress, although the Library dates a few as January 1940. Delano took a large number of photographs in the Pittsburgh area, including Aliquippa, that are dated January 1941. As noted above, the January 1940 date could not be correct

(Delano's first FSA assignment was in Virginia in May 1940).

### Gravestone in Bethlehem graveyard

December 1935
Walker Evans
Titled digital image: fsa 8c52891 :
LC-USF342-001160-A. (P. 53)

*Notes:* The fiche title is "Gravestone in a graveyard." The image is also available in the fiche and microfilm editions, with prints in NYPL and the Walker Evans Archive. The NYPL title is "Gravestone, Bethlehem." The Evans Archive indicates the date as November 10, 1935; the fiche edition and the Library of Congress indicate the date as December 1935. Reproduced in *Walker Evans: Photographs for the FSA*, no. 62, as "Gravestone, Bethlehem, November 1935."

### The Greyhound bus station

Gettysburg, September 1943
Esther Bubley
Titled digital image: fsa 8d32782 :
LC-USW3-036955-E. (P. 114)

*Notes:* Bubley's contribution to the OWI project was her extensive photographic essay revolving around the Greyhound Bus Company. The Pennsylvania photographs represent just one part of her journey on the Greyhound bus from Washington, D.C., to Memphis, and her return in September 1943. An essay on her experience appears in *Documenting America, 1935–1943*, ed. Carl

Fleischhauer and Beverly W. Brannan (Berkeley and Los Angeles: University of California Press, 1988), 312–14. There is another titled photograph on this subject, and the fiche and microfilm editions have these images.

### The Greyhound bus station

Harrisburg, July 1940
John Vachon
Titled digital image: fsa 8a06579 :
LC-USF33-001933-M5. (P. 115)

*Notes:* There are other related photographs on this subject, both titled and untitled. The fiche edition has the titled images, and NYPL also has a print.

### Guardian of the community scrap pile, asleep

Lancaster, November 1942
Marjory Collins
Titled digital image: fsa 8d10023 :
LC-USW3-010896-D. (P. 202)

*Notes:* The fiche and microfilm editions also have this image.

### Home-made swimming pool built by steel workers for their children

Pittsburgh, July 1938
Arthur Rothstein
Titled digital image: fsa 8a10004 :
LC-USF33-002839-M4. (P. 110)

*Notes:* Rothstein took extensive photographs in Pittsburgh, including scenes of life inside

and outside the steel mills. There are a number of titled and untitled photographs on this theme. The fiche and microfilm editions have images of the titled photographs, and NYPL has a print of one of them. The fiche title is used here; the Library of Congress title is a variant. Reproduced in *The Depression Years as Photographed by Arthur Rothstein* (New York: Dover, 1978) as "Swimming pool, Pittsburgh, 1938," and in *Long Time Coming: A Photographic Portrait of America, 1935–1943,* by Michael Lesy (New York: Norton, 2002), 95.

### Homemade tractor on the farm of FSA client Dallas E. Glass

Birdsboro vicinity, Berks County, August 1938

Sheldon Dick

Titled digital image: fsa 8c02136 : LC-USF34-040172-D. (P. 130)

*Notes:* This is one of the many photographs that Sheldon Dick took of farming activities and FSA clients. The fiche and microfilm editions also have the image. Titles given in different sources vary slightly.

### Houses and slag heap

Nanty Glo, 1937

Ben Shahn

Titled digital image: fsa 8a17095 : LC-USF33-006225-M4. (P. 55)

*Notes:* The fiche and microfilm editions have the image. A print is in the Harvard collection of Shahn photographs. It is untitled at

Harvard, with a date of October 1935. The Library of Congress dates the photograph 1937. The Harvard and Library of Congress prints are slightly different.

### Houses on "The Hill" slum section

Pittsburgh, July 1938

Arthur Rothstein

Titled digital image: fsa 8a09987 : LC-USF33-002836-M3. (P. 65)

*Notes:* This is one of the many Pittsburgh photographs taken by Rothstein, quite a few of which are related to the steel industry. There are also a number of titled and untitled photographs with this subject. The fiche and microfilm editions have images of the titled photographs, and NYPL has a number of prints. One of the NYPL prints has the title "Pittsburgh."

### Housing conditions in Ambridge, home of the American Bridge Company

July 1938

Arthur Rothstein

Titled digital image: fsa 8b17089 : LC-USF34-026529-D. (P. 64)

*Notes:* A series of photographs on housing in another western Pennsylvania steel town. There are numerous titled and untitled photographs on this subject. The fiche and microfilm editions also have images of these photographs, and NYPL has a number of prints, some of which are incorrectly placed in Aliquippa. The titles vary in different sources,

some of which indicate that these houses are in "slums."

### In curb scrap collection drive, one housewife donated a sewing machine

Lititz, November 1942

Marjory Collins

Titled digital image: fsa 8d23536 : LC-USW3-011293-E. (P. 193)

*Notes:* This photograph is one of many that Collins took in Lititz during the war, and it is an example of wartime activities at home. There is another titled photograph on the same subject. The fiche and microfilm editions have these images.

### Irwin R. Steffy having his car gone over in the Pierson Motor Company garage. He uses it to go into Lancaster every day, where he is doing a defense job at the Armstrong Cork Company; he shares a ride when hours permit. Before the war he worked for nine years for Spachts, the undertaker. Now he serves four hours a week as an airplane spotter at the nearby observation post

Lititz, November 1942

Marjory Collins

Titled digital image: fsa 8d10146 : LC-USW3-011128-D. (P. 196)

*Notes:* This is another of the photographs that Collins took in Lititz showing people at home during the war and what they were doing. There is another titled photograph of this subject. The fiche and microfilm editions

also have the images. One of the versions is reproduced in *Documenting America, 1935–1943,* ed. Carl Fleischhauer and Beverly W. Brannan (Berkeley and Los Angeles: University of California Press, 1988), 263c, with the title "Defense industry worker Irwin R. Steffy, who commutes to Lancaster every day, having his car serviced at the Pierson Motor Company, Lititz, 1942."

**Italian workers from Trenton and nearby areas grading and bunching asparagus in the packing house**
  Starkey Farms, Morrisville, May 1941
  Marion Post Wolcott
  Titled digital image: fsa 8c15015 :
    LC-USF34-057567-D. (P. 122)

*Notes:* There are four titled photographs on this theme. The fiche and microfilm editions also have the images, and NYPL has one of the prints. Titles given in different sources vary slightly.

**Jack Cutter and his family, who have lived in the FSA trailer camp about two weeks. They came from Indiana for a job in the General Electric plant**
  Erie, June 1941
  John Vachon
  Titled digital image: fsa 8c19264 :
    LC-USF34-062778-D. (P. 94)

*Notes:* This is one of a series of photographs that Vachon took of the Cutter family. The fiche and microfilm editions also have the

image, and NYPL has the print. There is a slight variation in the title given in the various sources.

**John L. Lewis, center, at the stadium on the occasion of a district[?] meeting of the mine workers, seen among a crowd of people**
  Shenandoah[?], 1938[?]
  Sheldon Dick
  Titled digital image: fsa 8a33660 :
    LC-USF33-020193-M4. (P. 156)

*Notes:* A series of photographs of the famous union leader. There are numerous titled and untitled photographs. Titles vary for all of the photographs that are part of this series. At least two of the photographs have titles in the fiche edition but are untitled in the Library of Congress.

**Johnstown housing**
  December 1935
  Walker Evans
  Titled digital image: fsa 8c52080 :
    LC-USF342-001159-A. (P. 54)

*Notes:* This photograph appears to be the only one taken in Johnstown. There is also an image in the fiche and microfilm editions. Reproduced in *Walker Evans: Photographs for the FSA,* no. 70, as "View of Johnstown."

**Jones and Laughlin Steel Company on both sides of the river**
  Pittsburgh, June 1941
  John Vachon

Titled digital image: fsa 8c19387 :
    LC-USF34-062906-D. (P. 170)

*Notes:* Vachon took a number of photographs of this steel company. (Jack Delano and Arthur Rothstein also took photographs of the company in other places.) The fiche and microfilm editions have the image.

**Lancaster, February 1942**
  John Vachon
  Titled digital image: fsa 8d12447 :
    LC-USW3-014658-D. (P. 61)

*Notes:* In addition to the titled photograph, there are untitled ones on the same subject. All sources have no title other than the place—"Lancaster, Pennsylvania." The fiche and microfilm editions also have the titled image.

**Legionnaire**
  Bethlehem, November 1935
  Walker Evans
  Titled digital image: fsa 8a19591 :
    LC-USF33-009026-M2. (P. 186)

*Notes:* There is also an untitled photograph on the same subject. Evans took a number of other photographs related to this subject, one of which is reproduced in this book—"Sons of American Legion." See the on-line catalog for information on "[Women's auxiliary members and sons of American Legion]." The fiche and microfilm editions have the titled image, and the Roy Stryker Collection has a print. Reproduced in *Walker Evans: Photographs for*

*the* FSA, no. 65; Tod Papageorge, *Walker Evans and Robert Frank: An Essay on Influence,* catalog of an exhibition held at the Yale University Art Gallery, January 21–March 15, 1981 ([New Haven]: Yale University Art Gallery, 1981), no. 28; and *Walker Evans at Work,* 115.

**Little boy in Conway**

> January 1941
> Jack Delano
> Titled digital image: fsa 8c04652 :
>     LC-USF34-043200-D. (P. 45)

*Notes:* A related untitled photograph reproduces the same scene without the "little boy" in it. The Library of Congress indicates the date as January 1940, as it does for another Conway photograph. Delano took a large number of photographs in various places in western Pennsylvania around Pittsburgh, of which Conway is one. These photographs are dated January 1941. As noted above, the January 1940 date could not be correct (Delano's first FSA assignment was in Virginia in May 1940). The fiche and microfilm editions have the titled image, and NYPL has a print.

**Lloyd Kramer farm**

> Farmersville, Northampton farm site,
>     November 1936
> Carl Mydans
> Titled digital image: fsa 8a02815 :
>     LC-USF33-000896-M2. (P. 121)

*Notes:* Mydans took a number of photographs of different farm families in different areas.

There are titled and untitled photographs in this series. The fiche edition also has images of the titled photographs; the Library of Congress only has a digital image for the photograph chosen for the book. NYPL has prints for two of the photographs. Titles given in different sources vary slightly.

**Long stairway in the mill district of Pittsburgh**

> January 1941
> Jack Delano
> Titled digital image: fsa 8c29017 :
>     LC-USF34-043202-D. (P. 59)

*Notes:* There is another titled version of this subject, called "In a working-class section of Pittsburgh." The fiche title for this other version is "A working-class section, Pittsburgh." There are also some untitled photographs. The fiche and microfilm editions have the titled images, and NYPL and the Roy Stryker Collection also have prints. Titles vary. This version is reproduced in *The Years of Bitterness and Pride,* no. 75, and in *Portrait of a Decade: Roy Stryker and the Development of Documentary Photography in the Thirties,* by F. Jack Hurley (Baton Rouge: Louisiana State University Press, 1972), 151, as "Pittsburgh." Another version of the image is cited in *Just Before the War: Urban America from 1935 to 1941 as Seen by Photographers of the Farm Security Administration,* intro. Thomas H. Garver, catalog of an exhibition held at the Newport Harbor [Calif.] Art Museum, September 30–November 10, 1968, and the

Library of Congress, February 14–March 30, 1969 (New York: October House, 1968), but no photograph appears in that book. Delano's Pittsburgh photographs are dated by the Library of Congress as either January 1940 or January 1941. He took many photographs in Pittsburgh and the surrounding area in January 1941. As noted above, the January 1940 date could not be correct (Delano's first FSA assignment was in Virginia in May 1940).

**Man gathering good coal from the slag heaps at Nanty Glo**

> 1937
> Ben Shahn
> Titled digital image: fsa 8a17114 :
>     LC-USF33- 006229-M2. (P. 145)

*Notes:* Another of Shahn's photographs on this general theme. There are three others reproduced in the book, and the on-line catalog indicates a number of others. In addition to the titled photographs, there is an untitled one. The fiche and microfilm editions have images of the titled photograph. There is no indication that prints of this photograph are in the Shahn Archive at Harvard. Reproduced in *The Photographic Eye of Ben Shahn,* ed. Davis Pratt (Cambridge: Harvard University Press, 1975), 89, as "Man collecting coal from slag heap," and in *Long Time Coming,* 266.

**Members of the picket line at the King Farm strike**

> Morrisville, August 1938
> John Vachon

Titled digital image: fsa 8b29420 :
LC-USF34-008550-D. (P. 43)

*Notes:* Vachon took a series of photographs on this farm strike. Of all the FSA photographs in Pennsylvania, this appears to be the only depiction of a labor strike. The fiche and microfilm editions have images of this photograph.

## A Mennonite and his wife at a public sale

Lititz, November 1942
Marjory Collins
Titled digital image: fsa 8d23562 :
LC-USW3-011704-E. (P. 134)

*Notes:* Collins took several photographs of the Mennonites. There is another view of the same subject reproduced in *In This Proud Land: America, 1935–1943, as Seen in the FSA Photographs,* by Roy Emerson Stryker and Nancy Wood (New York: Galahad Books, 1973), no. 45. The fiche and microfilm editions also have the images.

## Mennonite boy

Lancaster, March 1942
John Collier
Titled digital image: fsa 8c34004 :
LC-USF34-082449-E. (P. 137)

*Notes:* Collier took photographs of the Amish and Mennonites. There is also an untitled photograph of this subject. The fiche and microfilm editions have the titled image, and NYPL has a print of the titled photograph.

## Mennonite farmer going to town near Lancaster

May[?] 1941
Marion Post Wolcott
Titled digital image: fsa 8a40908 :
LC-USF33-030531-M1. (P. 133)

*Notes:* There is another view with this title. One of the photographs in the fiche edition has the same title, but it depicts another subject; the fiche edition also has the image for this subject, however. The microfilm edition has an image for this photograph as well. The Library of Congress indicates the date as May 1941[?]. Other sources indicate June 1939. There are a number of date discrepancies in different sources. There might even be some question as to whether Wolcott was taking many of the Pennsylvania photographs in June 1939, as there is some evidence that she was in the South in July 1939.

## Mennonite farmers at auction

Lancaster County, March 1942
John Collier
Titled digital image: fsa 8c33939 :
LC-USF34-082264-E. (P. 138)

*Notes:* There is another photograph with this title. The fiche and microfilm editions have the images, and NYPL has a print of one of the titled photographs.

## Mennonite girls waiting for "Deutsch School" to begin in Mennonite church

Hinkletown vicinity, March 1942
John Collier

Titled digital image: fsa 8c33960 :
LC-USF34-082403-E. (P. 135)

*Notes:* Collier took a series of photographs dealing with the "Deutsch School." The spelling is used interchangeably in some sources with "Deutch," but the Library of Congress uses "Deutsch," and that is the preferred form. Titles given in different sources vary. There are also other titled and untitled photographs with this subject. Both the fiche and microfilm editions have images of the titled photographs, and NYPL has prints of the titled photographs.

## Mennonite woman waiting for a bus on a rainy market day

Lancaster, November 1942
Marjory Collins
Titled digital image: fsa 8d23395 :
LC-USW3-010973-E. (P. 140)

*Notes:* The fiche and microfilm editions also have this image.

## Migrant workers hired as strikebreakers after the strike at the King Farm near Morrisville

August 1938
John Vachon
Titled digital image: fsa 8b14033 :
LC-USF34-008577-D. (P. 127)

*Notes:* Vachon took a series of photographs on this labor dispute. The fiche and microfilm editions also have this image. The caption list compiled by Vachon indicates another

photograph with the same title, but this image was not seen in the Library of Congress collection or in the fiche or microfilm editions. There is a slight variation in title.

## Miner and mule at the American Radiator Company Mine

> Mount Pleasant, Westmoreland County,
> February 1936
> Carl Mydans
> Titled digital image: fsa 8a00917 :
> LC-USF33-000364-M5. (P. 146)

*Notes:* Mydans took a series of photographs of the mine and miners of the American Radiator Company Mine. There is also an untitled photograph of the same subject. The fiche edition has the image of the titled photograph. Titles vary slightly.

## Miner at Dougherty's mines near Falls Creek

> August 1940
> Jack Delano
> Titled digital image: fsa 8c03091 :
> LC-USF34-041332-D. (P. 149)

*Notes:* Some farmers had their own coal mines on their farms. This is one example. (Delano took a number of photographs on this subject; another in this book is the photograph of Mr. Merritt Bundy.) There is another titled photograph of this subject. The fiche and microfilm editions also have images, and NYPL has a print of one of the photographs.

## Miners about to go below at the American Radiator Company Mine

> Mount Pleasant, Westmoreland County,
> February 1936
> Carl Mydans
> Titled digital image: fsa 8a00948 :
> LC-USF33-000375-M5. (P. 147)

*Notes:* There is also an untitled photograph of the same subject. The fiche edition has the image of the titled photograph. Titles vary.

## Miss Frances Heisler, a garage attendant at one of the Atlantic Refining Company garages. She was formerly a clerk in the payroll department of the Curtis Publishing Company

> Philadelphia, June 1943
> Jack Delano
> Titled digital image: fsa 8d31077 :
> LC-USW3-032930-E. (P. 201)

*Notes:* Delano and other photographers took a series of photographs on the role of women at home during the war years. There are titled and untitled photographs on this subject. The fiche and microfilm editions have images of some of the titled photographs.

## Mollie Day and children

> Bedford County, December 1937
> Arthur Rothstein
> Titled digital image: fsa 8b16889 :
> LC-USF34-026114-D. (P. 87)

*Notes:* Mollie Day lived on submarginal farmland. Rothstein took some photographs of her and her family. The fiche and microfilm editions have this image.

## Montour no. 4 mine of the Pittsburgh Coal Company. A trip of coal bound for the surface

> Pittsburgh vicinity, November 1942
> John Collier
> Titled digital image: fsa 8d09535 :
> LC-USW3-010231-C. (P. 155)

*Notes:* Collier created a major series of photographs of the Montour no. 4 mine. Photographs depict life inside and outside the mine as well as the area around the mine. There are also photographs of miners and their families at home. There are well more than two hundred titled and untitled photographs in this series, six of which are included in this book. Information on all of the Montour photographs can be found in the on-line catalog. The fiche and microfilm editions also have this image.

## Montour no. 4 mine of the Pittsburgh Coal Company. "Bean hole" where the miners gather to eat lunch

> Pittsburgh vicinity, November 1942
> John Collier
> Titled digital image: fsa 8d09853 :
> LC-USW3-010724-C. (P. 154)

*Notes:* There are numerous titled and untitled versions of the "bean hole" photographs. The fiche and microfilm editions have images, and the Roy Stryker Collection has prints. Titles vary.

**Montour no. 4 mine of the Pittsburgh Coal Company. Miners coming off shift**

Pittsburgh vicinity, November 1942

John Collier

Titled digital image: fsa 8d11028 : LC-USW3-012191-C. (P. 152)

*Notes:* There are numerous titled and untitled photographs on this subject. Variant titles are "Change of shift(s)" and "Miners meeting at change of shift." The fiche edition has the titled images, and the microfilm also has some of the images.

**Montour no. 4 mine of the Pittsburgh Coal Company. Miners waiting to go underground**

Pittsburgh vicinity, November 1942

John Collier

Titled digital image: fsa 8d23675 : LC-USW3-012268-E. (P. 148)

*Notes:* One of the miners in this photograph is also in the titled and untitled photographs 012266-E and 012267-E. Information on those photographs is in the on-line catalog. The fiche and microfilm editions also have this image.

**Montour no. 4 mine of the Pittsburgh Coal Company. Slag pile beneath company village**

Pittsburgh vicinity, November 1942

John Collier

Titled digital image: fsa 8d10630 : LC-USW3-011690-C. (P. 143)

*Notes:* Another view of the area around Montour can be found in "Above the coal seam, dairy and farmlands lay undisturbed. Only occasionally there will be 'sinks' and large 'pot holes' caused by the collapsing of 'mined out' areas of the seam." Information on that photograph is in the on-line catalog. The fiche edition also has the image.

**Montour no. 4 mine of the Pittsburgh Coal Company. Waiting for the noon shift**

Pittsburgh vicinity, November 1942

John Collier

Titled digital image: fsa 8d23670 : LC-USW3-012263-E. (P. 153)

*Notes:* There is also an untitled photograph on this subject. The fiche and microfilm editions have the image.

**Mother and daughter**

Upper Mauch Chunk, August 1940

Jack Delano

Titled digital image: fsa 8c28733 : LC-USF34-041116-E. (P. 83)

*Notes:* Not seen on fiche. NYPL has a print. There is also another photograph, "Woman in Upper Mauch Chunk," that is a view of this mother with another daughter.

**Mr. and Mrs. Benjamin Lutz, unmarried son Henry, and granddaughter Roberta Jean at home. Benny is a butcher; he also writes hymns and patriotic songs**

Lititz, November 1942

Marjory Collins

Titled digital image: fsa 8d10698 : LC-USW3-011823-D. (P. 90)

*Notes:* Collins took a series of photographs of the Lutz family. The fiche and microfilm editions also have this image.

**Mr. Merritt Bundy of the Tri-County Farmers Co-op Market at Du Bois at the entrance to his mine on his farm near Penfield**

August 1940

Jack Delano

Titled digital image: fsa 8c03053 : LC-USF34-041294-D. (P. 151)

*Notes:* The fiche and microfilm editions have this image, and NYPL and the Roy Stryker Collection also have a print. Reproduced in *In This Proud Land*, no. 59, as "Coal miner, near Penfield."

**Mrs. Bernice Stevens of Braddock, mother of one child, employed in the engine house of the Pennsylvania Railroad, earns fifty-eight cents per hour. She is cleaning a locomotive with a high-pressure nozzle. Mrs. Stevens' husband is in the U.S. Army**

Pitcairn, June 1943

Marjory Collins

Titled digital image: fsa 8d30409 : LC-USW3-030577-E. (P. 199)

*Notes:* Collins took a series of photographs of women at work during the war years. There are other titled photographs of this subject. The fiche and microfilm editions also have these images.

**Mrs. Julian Bachman at home with her family. Her brother is sixteen and in high school. She is twenty-three years old and has been married a year. Her husband is in Officers' Candidate School of the U.S. Army Air Corps in Kentucky, so she is living at home and works at the Animal Trap Company from 7 to 4. She spends her evenings writing him daily letters**

Lititz, November 1942

Marjory Collins

Titled digital image: fsa 8d10689 :
LC-USW3-011813-D. (P. 197)

*Notes:* Collins took a series of photographs of Mrs. Bachman. This caption is based on information provided for this photograph and for other photographs of her. There is also an untitled photograph of this subject. The fiche and microfilm editions have an image.

**Mrs. Lois Micheltree, thirty-six, is employed as a laborer at the Pennsylvania Railroad lumber yard, earning fifty-five cents per hour. She helps load and unload lumber from cars. Mrs. Micheltree has a son in the U.S. Navy**

Pitcairn, May 1943

Marjory Collins

Titled digital image: fsa 8d30171 :
LC-USW3-030038-E. (P. 200)

*Notes:* There are another titled and a number of untitled photographs of this subject. The fiche and microfilm editions have images of the titled photographs.

**Mrs. Paul Minnich in her living room on the farm of her father-in-law, C. F. Minnich**

Lititz vicinity, Lancaster County, August 1938

Sheldon Dick

Titled digital image: fsa 8c02118 :
LC-USF34-040154-D. (P. 88)

*Notes:* Sheldon Dick took a series of photographs of the Minnich family and farm. This photograph is cited in *Just Before the War*, no. 9, but no photograph appears in that book. The fiche and microfilm editions have the image.

**Mrs. Van Horn and her mother (85 years old)—two generations of Strohls—at the Strohl family reunion in Flagstaff Park**

Mauch Chunk, August 1940

Jack Delano

Titled digital image: fsa 8c28809 :
LC-USF34-041387-E. (P. 99)

*Notes:* Delano took a series of photographs of the Strohl family and their reunion. The age of Mrs. Van Horn's mother, who is not named in any of the photographs, is taken from information in another photograph of her. She is identified there as the oldest member of the Strohl family. The fiche and microfilm editions also have the image.

**Negro church in the mill district of Pittsburgh**

January 1941

Jack Delano

Titled digital image: fsa 8c04612 :
LC-USF34-043160-D. (P. 67)

*Notes:* There are also untitled photographs of the same subject. The fiche and microfilm editions have the image. The Library of Congress incorrectly dates the photograph as January 1940; it should be January 1941. (Other Pittsburgh photographs by Delano are dated January 1941, and Delano did not start working for the FSA until May 1940, as noted above.)

**Newsboy at Center Square on a rainy market day**

Lancaster, November 1942

Marjory Collins

Titled digital image: fsa 8d23376 :
LC-USW3-010954-E. (P. 50)

*Notes:* Title taken from fiche edition. The caption list also indicates "Newsboy." The Library of Congress indicates "Newsman," but the subject is a boy, not a man. Reproduced in *In This Proud Land*, no. 49, as "Lancaster, Pennsylvania, 1942," and in *Long Time Coming*, 461. The fiche and microfilm editions also have the image.

**Newsstand on South Broad Street**

Philadelphia, Spring 1939

Paul Vanderbilt

Titled digital image: fsa 8d37044 :
LC-USW3-056221-E. (P. 73)

*Notes:* Vanderbilt was responsible for organizing the FSA-OWI collection into a subject

arrangement, and he took a number of photographs of Philadelphia. The fiche edition also has the image.

### "Old age" near Washington

July 1936

Dorothea Lange

Titled digital images: fsa 8b29741 : LC-USF34-009679-C; fsa 8b29742 : LC-USF34-009681-C. (Pp. 84, 85)

*Notes:* These two photographs appear to be the only ones taken by Lange in Pennsylvania. The print in NYPL provides some interesting information for one of the prints: "'Old Age'—before Social Security Law was passed, coal country, near Washington. Photo by Lange." These annotations appear to be partly in Lange's hand (e.g., "before Social Security Law was passed"). A further handwritten note says, "there is another negative of same subject—better rendering. D. L." The fiche edition also has images of the two photographs.

### On a street in Upper Mauch Chunk

August 1940

Jack Delano

Titled digital image: fsa 8c28738 : LC-USF34-041121-E. (P. 79)

*Notes:* There are a number of titled and untitled photographs on this subject. The fiche and microfilm editions also have images of the titled photographs, and NYPL has prints for two of the titled photographs. The title varies in different sources.

### The owner of the Spring Run Farm and his wife

Dresher, July 1944

Pauline Ehrlich

Titled digital image: fsa 8d35962 : LC-USW3-053712-E. (P. 131)

*Notes:* Pauline Ehrlich's only Pennsylvania photographs are her series on the Spring Run Farm in Dresher. The fiche and microfilm editions have the image with the title "A farm owner of the Spring Run Farm and his wife."

### Part of the Valentine family at dinner

Bedford County, December 1937

Arthur Rothstein

Titled digital image: fsa 8b16887 : LC-USF34-026112-D. (P. 86)

*Notes:* Rothstein took photographs of the Valentine and Day families in Bedford County. The fiche and microfilm editions have the image, and NYPL has a print.

### Passengers in the waiting room of the Greyhound bus terminal

Pittsburgh, September 1943

Esther Bubley

Titled digital images: fsa 8d32877 : LC-USW3-037150-E; fsa 8d32838 : LC-USW3-037111-E. (Pp. 118, 119)

*Notes:* The numerous titled and untitled photographs on this theme are representations of different people in the Greyhound terminal. The fiche and microfilm editions also have these images.

### Passengers on a Greyhound bus going from Washington, D.C., to Pittsburgh

September 1943

Esther Bubley

Titled digital image: fsa 8d32796 : LC-USW3-036969-E. (P. 116)

*Notes:* There are a number of titled photographs on this topic, though the titles vary. The fiche and microfilm editions have the images.

### Pittsburgh, August 1941

Marion Post Wolcott

Titled digital image: fsa 8c15203 : LC-USF34-057831-D. (P. 60)

*Notes:* Wolcott took a number of titled and untitled photographs of Pittsburgh. The fiche edition also has images of the titled photographs, and NYPL has some of the prints.

### Pittsburgh, January 1941

John Vachon

Titled digital image: fsa 8c18906 : LC-USF34-062421-D. (P. 56)

*Notes:* Vachon took many titled and untitled photographs in Pittsburgh. The fiche and microfilm editions have these images, and NYPL has some prints. The Roy Stryker Collection has one print. Titles vary.

### Polish family living on High Street

Mauch Chunk, August 1940

Jack Delano

Titled digital image: fsa 8c28740 : LC-USF34-041124-E. (P. 91)

*Notes:* Delano took numerous photographs in Mauch Chunk. This particular photograph has been reproduced in *In This Proud Land,* no. 23, and in *Just Before the War,* no. 8, with the title "Polish family." The woman in the photograph is the same person in the photograph titled "Polish woman living on High Street." The fiche and microfilm editions have the image for "Polish family," and NYPL has the print.

**Practicing for the fair held on the U.S. Resettlement Administration's Subsistence Homestead Project**

Greensburg vicinity, Westmoreland Homesteads, 1937
Ben Shahn
Titled digital image: fsa 8a17492 : LC-USF33-006363-M4. (P. 180)

*Notes:* Shahn was one of a group of FSA photographers who took photographs of the Westmoreland Homesteads. There are titled and untitled photographs of this subject. The fiche and microfilm editions have the titled images; here, the fiche title is used. The Shahn Archive at Harvard has one print, as does the Roy Stryker Collection. The title varies. The Library of Congress title is "Practicing for the Westmoreland Fair." One of the photographs is reproduced in *Photographic Eye of Ben Shahn,* 99, with the title "Practicing for the Westmoreland Fair."

**Proprietor of a Greek coffee shop**

Aliquippa, July 1938
Arthur Rothstein
Titled digital image: fsa 8a09924 : LC-USF33-002823-M1. (P. 77)

*Notes:* Rothstein took many photographs in Aliquippa. The fiche and microfilm editions also have the image, and NYPL has a print. This is the same proprietor who is in "Steelworkers talking to the proprietor of a coffee shop whose name dedicates it to 'Liberty.'" Reproduced in *Long Time Coming,* 91.

**Prospective homesteaders in front of the post office at United, Westmoreland County**

October 1935
Ben Shahn
Titled digital image: fsa 8a16072 : LC-USF33-006003-M1. (P. 181)

*Notes:* The fiche and microfilm editions have images, and the Shahn Archive at Harvard and NYPL have prints. The Library of Congress title is used here. The fiche title is "Prospective homesteaders for the Westmoreland Subsistence Homesteads of the U.S. Resettlement Administration, in front of the post office, United, Westmoreland County." NYPL has a print that is indicated as untitled in the Library of Congress, but NYPL has the title "Post office in mining town."

**A public auction at a farm near York**

June 1939
Marion Post Wolcott

Titled digital image: fsa 8c10465 : LC-USF34-051984-D. (P. 128)

*Notes:* Wolcott took a series of photographs on auctions in the country. The fiche and microfilm editions have this image. Titles vary.

**Quack doctor's office**

Pittsburgh, May 1938
Arthur Rothstein
Titled digital image: fsa 8a09811 : LC-USF33-002797-M2. (P. 76)

*Notes:* The fiche title is used here. The Library of Congress title is "Quack doctor." The fiche and microfilm editions have this image.

**Rain**

Pittsburgh, June 1941
John Vachon
Titled digital image: fsa 8c19363 : LC-USF34-062880-D. (P. 58)

*Notes:* There are titled and untitled photographs with this subject. The fiche and microfilm editions have images; NYPL and the Roy Stryker Collection have one print. Reproduced in *People and Places of America: Farm Security Administration Photography of the 1930s,* an exhibition organized by Richard Kubiak and held at the Santa Barbara [Calif.] Museum of Art, October 15–November 20, 1977. Cited in *Just Before the War,* no. 27, but no photograph appears in that book.

**Row houses**

Philadelphia, October 1941
John Vachon

Titled digital image: fsa 8c20581 :
LC-USF34-064150-D. (P. 70)

*Notes:* Vachon took numerous photographs of this subject. The fiche and microfilm editions have images, and NYPL has prints. Titles vary.

**Saying grace before carving the turkey at Thanksgiving dinner in the home of Earle Landis**

Neffsville, November 1942
Marjory Collins
Titled digital image: fsa 8d10749 :
LC-USW3-011874-D. (P. 95)

*Notes:* Collins took a series of photographs of the Landis family, of which this is one. The fiche and microfilm editions also have this image.

**Scene in the alley on the east side of town**

Ambridge, July 1938
Arthur Rothstein
Titled digital image: fsa 8a10018 :
LC-USF33-002842-M3. (P. 74)

*Notes:* Rothstein took a series of photographs in Ambridge. There are also untitled photographs on this subject. The fiche and microfilm editions have the titled image.

**School child waiting for a bus in the rain**

Lancaster, November 1942
Marjory Collins
Titled digital image: fsa 8d23393 :
LC-USW3-010971-E. (P. 48)

*Notes:* In addition to her extensive work in Lititz, Collins took photographs in Lancaster

and the surrounding area. The fiche and microfilm editions have this image as well.

**The second shaft tower at Maple Hill Mine as seen from the first tower**

Shenandoah vicinity, 1938[?]
Sheldon Dick
Titled digital image: fsa 8c28687 :
LC-USF34-040381-D. (P. 157)

*Notes:* Sheldon Dick took a number of photographs of the Maple Hill mine. There is another titled photograph on this subject. The fiche and microfilm editions also have the titled images. Titles vary slightly.

**Sick child**

Aliquippa, January 1941
John Vachon
Titled digital image: fsa 8c18649 :
LC-USF34-062164-D. (P. 40)

*Notes:* Vachon took a number of photographs of housing conditions in Aliquippa. The fiche and microfilm editions also have this image. Reproduced in *Documenting America*, no. 10. Cited in *FSA: The Illiterate Eye: Photographs from the Farm Security Administration*, by Maurice Berger, catalog of an exhibition held at Hunter College Art Gallery, New York, November 26, 1985–January 10, 1986 (New York: Hunter College Art Gallery, 1985), but no photograph appears in that book.

**Some men and a woman at Filipek's Bar**

Shenandoah, 1938[?]
Sheldon Dick

Titled digital image: fsa 8c28684 :
LC-USF34-040376-D. (P. 107)

*Notes:* In addition to taking other photographs of life in Shenandoah, Sheldon Dick took some photographs of activities in Filipek's Bar. The fiche and microfilm editions also have this image.

**Sons of American Legion**

Bethlehem, November 1935
Walker Evans
Titled digital image: fsa 8a19592 :
LC-USF33-009026-M3. (P. 187)

*Notes:* The fiche and microfilm editions have this image. The titles given in different sources vary: "Sons of American Legionnaires" and "Legionnaire's Children." The Library of Congress image and fiche image are slightly different. Reproduced in *Walker Evans: Photographs for the FSA*, no. 66, and *Walker Evans and Robert Frank*, no. 30.

**Spectators and theatre at Labor Day parade in Du Bois**

September 1940
Jack Delano
Titled digital image: fsa 8c02980 :
LC-USF34-041221-D. (P. 191)

*Notes:* The Library of Congress title is used here. The fiche title is "Spectators at a Labor Day parade, theater in the background." Cited in *Just Before the War* as "Spectators at a Labor Day parade, movie theatre in the background," but no photograph in catalog. The fiche and microfilm editions have this image.

**Steelworker**

Midland, July 1938

Arthur Rothstein

Titled digital image: fsa 8b36386 :
   LC-USF34-026510-D. (P. 164)

*Notes:* This is one of many portraits of steelworkers by Rothstein. The fiche and microfilm editions have these images. The Library of Congress also gives the title to two additional photographs, but they depict more than one steelworker. Titles vary.

**Steel worker's children**

Midland, July 1938

Arthur Rothstein

Titled digital image: fsa 8b17084 :
   LC-USF34-026524-D. (P. 39)

*Notes:* This is one of a series of photographs taken by Rothstein on the living conditions of steelworkers and their families. The fiche and microfilm editions have this image; NYPL has the print. The LC title is used here.

**Steelworkers in a Greek restaurant**

Aliquippa, January 1941

Jack Delano

Titled digital image: fsa 8c04556 :
   LC-USF34-043105-D. (P. 108)

*Notes:* Delano took a series of photographs of life revolving around the Jones and Laughlin steel plant, including depictions of ethnic clubs and restaurants. (Delano and John Vachon were taking photographs in the same places simultaneously.) The fiche and microfilm editions also have this image, and NYPL has the print. Most of the Aliquippa photographs taken by Delano are dated January 1941 by the Library of Congress, but the Library dates a few of them as January 1940. Delano took a large number of photographs in the Pittsburgh area, including Aliquippa, dated January 1941. As noted above, the January 1940 date could not be correct (Delano's first FSA assignment was in Virginia in May 1940).

**Steelworkers' sons**

Aliquippa, January 1941

John Vachon

Titled digital image: fsa 8c18668 :
   LC-USF34-062183-D. (P. 44)

*Notes:* Vachon took a series of photographs revolving around the Jones and Laughlin steel plant. (Vachon and Jack Delano were taking photographs in the same places simultaneously.) There are titled and untitled photographs of this subject. The fiche and microfilm editions have the titled photographs, and NYPL has one of the prints.

**Street in the important anthracite town of Coaldale, showing the huge coal bank in the background**

August 1940

Jack Delano

Titled digital image: fsa 8c52712 :
   LC-USF342-041413-A. (P. 80)

*Notes:* There is also one untitled photograph of this subject, and one other photograph taken in Coaldale with the coal bank (or slag pile) in the background. Other photographers in the project took similar photographs. The fiche and microfilm editions have the image of the titled photograph, and NYPL also has a print. The Library of Congress indicates the date as September 1940, but all the other sources indicate August 1940 (including the dates of the other two photographs taken in Coaldale).

**Street scene**

Aliquippa, July 1938

Arthur Rothstein

Titled digital image: fsa 8a09963 :
   LC-USF33-002831-M1. (P. 75)

*Notes:* Rothstein took a series of photographs revolving around the plant and workers of the Jones and Laughlin company. The fiche and microfilm editions also have this image, and NYPL has a print.

**Sunday morning**

Pittsburgh, January 1941

John Vachon

Titled digital image: fsa 8c18886 :
   LC-USF34-062402-D. (P. 68)

*Notes:* Vachon took a number of photographs of churchgoers on a Sunday morning in Pittsburgh. There are titled and untitled photographs on this subject. Some other versions have the title "Going to church to attend mass." The fiche and microfilm editions have this image, and NYPL has a print.

**Swimming hole**

Pine Grove Mills, July 1941

Edwin Rosskam

Titled digital image: fsa 8a15996 :
LC-USF33-005214-M4. (P. 105)

*Notes:* Rosskam took a number of photographs depicting children engaged in various sports and recreational activities in central Pennsylvania. There are titled and untitled photographs with this subject. The fiche and microfilm editions have the titled images, and NYPL also has some of the prints, one of which has the title "Old swimming hole."

**Thomas Evans, an FSA client, giving a violin lesson to one of the neighbor's boys**

Barto, Berks County, August 1938

Sheldon Dick

Titled digital image: fsa 8c02175 :
LC-USF34-040211-D. (P. 102)

*Notes:* Sheldon Dick took a series of photographs of the Thomas Evans family and farm. There is also one untitled photograph with this subject. The fiche and microfilm editions have the titled image.

**Tourist and his wife looking at the view**

Allegheny Mountains, June 1939

Arthur Rothstein

Titled digital image: fsa 8a11018 :
LC-USF33-003057-M1. (P. 106)

*Notes:* There is another version with the title "A tourist stop, Lookout Point." The fiche edition also has the image, and NYPL has the print.

**Twins Amy and Mary Rose Lindich, twenty-one, are employed at the Pennsylvania Railroad as car repairmen helpers, earning seventy-two cents per hour. They reside in Jeanette and carpool with fellow workers**

Pitcairn, May 1943

Marjory Collins

Titled digital image: fsa 8d30160 :
LC-USW3-030027-E. (P. 198)

*Notes:* Collins took a series of photographs of women working for the Pennsylvania Railroad during the war. The fiche and microfilm editions also have this image. Titles vary slightly.

**Unemployed steelworker and his wife**

Ambridge, January 1941

John Vachon

Titled digital image: fsa 8c18613 :
LC-USF34-062126-D. (P. 163)

*Notes:* Vachon took a series of photographs on the lives of steelworkers. There is another photograph with this title. The fiche and microfilm editions have these titled images, and NYPL has a print of one of the photographs. Titles vary slightly.

**Union member distributing "Steel Labor" near the entrance to the Jones and Laughlin Steel Corporation**

Aliquippa, January 1941

Jack Delano

Titled digital image: fsa 8c04518 :
LC-USF34-043067-D. (P. 162)

*Notes:* There is another titled (and one untitled) photograph on this subject. The fiche and microfilm editions have images of the titled photographs, and NYPL also has prints of the two photographs. The titles given in different sources vary slightly. Most of the Aliquippa photographs taken by Delano are dated January 1941 by the Library of Congress, although the Library dates a few of them as January 1940. Delano took a large number of photographs in the Pittsburgh area, including Aliquippa, that are dated January 1941. As noted above, the January 1940 date could not be correct (Delano's first FSA assignment was in Virginia in May 1940).

**View of Westmoreland Homesteads**

September 1936

Arthur Rothstein

Titled digital image: fsa 8b28318 :
LC-USF34-005456-D. (P. 176)

*Notes:* There are a number of titled photographs that Rothstein took on this subject. The titles given in different sources vary. The fiche and microfilm editions also have images.

**Waiting for a bus at the Greyhound bus terminal**

Pittsburgh, September 1943

Esther Bubley

Titled digital image: fsa 8d32825 :
LC-USW3-037098-E. (P. 47)

*Notes:* Like "Passengers in the waiting room of the Greyhound bus terminal," this is a

photograph of activities in the Greyhound station. (There is yet another titled photograph on this subject as well.) The fiche edition has the image for one of the titled photographs, and the microfilm edition has images for both titled photographs.

**Westland coal mine. "Mantrip" going into a "drift mine"**

Pittsburgh vicinity, November 1942

John Collier

Titled digital image: fsa 8d11042 :
LC-USW3-012207-C. (P. 150)

*Notes:* In addition to the Montour no. 4 mine series, Collier also took a number of photographs of the Westland coal mine. The are a number of titled and untitled photographs on this subject. Variant titles of the same subject are "Enroute to work"; "'Mantrip' enroute to the mine"; and "Miners in 'Mine Trip' enroute to the mine." ("Mine trip" here may be a typographical error for "mantrip.") The fiche and microfilm editions also have images of the titled photographs.

**Westmoreland Project**

July 1935

Walker Evans

Titled digital image: fsa 8c52043 :
LC-USF342-000864-A. (P. 177)

*Notes:* Evans and some of the other FSA photographers took photographs of the Westmoreland Project. There is another titled and two untitled photographs on this subject. The

fiche and microfilm editions have images of the titled photographs, and NYPL also has prints of some of the photographs. Variant titles from different sources are "View of Westmoreland project," "A Subsistence Homestead Project of the U.S. Resettlement Administration, Greensburg (vicinity)," "Westmoreland Homesteads," and "View of some of the homesteads, Westmoreland Homesteads." These photographs are not included in the standard work on Evans's accomplishments with the FSA (*Walker Evans: Photographs for the FSA*).

**Wife of steelworker**

Pittsburgh, July 1938

Arthur Rothstein

Titled digital image: fsa 8a09890 :
LC-USF33-002816-M2. (P. 93)

*Notes:* Rothstein took a series of photographs on steel and life in Pittsburgh. There are titled and untitled photographs on this subject. The fiche and microfilm editions have images of the titled photographs. Titles vary slightly.

**Window in home of an unemployed steelworker**

Ambridge, January 1941

John Vachon

Titled digital image: fsa 8c18643 :
LC-USF34-062158-D. (P. 63)

*Notes:* Vachon took a series of photographs on steel and life in Ambridge. The fiche and microfilm editions also have this image. Titles vary slightly.

**Woman and child picking coal from a slag heap. They are paid ten cents for each 100-pound sack**

Nanty Glo, 1937

Ben Shahn

Titled digital image: fsa 8a17117 :
LC-USF33-006229-M5. (P. 144)

*Notes:* Shahn took a series of dramatic photographs on the lives of people in the coal regions during the Depression. This is one of them. A few others are reproduced for the book. In addition to this one titled photograph, there are also some untitled photographs. The fiche and microfilm editions have the image of the titled photograph. Titles vary slightly.

**Women checking filled orders at the W. Atlee Burpee Company, seed dealers**

Philadelphia, April 1943

Arthur Siegel

Titled digital image: fsa 8d16119 :
LC-USW3-022404-D. (P. 195)

*Notes:* Siegel's exclusive contribution to the OWI was his series of photographs of the W. Atlee Burpee Company, which still exists. The fiche and microfilm editions have an image of this title.

**Women in Upper Mauch Chunk**

August 1940

Jack Delano

Titled digital image: fsa 8c28731 :
LC-USF34-041114-E. (P. 92)

*Notes:* Delano took a series of many Mauch Chunk photographs. The fiche and microfilm editions also have the image, and NYPL has the print. The titles given in the Library of Congress collection and the fiche edition vary slightly.

**Workers' houses near the Pittsburgh Crucible Steel Company**
Midland, January 1941
Jack Delano
Titled digital image: fsa 8c04464 :
    LC-USF34-043014-D. (P. 62)

*Notes:* Delano and the other photographers taking photographs of coal mines and steel plants also took pictures of the workers' housing and its relationship to the places in which these workers labored. Another version of this photograph is "At the steel plant, Midland." The fiche and microfilm editions have the image of this title, and NYPL has the print. The Library of Congress indicates both January 1940 and January 1941 dates for photographs taken in Midland. Delano took a number of photographs in the Pittsburgh area, including Midland, dated January 1941. As noted above, the January 1940 date could not be correct (Delano's first FSA assignment was in Virginia in May 1940).

**Young boy who salvages coal from the slag heaps**
Nanty Glo, 1937
Ben Shahn
Titled digital image: fsa 8a17098 :
    LC-USF33-006226-M3. (P. 38)

*Notes:* Another of Shahn's dramatic photographs of people and their lives with coal. In addition to this titled photograph, there are two untitled ones on the same subject. The fiche and microfilm editions have the titled image, and the Shahn Archive at Harvard University has prints. Reproduced in *Ben Shahn, Photographer: An Album from the Thirties,* ed. Margaret R. Weiss (New York: Da Capo Press, 1973), no. 30.

**Young workers at the steel mill in Midland**
January 1941
Jack Delano
Titled digital image: fsa 8c04479 :
    LC-USF34-043029-D. (P. 167)

*Notes:* Another photograph in the series that Delano created in Midland on the Pittsburgh Crucible Steel Company and the life of its workers. The fiche and microfilm editions have this titled image, and NYPL also has a print. The titles given in different sources vary slightly. The Library of Congress indicates both January 1940 and January 1941 dates for photographs taken in Midland. Delano took a number of photographs in the Pittsburgh area, including Midland, dated January 1941. As noted above, the January 1940 date could not be correct (Delano's first FSA assignment was in Virginia in May 1940).

**Esther Bubley (1921–1998)**

Born in Phillips, Wisconsin, Bubley developed an interest in photography early in life. She completed the photography program at the Minneapolis School of Design and worked briefly for *Vogue* in 1940. One year later, Bubley took a position as a darkroom technician for the Farm Security Administration project. Roy Stryker soon began to give her photographic assignments. When the FSA-OWI effort came to an end, she went with Stryker to the Standard Oil of New Jersey project. She later worked for *Life* and rejoined Stryker as a staff photographer on the Pittsburgh Photographic Project. Bubley's Pennsylvania photos are all part of a photo-essay that she did of a Greyhound bus trip that originated in Washington, D.C., and stopped in Pittsburgh.

**John Collier (1913–1992)**

Originally from Sparkhill, New York, Collier studied painting at the California School of Fine Arts (now the San Francisco Art Institute) from 1931 to 1935. He was mainly self-taught in photography but did study informally with Dorothea Lange in San Francisco while he worked as a freelancer and as a photographic assistant in a commercial studio. Roy Stryker hired him as part of the Farm Security Administration project in 1941, and Collier stayed when the project moved to the Office of War Information. He joined the U.S. Merchant Marine in 1943 and served until the end of the war, after which he worked with Stryker on the Standard Oil of New Jersey photographic project. He later freelanced for a number of magazines, including *Fortune* and *Ladies' Home Journal*. During the latter part of his career, Collier concentrated on anthropological photographic studies. His noteworthy work for the FSA-OWI in Pennsylvania documents the Montour No. 4 Mine near Pittsburgh and Amish and Mennonite society in Lancaster County.

**Marjory Collins (1912–1985)**

Collins was born in New York City and attended Sweet Briar College in Virginia. After a divorce in 1935, Collins moved to Greenwich Village and began to attend lectures at the Photo League. She worked for Black Star and the Associated Press until Roy Stryker invited her to join the photographers at the Farm Security Administration. Collins worked for the FSA and for the Office of War Information when the photographic project transferred there. After the war, she freelanced and became active in social movements, especially the civil rights and women's movements. Collins's work in Pennsylvania centered on Lancaster County—and especially on Lancaster, Lititz, and Manheim. Her most famous photo-essay is a portrait of life in the community of Lititz during the war.

**Jack Delano (1914–1997)**

Born in Kiev, Delano emigrated from Russia to arrive in Philadelphia, where he received all of his schooling and graduated from the Pennsylvania Academy of Fine Arts. He took his first photographs while traveling in Europe during 1936 and 1937, and he returned home to a job as a photographer with the New Deal's Works Progress Administration. Delano joined the Farm Security Administration photographic project in 1940 and stayed on when the project moved to the Office of War Information. In 1943 he left the OWI to serve in the U.S. Army Corps of Engineers. After the war, Delano spent most of his time in Puerto Rico as a photographer, arts administrator, book illustrator, and filmmaker. He was among the most prolific FSA-OWI photographers in Pennsylvania. He ranged across the state, emphasizing western Pennsylvania steel towns such as Aliquippa, Beaver Falls, and

Midland. In addition, Delano documented the anthracite coal regions of northeastern Pennsylvania, especially Mauch Chunk (now Jim Thorpe) in Carbon County and the bituminous coal regions of central Pennsylvania, particularly around Du Bois.

## Walker Evans (1903–1975)

Evans was born in St. Louis, Missouri, and attended Phillips Academy and Williams College. Evans began making photographs in the 1920s, and he took photos for the Farm Security Administration for several years in the mid-1930s. He worked in a straightforward style, often photographing the American vernacular—signs, buildings, and people—as the truest representation of experience. In 1938 the Museum of Modern Art established Evans's place in the pantheon of American photography with a seminal exhibition devoted to the previous ten years of his work. He solidified his reputation with a landmark collaboration with the writer James Agee that produced a book entitled *Let Us Now Praise Famous Men* (1941). This account of cotton sharecroppers in the South during the Depression, with text by Agee and photos by Evans, contained what have come to be some of Evans's most famous images. He was a major contributor to *Fortune* magazine between 1945 and 1965. Evans's best-known photos for the FSA in Pennsylvania were taken in Easton and Bethlehem, located in the eastern part of the state. He also photographed in the western part of Pennsylvania, however, especially in Pittsburgh, in Johnstown, and at the U.S. Resettlement Administration's subsistence homestead project in Westmoreland County.

## Dorothea Lange (1895–1965)

Lange was, along with Walker Evans, perhaps the most established of the Farm Security Administration photographers when the project began. Born in Hoboken, New Jersey, she studied photography at Columbia University and then opened a portrait studio in San Francisco in 1919. But it was her documentation of the ravages of the Great Depression that brought her to Roy Stryker's attention. In the early 1930s, she began to photograph the unemployed and disadvantaged of San Francisco. Paul Taylor, whom she later married, hired her to take photographs of migrant workers for the California State Emergency Relief Administration. This led Lange to a job with the Resettlement Administration (later renamed the Farm Security Administration) in 1935. As best as can be determined, Lange took only two photos in Pennsylvania—both of an old man in the vicinity of Washington, located in the southwestern corner of the state. It is likely that they were taken while she was returning to California from Washington, D.C.

## Russell Lee (1903–1986)

Lee was born in Ottawa, Illinois, and graduated from Lehigh University in Bethlehem, Pennsylvania, with a degree in chemical engineering. He subsequently left the profession to study painting and photography. Roy Stryker hired Lee as a Farm Security Administration photographer in 1936. Lee left the FSA-OWI project to work for the U.S. Air Transport Command during World War II, but he rejoined Stryker on the Standard Oil of New Jersey project in 1947. Lee settled in Austin, Texas, where he taught at the University of Texas from 1965 to 1973 while continuing to work as a freelance photojournalist. He was one of the most prolific of the FSA-OWI photographers, but he apparently created very few images of Pennsylvania. There is one known photograph that Lee took in the Commonwealth—an image of a barn in the eastern part of the state.

## Carl Mydans (b. 1907)

Born and raised in Boston, Mydans graduated from Boston University in 1930. For the next several years he worked as a freelance writer and then as a reporter for *American Banker* magazine. During this period, he also studied photography at the Brooklyn Institute of Arts and Sciences. Mydans joined the Farm Security Administration project in 1935, but he left in 1937 when he was hired as one of the first five photographers for the newly founded *Life* magazine. As a combat photographer, Mydans covered major campaigns in World War II in the Pacific and in Europe as well as the Chinese Civil War and the Korean and

Indochina Wars. He was captured by the Japanese and held as a prisoner of war for more than eight months. After he retired from *Life* in 1972, he worked as a photojournalist for *Time* magazine. Mydans's limited work for the FSA in Pennsylvania centered on rural areas in Northampton County and on the American Radiator Company Mine in Mt. Pleasant, Westmoreland County.

## Edwin Rosskam (1903–1985)

Rosskam immigrated to the United States with his parents from Munich, Germany, in 1919. He studied painting at the Philadelphia Academy of Art and spent several years in Paris and Polynesia before returning to the United States. In 1936 he and his wife, Louise Rosskam, joined the staff of the *Philadelphia Record* as a photographic team. From 1938 to 1943, Rosskam worked for the Farm Security Administration and the Office of War Information as an editor and layout artist, but also, occasionally, as a photographer. He joined the Standard Oil of New Jersey project in 1943 and, with his wife, he documented petrochemical plants and life on the Mississippi River, a effort that resulted in the publication of *Towboat River* in 1948. Though his photographs are documentary, his art training frequently led to compositions that incorporate a strong sense of design and scale. Rosskam worked mostly in central Pennsylvania for the FSA, particularly around Huntingdon, Pine Grove Mills, and State College.

## Arthur Rothstein (1915–1985)

Born in New York City, Rothstein met Roy Stryker at Columbia University in 1934. He collaborated with Stryker soon after by supplying photographs to illustrate a book on agriculture that Stryker was writing. Rothstein was the first photographer hired when Stryker began the Resettlement Administration (later the Farm Security Administration) project, but he left the project to join the staff of *Look* magazine. During World War II he enlisted and served in the Pacific theater as a photographer for the U.S. Army Signal Corps. After the war he rejoined *Look,* where he served as director of photography until 1971. He was an associate editor of *Parade* magazine until his death. Rothstein was easily one of the most prolific of the FSA photographers in Pennsylvania. Although he worked in various parts of the state, he concentrated on the effects of the Depression on the steel towns of western Pennsylvania, especially Pittsburgh, Aliquippa, Ambridge, and Midland.

## Ben Shahn (1898–1969)

Best known as a painter and graphic artist, the Lithuanian-born Shahn's greatest period of photographic productivity took place between 1935 and 1938. He was one of the first members of the Documentary Photography Section of the Farm Security Administration. Before and after his FSA period, Shahn used photographs mainly as aids for his drawing and painting, but in his work with the FSA, Shahn paid less attention to the technical aspects of photography and more to its potential as a medium through which to document the effects of the Great Depression on social conditions and individual lives. (For a time, he shared a studio with Walker Evans.) Shahn worked mostly in western Pennsylvania for the FSA: he documented the U.S. Resettlement Administration's subsistence homestead project in Westmoreland County as well as the effects of the Depression on the coal mining town of Nanty Glo, located near Johnstown in Cambria County.

## Arthur Siegel (1913–1978)

Born in Detroit, Siegel studied photography under László Moholy-Nagy at the New Bauhaus School in Chicago during 1937 and 1938. He later turned his attention to documentary photography, working as a freelancer for several newspapers and magazines as well as for the Farm Security Administration project and the Associated Press. After the war, Siegel devoted most of his time to teaching at the Chicago Institute of Design, but he also became well known for his architectural photography of Chicago. His main work in Pennsylvania involved a photo-essay he did of the W. Atlee Burpee Seed Company in Philadelphia for the Office of War Information.

## John Vachon (1914–1975)

Vachon was born in St. Paul, Minnesota, and he graduated from St. Thomas College in St. Paul. Self-taught as a photographer, he joined the Farm Security Administration in 1936 as a messenger and moved quickly to a position as a staff photographer. He stayed on when the photographic project was transferred to the Office of War Information and remained with it until the project ended in 1943. Vachon and several other FSA photographers moved with Stryker to the Standard Oil of New Jersey photographic project in 1943. He later became a staff photographer for *Life* and *Look* magazines. Vachon was one of the most active FSA-OWI photographers in Pennsylvania. His work centered on the steel towns of western Pennsylvania, especially Pittsburgh, Ambridge, Aliquippa, and Midland. His photo-essay on the strike of agricultural workers in Morrisville, Bucks County, is noteworthy: it is the only documentation of labor strife in the Pennsylvania FSA photos.

## Paul Vanderbilt (1905–1992)

Vanderbilt received his early education in Europe and in Massachusetts public schools. He later attended Amherst College and Harvard University, graduating with a major in art history in 1927. In addition to his brief work with the Farm Security Administration project, he was a librarian, archivist, editor, and consultant on the staffs of the Philadelphia Museum of Art (1929–41), the Library of Congress (1946–54), and the State Historical Society of Wisconsin, where he curated the iconographic collections and served as a field photographer until his retirement in 1972. For reasons that remain obscure, few of the FSA photographers chose to portray Philadelphia. Vanderbilt was the exception. All of his work with the FSA in Pennsylvania took place in the City of Brotherly Love and environs.

## Marion Post Wolcott (1910–1990)

Marion Post Wolcott studied at the New School for Social Research and New York University before receiving her B.A. degree in 1934 from the University of Vienna, Austria. She then began her career as a photographer by studying with Ralph Steiner. In 1937 and 1938 she worked as a staff photographer for the *Philadelphia Evening Bulletin;* between 1938 and 1941, she worked in the Documentary Photography Section of the Farm Security Administration. For the next three decades she dropped out of professional photography, but she resumed her career in 1974 as a freelancer. Wolcott's limited work for the FSA in Pennsylvania centered on the south-central part of the state around Lancaster and York.

# NOTES

*Foreword*

1. Alan Trachtenberg, *Reading American Photographs* (New York: Hill and Wang, 1989), 195.

2. See Sekula, "The Body and the Archive," in *The Contest of Meaning,* ed. Richard Bolton (Cambridge: The MIT Press, 1989), 373: "Increasingly, photographic archives were seen as central to a bewildering range of empirical disciplines, ranging from art history to military intelligence."

3. John Vachon, "Standards of the Documentary File," typescript in Roy Stryker Papers, Special Collections, University of Louisville. The original is typed entirely in capital letters.

4. I am drawing on Eric Sandeen's *Picturing an Exhibition: The Family of Man and 1950s America* (Albuquerque: University of New Mexico Press, 1995).

*Pennsylvania from Depression to War*

Relatively little has been written that focuses specifically on Pennsylvania during the Great Depression and World War II. General histories of the Commonwealth deal with the period, but only in a summary way, as would be expected in books that cover the story from 1682 onward. Fortunately, we have benefited from the work of a small band of scholars who delved into the history of the period. Credit must first go to Thomas H. Coode, John F. Bauman, and their collaborators for producing *People, Poverty, and Politics: Pennsylvanians During the Great Depression* (Lewisburg: Bucknell University Press, 1981) and to Richard C. Keller for *Pennsylvania's Little New Deal* (New York: Garland Press, 1982). These books stand as the only two comprehensive treatments of the period, and we have drawn heavily on them to support this book's narrative. Bruce Stave's *The New Deal and the Last Hurrah: Pittsburgh Machine Politics* (Pittsburgh: University of Pittsburgh Press, 1970) illuminates the political sea change brought on by the Great Depression. Other valuable sources include Ari Hoogenboom and Philip S. Klein's *History of Pennsylvania* (University Park: The Pennsylvania State University Press, 1982) and Nelson McGeary's excellent biography, *Gifford Pinchot: Forester Politician* (Princeton: Princeton University Press, 1960).

A handful of invaluable articles supplements the available scholarly literature. For details and insights on the work of New Deal relief agencies in Pennsylvania, we consulted Priscilla Ferguson Clements's "The Works Progress Administration in Pennsylvania: 1935–1940," *Pennsylvania Magazine of History and Biography* 95 (April 1971): 244–60; James H. Henwood's "Experiment in Relief: The Civil Works Administration in Pennsylvania," *Pennsylvania History* 39 (January 1972): 50–71; Thomas H. Coode and John F. Bauman's "Depression Report: A New Dealer Tours Eastern Pennsylvania," *Pennsylvania Magazine of History and Biography* 104 (January 1980): 96–109; Kenneth E. Hendrickson Jr.'s "The Civilian Conservation Corps in Pennsylvania: A Case Study of a New Deal Relief Agency in Operation," *Pennsylvania Magazine of History and Biography* 100 (January 1976): 66–96; Joseph D. Cornwall's "Back to the Land: Pennsylvania's New Deal Era Communities," *Pennsylvania Heritage* 10 (Summer 1984): 12–17; and Mary Ellen Romeo's "The Greatest Thing That Ever Happened to Us Country People," *Pennsylvania Heritage* 12 (Spring 1986): 4–11. The effect of the New Deal on politics in Philadelphia, and especially the role of African Americans and the city's ethnic groups, is the subject of John L. Shover's "Emergence of a Two-Party System in Philadelphia," *Journal of American History* 60 (April 1976).

While this is the first book to deal with the Farm Security Administration–Office of War Information photographic project in Pennsylvania, there exists a large literature on the national project written by photographic historians and critics. Much of this writing takes the form of essays, often accompanying catalogs of exhibitions or as prefatory material in books that showcase a selection of the photographs. Of particular value for this project were the essays by Lawrence W. Levine and Alan Trachtenberg in *Documenting America, 1935–1943,* ed. Carl Fleischhauer and Beverly W. Brannan (Berkeley and Los Angeles: University of California Press, 1988), and especially Michael Carlebach and Eugene F. Provenzo Jr.'s introduction to *Farm Security Administration Photographs of Florida* (Gainesville: University Press of Florida, 1993). Also useful were the brief memoirs by Roy Stryker, Arthur Rothstein, and John Vachon that appear in *Just Before the War: Urban America from 1935 to 1941 as Seen by Photographers of the Farm Security Administration,* with an introduction by Thomas H. Garver and prefatory notes by Arthur Rothstein, John Vachon, and Roy Stryker (New York: October House, 1968), and Hiag Akmakjian's preface to *The Years of Bitterness and Pride: Farm*

*Security Administration, FSA Photographs, 1935–1943* (New York: McGraw-Hill, 1975).

1. Frederick Lewis Allen, *Only Yesterday* (New York: Harper and Row, 1959), 252.

2. H. L. Mencken, *Prejudices: Sixth Series* (New York: Alfred E. Knopf, 1927), 187.

3. Coode and Bauman, *People, Poverty, and Politics*, 30.

4. Keller, *Little New Deal*, 71.

5. Ibid., 79, 80, 88.

6. Ibid., 71.

7. Ibid., 218.

8. Henwood, "Experiment in Relief," 51–52; McGeary, *Gifford Pinchot*, 370–72.

9. Hoogenboom and Klein, *History of Pennsylvania*, 453.

10. Ibid., 441.

11. Ibid., 454.

12. Ibid., 454; McGeary, *Gifford Pinchot*, 400.

13. Keller, *Little New Deal*, 103.

14. Ibid., 122.

15. Hoogenboom and Klein, *History of Pennsylvania*, 455–56.

16. Ibid., 456–57.

17. Keller, *Little New Deal*, 225.

18. Ibid., 242–43.

19. Ibid., 262.

20. Hoogenboom and Klein, *History of Pennsylvania*, 459.

21. Ibid.

22. Keller, *Little New Deal*, 69–70.

23. Peter Gottlieb, "Shaping a New Labor Movement, 1917–1941," in *Keystone of Democracy: A History of Pennsylvania Workers*, ed. Howard Harris and Perry K. Blatz (Harrisburg: Pennsylvania Historical and Museum Commission, 1999), 189.

24. Henwood, "Experiment in Relief," 54–55.

25. Ibid., 57; Coode and Bauman, "Depression Report," 101–2, 104.

26. Coode and Bauman, "Depression Report," 98.

27. Henwood, "Experiment in Relief," 55.

28. Ibid., 59.

29. Coode and Bauman, *People, Poverty, and Politics*, 166.

30. Hendrickson, "Civilian Conservation Corps," 73.

31. Stefan Lorant, *Pittsburgh: The Story of an American City* (Lenox, Mass.: Authors Editions, 1980), 357.

32. Hoogenboom and Klein, *History of Pennsylvania*, 460.

33. Clement, "Works Progress Administration," 246.

34. Romeo, "The Greatest Thing," 5.

35. Ibid., 9.

## The FSA-OWI Photographic Project

1. Carlebach and Provenzo, *Photographs of Florida*, 22–23.

2. Akmakjian, *Years of Bitterness and Pride*, preface.

3. Carlebach and Provenzo, *Photographs of Florida*, 31.

4. Ibid., 27.

5. "Arthur Rothstein," in *Just Before the War*, ed. Garver.

6. Lawrence W. Levine, "The Historian and the Icon: Photography and the History of the American People in the 1930s and 1940s," in *Documenting America*, ed. Fleischhauer and Brannan, 25.

7. Akmakjian, *Years of Bitterness and Pride*, preface.

8. Carlebach and Provenzo, *Photographs of Florida*, 27.

9. Alan Trachtenberg, "From Image to Story: Reading the File," in *Documenting America*, ed. Fleischhauer and Brannan, 60.

10. Ibid., 62.

11. Ibid.

12. Levine, "The Historian and the Icon," 39.

13. Carlebach and Provenzo, *Photographs of Florida*, 40.

14. "John Vachon," in *Just Before the War*, ed. Garver.

15. "Small Town in Wartime," in *Documenting America*, ed. Fleischhauer and Brannan, 252.

16. Levine, "The Historian and the Icon," 30.

# RESOURCES AND SELECTED BIBLIOGRAPHY

## Records of the FSA-OWI Photographs on the Internet

*These collections consist of digital images of the FSA-OWI photographs. The most complete compilation is on the Library of Congress Web site, but other institutions also have selected collections of prints created from the original negatives located at the Library of Congress.*

"America from the Great Depression to World War II: Photographs from the FSA-OWI, 1935–1945." Prints and Photographs Division, Library of Congress. American Memory Historical Collection for the National Digital Library. December 15, 1998. Available: <http://memory.loc.gov/ammem/fsowhome.html>. [Note: This links to the thousands of photographs on the Library of Congress Web site. Black-and-white photographs can be searched at <http://lcweb2.loc.gov/pp/fsaquery.html>, and color photographs can be searched at <http://lcweb2.loc.gov/pp/fsacquery.html>.]

"Ben Shahn at Harvard." Harvard University Art Museums. February 4, 2000. Available: <http://www.artmuseums.harvard.edu/Shahn/index.html>.

"Roy Stryker Papers." Series 4: Photographs. University of Louisville Libraries. 1999.

Available: <http://digilib.kyvl.org/dynaweb/kyvldigs>.

## FSA-OWI Records on Microforms

*America, 1935–1946. The FSA/OWI Photographs.* Cambridge, England: Chadwyck-Healey; Teaneck, N.J.: Somerset House, 1980. [Note: Includes 1,502 microfiche; northeast region (including Pennsylvania), 434 fiche. Guide to the collection: *America, 1935–1946: Index to the Microfiche* (Cambridge, England: Chadwyck-Healey, 1981).]

FSA-OWI Written Records, 1935–1946. Washington, D.C.: Library of Congress, n.d. [Note: Includes 23 microfilm reels. A guide accompanies the set: see Annette Melville, *Farm Security Administration, Historical Section: A Guide to Textual Records in the Library of Congress* (Washington, D.C.: Library of Congress, 1985).]

*Roy E. Stryker Papers, 1912–1972.* Sanford, N.C.: Microfilming Corporation of America, [1978–81]; distributed by Chadwyck-Healey. [Note: Includes 14 microfilm reels. A guide accompanies the set: see David G. Horvath, ed., *Roy E. Stryker Papers, 1912–1972: A Guide to the Microfilm Edition* (Sanford, N.C.: Microfilming Corporation of America, 1982).]

*U.S. Farm Security and Office of War Information [Collection].* Washington, D.C.: Library of Congress Photoduplication Service, [1943–8-?] [Note: Includes 109 microfilm reels. This is the set with the so-called lots. The title is a corrupted form of the FSA and OWI that presumably was provided by the Photoduplication Service and appears on the boxes of microfilm. Guide: *Library of Congress: Photograph Section: Index to Microfilm Reproductions in the Photograph Section: Series A, Lots 1–1737 (1946)*. There is also an internal index in the Reading Room of the Prints and Photographs Division, Library of Congress.]

U.S. Office of War Information. *Information Control and Propaganda: Records of the Office of War Information [1942–1945].* Edited by David H. Culbert. Frederick, Md.: University Publications of America, 1987. [Note: Includes 27 microfilm reels. Accompanied by pamphlet by Janice H. Mitchell and Nanette Dobrosky.]

## Papers of the FSA-OWI Photographers

*Information on the papers of individual photographers can be found in the National Union Catalog of Manuscript Collections (NUCMC),*

located at <http://lcweb.loc.gov/coll/nucmc/nucmc.html>.

Collins, Marjory. Papers. Schlesinger Library, Radcliffe College. Cambridge, Mass.

Delano, Jack. Papers. Archives of American Art, Smithsonian Institution. Washington, D.C.

*Documenting America, 1935–1943.* Project Records. Supplementary Archives, Prints and Photographs Division, Library of Congress. Washington, D.C.

Lange, Dorothea. Papers. Oakland Museum of California. Oakland, Calif.

Lee, Russell. Papers. Southwest Texas State University. San Marcos, Tex.

Rothstein, Arthur. Papers. Archives of American Art, Smithsonian Institution. Washington, D.C.

Shahn, Ben. Papers. Archives of American Art, Smithsonian Institution. Washington, D.C.

Stryker, Roy E. Papers. Archives of American Art, Smithsonian Institution. Washington, D.C.

Vanderbilt, Paul. Papers. Archives of American Art, Smithsonian Institution. Washington, D.C.

Wolcott, Marion Post. Papers. Center for Creative Photography, University of Arizona. Tucson, Ariz.

## Interviews with the Photographers and Others Associated with the Project

*Interviews in the collection of the Archives of American Art, Smithsonian Institution, Washington, D.C., are available through the Interlibrary Loan departments of libraries. More information on the collection and its accessibility is available at the Archives Web site: see <http://artarchives.si.edu>. This information pertains to the major figures in the FSA-OWI photographic project. There were no interviews found in the Archives of American Art or any other repositories for Sheldon Dick, Pauline Ehrlich, Howard Hollem, or Edwin Locke.*

Bubley, Esther. Interview by Beverly W. Brannan. March 6, 1986. *Documenting America, 1935–1943* Project Records, Supplementary Archives, Prints and Photographs Division, Library of Congress.

Collier, John. Interview by Richard Doud. January 18, 1965. Archives of American Art.

———. Monologue. March 1959. Archives of American Art. [Note: "This is a tape made by John Collier for Roy Stryker."]

Delano, Jack. Interview by Richard Doud. June 12, 1965. Archives of American Art.

Evans, Walker. Interviews by Paul Cummings. October 13–December 23, 1971. Archives of American Art.

———. *Walker Evans: Incognito.* New York: Eakins Press Foundation, 1995. [Note from colophon: "Edited by Leslie George Katz and Walker Evans in 1971. The text with eight photographs reproduced here first appeared in *Art in America* (March/April 1971)."]

Javitz, Romana. Interview by Richard Doud. February 23, 1965. Archives of American Art. [Note: Javitz was the first director of the New York Public Library Picture Collection. The NYPL has an extensive FSA print collection.]

Lange, Dorothea. "Dorothea Lange: The Making of a Documentary Photographer." Interviews by Suzanne Riess. Berkeley: Bancroft Library, Regional Oral History Office, University of California, 1968. [Note: Interviews held between October 1960 and August 1961.]

———. Interview by Richard Doud. May 22, 1964. Archives of American Art.

Lee, Jean. Interview by Carl Fleischhauer and Beverly W. Brannan. April 30, 1986. *Documenting America, 1935–1943* Project Records, Supplementary Archives, Prints and Photographs Division, Library of Congress.

Lee, Russell, and Jean Lee. Interview by Richard Doud. June 2, 1964. Archives of American Art.

Mydans, Carl. Interview by Richard Doud. April 29, 1964. Archives of American Art.

Rosskam, Edwin, and Louise Rosskam. Interview by Richard Doud. August 3, 1965. Archives of American Art.

Rothstein, Arthur. Interview by Richard Doud. May 25, 1964. Archives of American Art.

———. "Showing Reality." Interview by Leslie G. Kelen. Salt Lake City: Oral History Institute, 1994.

Shahn, Ben. Interview by Richard Doud. April 14, 1964. Archives of American Art.

Shahn, Bernarda Bryson. Interview by Pamela J. Meecham. July 3, 1995. Archives of American Art. [Note: Bernarda Shahn was Ben Shahn's wife and close collaborator, and she accompanied him on his FSA assignments.]

Siegel, Arthur. Interviews by James McQuaid and Elaine King. Chicago, October 29–November 6, 1977. Oral History Project, International Museum of Photography at George Eastman House, Rochester, N.Y.

Stryker, Roy Emerson. Interviews by Richard Doud. October 17, 1963; June 13–14, 1964; January 23, 1965. Archives of American Art. [Note: Stryker was the director of the Farm Security Administration Historical Section. He hired the FSA photographers and directed their assignments.]

Tugwell, Rexford. Interview by Richard Doud. January 21, 1965. Archives of American Art. [Note: Tugwell was an administrator for the Resettlement Administration, which later became the Farm Security Administration. He worked with Roy Stryker.]

Vachon, John. Interview by Richard Doud. April 28, 1964. Archives of American Art.

Vanderbilt, Paul. Interview by Richard Doud. November 10, 1964. Archives of American Art.

Wolcott, Marion Post. Interview by Richard Doud. January 18, 1965. Archives of American Art.

## Works Cited in On-line Catalog as Sources for Published Photographs

Bendavid-Val, Leah. *Propaganda and Dreams: Photographing the 1930s in the USSR and the U.S.* New York: Edition Stemmle, 1999.

Berger, Maurice. FSA: *The Illiterate Eye: Photographs from the Farm Security Administration.* Catalog of an exhibition held at Hunter College Art Gallery, New York, November 26, 1985–January 10, 1986. New York: Hunter College Art Gallery, 1985.

Daniel, Peter, et al. *Official Images: New Deal Photography.* Washington, D.C.: Smithsonian Institution Press, 1987.

Evans, Walker. *American Photographs.* With an essay by Lincoln Kirstein. New York: Museum of Modern Art, 1988.

———. *Walker Evans at Work: 745 Photographs Together with Documents Selected from Letters, Memoranda, Interviews, Notes.* With an essay by Jerry L. Thompson. New York: Harper and Row, 1982.

———. *Walker Evans, First and Last.* New York: Harper and Row, 1978.

———. *Walker Evans: Photographs for the Farm Security Administration, 1935–1938: A Catalog of Photographic Prints Available from the Farm Security Administration Collection in the Library of Congress.* With an introduction by Jerald C. Maddox. New York: Da Capo Press, 1973.

Fisher, Andrea. *Let Us Now Praise Famous Women: Women Photographers for the U.S. Government, 1935–1944.* London: Pandora, 1987.

Fleischhauer, Carl, and Beverly W. Brannan, eds. *Documenting America, 1935–1943.* Berkeley and Los Angeles: University of California Press, 1988.

Hambourg, Maria Morris, Jeff L. Rosenheim, Douglas Eklund, and Mia Fineman. *Walker Evans.* New York: Metropolitan Museum of Art in association with Princeton University Press, 2000.

Hurley, F. Jack. *Portrait of a Decade: Roy Stryker and the Development of Documentary Photography in the Thirties.* Baton Rouge: Louisiana State University Press, 1972.

*Just Before the War: Urban America from 1935 to 1941 as Seen by Photographers of the Farm Security Administration.* With an introduction by Thomas H. Garver and prefatory notes by Arthur Rothstein, John Vachon, and Roy Stryker. Catalog of an exhibition held at the Newport Harbor [Calif.] Art Museum, September 30–November 10, 1968, and the Library of Congress, February 14–March 30, 1969. New York: October House, 1968.

Lesy, Michael. *Long Time Coming: A Photographic Portrait of America, 1935–1943.* New York: Norton, 2002.

MacLeish, Archibald. *Land of the Free.* New York: Harcourt Brace, 1938.

Papageorge, Tod. *Walker Evans and Robert Frank: An Essay on Influence.* Catalog of an exhibition held at the Yale University Art Gallery, January 21–March 15, 1981. [New Haven]: Yale University Art Gallery, 1981.

*People and Places of America: Farm Security Administration Photography of the 1930s.* An exhibition organized by Richard Kubiak and held at the Santa Barbara [Calif.] Museum of Art, October 15–November 20, 1977.

Pratt, Davis, ed. *The Photographic Eye of Ben Shahn.* Cambridge: Harvard University Press, 1975.

Rothstein, Arthur. *The Depression Years as Photographed by Arthur Rothstein.* New York: Dover, 1978.

Stryker, Roy Emerson, and Nancy Wood. *In This Proud Land: America, 1935–1943, as Seen in the FSA Photographs.* Greenwich, Conn.: New York Graphic Society; New York: Galahad Books, 1973.

*U.S. Camera Annual.* 1939.

*Walker Evans.* With an introduction by John Szarkowski. New York: Museum of Modern Art, 1971.

Weiss, Margaret R., ed. *Ben Shahn, Photographer: An Album from the Thirties.* New York: Da Capo Press, 1973.

*The Years of Bitterness and Pride: Farm Security Administration, FSA Photographs, 1935–1943.* New York: McGraw-Hill, 1975.

## Selected Bibliographies for Individual Photographers

### ESTHER BUBLEY

Bubley, Esther. *Esther Bubley's World of Children in Photographs.* New York: Dover, 1981.

"Cross-Country Bus Trip." In *Documenting America, 1935–1943,* ed. Carl Fleischhauer and Beverly W. Brannan, 312–14. Berkeley and Los Angeles: University of California Press, 1988.

Dieckmann, Katherine. "A Nation of Zombies." *Art in America* 77, no. 11 (1989): 55. [Note: Photographer Esther Bubley's pictures from a 1943 bus ride across America.]

Ellis, Jacqueline. "Revolutionary Spaces: Photographs of Working-Class Women by Esther Bubley, 1940–1943." *Feminist Review* 53 (Summer 1996): 74.

———. *Silent Witnesses: Representations of Working-Class Women in the United States.* Bowling Green: Bowling Green State University Popular Press, 1998.

*Esther Bubley on Assignment: Photographs Since 1939: An Exhibition.* Curated by Tyrone Georgiou and Cheryl St. George. Buffalo, N.Y.: Bethune Gallery, University at Buffalo, 1989.

Fisher, Andrea. *Let Us Now Praise Famous Women: Women Photographers for the U.S. Government, 1935–1944.* London: Pandora, 1987.

Lemann, Nicholas. "Esther Bubley's America." *American Heritage* 52, no. 3–4 (2001): 66.

Loke, Margarett. "Documenting America, From Industrial Behemoth to Sweet Innocent." *New York Times,* August 17, 2001, B28+. [Note: Exhibition held at the UBS Paine Webber Art Gallery, New York City.]

Obituary. *New York Times,* March 20, 1998, A20.

Plattner, Steven W. *Roy Stryker, U.S.A., 1943–1950: The Standard Oil (New Jersey) Photography Project.* Austin: University of Texas Press, 1983.

### JOHN COLLIER

Collier, John, Jr. *Cultural Energy.* An exhibition held at the Field Museum of Natural History, Chicago, September 19–November 8, 1987.

———. *Visual Anthropology: Photography as a Research Method.* New York: Holt, Rinehart, and Winston, 1967.

Doty, C. Stewart. *Acadian Hard Times: The Farm Security Administration in Maine's St. John Valley, 1940–1943.* With photographs by John Collier Jr., Jack Delano, and Jack Walas. Orono: University of Maine Press, 1991.

Doty, C. Stewart, Dale S. Mudge, and Herbert J. Benally. *Photographing Navajos: John Collier, Jr. on the Reservation, 1948–1953.* Albuquerque: University of New Mexico Press, 2002.

Fondiller, Harvey V. "Color Photographs of the Farm Security Administration." *Popular Photography*, January 1964, 26.

"John Collier, Jr.: A Visual Journey." [Berkeley]: University of California Extension Center for Media and Independent Learning, 1993. [Note: Videorecording: VHS tape, 1 videocassette (approx. 26 min., 30 sec.).]

Lee, Russell. *Far from Main Street: Three Photographers in Depression-Era New Mexico.* With photographs by Russell Lee, John Collier Jr., and Jack Delano and essays by J. B. Colson et al. Santa Fe: Museum of New Mexico Press, 1994.

Obituary. *New York Times*, March 5, 1992, A16+.

O'Neal, Hank. *A Vision Shared: A Classic Portrait of America and Its People, 1935–1943.* New York: St. Martin's Press, 1976.

MARJORY COLLINS

Fisher, Andrea. *Let Us Now Praise Famous Women: Women Photographers for the U.S. Government, 1935–1944.* London: Pandora, 1987.

JACK DELANO

Delano, Jack. *Photographic Memories.* Washington: Smithsonian Institution Press, 1997.

———. *Puerto Rico Mio: Four Decades of Change = Cuatro Decadas de Cambio: Pho-tographs by Jack Delano.* Washington: Smithsonian Institution Press, 1990.

Doty, C. Stewart. *Acadian Hard Times: The Farm Security Administration in Maine's St. John Valley, 1940–1943.* With photographs by John Collier Jr., Jack Delano, and Jack Walas. Orono: University of Maine Press, 1991.

Fondiller, Harvey V. "Color Photographs of the Farm Security Administration." *Popular Photography*, January 1964, 26.

Goldberg, Vicki. "Introducing the Poor to the Middle Class." *New York Times*, November 3, 1991, sec. 2, H35(N), H35(L).

Lee, Russell. *Far from Main Street: Three Photographers in Depression-Era New Mexico.* With photographs by Russell Lee, John Collier Jr., and Jack Delano and essays by J. B. Colson et al. Santa Fe: Museum of New Mexico Press, 1994.

"Making Ordinary People Important." *Chronicle of Higher Education* 38, no. 36 (1992): B40.

Natanson, Nicholas. *The Black Image in the New Deal: The Politics of FSA Photography.* Knoxville: The University of Tennessee Press, 1992.

Obituary. *New York Times*, August 5, 1997, C20.

O'Neal, Hank. *A Vision Shared: A Classic Portrait of America and Its People, 1935–1943.* New York: St. Martin's Press, 1976.

Ranck, Rosemary. Review of *Far from Main Street: Three Photographers in Depression-Era New Mexico,* by Russell Lee, with photographs by Russell Lee, John Collier Jr., and Jack Delano. *New York Times Book Review,* August 14, 1994, 18.

Valle, James E. *The Iron Horse at War: The United States Government's Photodocumentary Project on American Railroading During the Second World War.* Berkeley, Calif.: Howell-North Books, 1977. [Note: Includes 272 photos by Jack Delano.]

SHELDON DICK

Mackie, Edith, and Sheldon Dick. *Mexican Journey: An Intimate Guide to Mexico.* New York: Dodge Publishing, [1935].

PAULINE EHRLICH

Fisher, Andrea. *Let Us Now Praise Famous Women: Women Photographers for the U.S. Government, 1935–1944.* London: Pandora, 1987.

WALKER EVANS

Agee, James, and Walker Evans. *Let Us Now Praise Famous Men: Three Tenant Families.* Boston: Houghton Mifflin, 1941.

Brannan, Beverly W., and Judith Keller. "Walker Evans: Two Albums in the Library of Congress." *History of Photography* 19, no. 1 (1995): 60–66.

Cummings, Paul. *Artists in Their Own Words.* New York: St. Martin's Press, 1979.

Epstein, Daniel Mark. "The Passion of Walker Evans." *New Criterion* 18 (March 2000): 14.

Evans, Walker. *American Photographs.* With an essay by Lincoln Kirstein. New York: Museum of Modern Art, 1988.

———. *Many Are Called.* With an introduction by James Agee. Boston: Houghton Mifflin, 1966.

———. *Message from the Interior.* New York: Eakins Press, [1966].

———. *Walker Evans.* New York: Aperture Foundation, 1993.

———. *Walker Evans.* New York: Sidney Janis Gallery, 1978.

———. *Walker Evans, America.* Edited by Michael Brix and Birgit Mayer with an essay by Michael Brix. New York: Rizzoli, 1991.

———. *Walker Evans: An Exhibition of Photographs by Walker Evans from the Collection of the Museum of Modern Art, New York.* Selected by John Szarkowski and organized by the Department of Circulating Exhibitions, Museum of Modern Art. Circulated in Canada by The National Gallery of Canada. [Ottawa: Queen's Printer, 1966].

———. *Walker Evans at Work: 745 Photographs Together with Documents Selected from Letters, Memoranda, Interviews, Notes.* With an essay by Jerry L. Thompson. New York: Harper and Row, 1982.

———. *Walker Evans, First and Last.* New York: Harper and Row, 1978.

———. *Walker Evans: Photographs.* Catalog of an exhibition circulated under the auspices of the International Council of the Museum of Modern Art, New York, and Held at the Museum of Modern Art, Oxford. [London]: Arts Council of Great Britain, 1976.

———. *Walker Evans: Photographs for the Farm Security Administration, 1935–1938: A Catalog of Photographic Prints Available from the Farm Security Administration Collection in the Library of Congress.* With an introduction by Jerald C. Maddox. New York: Da Capo Press, 1973.

———. *Walker Evans: Photographs from the Let Us Now Praise Famous Men Project.* Austin: University of Texas, 1974.

———. *Walker Evans: The Lost Work.* Santa Fe: Arena Editions, 2000.

Goldberg, Vicki. "Introducing the Poor to the Middle Class." *New York Times,* November 3, 1991, sec. 2, H35(N), H35(L).

Greenough, Sarah. *Walker Evans: Subways and Streets.* Washington, D.C.: National Gallery of Art, 1991.

Hambourg, Maria Morris, Jeff L. Rosenheim, Douglas Eklund, and Mia Fineman. *Walker Evans.* New York: Metropolitan Museum of Art in association with Princeton University Press, 2000.

Keller, Judith. "Walker Evans and *Many Are Called.*" *History of Photography* 17, no. 2 (1993): 152.

———. *Walker Evans: The Getty Museum Collection.* Malibu, Calif.: J. Paul Getty Museum, 1995.

Kimmelman, Michael. "Not Easy to Like, But Impossible to Forget." *New York Times,* February 4, 2000, B27(N); E29(L).

Kingston, Rodger. *Walker Evans in Print: An Illustrated Bibliography.* Bellmont, Mass.: P. R. Kingston Photographs, 1995.

Lacks, Cecilia. "Documentary Photography: A Way of Looking at Ourselves." Ph.D. diss., Saint Louis University, 1987.

Lane, Anthony. "The Eye of the Land: How Walker Evans Reinvented American Photography." *The New Yorker,* March 13, 2000, 14.

Maharidge, Dale, and Michael Williamson. *And Their Children After Them: The Legacy of* Let Us Now Praise Famous Men: *James Agee, Walker Evans, and the Rise and Fall of Cotton in the South.* New York: Pantheon Books, 1989.

Mayer, Henry. "Famous Men." *New York Times Book Review,* May 14, 2000, 47.

Mellows, James R. *Walker Evans.* New York: Basic Books, 1999.

Mora, Gilles. *Walker Evans: The Hungry Eye.* New York: Abrams, 1993.

Natanson, Nicholas. *The Black Image in the New Deal: The Politics of FSA Photography*. Knoxville: The University of Tennessee Press, 1992.

Obituary. *New York Times*, April 11, 1975, 11.

Olin, Margaret. "'It Is Not Going to Be Easy to Look into Their Eyes': Privilege of Perception in *Let Us Now Praise Famous Men*." *Art History* 14, no. 1 (1991): 92.

O'Neal, Hank. *A Vision Shared: A Classic Portrait of America and Its People, 1935–1943*. New York: St. Martin's Press, 1976.

Papageorge, Tod. *Walker Evans and Robert Frank: An Essay on Influence*. Catalog of an exhibition held at the Yale University Art Gallery, January 21–March 15, 1981. [New Haven]: Yale University Art Gallery, 1981.

Perl, Jed. "On Art—in the American Grain." *The New Republic*, February 14, 2000, 31.

Rathbone, Belinda. *Walker Evans: A Biography*. Boston: Houghton Mifflin, 1995.

Retman, Sonnet Helene. "The 'Real' Collective in New Deal Documentary and Ethnography: The Federal Writers' Project, the Farm Security Administration, Zora Neale Hurston's *Mules and Men*, and James Agee's and Walker Evans's *Let Us Now Praise Famous Men*." Ph.D. diss., University of California, Los Angeles, 1997.

Rosenheim, Jeff, and Douglas Eklund. *Unclassified: A Walker Evans Anthology: Selections from the Walker Evans Archive, Department of Photographs, Metropolitan Museum of Art*. With Alexis Schwarzenbach. New York: Scalo, 2000.

Rubenfien, Leo. "The Poetry of Plain Seeing." *Art in America* 88 (2000): 74.

Spence, Steven Anderson. "Photographic Culture and the American Thirties." Ph.D. diss., University of Florida, 1999.

Thompson, Jerry L. *The Last Years of Walker Evans: A First-hand Account*. New York: Thames and Hudson, 1997.

*Walker Evans*. With an introduction by John Szarkowski. New York: Museum of Modern Art, 1971.

Wallace, Neal P. "Influencing Public Opinion: The Power of Photographic Imagery." M.A. thesis, University of North Colorado, 1992.

## Dorothea Lange

Arrow, Jan. *Dorothea Lange*. London: Macdonald, 1985.

Borhan, Pierre. *Dorothea Lange: The Heart and Mind of a Photographer*. Boston: Little, Brown, 2002.

Curtis, Charlie. "Signs of the South." *Southern Culture* (Summer 2000): 31.

Curtis, James C. *Dorothea Lange, Migrant Mother, and the Culture of the Great Depression*. Chicago: University of Chicago Press for the Winterthur Museum, 1986.

Davidov, Judith Fryer. "The Color of My Skin, the Shape of My Eyes: Photographs of the Japanese-American Internment by Dorothea Lange, Ansel Adams, and Toyo Miyatake." *Yale Journal of Criticism* 9, no. 2 (1996): 223.

Ellis, Jacqueline. *Silent Witnesses: Representations of Working-Class Women in the United States*. Bowling Green: Bowling Green State University Popular Press, 1998.

Fink, Barbara. "Dorothea Lange." *Christian Science Monitor*, December 3, 1982, sec. B, 6.

Fisher, Andrea. *Let Us Now Praise Famous Women: Women Photographers for the U.S. Government, 1935–1944*. London: Pandora, 1987.

Frankel, Ronni Ann. *Photography and the Farm Security Administration: The Visual Politics of Dorothea Lange and Ben Shahn*. Senior honors thesis, Department of History of Art, Cornell University, 1969.

Gawthrop, Louis C. "Images of the Common Good." *Public Administration Review* 53, no. 6 (1993): 508–15.

Hagen, Charles. "The Images That Penetrated to the Heart of a Weary Era." *New York Times*, March 17, 1995, B1(N), C26(L).

Heyman, Therese Thau. *Celebrating a Collection: The Work of Dorothea Lange*. With contributions by Daniel Dixon, Joyce Minick, and Paul Schuster Taylor. [Oakland, Calif.]: Oakland Museum, 1978. [Note: Issued to accompany a traveling exhibition of photographs selected from the Oakland Museum's Dorothea Lange Collection, organized by and first shown at

the Oakland Museum in the summer of 1978.]

Heyman, Therese Thau, Sandra S. Phillips, and John Szarkowski. *Dorothea Lange: American Photographs.* San Francisco: San Francisco Museum of Modern Art in association with Chronicle Books, 1994.

Holmstrom, David. "The Humanity Behind the Despair." *Christian Science Monitor,* July 5, 1994, 12.

Keller, Judith. *Dorothea Lange: Photographs from the J. Paul Getty Museum.* Los Angeles: J. Paul Getty Museum, 2002.

King, Hailey. "American Women Photographers of the Depression: Dorothea Lange and Marion Post Wolcott." Senior thesis, Colorado College, 2000.

Lacks, Cecilia. "Documentary Photography: A Way of Looking at Ourselves." Ph.D. diss., Saint Louis University, 1987.

Lange, Dorothea. *Dorothea Lange: Farm Security Administration Photographs, 1935–1939: From the Library of Congress.* Edited by Howard M. Levin and Katherine Northrup, with writings by Paul S. Taylor and an introduction by Robert J. Doherty. Glencoe, Ill.: Text-Fiche Press, 1980.

———. *Photographs of a Lifetime.* With an essay by Robert Coles and an afterword by Therese Heyman. Millerton, N.Y.: Aperture, 1982.

———. *The Photographs of Dorothea Lange.* [Edited by] Keith F. Davis with contribu-

tions by Kelle A. Botkin. Kansas City, Mo.: Hallmark Cards in association with Abrams, 1995.

Lange, Dorothea, and Paul Schuster Taylor. *An American Exodus: A Record of Human Erosion.* New York: Reynal and Hitchcock, [1939].

*Life and Land: The Farm Security Administration Photographers in Utah, 1936–1941.* Catalog of an exhibition held at the Nora Eccles Harrison Museum of Art, Utah State University, January 10–March 6, 1988. Curated by Peter S. Briggs and with an essay by Brian Q. Cannon. [Salt Lake City]: Nora Eccles Harrison Museum of Art, Utah State University, 1968.

Lippincott, Robin. Review of *Dorothea Lange: A Visual Life,* edited by Elizabeth Partridge. *New York Times Book Review,* March 12, 1995, 18.

McEuen, Melissa A. *Seeing America: Women Photographers Between the Wars.* Lexington: The University Press of Kentucky, 2000.

Meltzer, Milton. *Dorothea Lange: A Photographer's Life.* New York: Farrar, Straus, Giroux, 1978.

Miceli-Hoffman, Gina. "The Madonna and Child Motif in the Photography of Jacob Riis, Lewis W. Hine, and the RA/FSA photographers Ben Shahn, Dorothea Lange, and Russell Lee." M.A. thesis, Northern Illinois University, 1999.

Miller, Wendi. "Stereotypes of Women and Social Class Addressed by Twentieth-Century Women Photographers." M.A. thesis, University of Utah, 1996.

Museum of Modern Art. *Dorothea Lange.* Exhibition catalog. With an introductory essay by George P. Elliott. New York: Museum of Modern Art, [1966]; distributed by Doubleday.

Natanson, Nicholas. *The Black Image in the New Deal: The Politics of FSA Photography.* Knoxville: The University of Tennessee Press, 1992.

Obituary. *New York Times,* October 14, 1965, 47.

Ohrn, Karin Becker. *Dorothea Lange and the Documentary Tradition.* Baton Rouge: Louisiana State University Press, 1980.

O'Neal, Hank. *A Vision Shared: A Classic Portrait of America and Its People, 1935–1943.* New York: St. Martin's Press, 1976.

Partridge, Elizabeth, ed. *Dorothea Lange: A Visual Life.* Washington, D.C.: Smithsonian Institution Press, 1994.

Perchick, Max. "Dorothea Lange: The Greatest Documentary Photographer in the United States." *PSA Journal* 61, no. 6 (1995): 26.

Priest, Jeannette Smothers. "Four Definitions of Women in Dorothea Lange's Great Depression Photographs: A Feminist Cluster Analysis." M.A. thesis, Regent University, 2001.

Rachleff, Melissa. "Scavenging the Landscape: Walker Evans and American Life." *Afterimage* 23, no. 4 (1996): 7.

Rasmussen, Evelyn Becker. "Secret Places of the Heath: An Investigation into the Developmental Life Cycle of Photographer Dorothea Lange." M.S. thesis, San Jose State University, 1979.

Tsujimoto, Karen. *Dorothea Lange: Archive of an Artist.* With an introduction by Therese Thau Heyman. Oakland, Calif.: Oakland Museum of California, 1995.

Wallace, Neal P. "Influencing Public Opinion: The Power of Photographic Imagery." M.A. thesis, University of North Colorado, 1992.

Wilson, Stephanie K. "A Personal Vision: The Life of Dorothea Lange." M.A. thesis, California State University at Dominguez Hills, 1996.

RUSSELL LEE

Berland, Dinah. "Russell Lee, in the Service of History." *Los Angeles Times,* May 1, 1983, sec. C, p. 88.

Fondiller, Harvey V. "Color Photographs of the Farm Security Administration." *Popular Photography,* January 1964, 26.

Greene, Janet Wells. "Camera Wars: Images of Coal Miners and the Fragmentation of Working-Class Identity, 1933–1947." Ph.D. diss., New York University, 2000.

Hurley, F. Jack. *Russell Lee, Photographer.* Dobbs Ferry, N.Y.: Morgan and Morgan, 1978.

Lee, Russell. *Far from Main Street: Three Photographers in Depression-Era New Mexico.* With photographs by Russell Lee, John Collier Jr., and Jack Delano and essays by J. B. Colson et al. Santa Fe: Museum of New Mexico Press, 1994.

———. *Russell Lee.* [Edited by] Thomas A. Livesay. Amarillo, Tex.: Amarillo Art Center, 1979. [Note: Exhibition organized by the International Museum of Photography at George Eastman House.]

———. *Russell Lee: A Portfolio of Photographs.* Rochester, N.Y.: International Museum of Photography at George Eastman House, 1973.

———. *Russell Lee: Retrospective Exhibition, 1934–64.* Exhibition held at the Upper Gallery, University Art Museum of the University of Texas, Austin, February 28–March 29, 1965.

———. *Russell Lee's FSA Photographs of Chamisal and Penasco, New Mexico.* Edited by William Wroth. Santa Fe: Ancient City Press; Colorado Springs: Taylor Museum of the Colorado Springs Fine Arts Center, 1985.

*Life and Land: The Farm Security Administration Photographers in Utah, 1936–1941.* Catalog of an exhibition held at the Nora Eccles Harrison Museum of Art, Utah State University, January 10–March 6, 1988.

Curated by Peter S. Briggs and with an essay by Brian Q. Cannon. [Salt Lake City]: Nora Eccles Harrison Museum of Art, Utah State University, 1968.

Margolis, Eric. "In the Footsteps of Russell Lee." *Society* 26, no. 2 (1989): 77.

Miceli-Hoffman, Gina. "The Madonna and Child Motif in the Photography of Jacob Riis, Lewis W. Hine, and the RA/FSA Photographers Ben Shahn, Dorothea Lange, and Russell Lee." M.A. thesis, Northern Illinois University, 1999.

Murphy, Mary. "Picture/Story: Representing Gender in Montana Farm Security Administration Photographs." *Frontiers* 22, no. 3 (2001): 93.

Natanson, Nicholas. *The Black Image in the New Deal: The Politics of FSA Photography.* Knoxville: The University of Tennessee Press, 1992.

Obituary. *New York Times,* August 30, 1986, 31.

O'Neal, Hank. *A Vision Shared: A Classic Portrait of America and Its People, 1935–1943.* New York: St. Martin's Press, 1976.

Smyth, Russell. *Retracing Russell Lee's Steps: A New Documentary.* Exhibition catalog. [San Marcos]: Southwest Texas State University, 1992.

Thorton, Gene. "Country People Were His Inspiration." *New York Times,* September 26, 1982, sec. 2, H25.

Wilson, Taylor H. "Documentary Photography and the Great Depression: A Historical

Analysis of the Farm Security Administration Photographs of Russell Lee." B.A. thesis, Amherst College, 1985.

CARL MYDANS

"Almanac." *Life* 20, no. 5 (1997): 40.

Higgins, Marguerite. *"War in Korea": The Report of a Woman Combat Correspondent.* Garden City, N.Y.: Doubleday, 1951.

Loke, Margarett. "A Witness to History, From War's Generals to Poverty's Victims." *New York Times,* November 12, 1999, B38.

Manning, Jack. "Carl Mydans, Photojournalist." *New York Times,* October 6, 1985, sec. 7, p. 28.

Morgan, Thomas. "A Photographer Looks at War and Peace." *New York Times,* January 23, 1986, 18.

Mydans, Carl. "The Best Job in the World." *Time,* Fall 1989, 49.

———. *Carl Mydans, Photojournalist.* With an interview by Philip B. Kunhardt Jr. New York: Abrams, 1985.

———. *More Than Meets the Eye.* New York: Harper [1959].

———. "Photographer: Alfred Eisenstaedt's Works Show His Tireless Curiosity and the Real Genius Behind the Lens." *Los Angeles Times,* August 28, 1995, F1.

Mydans, Carl, and Michael Demarest. *China: A Visual Adventure.* New York: Simon and Schuster, 1979.

Mydans, Carl, and Shelley Mydans. *The Violent Peace.* New York: Atheneum, 1968.

*Ohio: A Photographic Portrait, 1935–1941: Farm Security Administration Photographs.* By Carl Mydans et al. An exhibition organized by Carolyn Kinder Carr. Akron, Ohio: Akron Art Institute, 1980; distributed by The Kent State University Press.

O'Neal, Hank. *A Vision Shared: A Classic Portrait of America and Its People, 1935–1943.* New York: St. Martin's Press, 1976.

Orkent, Daniel. "Constant Companion." *Life* 19, no. 11–12 (1996): 8.

ALFRED PALMER

Carson, Jeanie Cooper. "Interpreting National Identity in Time of War: Competing Views in United States Office of War Information (OWI) Photography, 1940–1945." Ph.D. diss., Boston University, 1995.

ANN ROSENER

Fisher, Andrea. *Let Us Now Praise Famous Women: Women Photographers for the U.S. Government, 1935–1944.* London: Pandora, 1987.

EDWIN ROSSKAM

Rosskam, Edwin. *The Alien.* New York: Grossman, 1964.

———. *Roosevelt, New Jersey: Big Dreams in a Small Town and What Time Did to Them.* New York: Grossman, 1972.

———. *San Francisco, West Coast Metropolis.* With an introduction by William Saroyan. New York: Alliance Book, [1939].

Rosskam, Edwin, and Louise Rosskam. *Towboat River.* New York: Duell, Sloan, and Pearce, 1948.

Rosskam, Edwin, and Ruby A. Black. *Washington, Nerve Center.* With an introduction by Eleanor Roosevelt. New York: Longmans, Green, [1939].

Wright, Richard. *12 Million Black Voices: A Folk History of the Negro in the United States.* With photo-direction by Edwin Rosskam. New York: Viking Press, 1941.

LOUISE ROSSKAM

Fisher, Andrea. *Let Us Now Praise Famous Women: Women Photographers for the U.S. Government, 1935–1944.* London: Pandora, 1987.

ARTHUR ROTHSTEIN

*Arthur Rothstein: 200 Photographs. A George Eastman House Exhibition with the cooperation of Look Magazine.* Rochester, N.Y.: George Eastman House, 1956.

"Arthur Rothstein, His Words and Pictures." *PSA Journal,* July 1984, 12.

Daniel, Peter, ed. *America in the Depression Years.* With a preface by Arthur Rothstein. Laurel, Md.: Instructional Resources, 1979. [Note: Includes 450 slides of the FSA-OWI, and a guide.]

Fondiller, Harvey V. "Color Photographs of the Farm Security Administration." *Popular Photography*, January 1964, 26.

Gilleson, Lewis W., and Arthur Rothstein. "Photography Gets a Museum." *Look* 14, no. 3 (1950): 49.

Hagen, Charles. "Arthur Rothstein." *New York Times*, November 18, 1994, C22.

Huang, Edgar Shaohua. "Afterthoughts on the Truth Strategy in Rothstein's Skull Photograph." *News Photographer*, January 1999, VCQ8.

*Just Before the War: Urban America from 1935 to 1941 as Seen by Photographers of the Farm Security Administration.* With an introduction by Thomas H. Garver and prefatory notes by Arthur Rothstein, John Vachon, and Roy Stryker. Catalog of an exhibition held at the Newport Harbor [Calif.] Art Museum, September 30–November 10, 1968, and the Library of Congress, February 14–March 30, 1969. New York: October House, 1968.

"Just Folks." *New York*, September 30, 1985, 26.

Kaufman, James. Review of *Arthur Rothstein's America in Photographs, 1930–1980. Christian Science Monitor*, February 1, 1985, sec. B, 8.

Kiel, Colleen. "Documentary Photography." *Modern Photography* 52, no. 7 (1988): 12.

*Life and Land: The Farm Security Administration Photographers in Utah, 1936–1941.* Catalog of an exhibition held at the Nora Eccles Harrison Museum of Art, Utah State University, January 10–March 6, 1988. Curated by Peter S. Briggs and with an essay by Brian Q. Cannon. [Salt Lake City]: Nora Eccles Harrison Museum of Art, Utah State University, 1968.

Natanson, Nicholas. *The Black Image in the New Deal: The Politics of FSA Photography.* Knoxville: The University of Tennessee Press, 1992.

Obituary. *New York Times*, November 12, 1985, D34(L) and November 13, 1985, 18(N).

O'Neal, Hank. *A Vision Shared: A Classic Portrait of America and Its People, 1935–1943.* New York: St. Martin's Press, 1976.

Rothstein, Arthur. *The American West in the Thirties: 122 Photographs by Arthur Rothstein.* New York: Dover, 1981.

———. *Arthur Rothstein's America in Photographs, 1930–1980.* New York, Dover, 1984.

———. *Arthur Rothstein, Words and Pictures.* New York: Amphoto/Billboard Publications, 1979.

———. *Color Photography Now.* New York: American Photographic Book, 1970.

———. *Creative Color in Photography.* Philadelphia: Chilton Books, 1962.

———. *The Depression Years as Photographed by Arthur Rothstein.* New York: Dover, 1978. [Note: *The Depression Years* was reviewed in the *New York Times*, May 28, 1978, 23.]

———. "Direction in the Picture Story." *The Complete Photographer* 21 (10 April 1942): 1356–63. [Note: Revised version in *The Encyclopedia of Photography 7*, edited by Willard D. Morgan (New York: Greystone Press, 1974).]

———. *Documentary Photography.* Boston: Focal Press, 1986.

———. *Photojournalism.* 4th ed. Garden City, N.Y.: Amphoto, 1979.

Saroyan, William. *Look at Us; Let's See; Here We Are; Look Hard, Speak Soft; I See, You See, We All See; Stop, Look, Listen; Beholder's Eye; Don't Look Now, but Isn't That You? (US? U.S.?)* With photographs by Arthur Rothstein. New York: Cowles Education, 1967.

Taniguchi, Nancy J. "The Other Utahns: A Photographic Portfolio." *Journal of the West* 29, no. 1 (1990): 98.

Traver, Joe. "His Strong Images Pass Test of Time." *News Photographer* 50, no. 3 (1995): 4.

United States. Farm Security Administration. Photographs of Migrant Camps [graphic], 1938–40. Berkeley: Bancroft Library, University of California. [Note: Includes 38 black-and-white photographic prints primarily by Arthur Rothstein.]

University of Utah. Oral History Institute. *The Other Utahns: A Photographic Portfolio: Photographs from the Oral History Institute's Ethnic and Minority Documentary Project.* Edited by Leslie G. Kelen and Sandra T. Fuller. Photographs by George Janecek, Kent Miles, and Arthur Rothstein.

Salt Lake City: University of Utah Press, 1988.

BEN SHAHN

Allen, Henry. "Snapshots of the Soul: Ben Shahn's Depression Era Photographs Focus on Lives and Spirits, Not Politics." *Washington Post*, June 25, 2000, G01.

Baker, Kenneth. "When Artists Became Workers." *ARTnews* 96, no. 4 (1997): 138. [Note: Exhibition held at the Judah L. Magnes Museum, Berkeley, Calif.]

Beachley, DeAnna E. "Ben Shahn and Art as Weapons." Ph.D. diss., Northern Arizona University, 1997.

Brownlee, Peter. "Ben Shahn's New York: The Photography of Modern Times." *American Studies International* 39, no. 2 (2001): 96.

Carlisle, John Charles. "A Biographical Study of How the Artist Became a Humanitarian Activist: Ben Shahn, 1930–1946." Ph.D. diss., University of Michigan, 1972.

Cohen, David. "Art for the Workers' Sake: The Painter Ben Shahn Was Proud to Be a Propagandist." *New York Times Book Review*, January 17, 1999, 18.

"A Different Lens on Ben Shahn's Work." *The Christian Science Monitor*, March 20, 2000, G01.

Edwards, Susan H. *Ben Shahn and the Task of Photography in Thirties America.* Catalog of an exhibition held at Hunter College of the City University of New York, February 8–March 25, 1995. New York: Hunter College, 1995.

———. "Ben Shahn: A New Deal Photographer in the Old South." Ph.D. diss., City University of New York, 1996.

Eskedal, Jeanette Budicin. "Ben Shahn: His Philosophy, Style and Development." M.A. thesis, Michigan State University, 1967.

Frankel, Ronni Ann. *Photography and the Farm Security Administration: The Visual Politics of Dorothea Lange and Ben Shahn.* Senior honors thesis, Department of History of Art, Cornell University, 1969.

Goldberg, Vicki. "In a Leftist's Lens, the 'Common Man' of a Dark Decade." *New York Times*, December 3, 2000, AR33.

———. "Looking at the Poor in a Gilded Frame: A Series of Recent Photography Shows Suggest Real Concern About Poverty—and a Wish to Deal with It at Arm's Length." *New York Times*, April 9, 1995, H1.

Greenfeld, Howard. *Ben Shahn: An Artist's Life.* New York: Random House, 1998.

Hagen, Charles. "The Shahn Who Could Break Free of Politics." *New York Times*, February 20, 1995, B5.

Institute of Contemporary Art (Boston). *Ben Shahn: A Documentary Exhibition, April 10 to May 31.* Exhibition catalog. [Boston]: The Institute, 1957.

Janet Lehr, Inc. *Beyond the Image: Present and Past: Photographs by Marilyn Bridges, Rick Dingus, Ben Shahn, Harold Edgerton, Arthur F. Gay, Eadweard Muybridge.* New York: Janet Lehr, 1983.

Katzman, Laura. "The Politics of Media: Ben Shahn and Photography." Ph.D. diss., Yale University, 1997.

———. "The Politics of Media: Painting and Photography in the Art of Ben Shahn." *American Art* 7, no. 1 (1993): 60.

Miceli-Hoffman, Gina. "The Madonna and Child Motif in the Photography of Jacob Riis, Lewis W. Hine, and the RA/FSA Photographers Ben Shahn, Dorothea Lange, and Russell Lee." M.A. thesis, Northern Illinois University, 1999.

Morse, John D. *Ben Shahn.* New York: Praeger, [1972].

Natanson, Nicholas. *The Black Image in the New Deal: The Politics of FSA Photography.* Knoxville: The University of Tennessee Press, 1992.

Obituary. *New York Times*, March 15, 1969, 1.

O'Neal, Hank. *A Vision Shared: A Classic Portrait of America and Its People, 1935–1943.* New York: St. Martin's Press, 1976.

Pohl, Frances Kathryn. *Ben Shahn: New Deal Artist in a Cold War Climate, 1947–1954.* Austin: University of Texas Press, 1989.

———. *Ben Shahn, with Ben Shahn's Writings.* San Francisco: Pomegranate ArtBooks, 1993.

Pratt, Davis, ed. *The Photographic Eye of Ben Shahn.* Cambridge: Harvard University Press, 1975.

Ricci, Daniel J. "Ben Shahn, Art as Documentary: 1932–1947." B.A. thesis, Lake Forest College, 1990.

Ritchin, Fred. "Ben Shahn's New York: The Photography of Modern Times." *Print* 54, no. 5 (2000): 54.

Rodman, Selden. *Portrait of the Artist as an American: Ben Shahn, a Biography with Pictures.* New York: Harper, [1951].

Sadler, Kimberely E. "Ben Shahn: Moving Toward a Universal Idea." Honors thesis, University of Nebraska, 1993.

Shahn, Ben. *The Art of Ben Shahn.* Exhibition catalog. Cambridge, Mass.: Fogg Art Museum, Harvard University, 1956.

———. *Ben Shahn: A Retrospective, 1898–1969.* Catalog of an exhibition held at the Jewish Museum, New York, October 20, 1976–January 2, 1977. Curated by Kenneth W. Prescott. New York: The Museum, 1976.

———. *Ben Shahn as Photographer.* Catalog of an exhibition held at the Fogg Art Museum, Cambridge, Mass., October 29–December 14, 1969. [Cambridge, Mass.: Fogg Art Museum, Harvard University, 1969.]

———. *Ben Shahn: Photographs.* Storrs, Conn.: William Benton Museum of Art, University of Connecticut, 1983.

[Note: Catalog of an exhibition held November 28–December 22, 1983. Based on a 1976 essay by Mark Greenberg.]

———. *Ben Shahn Retrospective Exhibition, Japan 1991.* Tokyo: Fukushima Prefectural Museum of Art, 1991. [Note: Exhibition held at five art museums in Japan, May 9–November 11, 1991. Curated by Kenneth W. Prescott.]

———. *Ben Shahn's New York: The Photography of Modern Times.* Essays by Deborah Martin Kao, Laura Katzman, and Jenna Webster. Cambridge, Mass.: Fogg Art Museum, Harvard University Art Museums; New Haven: Yale University Press, 2000.

———. *Ben Shahn, the Thirties.* [Williamstown, Mass.: Williams College Museum of Art, 1977.] [Note: Catalog of an exhibition held in November 1977. Exhibition organized by Jay Richard DiBiaso; catalog edited by Franklin W. Robinson; text by Bernarda Bryson Shahn; photographs lent by Prakapas Gallery, New York.]

———. *Ben Shahn, Voices and Visions: Exhibition, September 18–October 31, 1981.* With Alma S. King and John Canaday. Santa Fe: Santa Fe East/Sunshine Press, 1981.

———. *The Shape of Content.* Cambridge: Harvard University Press, 1957.

Shahn, Bernarda Bryson. *Ben Shahn.* New York: Abrams, [1972].

Soby, James Thrall. *Ben Shahn.* [West Dayton, England]: Penguin Books, [1947].

Weinberg, Jonathan. "Ben Shahn: Picture Maker." *Art Journal* (Spring 2001): 104.

Weiss, Margaret R., ed. *Ben Shahn, Photographer: An Album from the Thirties.* New York: Da Capo Press, 1973.

ARTHUR SIEGEL

Siegel, Arthur. *Arthur Siegel: Retrospective.* An exhibition held September 10–October 30, 1982. Chicago: Edwynn Houk Gallery, 1982.

Siegel, Arthur, and J. Carson Webster. *Chicago's Famous Buildings: A Photographic Guide to the City's Architectural Landmarks and Other Notable Buildings.* 2d ed., rev. and enl. Chicago: University of Chicago Press, 1969.

JOHN VACHON

Fondiller, Harvey V. "Color Photographs of the Farm Security Administration." *Popular Photography,* January 1964, 26.

Hoffman, Eva. Review of *Poland, 1946: The Photographs and Letters of John Vachon. New York Times Book Review,* January 28, 1996, 21.

*Just Before the War: Urban America from 1935 to 1941 as Seen by Photographers of the Farm Security Administration.* With an introduction by Thomas H. Garver and prefatory notes by Arthur Rothstein, John Vachon, and Roy Stryker. Catalog of an exhibition held at the Newport Harbor

[Calif.] Art Museum, September 30–November 10, 1968, and the Library of Congress, February 14–March 30, 1969. New York: October House, 1968.

Morgan, Thomas B. "John Vachon: A Certain Look." *American Heritage* 40, no. 1 (1989): 94.

"Notes from the Road: The Way America Was—as Told in the Letters and Photos of Famed Photographer John Vachon." *American Photo* 2, no. 3 (1991): 44.

O'Neal, Hank. *A Vision Shared: A Classic Portrait of America and Its People, 1935–1943.* New York: St. Martin's Press, 1976.

Vachon, John. *Poland, 1946: The Photographs and Letters of John Vachon.* Edited by Ann Vachon and with an introduction by Brian Moore. Washington, D.C.: Smithsonian Institution Press, 1995.

PAUL VANDERBILT

Vanderbilt, Paul. *Between the Landscape and Its Other.* Baltimore: The Johns Hopkins University Press, 1993.

MARION POST WOLCOTT

Boddy, Julie. "The Farm Security Administration Photographs of Marion Post Wolcott: A Cultural History." Ph.D. diss., State University of New York at Buffalo, 1984.

Carson, Jeanie Cooper. "Interpreting National Identity in Time of War: Competing Views in United States Office of War Information

(OWI) Photography, 1940–1945." Ph.D. diss., Boston University, 1995.

Ellis, Jacqueline. *Silent Witnesses: Representations of Working-Class Women in the United States.* Bowling Green: Bowling Green State University Popular Press, 1998.

Fisher, Andrea. *Let Us Now Praise Famous Women: Women Photographers for the U.S. Government, 1935–1944.* London: Pandora, 1987.

Fondiller, Harvey V. "Color Photographs of the Farm Security Administration." *Popular Photography,* January 1964, 26.

Glueck, Grace. "Marion Post Wolcott." *New York Times,* March 15, 1998, B35(N), E35(L).

Hendrickson, Paul. *Looking for the Light: The Hidden Life and Art of Marion Post Wolcott.* New York: Knopf, 1992.

———. "What Made Her Stop." *Life* 15, no. 5 (1992): 80.

Hurley, F. Jack. *Marion Post Wolcott: A Photographic Journey.* With a foreword by Robert Coles. Albuquerque: University of New Mexico Press, 1989.

King, Hailey. "American Women Photographers of the Depression: Dorothea Lange and Marion Post Wolcott." Senior thesis, Colorado College, 2000.

McEuen, Melissa A. *Seeing America: Women Photographers Between the Wars.* Lexington: The University Press of Kentucky, 2000.

Miller, Wendi. "Stereotypes of Women and Social Class Addressed by Twentieth-Cen-

tury Women Photographers." M.A. thesis, University of Utah, 1996.

O'Neal, Hank. *A Vision Shared: A Classic Portrait of America and Its People, 1935–1943.* New York: St. Martin's Press, 1976.

Ranck, Rosemary. Review of *Looking for the Light: The Hidden Life and Art of Marion Post Wolcott. New York Times Book Review,* July 12, 1998, 18.

Thornton, Gene. "People Won Out Over Landscapes." *New York Times,* June 24, 1984, H27.

"What a Time She Had! (Fifty Years and Counting . . . )" *News Photographer* 50, no. 4 (1995): F2.

Wolcott, Marion Post. *FSA Photographs and Recent Works.* Exhibition catalog. [Amarillo, Texas]: Amarillo Art Center, 1979.

———. *Marion Post Wolcott.* Catalog of an exhibition held at the Robert B. Menschel Photography Gallery, September 1–October 12, 1986. Syracuse, N.Y.: The Gallery, [1986].

———. *Marion Post Wolcott: FSA Photographs.* With an introduction by Sally Stein. Carmel, Calif.: Friends of Photography, 1983.

**Books with Pennsylvania Photographs, Some of Which May Include FSA-OWI Photographs**

Becher, Bernd, and Hilla Becher. *Pennsylvania Coal Mine Tipples.* Catalog of an exhibition

held December 14, 1989–June 21, 1991. New York: Dia Center for the Arts, 1991.

Beck, Tom. *George M. Bretz, Photographer in the Mines.* [Catonsville]: University of Maryland Baltimore County Library, 1977.

Blake, Jody, and Jeannette Lasansky. *Rural Delivery: Real Photo Postcards from Central Pennsylvania, 1905–1935.* [Lewisburg, Pa.]: Union County Historical Society, 1996.

Coleman, Bill. *Amish Odyssey: Photographs by Bill Coleman.* New York: Van der Marck Editions, 1988.

Dinteman, Walter. *Anthracite Ghosts.* Scranton: The University of Scranton Press, 1995.

Fegley, H. Winslow. *Farming, Always Farming: A Photographic Essay of Rural Pennsylvania German Land and Life.* With an introduction by Scott T. Swank. Birdsboro, Pa.: Pennsylvania German Society, 1987.

Friedlander, Lee. *Factory Valleys: Ohio and Pennsylvania.* New York: Callaway Editions, 1982.

Kane, Martin W., Christopher T. Baer. *Works: Photographs of Enterprise.* Catalog of an exhibition held May 2–December 30, 1992. Wilmington, Del.: Hagley Museum and Library, 1992; distributed by the University of Pennsylvania Press.

Miller, George. *A Pennsylvania Album: Picture Postcards, 1900–1930.* University Park: The Pennsylvania State University Press, 1979.

Niemeyer, Lucian. *Old Order Amish: Their Enduring Way of Life.* With text by Donald Kraybill. Baltimore: The Johns Hopkins University Press, 1993.

*Pittsburgh Revealed: Photographs Since 1850.* Catalog of an exhibition held November 8, 1997–January 25, 1998. With an introduction by Jan Beatty. Pittsburgh: Carnegie Museum of Art, 1997.

Powell, Pamela C. *Reflected Light: A Century of Photography in Chester County.* Catalog of an exhibition held October 1, 1998–February 12, 1999. Edited by Ann Barton Brown. West Chester, Pa.: Chester County Historical Society, 1988.

Scranton, Philip, and Walter Licht. *Work Sights: Industrial Philadelphia, 1890–1950.* Philadelphia: Temple University Press, 1986.

Seitz, Ruth Hoover. *Amish Country.* With photographs by Blair Seitz. New York: Crescent Books, 1987.

Smith, Arthur G. *Pittsburgh, Then and Now.* Pittsburgh: University of Pittsburgh Press, 1990.

Stryker, Roy Emerson, and Mel Seidenberg. *A Pittsburgh Album.* Rev. ed. Pittsburgh: Pittsburgh Post Gazette, 1986. [Note: The title of the earlier edition (from 1959) was *A Pittsburgh Album, 1758–1958: Two Hundred Years of Memories in Pictures and Text.*]

Testa, Randy-Michael. *In the Valley of the Shadow: An Elegy to Lancaster County.* With photographs by Ed Worteck. Hanover: University Press of New England, 1996.

Wallace, Kim E., ed. *The Character of a Steel Mill City: Four Historic Neighborhoods of Johnstown, Pennsylvania.* With contributions by Natalie Gillespie et al. Washington, D.C.: Historic American Buildings Survey/Historic American Engineering Record, National Park Service, 1989.

Warner, James A. *The Quiet Land.* New York: Grossman, 1970.

## Selected General Bibliography

*American Photographers of the Depression: Farm Security Administration Photographs, 1935–1942.* With an introduction by Charles Hagan. New York: Pantheon Books, 1985.

Anderson, Sherwood. *Home Town.* With photographs by Farm Security Photographers. New York: Alliance Book, 1940.

Baldwin, Sidney. "The Farm Security Administration: A Study in Politics and Administration." Ph.D. diss., Syracuse University, 1955.

———. *Poverty and Politics: The Rise and Decline of the Farm Security Administration.* Chapel Hill: The University of North Carolina Press, 1968.

Banfield, Edward C. *Government Project.* With a foreword by Rexford G. Tugwell. Glencoe, Ill.: Free Press, [1951].

Bendavid-Val, Leah. *Propaganda and Dreams: Photographing the 1930s in the USSR and the U.S.* New York: Edition Stemmle, 1999.

Bennett, William Edward. "The Concept of Community: A Study of the Communitarian Programs of the New Deal." Ph.D. diss., University of Southern Mississippi, 1983.

Berger, Maurice. FSA: The Illiterate Eye: Photographs from the Farm Security Administration. Catalog of an exhibition held at Hunter College Art Gallery, New York, November 26, 1985–January 10, 1986. New York: Hunter College Art Gallery, 1985.

Bernstein, Irving. A Caring Society: The New Deal, the Worker, and the Great Depression: A History of the American Worker, 1933–1941. Boston: Houghton Mifflin, 1985.

Bezner, Lili Corbus. Photography and Politics in America: From the New Deal into the Cold War. Baltimore: The Johns Hopkins University Press, 1999.

Brannan, Beverly W., and David Horvath, eds. A Kentucky Album: Farm Security Administration Photographs, 1935–1943. Lexington: The University Press of Kentucky, 1986.

Campbell, Edward. "Shadows and Reflections: The Farm Security Administration and Documentary Photography in Kentucky." Register of the Kentucky Historical Society 85, no. 4 (1987): 291.

Carlebach, Michael L. "Art and Propaganda: The Farm Security Administration Photography Project." M.A. thesis, Florida State University, 1980.

Carlebach, Michael L., and Eugene F. Provenzo Jr. Farm Security Administration Photographs of Florida. Gainesville: University Press of Florida, 1993.

Carson, Jeanie Cooper. "Interpreting National Identity in Time of War: Competing Views in United States Office of War Information (OWI) Photography, 1940–1945." Ph.D. diss., Boston University, 1995.

Clements, Priscilla Ferguson. "The Works Progress Administration in Pennsylvania: 1935–1940." Pennsylvania Magazine of History and Biography 95 (April 1971): 244–60.

Conkin, Paul K. Tomorrow a New World: The New Deal Community Program. Ithaca: Cornell University Press, 1959.

Coode, Thomas H., and John F. Bauman. "Depression Report: A New Dealer Tours Eastern Pennsylvania." Pennsylvania Magazine of History and Biography 104 (January 1980): 96–109.

Coode, Thomas H., John F. Bauman, et al. People, Poverty, and Politics: Pennsylvanians During the Great Depression. Lewisburg: Bucknell University Press, 1981.

Cornwall, Joseph D. "Back to the Land: Pennsylvania's New Deal Era Communities." Pennsylvania Heritage 10 (Summer 1984): 12–17.

Cross, Robert W. "The History, Types of Projects, Plans, and Policies of the Farm Security Administration." M.S. thesis, Prairie View A&M College, 1947.

Curtis, James. Mind's Eye, Mind's Truth: FSA Photography Reconsidered. Philadelphia: Temple University Press, 1989.

Dablow, Dean. The Rain Are Fallin: A Search for the People and Places Photographed by the Farm Security Administration in Louisiana, 1935–1943. Tollhouse, Calif.: Scrub Jay Press, 2001.

Daniel, Peter, ed. America in the Depression Years. With a preface by Arthur Rothstein. Laurel, Md.: Instructional Resources, 1979. [Note: Includes 450 slides of the FSA-OWI, and a guide.]

Dinwiddie, Courtenay. How Good Is the Good Earth? A Venture in Re-discovery. New York: National Child Labor Committee, [1942].

Dixon, Penelope. Photographers of the Farm Security Administration: An Annotated Bibliography. New York: Garland Publishing, 1983.

Doty, C. Stewart. Acadian Hard Times: The Farm Security Administration in Maine's St. John Valley, 1940–1943. With photographs by John Collier Jr., Jack Delano, and Jack Walas. Orono: University of Maine Press, 1991.

Dunn, James William. "The Farm Security Administration in the Rural South, 1937–1940." M.S. thesis, Florida State University, 1967.

Finnegan, Cara Anne. "Circulating Images: Visual Rhetorics of Poverty in Farm Security

Administration Documentary Photography." Ph.D. diss., Northwestern University, 1999.

———. *Picturing Poverty: Print Culture and FSA Photographs.* Washington, D.C.: Smithsonian Institute Press, in press.

Fisher, Andrea. *Let Us Now Praise Famous Women: Women Photographers for the U.S. Government, 1935–1944.* London: Pandora, 1987.

Fleischhauer, Carl, and Beverly W. Brannan, eds. *Documenting America, 1935–1943.* Berkeley and Los Angeles: University of California Press, 1988.

Ganzel, Bill. *Dust Bowl Descent.* Lincoln: University of Nebraska Press, 1984.

Gawthrop, Louis C. "Images of the Common Good." *Public Administration Review* 53, no. 6 (1993): 508.

Goldstein, Rodney. "Selling America: Roy Stryker and the Concept of Documentary Photography, 1935–1950." B.A. thesis, Princeton University, 1974.

Greene, Janet Wells. "Camera Wars: Images of Coal Miners and the Fragmentation of Working-Class Identity, 1933–1947." Ph.D. diss., New York University, 2000.

Grey, Michael R. *New Deal Medicine: The Rural Health Programs of the Farm Security Administration.* Baltimore: The Johns Hopkins University Press, 1999.

Guimond, James. *American Photography and the American Dream.* Chapel Hill: The University of North Carolina Press, 1991.

Hendrickson, Kenneth E., Jr. "The Civilian Conservation Corps in Pennsylvania: A Case Study of a New Deal Relief Agency in Operation." *Pennsylvania Magazine of History and Biography* 100 (January 1976): 66–96.

Henwood, James H. "Experiment in Relief: The Civil Works Administration in Pennsylvania." *Pennsylvania History* 39 (January 1972): 50–71.

Holley, Donald. "The Negro in the New Deal Resettlement Program." *Agricultural History* 45, no. 3 (1971): 179.

Hoogenboom, Ari, and Philip S. Klein. *The History of Pennsylvania.* University Park: The Pennsylvania State University Press, 1982.

Hurley, F. Jack. *Portrait of a Decade: Roy Stryker and the Development of Documentary Photography in the Thirties.* Baton Rouge: Louisiana State University Press, 1972.

*Just Before the War: Urban America from 1935 to 1941 as Seen by Photographers of the Farm Security Administration.* With an introduction by Thomas H. Garver and prefatory notes by Arthur Rothstein, John Vachon, and Roy Stryker. Catalog of an exhibition held at the Newport Harbor [Calif.] Art Museum, September 30–November 10, 1968, and the Library of Congress, February 14–March 30, 1969. New York: October House, 1968.

Keller, Richard C. *Pennsylvania's Little New Deal.* New York: Garland Press, 1982.

Keller, Ulrich. *The Highway as Habitat: A Roy Stryker Documentation.* Exhibition catalog. Santa Barbara, Calif.: University Art Museum, 1986.

Kozol, Wendy. "Depiction of Motherhood in Resettlement Administration–Farm Security Administration Photographs." M.A. thesis, University of California, Los Angeles, 1986.

Lacks, Cecilia. "Documentary Photography: A Way of Looking at Ourselves." Ph.D. diss., Saint Louis University, 1987.

Lesy, Michael. *Long Time Coming: A Photographic Portrait of America, 1935–1943.* New York: Norton, 2002.

Leuchtenberg, William E. *Franklin D. Roosevelt and the New Deal, 1932–1940.* New York: Harper and Row, 1963.

*Life and Land: The Farm Security Administration Photographers in Utah, 1936–1941.* Catalog of an exhibition held at the Nora Eccles Harrison Museum of Art, Utah State University, January 10–March 6, 1988. Curated by Peter S. Briggs and with an essay by Brian Q. Cannon. [Salt Lake City]: Nora Eccles Harrison Museum of Art, Utah State University, 1968.

MacLeish, Archibald. *Land of the Free.* New York: Harcourt Brace, 1938.

Maddox, James Gray. "The Farm Security Administration." Ph.D. diss., Harvard University, 1950.

Mayer, Robert A. "Blacks in America: Prejudice, Poverty, and Pride." *USA Today,* May 1988, 48.

McElvaine, Robert S. *The Great Depression: America, 1929–1941.* New York: Times Books, 1984.

McEuen, Melissa A. *Seeing America: Women Photographers Between the Wars.* Lexington: The University Press of Kentucky, 2000.

McGeary, Nelson. *Gifford Pinchot: Forester Politician.* Princeton: Princeton University Press, 1960.

Mehlman, Michael Harris. "The Resettlement Administration and the Problems of Tenant Farmers in Arkansas, 1935–1936." Ph.D. diss., New York University, 1971.

Miller, Alicia. "Muddying the Waters: Color in the Documentary Photography of the Farm Security Administration." M.A. thesis, University of New Mexico, 1996.

Mills, Kathryn Aldrich. "A Study of Farm Security Administration Record Books from Pennsylvania." M.S. thesis, Pennsylvania State College, 1944.

Natanson, Nicholas. *The Black Image in the New Deal: The Politics of FSA Photography.* Knoxville: The University of Tennessee Press, 1992.

*Ohio: A Photographic Portrait, 1935–1941: Farm Security Administration Photographs.* By Carl Mydans et al. An exhibition organized by Carolyn Kinder Carr. Akron, Ohio: Akron Art Institute, 1980; distributed by The Kent State University Press.

O'Neal, Hank. *A Vision Shared: A Classic Portrait of America and Its People, 1935–1943.* New York: St. Martin's Press, 1976.

Panor, Marie. "The Resettlement Administration: A Study in the Evolution of Major Purposes." M.A. thesis, University of Chicago, 1951.

Peeler, David P. *Hope Among Us Yet: Social Criticism and Social Solace in Depression America.* Athens: University of Georgia Press, 1987.

*People and Places of America: Farm Security Administration Photography of the 1930s.* An exhibition organized by Richard Kubiak and held at the Santa Barbara [Calif.] Museum of Art, October 15–November 20, 1977.

Plattner, Steven. *Roy Stryker: U.S.A., 1943–1950.* Austin: University of Texas Press, 1983.

Preston, Catherine L. "In Retrospect: The Construction and Communication of a National Visual Memory." Ph.D. diss., University of Pennsylvania, 1995.

Reid, Robert. *Picturing Texas: The FSA-OWI Photographers in the Lone Star State, 1935–1943.* Austin: State Historical Association, 1994.

Romeo, Mary Ellen. "The Greatest Thing That Ever Happened to Us Country People." *Pennsylvania Heritage* 12 (Spring 1986): 4–11.

*Roy Stryker, the Humane Propagandist.* Exhibition catalog. Edited by James C. Anderson. [Louisville, Ky.: Photographic Archives, University of Louisville], 1977.

Severin, Werner Joseph. "Photographic Documentation by the Farm Security Administration, 1935–1942." M.A. thesis, University of Missouri, 1959.

Shover, John L. "Emergence of a Two-Party System in Philadelphia." *Journal of American History* 60 (April 1976).

Smith, J. Russell. *North America, Its People and the Resources, Development, and Prospects of the Continent as an Agricultural, Industrial, and Commercial Area.* New York: Harcourt, Brace, 1925.

Spence, Steven Anderson. "Photographic Culture and the American Thirties." Ph.D. diss., University of Florida, 1999.

Stange, Maren. *Symbols of Ideal Life: Social Documentary Photography in America, 1890–1950.* New York: Cambridge University Press, 1989.

Stave, Bruce. *The New Deal and the Last Hurrah: Pittsburgh Machine Politics.* Pittsburgh: University of Pittsburgh Press, 1970.

Steichen, Edward. *The Bitter Years, 1935–1941.* New York: Museum of Modern Art, 1962.

Stott, William. *Documentary Expression in Thirties America.* New York: Oxford University Press, 1973.

Stryker, Roy E. "Documentary Photography." *The Complete Photographer* 21 (April 10, 1942): 1364–74. [Note: Revised version in *The Encyclopedia of Photography* 7, edited

by Willard D. Morgan. New York: Grey-stone Press, 1974.]

Stryker, Roy Emerson, and Nancy Wood. *In This Proud Land: America, 1935–1943, as Seen in the* FSA *Photographs.* Greenwich, Conn.: New York Graphic Society; New York: Galahad Books, 1973.

Susman, Warren. *Culture as History: The Transformation of American Society in the Twentieth Century.* New York: Pantheon Books, 1984.

Taylor, Brenda Jeanette. "The Farm Security Administration: Meeting Rural Health Needs in the South, 1933–1946." Ph.D. diss., Texas Christian University, 1994.

Thompson, Kathleen, and Hilary MacAustin, eds. *Children of the Depression.* Bloomington: Indiana University Press, 2001.

Trachtenberg, Alan. *Reading American Photographs: Images as History, Mathew Brady to Walker Evans.* New York: Noonday Press, 1989.

Tugwell, Rexford G., Thomas Munro, and Roy E. Stryker. *American Economic Life and the Means of Improvement.* 3d ed. New York: Harcourt, Brace, 1930.

United States. Farm Security Administration. *The Farm Security Administration.* Washington, D.C.: GPO, 1941.

———. *Resettlement Administration.* Washington, D.C.: GPO, 1936.

———. *Toward Farm Security: The Problem of Rural Poverty and the Work of the Farm Security Administration.* Prepared by Joseph Gaer. Washington, D.C.: GPO, 1941.

Vanderpool, Guy C. *Building for a Better Tomorrow: The Farm Security Administration in Arkansas.* Texarkana, Ark./Tx.: Texarkana Museums System, 1996.

Watkins, T. H. *The Hungry Years: A Narrative History of the Great Depression in America.* New York: Henry Holt, 1999.

White, George Abbott. "Vernacular Photography: FSA Images of Depression Leisure." *Visual Communication* 9, no. 1 (1983): 53–75.

Winkler, Allan M. *The Politics of Propaganda: The Office of War Information, 1942–1945.* New Haven: Yale University Press, 1978.

*The Years of Bitterness and Pride: Farm Security Administration,* FSA *Photographs, 1935–1943.* New York: McGraw-Hill, 1975.